the eight techno logies of other ness

The eight technologies of otherness is a bold and provocative re-thinking of identity, politics, philosophy, ethics and cultural practices – a book which journeys amongst and through the very unholy groundings of corrupted surfaces, shot through with strange time, space, matter, and speed. Old essentialisms and binaric divides collapse under the weight of a new and impatient necessity, which is itself nothing more nor less than the various everyday strategies and technologies of making meaning 'stick'.

But as sue golding asks in her *Word of Warning*, what would happen to the so-called 'postmodern' if we were to stop sterilizing the wounds? If we were to take seriously political freedom; cultural revolution; fear; disease; trash; flesh; multiple ethics; homelessness; rhythm; violence; virtual bodies; computing sciences; boredom; anger; light; experimentation; art – and all the myriad joys and fears that come from a refusal to be comforted by the easy, neat, and clean? The short answer: we would be playing with fire.

The longer answer, in all its tactile rawness, spins out in the eight technologies: **curiosity, noise, cruelty, appetite, skin, nomadism, contamination**, and **dwelling**. These technologies stand, in a way, on their own; and yet are not fully resolved in and of themselves. But why only eight technologies? And why these eight, in particular? The thirty-three artists, philosophers, film-makers, writers, photographers, political militants, and 'pulp-theory' practitioners whose work (or life) has contributed to the re-thinking of 'otherness' to which this book bears witness throw out a few clues. We might wish to say: the unbearable lightness of necessity, suspense, horror . . .

Contributors: Kathy Acker, AJAMU, Shannon Bell, Andrew Benjamin, Steven Berkoff, Pascal Brannan, Carolyn Brown, Anthony Burke, Chila Kumari Burman, Richard A. Etlin, Christopher Fynsk, Sky Gilbert, Paul Gilroy, Sue Golding, Paul Hallam, William Haver, Gad Horowitz, Pierre Gottfried Imhof, Arthur and Marilouise Kroker, Ernesto Laclau, Doreen Massey, Jean-Luc Nancy, Zachary I. Nataf, Joan Nestle, Catherine Opie, Adrian Rifkin, Hans A. Scheirl, Allucquère Rosanne Stone, Jeliça Šumič-Riha, Clive van den Berg, Bernard Walsh, Vron Ware, Jeffrey Weeks.

Sue Golding is a political philosopher and director (theatre/mobile arts/digital media). She was born in New York and currently lives in London, where she is Reader in Contemporary Political Philosophy, Ethics and Aesthetics at the University of Greenwich.

the
eight
techno

London and New York

logies
of
otherness

author-
editor

sue golding

First published 1997 by

Routledge
11 New Fetter Lane,
London EC4P 4EE

Simultaneously published
in the USA and Canada by

Routledge
29 West 35th Street,
New York, NY 10001

© 1997

Editorial selection © Sue Golding;
individual chapters, the contributors

Typeset by

Keystroke, Jacaranda Lodge,
Wolverhampton

Printed and bound in Great Britain by

Butler & Tanner, Frome, Somerset

British Library Cataloguing in Publication Data

A catalogue record for this book is available
from the British Library

Library of Congress Cataloguing in Publication Data

The eight technologies of otherness / author-editor
Sue Golding.
 p. cm.
 Includes bibliographical references and index.
 1. Postmodernism—Social aspects. 2. Culture.
3. Difference (Philosophy) 4. Difference (Literature/
Psychoanalysis/Psychology) 5. Identity (Politics)
I. Golding, Sue, 1959–
HM73.E55 1997
306—dc21 96–48848
 CIP

ISBN 0–415–14579–1 (pbk)
 0–415–14580–5

CONTENTS

Acknowledgements

The sustenance and inspiration for this book comes from the many brave philosophic-political thinkers, artists, students, and technicians who, by way of laughter and long conversations (or just by way of 'being there' in memoria or otherwise), were central to its conception and execution: first, to my personal assistants: Jonathan Kemp, Holly Mountain and Kathy Kosmider; and to my editors at Routledge, Rebecca Barden and Chris Cudmore who supported this book and all its complications from day one, and to the visual eye of the book, Andrew Byrom, and the text editors Vivien Antwi, Anne Owen and John Banks. And in alphabetized order: Zackie Achmat, Stephen Andrews, Alice Arnold, Ron Athy, Gwen Bartleman, Chetan Bhatt, Tessa Boffin, Paul Bouissac, Buddies in Bad Times Theatre (Toronto), Anthony Burke, Alan Cherwinsky, Karen Colvin, Frank Cunningham, Do Tongues (Brighton), Virgil Duff, Alan Foster, Michel Foucault, Bob Gallagher, Edwin I. Golding, Joyce E. Golding, Judi Golding, Frank Golding, Ken Golding, Paul Hallam, Noreen Harburt, Barnor Hesse, Samuel Hollander, Ryan Hotchkiss, The Institute for Contemporary Arts (London), Bob Jackson, Garnet Jones, Jude, Roz Kavney, Ernesto Laclau, Chris Lee, Jack Lewis, Mary MacIntosh, Catherine McTeer and the folks at ICARE (London), Manhattan & Mustapha, Dawn Mellor, Chantal Mouffe, The Noise Control Team (Westminster Council), Alvin Novick, Barry O'Neill, Solly Patel, The Parallax crew (especially Jo and Marq) Kathleen Pirrie Adams, Simon Rice, Colin Richards, Stuart Richmond, Elisabeth Ritchie, Dafydd Roberts, Ellen Rossiter, Gayle Rubin, Joan Ryan, Mick Ryan, T. K. Shepard, Svar Simpson, Penny Siopis, Paul Stigant, Esther T, Catherine Ugwu, Jeremy Valentine, Bernard Walsh, Tania Wade, Ruthe Whiston, Alexander Wilson, Patricia Wilson. A special thanks to my students at the University of Greenwich. Thanks also to The Toronto Arts Council, the glorious residents of Soho Square, Toshiba and related computer-mad connections.

Lastly, thanks to New York City (especially the East Village), Johannesburg, Cape Town, Toronto, and of course London – all having taught me a thing or two about the eight technologies of otherness.

To my mother, Joyce E. Golding, for her courage,
humour and aesthetic sense of beauty

A word of warning

SUE GOLDING

[*Anyone who does not understand why we talk about these things must feel what we say to be mere trifling.*]
Wittgenstein 1974, 174, no. 125

We are at a peculiar moment. Suddenly and without proper counsel, this erstwhile thing called 'political philosophy' turns strange. No longer do the old clothes fit, and there are many amongst its followers who advocate its annihilation, having, for at least the last fifteen to twenty-five postmodernist years tried the second-hand shops and recycling bins once too often. Navel-gazing has always had its shortcomings, one has to say, despite its popularity in the hallowed halls of academe and aesthetic angst, alike.

But what if we were to stop sterilizing the wounds?

What if it were to be admitted that the usual, empty phrases – like the so-called 'deep and violent cut' of meaning, truth, death, indeed identity itself: the 'who are we' and 'what are we to become' of science and of life – have collapsed under their own bloodless, sexless weight of self-reflexive reason? For though the very cunning of dialectical logic (historical, metaphysical, or otherwise) has already produced many interesting political dalliances with empowerment, necessity and change, it has, more often than not, simply recast, or (worse) simply reproduced, the very practices it is seeking to overcome – the usual either/or 'deep cut' posturings nonchalantly taking as given a binaric divide: male as an entity distinctly 'opposite' to female; or black as opposed to white, Jew to Muslim, gay to straight, and so on right down the proverbial line. Usually in the name of marginality, excess and diversity, but now, more frequently still, in the name of otherness itself, we sadly, annoyingly, are often left with a kind of 'shopping list' of so-called subjective 'other' identities – be it woman, Jew, immigrant, person of colour, s/m dyke, whore, etc. – gathered together in opposition to the so-called objective 'dominant-power' forms of identities, often named male, white, heterosexual, middle or ruling class.

There is something not quite right with this picture . . .

Yes, yes: difference, multiplicity, excess, indeed (and especially) otherness 'exist'; yes: racism and other forms of hate – sexism, classism, homophobia, war, gangland targeting against an x or a y – run rampant. Even so, there is something not quite right with the identity politics, 'shopping list of oppressions' picture.
 Perhaps it was the mere fact of witnessing. Of bearing witness to the savage meanness of HIV-related illnesses playing violent-nasty with the bodies of friends. Over fifty dead (and this utterly minimal next to someone else's story) – movement politics aside, one feels like standing on street corners, so bereft, except with a photo in hand, finally reduced to grabbing anyone in passing and asking: did you know David? or Brian? or Jamie? or Alexander? or Lorne? let me tell you what he was like, the music he loved, the nightclubs he frequented, the type of funeral he chose, the kind of breakfast he loved to eat, the humour, the anger, the pastiche in which he would engage, against the drug barons, the tabloids,

the employer; against the nightmare of memory or the fear of forgetting. Against the movement itself.

Perhaps it was the mere fact of pleasure-seeking. Of taking seriously the right to happiness and fun, liberty, sexual freedoms; of engaging, wrestling, jousting with all forms of knowledge from the carnal to the cerebral and back again. Of the draw to the city, to the urban. A kind of light joy one minute, but the next: unexpected assault, broken noses and bruised body parts by hate-brooding stalkers or moral-authority gatekeepers or, worse still, by those with 'no reason' at all: utter caprice, boredom.

Perhaps it was the mere fact of the web-site surfing. Of donning different personas (or even non-personas) with other techno-nerds and cyberpunk 'officianados'. Trans-moving, trans-lating, trans-locating over a virtual skein whose porosity broke the promise, at least for a nanosecond or two, of an established order, whatever that order might be, without, in its wake, establishing another.

Perhaps it was the mere fact of Gregorian chants – and Hildegard von Bingen in particular, with her twelfth-century 'Voice of the Blood' and 'Canticles of Ecstasy'. Or of her peculiar time and her, even more peculiar, timing. Or maybe it was Elvis. Or Warhol. Or metamorphosing from Daddy-boy to dada-borg in twelve less-than-easy steps.

Perhaps it was all these things or something else altogether. But Reader: beware! For whatever it was, and whatever it is, and whatever it will be, the bitty, natty, everyday pieces and points of what constitutes 'identity' in all its singular and plural shadings and tones, turns on a very different notion of 'otherness' than that old bugbear of eternal deep divide, of the 'that' and its 'not'. At its most basic understanding, otherness is simply and only a cosmetic wound; a very thin, virtual, and in this sense 'impossible' limit. It can never be a person, or a thing, animal, vegetable or mineral. It is neither violent nor cruel, nor for that matter loving and joyous. For this 'cut' is only and always just a superficial dimension: a surface. But it is 'surface' – superficial (though not in the slightest 'trivial') – not in the sense of being the 'last layer' or 'top' of say, a table or a body. On closer inspection, it *is* the 'is' – the '/' – between the either and its or. And yet this planed notion of surface is rather vampiric. For it requires a certain kind of blood and food, a certain kind of something, necessary for it to 'make sense' and, in its turn, give meaning 'back'. That certain 'something' or somethings are precisely the, in this case, eight technologies which are themselves nothing more or less than relations, 'techniques', or *technē* (in Foucault's sense): the everyday strategies we use, wittingly or no, to make all the we-selves into me-selves.

These technologies, all eight of them (curiosity, noise, cruelty, appetite, skin, nomadism, contamination and dwelling), stand, in a way, 'on their own'; and yet are not fully resolved in and of themselves. Taken together or apart, they form a kind of spider leg to the 'spider' of otherness – itself also nothing but a kind of gaseous blob (one searches for the most accessible 'picture' available) that disappears the

moment it is nearest at hand. A corruption of the limit, whilst limiting none the less.

The eight technologies skates along this very tactile and restless surface and its – sometimes perverse and iconoclastic – technologies. In fact, the book is itself a construction of otherness; the very articles in it are not simply preoccupying a certain set of themes, values, ethics, pornographies, etc. Rather, they are, also, fictive, but no less 'real', ingredients, which create (as do the named technologies to which they are attached) long-legged spider-tropes connecting, in form as well as content, the cybernetics of the everyday. A kind of rhythmic beat-beatings of an 'otherness' which is nothing but a pluralised 'surface', whose technologies give it life, and whose life bleeds into uncontainable or differently containable identities.

And therein lies their spell; their seduction and repulsion and boringness of the 'that' which makes meaning 'stick'.

But why only eight technologies? And why these and not other ones? Indeed. Why only Ten Commandments, and not, say, eleven or even two thousand? In searching for the answer to the 'why question', the earnest students in my first year Meanings and Moralities class kindly offered this as an initial response: 'God had only two tablets, and it would have been impossible to have squeezed any more on to those stones.' 'But it was *God*!' I countered. 'Couldn't God have found, or even made on spec, larger tablets, or written whole soliloquies in the sky or all over the universe, had he so wanted?'

A tough series of questions to be sure.

The thirty-three artists, philosophers, film-makers, writers, photographers, political militants and 'pulp-theory' practitioners whose work (or life) has contributed to a wholly different concept – and technique/use/practice – of otherness throw out a few clues.

We might wish to say: the unbearable lightness of necessity, suspense, horror . . .

But in any case, and suddenly and without proper counsel, this erstwhile thing called 'political philosophy' turns strange.

Reference

Wittgenstein, Ludwig (1974) *Philosophical Grammar*, Basil Blackwell, Oxford.

Curiosity

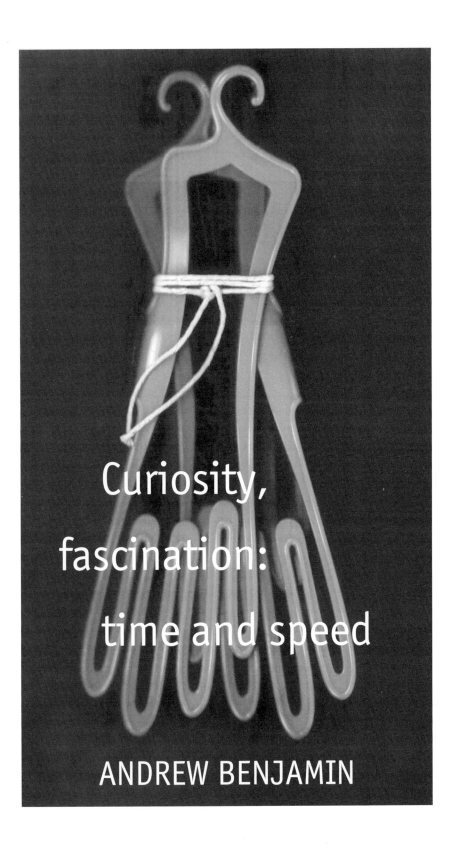

Curiosity,
fascination:
time and speed

ANDREW BENJAMIN

- *Je serai curieux de te revoir.*

- Returning will indicate the impossibility of a final separation and thus an exacting moment of freedom. The hold of fascination, the lingering that marks curiosity will give rise to another freedom.

- There will have to be a place in which coming back, returning, brings with it what for some will be a certain emptiness, but for the one held by curiosity, longing within fascination, the return is the moment in which fascination and curiosity will be able to figure. They will have effected a movement of return eschewing recovery.

- To have allowed for a certain interest.

- Without the determining will to know, to master, and yet without the indifference that marks having yielded to complacency, there exists a possibility of entry. A way in still allowing for the hold of a certain negativity.

- There will be the joy of abandoning oneself – giving up myself – to another form of knowing. A knowledge without knowledge and therefore of taking the path of another pursuit.

- What comes to be held in place is allowing for a certain threat; holding to a form of seduction; a holding yielding an engagement, even another passion. Curiosity sustains attention. Its sustaining attention is the founding mark of the curious.

- Writing of C. G. (Constantin Guys), writing of his art, Baudelaire substitutes the expression *homme du monde* for the word *artiste*. Artists, in this formulation, remain restricted, held in place, by having the mentality of the village, the hamlet. In contrast to this placing there is the '*citoyen spirituel de l'univers* [spiritual citizen of the universe]'. It will be in terms of this geography that Baudelaire will introduce curiosity:

> *Ainsi pour entrer dans la compréhension de C. G prenez note toute de suite de ceci: c'est que la curiosité peut être considérée comme le point de départ de son génie.* (794)[1]

[Thus, in order to begin to understand C. G., the following should immediately be noted: that curiosity should be considered as the starting point of his genius.]

- In this complex passage, and thus in how curiosity comes to be worked out in *Le Peintre de la vie moderne*, speed has to be taken as a point of departure. (Baudelaire's own formulation demands it; '*prenez note toute de suite*'.) Curiosity is neither deliberative nor intentional. Whatever complications may be introduced by the term *génie*, its real force lies in its opening up the space of immediacy. Curiosity will be an already present relation to the world.

- It was not knowing how not to look. Fascination was a holding of the eye that forced it there.

1 All references are to *Baudelaire Oeuvres complètes* (Robert Laffot, Paris, 1980).

● My eye. Whatever had made it mine, what power the possessive may have had slipped away. Mine, though no longer mine.

● The eye, in being held, is a limited presence. Here the eye can no longer exert an absolute hold. Even in the depth of seeing, within fascination, the eye's work remains partial, necessarily, productively, incomplete.

● Partiality *could* have been a limit to have been overcome or effaced. The eye *could* have needed to have been opened or, and this would be the other possibility, its closure recognized. Within this setting blindness would have to have been seen for what it was. And yet, it is here that the eye has a different opening. Fascination and curiosity displace this setting. They will force a repositioning of the eye; freeing it by holding it to another form of vision.

● Writing in the same text though this time of Poe, Baudelaire charts the project – the specificity of a particular *recherche*. The temptation will be that the search for an unknown individual (*un inconnu*) must retain that state of being. The unknown cannot come to be known. Describing the actions of the observer, the coming participant – the 'man' of *L'homme des foules* – Baudelaire describes his compulsive decision in a way that draws upon having to secure the status of the unknown.

> *il se précipite à travers cette foules à la recherche d'un inconnu dont la physionmie entrevue l'a, en un clin d'oeil, fasciné. La curiosité est devenue une passion fatale, irrésistible.* (794)

> [he rushes out into the crowd in search of an unknown individual a glimpse of whose face had, in the blink of an eye, fascinated him. Curiosity has become an inevitable, fatal, irresistible passion.]

● Insisting here are questions to do with the body, the interplay of time and speed '*en un clin d'oeil*' ['in the blink of an eye'], of an inherent partiality of seeing and the necessity to hold to the presence of an irresistible though none the less fatal passion. How do they come to be linked to curiosity and fascination? Initially they seem to be placed within the ambit of death. And yet, here the fatality of passion, breaks the hold of death – the interdictions yielding retribution – by linking fatality to a form of release. A hold will have been broken, as the hold of the irresistible takes over.

● Curious in the place of death.

● I cannot help but look. However in looking my gaze cannot be returned with any form of full acknowledgement.

● The object of curiosity – equally that which fascinates – will complicate alterity. Demanding a different other will be the demand that it sets in play.

● There need not have been a response. I could have been drawn – my hold held – by that which would otherwise have refused being seen. Part of the complexity at work within fascination is its link to the abject. Once curiosity and fascination are drawn together then the abject potential inhering within fascination can be named, not just as curiosity's other dimension, but as its

potential. The mark of the curious is the place of the unsettled, the unsettling, the aberrant, that which resists assimilation, what will endure as the curious. With enduring time figures.

● To be curious, to be fascinated is to have been positioned. What fascinates, what engenders curiosity, positions. Between the positioned and that which positions a space will be held open. Time and space come to be linked. Enduring is as much a spatial relation as it is temporal.

● Baudelaire's own fascination with Poe should not be the central concern. And yet within the continuity of his writings on Poe – two major pieces between 1852 and 1855 – there endures a complex consideration of Poe's own aesthetic. Poe and Guys were creators of the minor. With Poe it was *la Nouvelle*. The force of this work, in part linked to its size, lay in its capacity for intensity '*sa brièvetè ajoute à l'intensité de l'effet*' ['its brevity adds to the intensity of the effect']. The limit of *la Nouvelle* lay in the link Baudelaire will establish between rhythm, beauty, and truth. With it, poetry emerges as superior. (In 1860 Baudelaire signed a contract for four books. One was to be entitled *Curiosités esthétiques*.)

● The presence of intensity is maintained within the pursuance of the *l'inconnu* within (perhaps also as) the unmasterable crowd. What will identify the play of minor is the deferral of beauty because of the retention of intensity. *L'amoureux de la vie universelle entre dans la foule comme dans un immense réservoir d'électricité* ['The lover of universal life steps into the crowd as into an enormous reservoir of electricity'] *(795)*. Again, it is the lover of *la vie universelle* who, in being held apart from the artist, allows for the possibility of creating an irreparable opening. Its consequence might be that Baudelaire's demand that the transitory and the eternal work together would no longer be tenable. As such Baudelaire's own conception of modernity will have become impossible. Modernity's possibility, what defines its presence, demands another enactment and therefore a different description.

● With the possible abeyance of the eternal, speed and time may come to define the place of the modern and thus the work of modernity.

● I turn towards that which cannot be assimilated. It is not a question of whether it could be taken in, or even when it will be, it is positioned outside, refusing incorporation. Not wanting to look, perhaps wanting not to look, I continue to turn to that which cannot be assimilated.

● The space allowing for distance may be traversed by hand or the fingers. What fascinates perhaps that which yields to the caress will be an element, a part. And yet it could never be, as long as it fascinates, part of the whole. Neither metonymy nor universality figure with fascination.

● My fingers were held at this opening; this giving forth that will always, and of necessity be held back. What was held back remained unnoticed, it did not figure, such is fascination's insistence on particularity.

● The particular of fascination is almost self-defined. It need not reach beyond

itself – demanding a form of actual or potential incorporation – in order that it be what it is. Here particularity will announce itself.

● Part of the particular, part of what holds it in place, is space. However, the space in question is not that which would otherwise be defined as an absence which came to be filled; space as empty. Here, space is an activity. Spacing is required in order that the unassimilated remain in a relation of distance. Spacing holds the object in place by defining and maintaining a place in which fascination can reign.

● Spacing allows for fascination. Curiosity demands the impossibility of a completing knowledge. Completion can be defined as an elimination of a productive and sustaining spacing.

● Speed has been given in relation to the eye: '*en un clin d'oeil*' ['in the blink of an eye']. The eye will come to open up. Curiosity and fascination arise. They cannot be summoned. Poe did not gradually become fascinated. Fascination – for Poe's man in the crowd – was not the consequence of reflection. It was irresistible; thus a fatal passion.

● Not to be able to resist, is not passion *tout court*? Not being able to resist defines passion in terms of time. Immediate passion. Equally, it is defined in terms of speed. Speed and time are intertwined. That relation is announced thus – '*en un clin d'oeil*' ['in the blink of an eye'].

● Modernity, for Baudelaire, will have become the constant interplay of the eternal and that which designates the place of the present. The transitory and the fugitive – the two defining qualities of the presentness of the modern – have to endure, otherwise all that would be left is the emptiness of abstraction. What has to be retained is '*la mémoire du présent*' ['the memory of the present']. What form, however, will this memory have? Baudelaire will have already addressed its necessity.

> *presque toute notre originalité vient de l'estampille que le temps imprime à nos sensations.* (798)

> [Nearly all our originality comes from the stamp that time imprints upon our sensations]

The impression of time will have to be set against beauty. Writing in 'Note Nouvelle sur Edgar Poe', Baudelaire has to distance the concerns of Poe from the activity of poetry. The latter has only one end, namely, the idea of beauty. Rhythm is essential in order that this idea be attained. Poe had language. However for Baudelaire such resources were almost the repudiation of poetry and the refusal of beauty. Rhythm remained necessarily absent. And yet, it may be that another way of construing rhythm will have fallen within the province of Poe.

● There will have been a type of continuity. Once the moment had begun, there was a withdrawal, something no longer pertained. Addressing this absence does not demand the recall of the structure of melancholia. What is absent is the hold of discrimination.

● I encounter that which repels. I am held by repulsion.

● Allowing what would otherwise have caused the eye to close – otherwise if it had been a written or spoken explanation, 'this is what you will see' – now, with the hold of sight, there is the demand that the eye no longer decide.

● Be it mere object, or the insistent presence of the abject, an almost fatal fascination will continue to endure.

● What held Baudelaire, what allowed for the hold of the minor, may have been the instability of the eternal. It may have been, moreover, the growing impossibility of linking rhythm to the poetic act and only to that act. Crowds move. They may allow for their own rhythm. Not rhythm as the stirring of the soul but the irregular changing of place – the disappearance and the reappearance – that marks the hold of the crowd.

● Once intensity began to play a determining role, once speed, the brevity that heightened the place of writing and thus the grip it exercised, figured as that which introduced the possibility of other literatures, there will have been an opening. Furthermore, once it becomes possible to link speed and time to the placing and thus the unfolding of the body within the crowd, then its written equivalent will force aside the place of the eternal because of its – the eternal's – insistence on the very movement of process and thus of writing. In other words, as the eternal takes place in writing its hold on eternality begins to slip because of its presentation in and as writing.

● The eternal – Baudelaire's 'idea of beauty' – must resist the hold of abstraction; the reduction to pure beauty at the expense of the modern. Pure though impoverished. Moving from the place of abstraction will demand having to introduce that which the eternal may not be able to control. Countering the place of the eternal – its playing itself out in the movement of poetry – is intensity.

● Intensity will have become another way of identifying the particularity of fascination and with it the hold of curiosity.

● The threat will have already been there. What will have to be maintained is a certain harmony – the shocking harmony –and an admiration for eternal beauty. Maintaining it will occur at the same time as the tumult of *la liberté humaine* [human freedom] begins to exercise its own pressure. One must be seen in the other. On the one hand there would be the threat of pure chaos if they – the eternal and the transitory – were not located in relation to each other. And yet, on the other hand, there is the possibility that once the tumult is allowed its place, then what will vanish is its counter-positioning to the eternal. The tumult will have been freed. Electricity, its rhythmic power will have dictated another possible order; perhaps, a minor order.

● How could this possibility have been excised? Any answer will need to commit itself to the necessity of writing to secure the eternal: to have become its home. Writing, the practice that will be at work in poetry, may

bring a rhythm and an intensity into play, which, rather than securing the eternal, will, in fact write it. The idea of beauty, Baudelaire's continual site of return – a site in which the presence of the eternal controls by orchestrating all activity – may be there because of the activity of writing. What it tried to control is that which in inscribing, placing, its presence rids it of control by giving it the object of control. Eternality would emerge therefore as having been stripped of the counter measure of the transitory by having become the result of writing.

● Eternally written; the transitory place of writing.

● Might there have been a reason restricting the play, the movement, of that which fascinates? Is there a morality that will check its hold? Will it come to restrict the place of curiosity?

● With the question of morality both curiosity and fascination may well have been checked. Once the nature of the object – of that which holds the eye – arises as a question; once it becomes possible to delimit the object's quality; once it is necessary to identify that quality thereby restricting its force and loosening its hold – the eye fades – then, rather than the determining hold of the moral being central, there will be the possibility that curiosity and fascination could come to exercise their own hold on the question of morality.

● What must be questioned is the place of curiosity and fascination. With that questioning space and time will return. Arising with that return is the difficult problem of linking the necessity of space – spacing as the precondition for curiosity and fascination – time, enduring as that which is produced by spacing, and the emergent obligation of having to attribute a specific quality to the object.

● At first glance the attribution of quality will close the incision, yielding fascination and curiosity.

● Freedom as given by a response to an object where the response while owned shakes itself free of the hold of real possession. A freedom from which another, this time a different freedom will have emerged. Freedom will have come into contact with the possibility of anonymity. Not the anonymity of freedom but freedom as the release of the anonymous.

● Once possession begins to lose its hold – my eye though no longer strictly mine – I maintain myself but in its – this *my* – dispersal into the practice, the activity of seeing.

● I will have reached back – attained myself – by allowing for a repositioning in which my having been dispersed – lost, lingering within curiosity – will itself have been lost. This second loss is intentional. The former could never have been. Freedom as having become free. Again the complex presence of differing types of freedom.

● Poe, even within the setting provided by Baudelaire, had given to the 'man in the crowd' a type of freedom. It was not the freedom that would have absolved him from responsibility; an unfettered – though only putatively – freedom to act. It was the more complex freedom in which

the loss of control – the release of the controlling *mine* – engendered the freedom into which he was given. In giving himself – releasing himself from himself was his becoming enmeshed within fascination. He has become subject to it; thus he had become its subject.

● Release, here – the subject of fascination – has become the correlate to the threat that will work away at the eternal.

● Freedom is connected to the unknown; thus to what cannot be known. Accepting the determining place of anonymity enjoins the necessity to hold to a distance in which the unknown can figure. Allowing for distance and thus the role of an ineliminable spacing is to yield to the place of writing. Writing fascinates to the extent that spacing is maintained. Baudelaire's own fascination with Poe generates such an aesthetic. Poe endures not as the unknown but as the writer of the unmasterable; allowing writing to be guide of, to be guided by, the necessity to maintain the unknown. Known yet unknown will have become the practice of writing. Writing out the eternal by stripping it of its necessity even if its place – the eternal's place – is subsequently written back in. What is subsequent – its quality – enacts the eternal's presence.

● The eternality of writing practises the eternal not as idea, but as the constant interplay of the finite within the infinite; thus as writing.

● Freedom; my having been dispersed. As a part of what is mine, apart from what is mine, my presence is constructed by the hold of curiosity and by the lines of fascination. Having been freed from myself another obligation holds sway; it is still mine.

● Allowing for spacing, holding distance in place, opens up the insistent reality that my presence, thus my own possibility, is no longer merely mine. Being held yields a me that is not just mine.

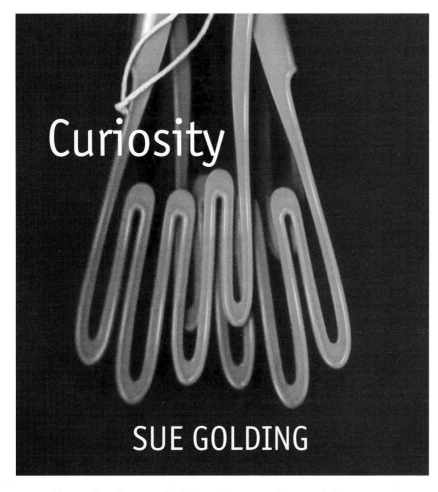

Curiosity

SUE GOLDING

How to describe a world that evades us, not because it is
ungraspable but, on the contrary, because there is too much
to grasp? (Blanchot 1982, 24)

I want to take issue with (or perhaps, better put, I want to re-issue) three things:
the problem of negation understood often as void or lack (and the abyssal logics
therein implied); the privileging of temporality (and with it the so-called
subordination of space); and, finally, the question of the [a-]moral interregnum
and the possibility of a (contingently exiled) ethical ground. Shall we, maybe for
the sake of brevity – though, maybe not – say that the intersection of these three
axes creates a peculiar sort of land, a desert land, a land I shall name: curiosity?

 As with every investigation, this 'curious' problem can best be situated with an
echo from the past; in this case by beginning with Ricardo's now infamous
suggestion of taking as a given the 'supposing that . . . ' of science and of life.[1]
Supposing that we are interested in, for example: change; not just for the sake of
it, of course, but rather, because the democratic world towards which we strive
and wish to partake, continually, happily, and in perpetuity, just does not seem to
be quite 'here', at least, not yet. Supposing that, moreover, in thinking the

1 See also, Golding, 1992,
56.

possibility of such a radical political space called 'democracy', we start re-thinking the implicit assumptions inherent in what it is (and what it is not) to be human or, for that matter, what this 'being human' could conceivably become. Immediately we are struck by the (not so subsidiary) problem of objectivity and, more to the point, of this seemingly slippery slope, offhandedly called 'the truth' –an objective/truth so very slippery especially when wanting to include (in that beingness of human) this fanciful thing called imagination.

Supposing that, finally, we are struck by the paradox that the very world in which we dwell does not at all resemble our picture of it – not because we have yet to discover or trace it properly, but because its boundaries elude the very land-scape of our framework. If asked at point blank range, 'show me the edge of the earth, the precise precipice, the absolute moment at which it goes otherwise into space', we could never point exactly to it and say 'look over here; here is where it is'. This does not, for a single minute, prevent us from having a picture of our world or, indeed, of our universe.

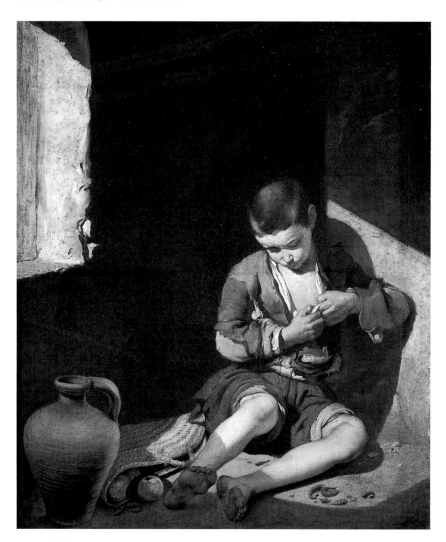

Le Jeune Mendiant, Bartolome Murillo (1617–82), Musée du Louvre, Paris. © Photo: RMN – Jean.

Taking up the void

As we know from reading our Hegel, particularly the Hegel of the *Encyclopedia* and, more to the point, of *The Phenomenology*, the immediate presence of a thing is always-already 'im-mediate'.[2] That is, it is always-already mediated by the division between the here and the not-here, i.e., the this and its other. Or, to put it slightly differently, whatever one understands by the 'is' must always, of necessity, be set in relation to the that which is its 'not'. At once we have at our disposal the concept of the 'this' as something which must always be understood as a unity, a self-differentiating unity, whose totality exhausts the entirety of the real, in all its possible and impossible permutations. But at the same time, we are also confronted with the irritation that this positive/negative relationship – which, taken together, includes all that might or could be thinkable – remains abstract, neatly grounded as it is (up to this point) only in the tautology of that which is its not. Enter the Hegelian dialectic.

2 See for example Hegel, 1977, 104–11.

Without repeating all the profound and subtle intricacies of this particular logic, suffice it to say that in deepening (or widening) the scope – that is, in contextualizing any self-differentiating unity as a synthetic unity, made meaningful only on the basis of a teleological/dialectical synthesis, i.e., on the basis of a becoming-ness from which it emerges and to which it points – we grasp the very relation around which identity, and therewith meaning, is itself produced. It is on this basis that we come to understand that there can be no identity, and therewith no meaning, without a (relational) separation, a distinction, between the 'this' and its negation, unified and plunged as it must, of necessity, be in the very movement of its immanent realization.

And yet, despite the insistence, logical or otherwise, on the immediacy of the split-shift, a whole set of worries emerges. It is a set of worries that can, partially, be summed up by the very different uses of one word: negation. For, is it not the case that often in leaping from theory to practice (and back and forth again), we find in the very concept of identity a whole series of oppositional relations which, taken as a unity, are supposed to exhaust the entirety of the field; i.e., differential unities claiming, say, woman as that which is distinct and opposed to man; or gay as that which is distinct and opposed to straight; or person of colour as that which is distinct and opposed to white; or Jew as that which is distinct and opposed to Christian – all of which, in the unity of their self-differentiality are supposed to circumscribe the whole of the field. Indeed, has not woman or gay or black or Jew or working class often been understood as Other or Lack or the Not-of-the-Something, always-already established as such?

Adorno was probably not the first, but he certainly was one of the more articulate, of the worriers around this very problem. For him, negation could never be subsumed under the rubric of a positivity, be it dialectic, synthetic, or otherwise. Indeed, negation was precisely the 'not-is' of the something, and therewith could not possibly be presented as if a homogeneous repository, let alone staged as the 'equivalence' of any category, be it woman or black or Jew or working class or the Other or person of colour or void; i.e., as the female 'castrated' container (as it were) of so-called otherness, always-already pitted against and utterly subsumed in terms of the 'phallic' real itself. 'Against this',

says Adorno, 'the seriousness of unswerving negation lies in its refusal to lend itself to *sanctioning* things as they *are*' (Adorno, 1966a, 159, my emphasis).

So, on the one hand, negation ought not to be understood as if standing outside, opposite, or apart from the 'is'; nor, on the other hand, does negation cleverly disguise itself as affirmation; nor, finally, does it seek to replace it, to become, that is to say, a positivity. Reflecting on the problem in his *Negative Dialectics*, Adorno clarifies it like this:

> We can see through the identity principle, but we cannot think without identifying. Any definition is identification [. . .] But [. . .] *Non-identity is the secret telos of identification. It is the part that can be salvaged. The mistake in traditional thinking is that identity is taken for the goal.* (Adorno, 1966b, 149)[3]

[And yet the] nonidentical is not to be obtained directly, as something positive on its part, nor is it obtainable by a negation of the negative. *This negation is not an affirmation itself, as it is to Hegel.* The positive which, to his mind, is due to the result from the negation has more than its name in common with the positivity he fought in his youth. To equate the negation of negation with positivity is the quintessence of identification; it is the formal principle in its purest form. What thus wins out in the inmost core of dialectics is [actually] the anti-dialectical principle: that traditional logic, which *more arithmetico*, takes minus times minus for a plus. It was borrowed from that very mathematics to which Hegel reacts so idiosyncratically elsewhere. [But if] *the whole is the spell, if it is the negative,* [then] *a negation of particularities – epitomized in that whole – remains negative.* (Adorno, 1966a, 158)

Not only, then, does this mean to say that objectivity cannot be 'static'; it always recruits its meaning within and in terms of a process of synthesis, a synthesis whose identity – and thus, whose subjectivity – is established precisely in terms of its (in this case, dialectic-teleological) negativity. So we find, continuing with the heterogeneity of the negative logic thus implied, that there must always exist some kind of 'excess' which slips past the mirrored reflection of a positivity netted point-for-point against its oppositional distinction. And while this excess cannot be understood as a 'something', neither can it be understood as absolute ether or void. Indeed, this very concept of the excess-as-negation has but a family resemblance to its more vacuous cousin, *l'abysme*.

Why must this be the case? And, more to the point, what is implied, politically, ethically, not to mention theoretically, by claiming that it must be so?

Let's unravel these questions like this: If truth is no longer objective (or, perhaps more efficiently stated, if objectivity is no longer 'static' or 'fixed'); if, that is to say, we have indeed gone beyond Good and Evil as circumscribing the entirety of the field – precisely because there cannot be a point-for-point mimetic relation of fixed identity (since, without some kind of differentiation, identity would either become meaningless or one big indistinguishable lump, which in reality squares to the same thing) – then there must exist somewhere

3 My emphasis and brackets. Indeed, and continuing with this argument, Adorno says, 'The force that shatters the appearance of identity is the force of the thing: the use of 'it is' undermines the form of that appearance, which remains inalienable just the same. Dialectically, cognition of nonidentity lies also in the fact that this very cognition identifies – that *it* identifies to a greater extent, and in other ways, than identitarian thinking. This cognition seeks to say what something is, while identitarian thinking says what something *comes under*, what it exemplifies or represents, and what, accordingly, it is not itself. The more relentlessly our identitarian thinking besets its object, the farther will it take us from the identity of the object (Adorno, 1966b, 149).

(logically, reasonably) a 'something' which is a 'not' (and hence, an excess) of that very identity relation. This, then, is to say, further and on the other hand, that this 'something-which-is-a-not' is utterly part and parcel of the is, standing neither outside nor inside. But it is to say, also (though not as 'addendum'), that because of this peculiar relation to the space (and time) of the outside or the in, which both contains the 'something-which-is-a-not' while simultaneously noting its necessary 'excessiveness' (to the very thing to which it's bound), this strange kind of negation situates any identity, indeed constitutes and establishes its meaning.

Think of a melody, any melody either real or imagined. The notes are arranged like so and so along the scale. Their distinction from one another is qualified in a number of ways, say for example with notes c and d, cast perhaps in a minor key of g. However complex or simple we wish to make our melody, none of it is meaningful if the breadth and width and timing does not at once also include the not-spacings between and amongst the notes in question, which, in all their multiple excessiveness, 'contour' and, in that sense, (de-)limit, our song. But also, and even though, this is a 'limiting' or 'contouring' – a 'defining' – it bears no self-reflexive interiorization, no indubitable certainty of an ego-I/self. Nevertheless, it 'makes sense'. Wittgenstein characterizes it like this:

> 216. 'A thing is identical with itself.' – There is no finer example of a useless proposition . . . Does this spot ✳ 'fit' into its white surrounding?
> – But that is just how it would look if there had at first been a hole in its place and it then fitted into the hole. But when we say 'it fits' we are not simply describing this appearance; not simply this situation.
> 'Every coloured patch fits exactly into its surrounding' is a rather specialized form of identity.

> 523. I should like to say 'What the picture tells me is itself.' That is, it's telling me something consists in its own structure, in its own lines and colours. (What would it mean to say 'What this musical theme tells me is itself'?)

> 524. Don't take it as a matter of course, but as a remarkable fact, that pictures and fictitious narratives give us pleasure, occupy our minds . . .

> 527. Understanding a sentence is much more akin to understanding a theme in music than one may think. What I mean is that understanding a sentence lies nearer than one thinks to what is ordinarily called understanding a musical theme. Why is just this the pattern of variation in loudness and tempo? One would like to say 'Because I know what it's all about.' But what is it all about? I should not be able to say . . .
> (Wittgenstein, n.d., 84–5, 142, 143)[4]

To put the same point differently (and therewith perhaps say another thing altogether), this 'something-which-is-a-not', standing outside and inside exactly at the same time, all the time, in all time's varying dimensions, corruptions and decay, saddles also (and without taming) the disparate and oppositional distinctions; and it does so, whether hovering around a first, second, third, or fourth dimension (or more) or somewhere in between. But this is to say, also

4 Compare Nietzsche's remark: '255. Conversation about music – which, among other things makes "pictures" or rather "sees" music; knows its colour, etc.' (Nietzsche, n.d., 145).

5 See, for example, where Bataille writes: 'Nothing exists that doesn't have this *senseless sense* – common to flames, dreams, uncontrollable laughter – in those moments when consumption accelerates, beyond the desire to endure. Even utter senselessness ultimately is always this sense made of the negation of all the others. (Isn't this sense basically that of each particular being who, as such, is the *senselessness* of all the others, but only if he doesn't care a damn about enduring – and thought (philosophy) is at the limit of this conflagration, like a candle blown out at the limit of a flame)' (1991, 20).

6 See, for example, Blanchot (1978, 51) where he writes of the connection between the 'outside'/excess (as that of terror/dread) with the problem of 'memory' and 'forgetting' – a connection we will excavate more thoroughly in our text: 'So she came into this room, and what did she meet up with here? From me, the motions of a madman who did not recognize her; for her, a feeling of dread which had forced her outside with the thought that she had seen something she had no right to see, so that my name was the one she would most happily have banished from her memory. I will add that when she answered the question I asked – "Why have you come?" – by saying, "I've forgotten," that answer was much more exact and more important (in my opinion) than the one this story holds.'

7 This conceptual in-between-ness is precisely the 'path', as it were, the 'distance' necessary to create/sustain any living (e.g.,'non-fixed') identity. Indeed, as Foucault puts it, it marks/contours/resuscitates the relation of the 'self to the self'. In his *The Care of the Self*, volume III of *The History*

then, that in this kind of example there is no *temporality* to the grammar of the 'that', i.e. to the paradigm to which it points. '[For] that connexion, a connexion of the paradigms and the names, is set up in our language', says Wittgenstein, 'And [so] our proposition is non-temporal because it only expresses the connexion of [in an example he uses later around colours to appropriate 'the fit'] the words "white", "black", "lighter" with a *paradigm*' (Wittgenstein, 1983, 76; no. 105).

We will return to this last remark in a moment. But for now, let us just say that with this strange little 'excess', we have here, then, an 'impossible' concept, existing and not existing exactly at the same time (or at a different time) all (or none) of the time in the *a-radicality* (the a-rootedness) of its spatial configurations. It is one which must, of necessity, escape the very sameness to which it is confined, and, in so escaping, contour – and, therefore, yes – 'define' the identity of the 'this', whatever that 'this' may come to mean.

But let us look at this 'escape' a bit more carefully. For if there is neither inside nor outside *per se*; if that is to assert, instead, that we have before us a kind of mutant negation which slithers out from the land of the 'neither/nor' rather than from that of the 'either/or', how do we trace the *specificities* of its wanderings or movement, especially if that escape is cast as an excessive relation to that which has never existed 'as such' (or rather, as that which only exists in relation to an impossible negativity)? How do we express the particularity of this kind of negation, especially if it is configured neither as an eternal 'nothingness' stretching off to infinity and beyond nor as some form of nomadic positivity? Burdensome questions, to be sure.

Several political philosophers, writers, artists and the like have attempted an answer. Bataille marks it as a kind of 'senseless sense' (Bataille, 1991);[5] Blanchot, as 'dread' (later as 'passion') (Blanchot, 1978).[6] And Foucault, in a pretend dialogue he never had with either, as 'thought from outside', as a quasi-something (or quasi-nothing)

> setting its limits as though from without, articulating its end, making its dispersion shine forth, taking in only its invincible absence . . . not in order to grasp its foundation or justification, but in order to regain the space of its unfolding, the void serving as its site. (Foucault, 1990, 15–16)

In each case, it marks (by re-marking) the death of the Other – replacing what would have been cast as an infinite void contrasted to the Something – now, rather, cast in terms of a contingent relation, a contingently negative relation, a relation contouring-yet-constituted-by the *distance* between the not and its other. Foucault names it as a *relation between the self and the self* (self, as future/past: other; and self as the present: and hence, impossible).[7] A kind of 'not-not-of the Other', or, as Derrida would say, an 'ineluctable' multiplicity, a series of differences, the *de-de*-negation, *desistance* or 'supplementary re-doubling of negation' (Derrida, 1989, 4).

It is a funny sort of excess, this not-not negativity, this multiplicity of the in-between (i.e. the negative 'between-ness' of the not and its other). A kind of spiralling (or, anyway, dizzying) interiority which regurgitates right *outside* the limit, and in that wake, constitutes it: neither/nor. Indeed, it is, precisely, a surface, or even a strategy of surfaces.

If we hold out for the negative along these configurations, three things become obvious – or, if not obvious, at least problematized. The first is that there exist several kinds of negation, the dialectical version of said negation being but one of many. The second is that confining it to a teleological (or, for that matter, a transcendentalist) dialectic infringes on the very suppleness of the kind of excess enlisted above, one that tends to smuggle in a whole set of assumptions around morality, politics and change, and in so doing tends to obfuscate rather than clarify the very problem (of identity/difference) it aims to resolve. It is precisely this (dialectical) version of negation which must be rejected, albeit (as Gramsci would say) 'with all honours due'. The third point is that, in groping awkwardly – maybe even blindly – towards some other a-systematic systemizing of negation, a peculiar elision comes to be established between the metaphoric and the metonymic, one that is a kind of 'struggle', as Kundera once said, 'of memory against forgetting' (Kundera, 1978/80, 3). Let us now detail, more exactly, where these last few remarks may lead and why.

A time of forgetting/a space to remember

As should be relatively clear by this point in our story (the story of negation), we have enlisted a kind of determinancy-of-the-not, that is to say, an *in-determinant* excess, as that which provides meaning and, therefore, as that which 'grounds' (as it were) any, and every, truth-game. Moreover, this is an indeterminancy which exceeds the very notion of eternal infinity; for it no longer adheres to a concept of homogeneous time nor one of empty space. Indeed, it could be said that it has more to do with a relation between some discrete, even deadly, form of rumination – i.e., an odd, purposeless wandering – and the 'not' of that existence; a journeying somewhere different from within (or against) a metaphysics of the present; a straying on some other path neither inside nor outside the oppositional binaries of a positivity and its Other. Nietzsche characterizes it in one word: forgetting. 'Consider the cattle, grazing as they pass you by', he says in his second untimely meditation, 'On the Uses and Disadvantages of History for Life',

> they do not know what is meant by yesterday or today; they leap about, eat, rest, digest, leap about again, and so, from morn till night and from day to day, fettered to the moment and its pleasure or displeasure [they are] neither melancholy nor bored . . . A human being may well ask an animal: 'Why do you not speak to me of your happiness but only stand and gaze at me?' The animal would like to answer, and say: 'The reason is I always forget what I was going to say' – but then he forgot this answer too, and stayed silent: so that the human being was left wondering . . .
>
> [Now] imagine the extremest possible example of a man who did not possess the power of forgetting at all and who was thus condemned to see everywhere a state of becoming: such a man would no longer believe in his own being, would no longer believe in himself, would see everything flowing asunder in a moving point and would lose himself in this stream of becoming: like a true pupil of Heraclitus, he would in the end hardly dare to raise his finger [. . .] Thus: it is possible to live almost without memory, and to live

of Sexuality, compare Seneca's remarks to Lucilius, quoted therein: 'I do not wish you ever to be deprived of gladness. I would have it born in your house; and it is born there, if only it is inside you . . . for it will never fail you when once you have found its source . . . look toward the true good, and rejoice only in that which comes from your own store [*de tuo*]. But what do I mean by "your own store"? I mean your very self and the best part of you.' (1988, 66–7).

happily moreover, as the animal demonstrates; but it is altogether impossible to live at all without forgetting. (Nietzsche, 1983, 60–1)

In short, in addressing this particular form of negation, we have landed in the un-dead realm of the present, that impossible – indeterminate and contingently negative – terrain which disappears at the very instant of its access and yet without which 'meaning', itself, cannot be sustained. Its 'un-historicality', as Nietzsche calls it in a later fragment, both sidesteps and absorbs a past and future tense; and, at the same time, makes that past or future 'decipherable', 'graspable'; that is to say, makes it 'possible'.[8] Indeed, in that sense, one could maintain that forgetting contributes to the making of 'what is' and becomes, part and parcel of an *inventive* process, of the process – or rather processes (after all, there is no reason to assume that forgetting or indeed the paths to which it points remain anything other than multiple) – of making the 'that' alive, real.

In a peculiar way, then, and inasmuch as 'forgetting' is constitutive, it 're-members'. But what exactly is remembered? It cannot be experience: for in the land of the un-dead there is clearly no room for *that*. And it cannot be rooted in an experimentation of any sort, for this would imply a sense of discovery, a sense of revelation (or a revealing) of some hidden truth or thing. But as we are speaking specifically of a (multiple) in-determinancy as the basis for a truth, there is nothing that *can* be concealed in here. Or, to put this on a slightly different register, one *can* never discover the *content* of what has been forgotten. This is precisely what it *is* to forget; what has been forgotten has in its place: nothing. This does not mean to suggest or imply that forgetting can be identified with 'vacuum'.

As we play upon an impossible terrain of an indeterminate nothing, what is it that is *able* to be re-membered? It can only ever be the use of a thing; its technique; its custom, though we are speaking of use or technique or custom in terms other than 'lying to hand'. 'Does this mean', asks Wittgenstein, 'that I have to say that the proposition "12 inches = 1 foot" asserts all those things which give measuring its present point? No. [It simply means:] The proposition *is grounded* in a technique [its use]' (Wittgenstein, 1983, 355; part VII, no. 1). But wouldn't this imply, we might want to ask, that there very well could exist someone who wished to use the proposition in some other (wrong) way, and that, therefore, a reliance on something as seemingly flimsy as the *use* of it might only encourage a chaotic nihilism (of sorts)? The possibility is entirely there: but the probability is not. For if there were no general commonality, no rule – a rule, in this context, meaning something quite different from *dictum* or *dogma* – the paradigm itself would disintegrate. 'The application of the concept "following a rule" presup-poses a custom. Hence it would be nonsense to say', says Wittgenstein, 'just once in the history of the world someone followed a rule (or a signpost; played a game, uttered a sentence, or understood one; and so on)' (1983, 322–3; section VI, no. 21).[9]

Could one say, then, that inasmuch as the (re-)membering of technique/application of a said rule has to do with establishing (inventing) the

8 Compare Nietzsche's sixth remark (within the same second 'untimely' meditation) regarding this point: '*If you are to venture to interpret the past you can do so only out of the fullest exertion of the vigour of the present* . . . Like to like! Otherwise you will draw the past down to you . . . When the past speaks it always speaks as an oracle: only if you are an architect of the future and know the present will you understand it' (1983, 94).

9 Compare Nietzsche's (now not so cryptic) remark on the importance of a rule in *Daybreak*, where he writes: '442. *The rule.* – I always find the rule more interesting than the exception – he who feels like that is far advanced in the realm of knowledge and is among the initiated' (Nietzsche, n.d., 187).

paradigm/framework of any truth game, that this [re-]membering plays a double function, albeit, let us not forget, in all its *negative indeterminancy*? For on the one hand, it could provide for a reproducing (repetition/imitation through *difference*) – of any proposition and, therefore, of any paradigmatic structure; whilst on the other hand, it could provide for a kind of ground – now established without depth or width or speed or length and yet encompassing all of that and more. We would have in front of us, then, no greater (more securing or deeper) ground to the ground than the indeterminate surface of the that; a surface 'indeterminate', but not, however, 'indefinitely homogeneous' or 'infinitely vague'. In part VI of his *Mathematics*, Wittgenstein puts it like this:

31. [. . .] The difficult thing here is not to dig down to the ground; no, it is to recognize the ground that lies before us as ground. For the ground keeps giving us the illusory image of a greater depth, and when we seek to reach this, we keep on finding ourselves on the old level. Our disease is one of wanting to explain.
[But] once you have got hold of the rule, you have the route traced for you. (Wittgenstein, 1983, 333, part VI)[10]

In short, what seems to 'lie before us' is the possibility of accepting a non-existent 'excess' of indeterminancy (now placed in terms of an impossible place: to wit, the present) as the ground to any paradigmatic truth-game – a kind of fiction (rather than a lie) as Foucault will put it; a superficiality (of sorts), says Maurice Blanchot – one that has less to do with grammar (and the rhetoric thus implied) than it has to do with *technē*, custom, 'the way in which it is used'.[11] We are recovering, then – in the fullest sense of that word (salvaging and accepting its invisibility) – the radicality of a fiction, a fictitious space herein epitomized by a contingent, anti-positivistic and non-affirmative 'excess'. Indeed, we are recovering, perhaps more interestingly still, an 'excess', an 'outside', an ever-effacing 'present' that seems to require not one whit of a dialectical logic or transcendental temporality to secure (as in 'invent') the horizon of its truth. Foucault says:

Not reflection, but forgetting; not contradiction, but a contestation that effaces; not reconciliation, but droning on and on; not mind in laborious conquest of its unity, but the endless erosion of the outside; not truth finally shedding light on itself, but the streaming and distress of language that has always-already begun. (Foucault, 1990, 22)

A shudder of disbelief! For who has not read their Marx, let alone their Heidegger! Who would wish to abandon time – and (seemingly) therewith history, not to mention, quite possibly, politics! Indeed, and irrespective of where one might stand on the question, who amongst us could fail to see the beauty inherent in the logic of the latter's *Identity and Difference*, precisely on this point (about forgetting and concealment, and the present and transcendence, not to mention time itself), wherein, amongst many, *many* other things, he reaches precisely the opposite conclusion: 'inasmuch', says Heidegger in his 'Onto-theo-ology', 'as we are thinking of unconcealing and keeping

10 Compare Nietzsche's remark on the error of dialectical logic: '474. *The only ways*. – Dialectics is the only way of attaining . . . being and getting behind the veil of appearance, – this is asserted by Plato as solemnly and passionately as Schopenhauer asserts it of the anti-thesis of dialectics – and both are wrong. For that to which they want to show us the way does not *exist*' (Nietzsche, n.d., 196–7).

11 On the question of the 'lie' versus 'fiction' in Foucault and Blanchot, see especially, 'I Lie, I Speak' and 'Reflection, Fiction', in Foucault, 1990, 9–13 and 21–6.

concealed, of transition (transcendence) and of arrival (presence)' (Heidegger, 1969, 67)? For we have, with Heidegger, the posing an ontology rooted precisely in/on difference – a difference, of course, quite dislodged from its metaphysical suppositions – but one which nevertheless requires (or better put, must of necessity require) a re-thinking of the present as entailing or, rather, as being equivalent to, a transcendent temporality.

> The outward evidence of this (though of course it is , merely outward evidence) is the treatment of Being as παρουσία or οὐσία, which signifies, in ontological-Temporal terms, 'presence' [*Anwesenheit*]. Entities are grasped in their Being as 'presence'; this means they are understood with regard to a definite mode of time – the '*Present*' . . . [Being is equal to no class or genus of entities, it pertains to every entity.] . . . Its 'universitality' is to be sought higher up. Being and the structure of Being lie beyond every entity and every possible character which an entity may possess. *Being is the transcendus pure and simple*. And the transcendence of Dasein's Being is destructive in that it implies the possibility and necessity of the most radical *individuation*. Every disclosure of Being as the *transcendens* is *transcendental* knowledge. *Phenomenological truth (the disclosedness of Being) is veritas transcendentalis.* (Heidegger, 1967, 47, 62; 'II. The Two-fold task in working out the Question of Being, Method and Design of our Investigation')

This is to say, then, that to capture the movement – i.e., the non-fixity, dislocated, a-stasis of truth (identity, objectivity and so forth as radical individuation) – clearly, says Heidegger, there must be the facility to re-present the present, a (re)presentation, which is, at one and the same time, ultimately 'impossible' and necessarily 'transcendent'. Its dislocation, 'movement', underwrites precisely what it is to be 'free'; a freedom no longer bound (if ever it was) to the exigencies of the spatial (why? because we are speaking here of a 'not'-location, a *dislocation*), which, given the argument, can therefore only ever and by definition be established with respect to time and the (transcendent) (de-)structuration of the present. Or, to say the same thing differently: if the possibilities of freedom are to be fully realized, they must primarily be established along the frontier or horizon of time, a frontier that would, *ipso facto*, maintain little or no room for the immovable, wholly sutured 'fixities' of life – a fixity (non-freedom) that would of necessity come under the rubric of, not surprisingly, and in a word: space.[12]

A dilemma. For we seem to be caught in the (not-so-delicate) web of an either/or division cast now in terms of a temporality quite distinct (in its oppositional role) from that of the spatial. Which is it to be, then: temporal over the spatial or spatial over the temporal? And does this require (in either case) some form of transcendence or not? These are not idle questions; to quote de Man, 'It turns out that in these innocent-looking didactic exercises, we are in fact playing for very sizeable stakes' (de Man, 1979, 15). And, indeed, we are.

I submit that there very well may be a way out of this impasse. And that is to take seriously the problem – no, the necessity – of pluralism itself. This requires, at the very minimum, an acknowledgement that 'indeterminacy' (and

12 On this point, see, for example, Ernesto Laclau's crucial intervention on the matter, in his 'Dislocation and Capitalism', where he says in part, 'Let us begin by identifying three dimensions of the relationship of dislocation . . . The first is that dislocation is the very form of temporality. And temporality must be conceived as the exact opposite of space . . . [Now] If dislocation involves contingency, and contingency power, the absence of dislocation leads in the Platonic schema to a radical communitarian essentialism that eliminates the very question of power and thus the possibility of politics . . . [On the other hand] . . . history's ultimate unrepresentability [e.g., its dislocation, temporality] is the condition for the recognition of our radical historicity' (Laclau, 1990, 41, 69, 84).

all we have said about it up to this point with respect to negation, forgetting, impossibility and so forth) is, in its most radical sense, paradoxical.[13] That is to say, this excess 'negation' – or, more to the point, its root, its 'division' or 'slash' ('/') – expresses that division (of difference) as always-already *incommensurably plural*. In any proposition, including that of contradiction, there is no fundamental unity (between a not and its other) or an ontological first, either as point of departure or as one of arrival.[14] We are speaking of a heterogeneic unity of the slash ('/') itself; not the heterogeneity of that which falls on 'either side' of the cut. This is a radical composition, a radical multiplicity in all its negative dimensionalities; and it is precisely un-thinkable, inasmuch as it is neither paradigmatic nor syntigmatic; neither metaphorical nor metynomic; neither time nor space; neither true nor false. It is all of the above (and probably more) in all its fictitious, un-thinkable cohesive impossibilities. We return to Wittgenstein:

> 200. Really 'The proposition is either true or false' only means that it must be possible to decide for or against it. But this does not say what the ground for such a decision is like.

> 205. If the true is what is grounded, then the ground is not true, nor yet false. (Wittgenstein, 1974, 27e–28e)

> 28. . . . [or to put it this way] That I can assume what is physically false and reduce it *ad absurdum* gives me no difficulty. But how to think the – so to speak – unthinkable? . . .

> 29. . . . [where geometrical illustrations cease to be *applications of Analysis*, they can be wholly misleading] . . . The idea of a 'cut' is one such dangerous illusion. (Wittgenstein, 1983, 285; section V)

> 4. . . . [Rather] It might be said: *imagination* tells it. And the germ of truth is here; only one must understand it right. (Wittgenstein, 1983, 224; section IV)

All right then, let us use our imagination. Let us imagine a different reading of the cut ('/') as something other than the (seemingly) deep and ceaseless slash, dividing the something from its other. It no longer demarcates a site of departure (or arrival) with respect to any truth or certainty, dialectical or otherwise, and yet despite its fiction (or because of it), rewrites a truth. It is closer in description to a 'forgotten' homeland, a bleeding land as it were, whose very landscapes circumscribe the nomadic dislocation of the neither/nor – the multiplicities of which are wholly unthinkable without a radical reinvention/re-membering of space (as the de-de-negation) and of time (as its dis-placed movement). We have here a paradigm shift, axiomatic at the point of a non-dialectics. And yet, it is one that manages to address, as central, the problem of 'change', 'movement', and the 'probability of certainty', along the axes of an impossible ground, without recourse to a teleological unfolding or

13 Apart from the texts cited above, de Man speaks at length about the importance of the paradox. See especially his 'Conclusions: Walter Benjamin's "The Task of the Translator"' (de Man, 1986, 83ff.)

14 Compare Wittgenstein's remark, part IV, of the *Mathematics*, where he says, '56. Contradiction. Why just this *one* bogey? That is surely very suspicious' (1983, 25).

transcendentalist logic. Instead we have here an always-already fragmented web of journeying, of exile, contingent at its very limit; one whose 'existence' is, in all the plurality of a finite infinity, opposite to nothing.

If we accept this proposition; if we accept that 'what tests the what' (to paraphrase Wittgenstein) is precisely the use of the rule itself and, therewith, we re-enlist the fiction of an indeterminate negation in the fullest sense of its multiplicity; then we may very well have managed to rescue (a not-)space from the ravages of time, without privileging one over the other. Indeed time itself may have, finally also, been unhinged from the fixity of an eternal Time; re-configured in 'the now' as radically heterogeneic and in dispersion.[15] But have we, in so accepting this radical neither/nor, space-time proposition – this *pluralism of the 'root'* – have we been able to avoid certain well-known problems of metaphysics (particularly around those that would seem to eradicate all forms of political struggle)? Moreover, in accepting what may appear to be a pure relativity of the rule (or indeed, of custom), have we not forfeited our ability to demarcate an ethical proposition – any ethical proposition – managing to escape from metaphysics, dialectic or otherwise, only to fall prey to a kind of chaotic meaninglessness, a kind of 'radical nihilism', that 'whatever is' is, *ipso facto*, good?

The longer reply follows in the next section.

But the shorter one to both these questions is: no. For in re-thinking the problem of identity and difference in terms of a radical pluralism of indeterminate negativity at its 'core' (one that is to say that, in its very 'exile', escapes and doubles [triples and, perhaps, quadruples] back to (re-)invent a contingent objectivity as such) in this movement, there is no collapse into an always-already given 'truth', nor one that conceals or reveals or revels within an ethical void.[16] This is precisely because political struggle, and indeed the political itself, becomes entirely central, placed exactly at, on, beside, over, and in terms of an (imaginary) 'ground'. A ground of bleeding land; a diasporic ground of space-time; a stain.

The a-moral interregnum

> I felt determined to transform the most simple details of life into so many insignificant words, that my voice, which was becoming the only space where I allowed her to live, forced her to emerge from her silence too, and gave her a sort of physical certainty, a physical solidity, which she would not have had otherwise. All this may seem childish. It does not matter. This childishness was powerful enough to prolong an illusion that had already been lost, to force something to be there which was no longer there. It seems to me that in all this incessant talking there was the gravity of one single word, the echo of that 'Come' which I had said to her; and she had come, and she would never be able to go away again.
> (Blanchot, 1978, 73)

The interregnum of this proximity and distance. It is fileted with the pathos of an imaginary beginning and, with it, the pathos of beginning an imaginary. We

15 This 'escape' of time from Time (whose route is aided and abetted by the imaginary 'not-space' of space) runs as a theme, certainly throughout the work of Proust (where time is invented/described as dead-time, real-time, living-time, memory-time and so forth) in his well-known and loved *Remembrance of Things Past* (Proust, 1983). But it is also taken up quite systematically by Walter Benjamin in *Illuminations*, particularly in 'The Storyteller' (Benjamin, 1969, 97–106). But I am also thinking about different *dimensionalities* of time: as in the time of virtual 'almostness'. See for example *The Lost Dimension* (Virilio, 1991) and Staffords, 'The Aesthetics of Almost' (1996, 465–79).

16 On the multiple uses of 'error' as a politics of journeying, see de Man, 'Walter Benjamin's "The Task of The Translator"' (de Man, 1986, 91–105)

could have started our story anywhere: though just because there never has been, is, and never will be a 'first', should not imply that there never was a 'once upon a time' (as the storyteller might say) or a 'supposing that' (as the political economy variation on storytelling might say). No first-causes; just beginnings/any beginnings/truncated beginnings: their weave produces the horizon (or is that a plateau? or a 'ground'?) of the start. In a way, it could be described as a tenuous weaving, threading together bits of memory, both dead and alive and somewhere in between, with the forgetting, the forgotten, the forgettable. We take from 'what lies around us', to echo Wittgenstein, and we *use it*; we use the dreams, the nightmares, the incidental dinners, the laundromats, to form our 'that'.

Indeed, and more specifically put, this struggle between and amongst memory and its forgetting produces the weave of a start – of a that – which has already begun. There is no horizon of the either/or; no identity invented 'against' the Something *per se*. We have instead the creating of the imaginary, creating the imaginary 'as if' real; producing the curve around which the present movement unfolds – a curve which is no more (or less) or shorter or fatter than a series of dots or maybe just one long dot stretched to infinity. Imagination. No lie (nor truth): only the radical geography of a fiction, continuous in all its dis-continuity.

Is it so difficult, then, to see how every 'as if' always-already re-presents a way of life, selecting a bit of this and a bit of that; re-presenting one's code of existence exactly at the same time as inventing it anew, and doing so 'as if' it were always eternally there 'beforehand' (or, at least remembering it as though it had been), in order to make the case that it now and for ever always ought to be so? Foucault names this 'as if' as a popular memory; Derrida brings it forward (in honour of de Man's death) as a mourningful one; in either case its function is precisely to constitute the impossible terrain of the 'to be' in all its present and future tenses. Indeed, it could be said that every first-year student of politics knows about this kind of 'as if': for without *some* kind of 'picture' of 'what ought to be' based somehow and in some way in terms of the 'what have beens' of life – in all their varying memories, myth-makings and decay, turning, as they must of necessity so do, between, with and against the exiled multiplicities of the 'what is' and the 'what lies before us' – that without that picture, one has at best only a recipe for disaster, one that is out of reach, out of touch and utterly unsustainable.

But this is also to say, simultaneously, that imagination, as powerful as it is (although or perhaps because its profundity remains but skin deep), is only ever able to be 'inscribed' – to become, that is to say, 'institutionalized', along the surface of an impossible ground – on the basis of immense political struggles to make it so. It is a risk that we take, a risk we must take, in order to make change 'stick'. A risk taken at the very surface of the 'that'.

And yet, if we follow the logic through, we are left with a not-so-baffling, but for some a conceivably dreadful, conclusion. By insisting on the radical political contingency of any social imaginary and the paradigmatic 'bleeding homelands' around which they turn, it is also to say, then, that the codes of existence – and, more to the point here, the moral and ethical truths implied by those codes – are only as solid as are the hegemonic expressions from whence they spring. For in exchanging a transcendental temporality (mixed metaphors and all) for the surface of the risk, we find at the end of the day that the very ethics of the social have been exiled to the margins of an impossible spatiality; the measure of its truth journeying precariously (it might seem) along the soiled interregnum of the imagination, attempting to fight the good fight on the ever slimy battlefield of the political.

The Hobbesian nightmare (*sans* the Leviathan) returns to a postmodern world in all its stunning brutality! And we, who have not the energy to struggle, are condemned to stand at the shore of a civilized Truth, forever waving a tearful farewell to the Good Life, our moral fibres cast away and adrift.

But I say: 'there is something wrong with this picture.'

For this re-invention, this imagination, all born and bred and sustained precisely in the space of that indeterminate pause, is a *social* ensemble. It no more falls from out of the sky than does language itself erupt from only one mouth. Indeed, this imagination marks by re-marking the history, custom, traditions of the immense variety of identities to which it is a part and from which it is most distant. Consequently, in that sense, not only does it (re-)mark the relation of itself to itself in all the ways we have described up to now; its meaning is established in the same way, exactly in the same way, as any sociality or law is established – be it scientific, civil, physical, theoretical or make-believe:

to wit, in a fantastical relativity to the 'that' which lies around us. In this sense, too, then, its identity (meaning, objectivity, truth) – already cast in relation to an (indeterminantly negative) plurality – is no more or less indefinite, no more or less whimsical, no more or less terrifying than is the statement $e = mc^2$.

'Everything has its day', as Nietzsche so eloquently reminds, musing on the prejudices of morality,

> When man gave all things a sex he thought, not that he was playing, but that he had gained a profound insight: – it was only very late [and after the intervention of the feminist movement – I should like to add!] that he confessed to himself what an enormous error this was, and perhaps even now he has not confessed it completely. – In the same way, man has ascribed to all that exists a connection with morality and laid an *ethical significance* on the world's back. One day this will have as much value, and no more, as the belief in the masculinity or femininity of the sun has today. (Nietzsche, n.d., 9; book I, no. 3)

By insisting that the ethical is both somewhere afloat in the imagination and, perhaps more dramatically, that the kind of ethics understood as if a (neutral) expression of any epoch, i.e., as the 'real' True Truth, is damning hypocrisy at best, have we squared the circle? For at the same time as exiling the ethical itself, we also want to say, for example, that *this* kind of democracy *is* better than that; that *this* kind of violence *is* worse than another. And we want to say it not just for any people, and not just for any time: but for now, and for us. Can we do this if we insist only on a presence that is not-here; or if we speak of an identity that is only ever difference captured in terms of some fractured impossible dimensionality called space-time; or if we insist on the radical pluralism of indeterminate negations as the core to any objectivity; or if we name the cut, the division, as bleeding homelands, i.e., as the exiled 'outside', the 'surface', reconfiguring/expressing the 'in'; or, finally, if we speak of an imagination collected from re-membering things which never were?

Yes. Yes, is the answer, and for precisely those reasons. For as it turns out, freedom is not the opposite of x ('un-freedom' or immobility, as it were, for example); indeed, it is not an 'opposite' at all. It is a fiction in the best sense of that word; and we have a right to that fiction, not only in terms of accessing it, re-re-membering it, institutionalizing it, but in terms of inventing it, playing with it and, yes, forgetting it, too. And *that,* apart from everything else, is *exactly* an ethical proposition; an ethical proposition with no morals, no morals to this story of negation.

Which is to say one last thing. 'Supposing that' we were never interested in anything any more ever again; supposing that our senses were so dulled and flattened (for whatever reasons: drugs, overwhelming odds, boredom, torture, homelessness, too little money or too much) that we lay prone all day and night, forever, not even wiping away flies that might migrate over our noses and our eyelids. We have a picture in front of us of utter dejection and hopelessness: the handmaidens to all things eternal, infinite and indistinguishable. But supposing that, on the other hand, we are to take seriously this problematic of a 'finite' infinity, i.e., a pluralistic negativity. What would become *its* handmaiden? It cannot be the Truth or the Temporal or the Ethical or the Moral or the Dialectical,

for the duties of this handmaiden are far too delicate than to be handled by those giants of modernity.

I dare say, at its most modest point, it would be curiosity: the gentle muse, who, in 'supposing that', embarks upon the ever impossible journey 'to find out'.

Note

An earlier version of this essay first appeared in A. Norval and D. Howarth (eds), *Re-Considering the Political* (Oxford, Anthony Rowe, 1995), 97–112.

References

Adorno, T. (1966a) 'Critique of Positive Negation', in *Negative Dialectics* (Continuum Publishing Company, New York).

—— (1966b) 'Cogitative Self-Reflection', in *Negative Dialectics* (Continuum Publishing Company, New York).

Bataille, G. (1991) 'A Story of Rats', *The Impossible*, trans. Robert Hurley (City Lights Books, San Francisco), 11–82.

Benjamin, W. (1969) *Illuminations*, ed. Hannah Arendt, trans. Harry Zohn (Schocken, New York).

Blanchot, M. (1978) *Death Sentence*, trans. Lydia Davis (Station Hill Press, New York).

—— (1982) *The Siren's Song*, trans. Sacha Rabinovitch (Harvester, Brighton).

de Man, Paul (1979) *Allegories of Reading: Figural Language in Rousseau, Nietzsche, Rilke, and Proust* (Yale University Press, New Haven and London).

—— (1986) *Resistance to Theory*, Theory and History of Literature (Manchester University Press, Manchester).

Derrida, J. (1989) 'Introduction: Desistance', in P. Lacoue-Labarthe, *Typography: Mimesis, Philosophy, Politics*, ed. Christopher Fynsk, (Harvard University Press, Cambridge, Mass.).

Foucault, M. (1988) *History of Sexuality: Care of the Self*, vol. III, trans. Robert Hurley (Vintage Books, New York).

—— (1990) *Maurice Blanchot: The Thought From Outside; Michel Foucault as I Imagine Him*, trans. Brian Massumi and Jeffrey Mehlman, respectively (Zone Books, New York).

Golding, Sue (1992) *Gramsci's Democratic Theory: Contributions to a Post-Liberal Democracy* (University of Toronto Press, Toronto).

Hegel, G. W. F. (1977) *The Phenomenology of Spirit*, trans. A. V. Miller (Oxford University Press, Oxford).

Heidegger, M. (1967) *Being and Time*, trans. J. Macquerie and E. Robinson (Basil Blackwell, Oxford).

—— (1969) *Identity and Difference*, trans. J. Stambaugh (Harper and Row, New York).

Kundera, M. (1978/80) *The Book of Laughter and Forgetting* (Penguin, London).

Laclau, E. (1990) *New Reflections on the Revolution of our Time* (Verso, London).

Nietzsche, F. (1983) *Untimely Meditations*, trans. R. J. Hollingdale (Cambridge University Press, Cambridge).

—— (n.d.) *Daybreak: Thoughts on the Prejudices of Morality*, trans. R. J. Hollingdale (Cambridge University Press, Cambridge).

Proust, M. (1983) *Remembrance of Things Past*, trans. C. K. Scott Moncrieff and Terence Kilmartin (Penguin, London).

Stafford, Barbara (1996) *Body Criticism: Imaging the Unseen in Enlightenment Art*

and Medicine (MIT Press, Cambridge, Mass.).

Virilio, P. (1991) *The Lost Dimension*, trans. D. Moshenberg (Semiotext(e), New York).

Wittgenstein, L. (1974) *On Certainty*, ed. G. E. M. Anscombe and G. H. von Wright, trans. D. Paul and G. E. M. Anscombe (Basil Blackwell, Oxford).

—— (1983) *Remarks on the Foundations of Mathematics (Revised Edition)*, ed. G. H. von Wright, R. Rhees and G. E. M. Anscombe (MIT Press, Cambridge, Mass. and London).

—— (n.d.) *Philosophical Investigations* (the English text to the third edition), trans. G. E. M. Anscombe (Macmillan, New York).

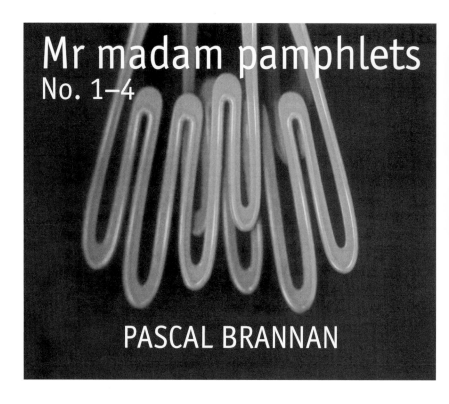

MR. MADAM – PAMPHLET NO. 1
GOD FOUND ME CAMP
EASTER, DUBLIN. 07.04.96

MR. MADAM – PAMPHLET NO. 2
EAT MORE ACORNS
GEORGIE BEST DAY, EURO '96

MR. MADAM – PAMPHLET NO. 3
WEAR MORE PONCHOS
FETE FETALE, LOLLARD STREET, SUMMER '96

MR. MADAM – PAMPHLET NO. 4
WHAT TO DO TO GO TO HELL
VIVA VIVA APATHY, MARKET TAVERN 30.08.96

CURIOSITY IS A FLOWER

Instructions/reproductions for Mr Madam graphic spread [pp. 29–32]
Photocopy templates [pp. 34–41]

MR. MADAM

PAMPHLET NO. 1

MR. MADAM

PAMPHLET NO. 2

MR. MADAM

PAMPHLET NO. 3

MR. MADAM

PAMPHLET NO. 4

**WEAR
MORE
PONCHOS**

**FREE ENTRANCE
WITH THIS FLYER**

Photocopy templates

PAMPHLET

NO. 1

MR. MADAM

MR. MADAM

WEAR MORE PONCHOS

FREE ENTRANCE WITH THIS FLYER

PAMPHLET NO. 3

MR. MADAM

WEAR MORE PONCHOS

FREE ENTRANCE WITH THIS FLYER

PAMPHLET **NO. 3**

PAMPHLET **NO. 4**

NOTHING.

NO. 4 PAMPHLET

HELL

TO
TO GO TO
TO DO
WHAT

MR. MADAM

OUR CORRESPONDENT

SUPERMAN
SAID:

"ANYONE WHO COMES NEAR ME.
WILL DIE.
INSTANTLY."

& I SAID:

"HOW LONG ARE YOU GOING
TO BE LIKE THIS?"

& SUPERMAN
SAID:

"THIRTY.
THOUSAND.
YEARS."

Noise

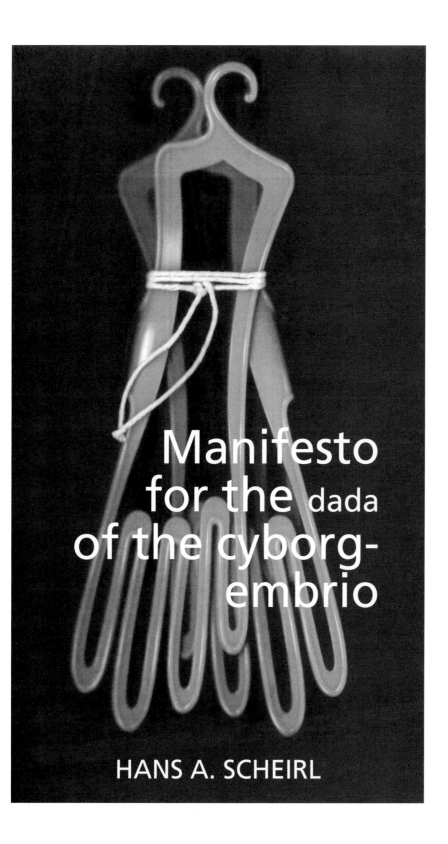

Manifesto
for the dada
of the cyborg-
embrio

HANS A. SCHEIRL

D@D@

MANIFESTO FOR THE dada OF THE CYBORG-EMBRIO

HANS SCHEIRL LONDON 199><5/6><2000

①♣DICTIONARY :

dada: [ORIGINALLY: ROCKING HORSE, BABYTALK ON HORSES]
 EJACULATE, PISS, TEARS, BLOOD, JOKE, MUD, FOUL LANGUAGE,
 WASTE, BROKEN BONES, MOULD, SLIME, MISTAKE, CUT-OFF PENIS+
 HEAD+ ARM, RIPPED-OUT HEART& INTESTINES
D@D@: dada; DANDY DRAG DADDY DADAISTS; CYBERNETIC CULT-
 PRODUCTION AROUND THE FILM >DANDY DUST<
DANDY: ARTIST OF LIFE

CY- FORMERLY HE, SHE, IT, HER, HIS, ITS. SINCE 2000: S/HE & IT,
THEN➜ INEVITABLY, THEY ALL FOUND EACH OTHER IN THE S/HIT!
(THE MATERIAL REVOLUTION: SHITTING AND PISSING ON EACH OTHER AS THE
MOST DIRECT FORM OF PHYSICAL CONFLICT ESTABLISHED ITSELF AFTER THE
FIRST WORLDWIDE RIOT)

S/HIT: SHE+HE+IT

H, -H-, h, -h-: HER+HIS, HE+SHE

CYBORG: BIO/TEC-INTERFACE; MYTHOLOGICAL END-OF-MILLENNIUM CHARACTER
IN 'CYBORG MANIFESTO' 1985 BY DONNA HARAWAY

'BUTCH/BITCH' : ART OF DIRECTIVITY; INCLUDES BOTH DIRECT/OPEN AND
INDIRECT/HIDDEN ATTACKS.

'SPRITZ- + SPIEL' : THE ART OF VOMITING & FOUL LANGUAGE

Æ: ALMOST

②CYBORG

'AS MONSTERS, CAN WE DEMONSTRATE ANOTHER ORDER OF SIGNIFICATION? CYBORGS FOR EARTHLY SURVIVAL!'
DONNA HARAWAY, CYBORG MANIFESTO 1984

CYBORG IS AN INTENSITY & LOCATED/IDENTIFIED IN THE INTERPENETRATION OF THE CLOUDS OF CY MOST PROBABLE WHEREABOUTS

THE CYBORG-EGO IS TOO EXPANSIVE, FLUID & CLEVER TO BE CARRIED BY WHAT IS INSIDE THE SKIN-SACK OF ONE HUMAN INDIVIDUAL. THE CYBORG-SELF IS A SITUATION, A LANGUAGE, A CULT/ure

THE CYBORG IS TRANS}VERSE: CY **CULTIVATES** MULTIPLE & FLEXIBLE PER}VERSIONS

INCEST IS THE CYBORGS BLOOD

'TABOO' = THE ART OF CREATION & DESTRUCTION OF TABOO

INSTEAD OF INSTITUTIONS: PROJECTS

THE GAZE IS NOT INSTITUTIONALLY CONTROLLED

MYTHOLOGY IS ONE OF THE PLACES THE CYBORG CALLS 'HOME'

WHAT THE CYBORG LEARNS FROM PSYCHOANALYSIS IS THE ART OF
LOSING/CONTROL OVER REMEMBERING AND ANTICIPATION. INSTEAD OF THE
ÜBER-ICH AND THE SMALL EGO AND ALL THAT SHIT THERE ARE A FEW MORE OR
LESS FLUID EGOS WATCHING EACH OTHER OR NOT WATCHING EACH OTHER.

THE CYBORG'S MIRROR IS THE COMPUTER

THE HUMAN BECOMES A CYBORG WHEN C RECOGNIZES A BLUTVERWANDTSCHAFT (BLOOD-RELATIONSHIP) WITH COMPUTER , VIDEO & INTERACTIVE TECNO.

THE MIRROR & VERISIMILITUDE NARRATION HAS LOST ITS IMPORTANCE IN THE CONSTRUCTION OF SELF TO INTERFACE & INTERACTIVE NARRATION. THE CYBORG'S 'MIRROR-PHASE' IS AN ON-GOING FORMATION-PROCESS.

THE CYBORG'S MOTHER-TONGUE IS SYNAESTHE***---+++SIA

REALITY=ATTENTION

THE CYBORG'S STRENGTH IS CY ABILITY TO FIND BALANCE IN A CONSTANT INSIDE-OUT & OUTSIDE-IN DYNAMIC: AS THE SURFACE FOR INFORMATION PROCESSING IS LIMITED, THE RAY† OF ATTENTION HAS TO BE WISELY DIRECTED: SPEED, RHYTHM, REPETITION.

† LIKE THE ELECTRON RAY, THAT BUILDS UP THE TV-IMAGE IN A FEW HUNDRED STOPS per SECOND, AND NOT TO FORGET THE EYE WHOSE FRANTIC MICRO MOVEMENTS PAINTS THE ILLUSION OF AN IMAGE!, THE RAY OF ATTENTION
MOVES SO FAST FROM POINT TO POINT ACROSS SURFACES, LAYERS &DIMENSIONS THAT IT BUILDS THE nDIMENSIONAL SPACE OF EXPERIENCE.

THE CYBORG IS THE CHOREOGRAPHER OF CY ATTENTION-RAY

STORAGE, EDITING & MANIPULATION OF MEMORY IS BEING REHEARSED EXTENSIVELY WITH THE USE OF VCR&PC. THE CYBORG IS A NATURAL EDITOR & PSYCHOANALYST

THE CYBORG CO-DIRECTS & CO-PRODUCES CY OWN EDUCATION, THEORY, CHEMICAL & PHYSICAL RE/PRODUCTION

IN
TIMES OF LEAPING TRANSFORMATION
THEORY, FICTION, DOCUMENTATION & ART ARE INSEPARABLE

A CULT NEEDS ITS MARTYRS↔**SUPER-SLUTS**
the new martyrs are pleasure><pain artists
BODY-ART !!

BARTER-PERFORMER CYBORG-SOCIETIES CULT(!)IVATE
MOURNING/SHEDDING/SPLATTER/SEPARATION/PORNO RITUALS

CYBORG IS... ↔MYTHOLOGY FEEDBACK CIRCLE↔EXPERIMENTAL PERSONALITY↔SHAPE-SHIFTER↔CAMP COMIX-CHARACTER

SWITCH-MODE: THE END OF A 'STATE'
DEATH: THE END OF A HUMAN BODY STATE {NOT COMPLETELY, AS THE INDIVIDUAL LEFT DIVERSE ELECTRONIC TRACES =MEMORIES&DATA: THE CYBORG DOES NOT DIE!}

THE CYBORG FANTASIZES ABOUT & RITUALIZES DEATH&SEX: AS C IS ELECTRONIC&HUMAN MANY DEATHS ARE EXPERIENCED, MEDIATED, COMMUNICATED &MYTHOLOGIZED

STATES ARE GEOGRAFICAL CULTS & POTENTIALLY EQUAL WITH NON-GEOGRAPHICAL CULTS. AN INDIVIDUAL IS AN ACTIVE PARTICIPANT IN MANY CULTS

THE FIN-DE-MILLENNIUM CYBORG IS A TRANSGRESSIVELY†† LIVING&PRODUCING INDIVIDUAL

††TRANSGRESSION: TRANSBEHAVIOUR IN THE BIO-ELECTRONIC CITY

>>>TRANSPATRIARCHAL ACTIVITIES/ATTITUDES!!!

AGE IS DISPERSED & REVERSED: GROWTH GOES IN MANY DIRECTIONS

THE CYBORG LIVES AN EXPERIMENTAL LIFE ALWAYS.

NATURE=CHARACTERISTIX

NARRATION=PATTERN

CREATING A MYTH=CROSS-MEDIA APPROPRIATION&ABSTRACTION

CYBORGS ARE NARCISSISTIC & ir/RESPONSIBLE

CYBORGS CELEBRATE EXCESSIVELY FLUID MOMENTS & CREATE TIME-SPACES OF RITUALISTIC DISPERSAL

CYBORGS ARE PROUD MACHINES

GENDER IS A COMPLEX OF ATTITUDES

✈

THE F2M MOVEMENT

IS A MORE-DIMENSIONAL DYNAMIC WITH A TENDENCY PARTICULAR TO
ITS TIMESPACE=CORROSION OF WWW.DOM .CULT.EARTH
THE TENDENCY:

=WOMEN IN THEIR 40IES BECOMING EXPERIMENTAL BOYS=
SHALL WE CALL IT:

OLDD

WELL ORGANIZED REBELLION FROM INSIDE

NO! WE CALL IT:

NEW

D✁DA D@DDY MACHINE

'NETWORKS OF CONNECTION AMONG PEOPLE ON THE PLANET ARE
UNPRECEDENTEDLY MULTIPLE, PREGNANT AND COMPLEX' HARAWAY

THE **E/MOTIONAL**DYNAMIX OF THE HUMAN-BECOMING-CYBORG
TIME/SPACE IS DRIVEN BY THE HUMAN-BECOMING-MACHINE,THE
DEATH/SWITCHMODE &THE HUMAN-BECOMING-PART-OF-THE-
CYBERNETIC-NOOSPHERE TRAUMA

AFTER THE AGE OF PROCREATION WE ARE ENTERING THE AGE OF PLAY.
POSSESSION/JEALOUSY>>>PLAY/INCEST. HUMANKIND'S PSYCHE WAS
FORCED TO IMMATURITY BY A STRICT ROLE SET-UP ACCORDING TO
BIOLOGICAL CHARACTERISTIX (GENDER, AGE, RACE)

THE BODY'S CONSCIOUSNESS HAS BEEN BED-DED INTO THE HUMAN'S
SUBCONSCIOUS. SEXUALITY HAS BEEN ABUSED AS A TOOL FOR POWER.
RADICAL BODY-ART BEDs NOMAD SOULS.

WE SEE GIRLS MASTURBATE MUCH

THE OLD HUMANIST BODY-IMAGE IS OBSOLETE AND WE ARE LOOKING FOR NEW
ONES, NOT A NEW ONE, BUT MANY, WE ARE SEARCHING FOR THE PHILOSOPHIES
OF MULTI-LAYERED COMMUNICATION. PLEASURE IS A TOOL.

(PAIN) IS A TOOL.

fuck the humanistic ideal/s fuck them all! as
humans become aware of their cyborgness they are
al/ready to question their human-ess and human-dom & cultivate
human-esse. As cyborgs.

cyborg identity: s/hit is a natural narcissist
(pleasurable self-therapy through self-eroticism
& sex) as the psyche has to accommodate for loss-
of-form, fear of transformation:

**identity= CLOUD of the most probable
whereabouts**

identity is the pattern written by the movements
of the attention-ray

identity=complex system of inwards & outwards
bulging hyrarchical identities with the potential
to blow up to pieces **nxt.** Only where there are
multiple identities, fear
of identity termination
fades

ARM PROSTHETIX: chainsaw, oilpump, ravenous maw

GADGET & TUBE SEX, IMMENSE VARIETY OF TRANSFORMER GENITALS

TERMINATE PRODUCTION OF COUNTLESS USELESS MACHINES AND BUILD USEFUL FUCKING ATTACHMENTS: CHROME-DILDO-MACHINES, RUBBERMUSCLES THAT GROW IN REACTION TO GUTTURAL NOISES, TOYS (BABY, MOTORBIKE, BOXER, BULL) REMOTE CONTROLLED BY FINGERS & OTHER BODYPARTS WORKING FROM THE SURFACE INTO THE INSIDES WITH RELENTLESS MOTORSTRENGTH. MICROCAMERAS! CUNT&INTESTINE CINEMA!

③scuola cybernetica

MAIN (INTER-)SUBJECTS IN CYBORG-(INTER-) EDUCATION:

COMPREHENSIVE, COMPULSORY SCHOOL FOR CYBORGS:

- MARTIAL ARTS (BODY, WORD, TECNO)
- ELECTRONICS 1) OF PERCEPTION, MEMORY &LEARNING 2) TECNO (RHYTHM, EDITING, DANCE) 3) ELECTRONIC&DIGITAL D.I.Y. (SOFT- &HARDWARE)
- APPARATUS 1)HUMAN ANATOMY 2) D.I.Y. (HOUSE, SEX-TOYS, FOOD, VEHICLES) 3)SEX
- POETRY&PHILOSOPHY (ALL ARTS)
- CONTRACTS&NEGOTIATION (S/M, LAW)
- RESEARCH (VIA TECHNOLOGY, VIA THE BODY)
- CHEMIX [CHEMICAL FUNCTION, SUPER-VISION & MANIPULATION OF 1) THE HUMAN BODY 2) ITS RESOURCES 3) ITS PLAY-AREA
- SELF & CO- RE/PRODUCTION (PERFORMANCE, SEXUAL RITUAL, PSYCHOTHERAPY, TEAMWORK, GAME-WRITING, MANAGEMENT, MARKETING)

FACTUAL KNOWLEDGE IS NOT COMPULSORY. **FAC.K.** = BUSINESS!

④the cinema of iemx-plosion CYBERSPLATTER-COMIX:

CYCOMSPLAT!

A CYBERNETIC GENRE

PLAYING

THE BECOMING

SPRITZ- & SPIEL©©©FILM: Multiple self/birth of the cyborg
into the era of interpenetration!

HYPERJUICY SPLATTERCUNTS, PYROTECHNIX, EVAPORATION

MOTHER FUCKING DADDIES BACK INSIDE

CULT OF DISPERSAL: MELAN CHOLIC PORNO SPLATTER

DADA TO BE IN EACH OTHER'S PORNO-CINEMA-EYES

THE SPRITZ†✚ SPIEL ✪ FILM SHATTERS (THE) BODY & SELF (-IMAGE) OF
THE HUMAN (ISM) & CELEBRATES THE END OF ALL DOMINANCE BY:

❶THE HYPERVISUAL
THE SUPER-AUTHORITY CONTROLS THE GAZE BY THE 'YOU MUST NOT
LOOK' THING & THE 'FORGET WHAT YOU HAVE SEEN' THING. THE
SPLATTER-ARTISTE GURGLES & EJACULATES A SPURT OF BLOOD † INTO
YOUR GREEDY EYE OUT OF CY IMMENSE &DISGUSTING RUBBER-PRICK:
YOU GET TO SEE MORE THAN YOU EVER WANTED TO SEE.

❷ MUTILATION
THE BODY IS TAKEN APART, ORGANS & BODYPARTS & SPOUTS OF FLUIDS
HAVE A LIFE OF THEIR OWN WHICH THEY EXPRESS IN THE LANGUAGE OF
THEIR CHARACTERISTIC MATERIAL. WHERE DOES THE ME START AND
WHERE DOES IT END? FEROCIOUS FLUIDITY BETWEEN ALL BIO-+TECNO
SOFT-+HARDWARES. NEW ORGANS NEW ORGANISMS, RESTRUCTURING,
REPLACEMENT

SPLATTER IS RITUAL OF
 SEPARATION& MELTING

PROTAGONIST

= theSPACE where ACTION can show itself

THE CYBORG AS A MYTHICAL FIGURE GIVES THE TROUBLED END-OF-
MILLENNIUM-SELF A PLAY/ACTION-**SPACE** FOR IDENTIFICATION &
SEPARATION

PROTAGONIST-SPACE>>>PROTAGONIST-MULTIPLICITY>>>SHAPE-SHIFTERS

narration

ELEMENTS OF THE CYBERNETIC NARRATIVE COMPLEX:
✕ SEQUENCE ✕ FEED-BACK ✕ EFFECT ✕ F/X ✕ MUTILATION ✕ BODY-
PARTS ✕ SPLATTER ✕ TECNO ✕ WASTE ✕ P/RE/PROGRAMMING ✕
TOOLS ✕ MUTILATION ✕ FEEDBACK ✕ FUNCTION

BASIC BIO-MACHINIC ASSEMBLAGE OF F/X CINEMA:
1) SEQUENCE
2) BODY-PARTS
3) BY-PRODUCTS

IN 'DRAMA' THE STORY IS CONSTRUCTED TO SEND THE MAIN
PROTAGONIST ON A QUEST: THROUGH CONFLICT TO RESOLUTION. IN
'SPLATTER' THE PLOT SERVES THE **SPECTACLE** OF DIS/SOLUTION.

STORY & PLOT >>> STRUCTURE&COLLAGE SPEAKING THE STORY/PLOT-
LANGUAGES DEVELOPED BY THE DIVERSE STORY-&PLOT-CONVENTIONS
ACROSS THE GENRES + CULTURES

CYBERNETIC/ E-MOTIONAL NARRATION = THE MACHINE THAT MOVES THE
EVENTS <u>AND</u> IS DRIVEN BY THEM: THE MOVIE DOES NOT HIDE ITS
MANIPULATIVE POWERS, IN THE CONTRARY: IT HAS FUN
SHOWING OFF

CYCOMSPLAT IS E-MOTIONAL CAUSE+ EFFECT ASSEMBLAGE

HOLLYWOOD NARRATIVE: FIRST YOU HAVE A STORY, THEN YOU
ILLUSTRATE THE STORY WITH IMAGES
CYBERNETIC/INTERACTIVE NARRATIVE: FIRST YOU COLLECT
MATERIALS, PICTURES, SOUNDS, ETC. OF THE FILM-TO-BE, THEN YOU
TRACE MOVEMENTS AND CREATE LINKS. THE SPECTATOR IS INSPIRED BY
THE EASE WITH WHICH THE MOVIE SWITCHES BETWEEN DIMENSIONS/MEDIA/
CINEMATOGRAPHIC LANGUAGES/IN&OUT TO DO LIKEWISE & WEAVES H OWN
STORIES

BIG AND SMALL, GOING THROUGH, THE DIMENSION 'SCALE', INSIDE/OUTSIDE
THE POLITICS OF BULGE AND CAVITY

ON TIME-SPACE-SCALE NARRATION:
THE NARRATION GOES <u>THROUGH</u> SPACE RATHER THAN <u>IN&OUT OF</u> SPACES.
IT DOES THAT BY TRAVELLING IN THE DIMENSION 'SCALE' . DANDY
DUST TRAVELS THROUGH THE 'BIG' UNIVERSE, APPROACHES AND GOES
INTO THE 'SMALL' UNIVERSE, SO FAR THAT S/HE ENDS UP IN
THE/ANOTHER 'BIG' UNIVERSE & AND CAN, OF COURSE, NOT DISCERN
BETW SMALL&BIG ANYMORE, S/HE EXPERIENCES SPACE AS SOMETHING
THAT CHANGES ACCORDING TO H OWN MOVEMENT, WHICH CAN BE OF
IMPLOSIVE, EXPLOSIVE OR OF SCANNING NATURE.

IMAGINE A SOFT/HARD OBJECT THAT LOOKS LIKE A HIGH DOUGHNUT
[WITHOUT ANY SPACE 4 LOOKING THROUGH] FOLDING ITS IN/OUT/SIDE
INSIDEOUT: A TRANGENDERED ARSEHOLE!!!

GOING <u>INTO</u> THE DETAIL [IN COMPUTERGAMES YOU OFTEN KLICK ON A DETAIL TO
GO TO ANOTHER PLANE]

©CYBERNETIC INTERACTIVITY IS THE NEW NARRATIVE SYSTEM (AFTER THE INVENTION OF WORDS)

HORROR: PLEASURE IN HIDING+UNVEILING, SINGLE/MAIN CLIMAX

SPLATTER: PLEASURE IN SHOWING, MULTI-CLIMAX, FETISHISTIC/MATERIALIST SCENES/RITUALS , SPECTACLE OVER STORY

SPLATTER-SPECTACLE: SHOCK-MATERIAL PUT INTO A FORM WITH THE POWER TO SEDUCE

SPECIAL-EFFECTS (F/X)

F/X ARE THE PROTAGONISTS OF THE SPECTACLE.

① **IDENTIFICATION:**THE SPECTATOR TEAMS UP WITH THE SPECIAL-EFFECT FOR SELF-MANIPULATION IN ORDER TO TRANSCEND BOUNDARIES OF MATTER, THOUGHT &PHANTASY

② **VOYEURISM:**THE SPECTATOR SEPARATES: 'YOU MUST BE BLOODY JOKING. YOU'VE LOST ME HERE, MAN, THIS IS WAY OVER THE TOP, BUT I MUST ADMIT THAT IT IS A TREMENDOUS PLEASURE TO BE LOST IN THE SHOCK&POETRY OF YOUR CRUEL INVENTION'

THE MOMENT WHEN THE SPECTATOR SWITCHES BETWEEN ①↔② IS NOT FIXED.

THE SPECTATORS KNOW THAT THE FILMMAKERS KNOW THAT THE SPECTATORS KNOW. WHEN THE MOVIE GIVES UP THE ARROGANT POSITION OF TRYING TO HIDE ITS FAULTS & PRETEND TO KNOW WHAT'S GOING ON, IT ENTERS INTO AN EQUAL DIALOGUE WITH THE AUDIENCE... 'EMOTION' IS NOT SO MUCH REPRESENTED, BUT THE FILM ITSELF, AS A CYBORG, SHOWS E/MOTIONS IN ITS MEDIA-SPECIFIC WAYS. F/X SOMETIMES WORK, SOMETIMES DON'T, SOMETIMES THEY WORK BETTER THAN INTENDED. AMBIGUITY IS AN OPEN MOVEMENT. THE TENSION BETWEEN JELLY & PHLEGM, POTATO-STARCH & BRAIN-GOBS CAN EXPLODE OR IMPLODE. THE FILM'S OWN SELF-IRONY MAKES IT PRONE TO HUMOUR OR SHOCK INVOLUNTARILY.

EXPRESSION

EXPLODES INTO A RAIN STRONG SPOUTS OF BLOOD A SCRAWL ON A WALL OF MISERABLE MOIST & CHALK . THE DETECTIVE TOMBOY HAS A POCKET SPLATTER-SCRAWL-DECYPHER & READS THE DYING CYBORGS' MESSAGES. BURSTS OF EXPRESSION IN THE MOMENT OF

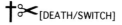[DEATH/SWITCH]

'...(S)ACRIFICE REMINDS US THAT THE SYMBOLIC EMERGES OUT OF MATERIAL CONTINUITY THROUGH A VIOLENT, UNMOTIVATED LEAP' KRISTEVA ↔KELLY

MODES OF EXPRESSION:
mutilation, melting, pressure, evaporation, swelling, splatter, explosion, shot, growth, erection, seepage, breaking, multiplication, animation, hybridization, invasion, immunization, plug in, make electrical contact, switch on/off; interpenetration of movements, synchronization

elements of excremental narration: 1)waste: blood, piss, body-part 2)pressure, speed, sound, form of excremental movement 3) writing-surface, touch, product of articulation 4) writing tool=relationship between body and excrement

loss&becoming are part of one process: mutilation is loss&becoming at the same time: **lose an arm>become a fountain**, get blown to pieces>get a new shape, get killed>become eatable left-overs

futuristic cinema tanks: cervix-theme park: simulation game, self/ experiment of the spectator as a cyborg-embrio experimenting with:

1- the production & supervision of chemicals

2- diverse trembling-languages! fast oscillation between attraction&repulsion, romanticism&shock, laughter & desperation creates a virtual playspace

A PREGNANT GENRE!!!!
sickness/vomiting, boil- pregnancy, cervix-rape (pressure, squashing), birth & reversed birth, incomplete birth (embrio trapped in body-part or other object), transgendered 'mother' monsters, disembodied fathers (the father who is 'slime' communicates via the mushrooms that grow on h!), transsexual shapeshifting, EXTRAterrible variety

Cyniborg (Suzie Krueger) in a still from Hans Scheirl's cyber-punk/ cyber splatter film *Dandy Dust* (London/Vienna, 1997).

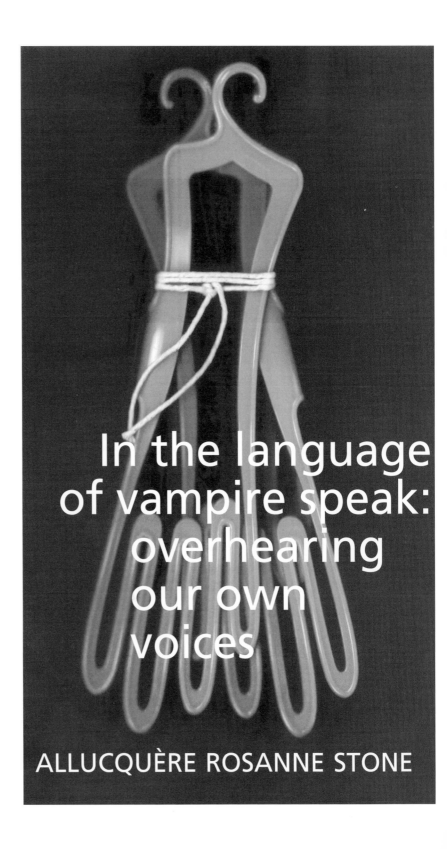

In the language of vampire speak

Why am I dragging you – us around like that? Why don't I just cut to the chase?

Because I can't. See, this is a book about desire. As such, it can't be a book about rationality, because desire is one of the processes – few though they are – that bypass the critical functions and so-called higher centres of the human mind. It is about forces that draw us towards centres of attraction – human, animal, or insect; living, once-living,or never-living; physical, conceptual, or impossible – centres that possess the uncanny power to rearrange our rational faculties and judgement, our sense of action and consequence, so as to further purposes that we may not understand, now or ever.

It's also about borderlands. You know the usual associations – the outer ridings, exotic foreign places, other worlds, perfumed seraglios, inscrutable sages, mountaintop gurus, the entire panoply of symbol by which we construct that which is not-us, and imbue it with that-which-we-do-not-have. Borderlands belong to no one and everyone; are spaces in which ordinary laws are suspended, common categories abandoned, the waking world of predictability and rhythm held at bay. Unlike our fantasies, real borderlands are rarely pleasant places to be.

But they are where the action is. They're where the vampires live.

And lastly its about memory. Memory makes our sense of self possible because it permits reflection, allows us to compare ourselves to past and possible future selves. Inevitably a book about memory is also going to be about what the sociologist Anselm Strauss called mirrors and masks and what the author Alan Watts called the taboo against knowing who you are. With memory comes the great unrolling of Narrative, of the Quest, the vast tales of adventure and redemption by which our storytelling culture has traditionally made meaning. So by calling on memory, I am making room for storytelling. Finally, then, this is a storybook that is about stories.

Of the things I've just mentioned, memory is arguably the most important. That's because we construct ourselves in the present by referring to the past, as a source of information, inspiration, and guidance. Here at the close of the mechanical age, a good deal of our experience of making meaning is mediated – that is, we learn how the world works by seeing or hearing it through TV, radio, and the Net. History is supposed to be something you read about in books, but we are rapidly becoming a culture that not only does not but cannot read – not because we don't know how to make sense of a printed page but because we are forgetting the strategies for absorbing the long, densely packed texts by which significant knowledge has been passed along since the invention of

printing. In my line of work we call this the crisis of orality, but we've got a few doozies on the fire already and orality's just one of them.

Another one is called the crisis of representation. Having grown up being taught that scholars should write dispassionately and objectively, we are beginning to notice that objectivity can be subject to the same whims as anything else, and that dispassionate observation can be a mask for the exercise of arbitrary power. For example, in the 1970s and 1980s anthropologists began to notice how their work could be used by their governments to subjugate 'other' cultures, that is, other than their own. Some began to make efforts to get the 'natives' into the process of describing native cultures. Some decided that the whole idea of cultural description was seriously flawed from the get-go. And some dug in and opted for dispassion and objectivity whether those terms still meant anything or not.

A deeper question that these arguments implied is how to describe another culture. Do you use their language, or yours? If you use yours, how do you deal with ideas, concepts, feelings that don't mean the same thing in your language? Or is the idea of translating experiences across cultural boundaries just fatally flawed?

I still think of myself as an academic, which is a dangerous act in a time when it sometimes seems as if lawmakers are doing everything in their power to eliminate academics just short of passing bills to have us all spayed. I've been blessed with a supportive environment and a cadre of bright, nasty, eager students, and together we inhabit – maybe I should say infest – the Advanced Communication Technologies Lab at the University of Texas, Austin. There we puzzle over what happens to memory when history is up for grabs, and what happens to literacy when most of us know only how to watch images.

Interestingly enough, we're finding out that there's a war on. I don't mean the myriad shooting wars that are unarguably going on in so many places in the world, but rather a war to settle who controls how things mean. Not what things mean, but how. The difference is crucial. 'How' refers to the structure of meaning itself – not to individual meanings, but to how we make the apparatus of meaning by which individual things and acts come to make sense. It doesn't appear to be a conscious war, in that nobody's going around claiming to be pulling the levers by which the apparatus of meaning is made. But the unusual and unprecedented conditions in which we live make such a conflict not only inevitable but dangerous.

Meanwhile the same conditions – the rapid changes in our world, outlook, and lifestyle, and in particular in the ways we have become totally immersed and saturated in certain kinds of technologies – have brought into being new kinds of creatures.

I'd point them out, but they are invisible to us. I don't mean that we bump into them blindly, but when we look at them we see something else. We don't possess the visual apparatus that would allow us to make proper sense out of what we see.

If we are going to survive into the next century, we need to learn how to see properly – how to make meaning, in all senses – in a world that has already changed beyond recognition, and that we still think we recognize only because nostalgia is such a terrifically powerful force. We can do that in two ways. One is by becoming aware that the control of the apparatus of meaning has slipped out from under us.

And the other is to accept the vampire's kiss. [. . .]

Overhearing our own voices

Some time ago I came across a story in which a person, by pressing a button, was able to eavesdrop on another person's mental musings. Eventually the 'other person' turned out to be the protagonist's alter identity. In other words, she was spying on herself. This suggests that we are, in fact, our own best informants.

This little story can also be seen as representing a conversation between perception and meaning. Recently I have been particularly interested in the ways in which the interface between meaning and perception has come to be mediated by technological prosthetics. There is no privileged way into this inquiry; numerous intersections exist between the ways that the concept of space is understood, exemplified in the character of philosophical and scientific inquiry before and after the first recorded uses of perspective, and in the ways that early devices for rationalizing the visually apprehensible world modulated the character of vision itself. The discourses of 'rational', value-neutral vision arose in the context of efforts to produce purely mechanical representation machines, such as the *camera obscura* and later the entire discipline of photography; and it was not immediately apparent that such concretized discourses helped to interactively produce the phenomena which they were intended to objectively represent.

Of course such a discussion is part of ongoing debates about the social construction of vision and perception, and we may note in passing that while the debates concerning their provenance and purpose have remained resolutely academic and theoretical, the machines of vision themselves have devolved into popular culture and become the simplest tools for stopping time. An example is the recyclable camera, which is sold with a single roll of film already installed and is returned for developing when the roll is completely exposed. Once again the gravity field of late capitalism encourages one to point the little time-machine at anything whatsoever, and

the complex effects of the consequent devaluation of the captured image have been studied at length by many scholars in various disciplines of inquiry.

Donna Haraway has pointed out that the privileging of vision as a means of knowing, whose origins we may trace back as far as Plato but which shifted into high gear with the development of 'objective science' around the time of the Enlightenment, is a contingent process deeply enmeshed in discourses of masculinity. As a performer for whom performance and theory are inseparable, I am acutely aware that performance, the privileging of vision, and the maintenance of social order are closely linked through the medium of political power. Recently I have been examining these links in relation to the trope of gender, which in our societies provides a structure through which power frequently expresses itself.

As Judith Butler, Kobena Mercer and other theorists have pointed out, gender is a trope of performance, and in the usual analyses gender finds a discursive grounding in the facticity of sex; most theories of sexuality argue that this grounding is a social production, arising in Networks of perceived political necessities. This is not to say that gender is ephemeral or even particularly plastic, because social relations – which originate as symbolic exchange – are capable of producing refractory objects, including discursive objects or 'facts'. Since space is one of those facts, there is an egregious area of intersection in the mutual discursivity of gender and space. One of the problems which must be faced in designing and constructing articulated inhabitable spaces is how such spaces enable or inhibit various kinds of performances associated with them. Performance is a public inscription practice, and thus presumes mutual interaction. The limits of performance and its articulation within public space are constrained by a variety of social contracts, exemplified by the difference between, say, presentation of self in the Elizabethan and later in the Victorian periods, not to mention the different ways in which human agency was made possible or restrained during those selfsame eras.

Since in virtual communities the social practices which ground and fix the types of performance of which gender is a variety have not yet been codified (and hopefully may escape codification for a time), the discursive and interactive field of cyberspace remains a hopeful locus for rearticulations of performative sociality. These will be profoundly influenced by choices *vis-à-vis* the meanings of distance, direction, and surface which anyone who designs virtual communities and their supporting structures must make. This implies a new kind of designer – one who understands and can access and manipulate the descriptors at the level of the programming code by means of which cyberspaces are generated. Using pre-existing code means building in someone else's universe,

thus foreclosing opportunities to experiment with the shape and quality of space itself; and hence with the kinds of social performance which are possible within virtual and physical spaces.

Our understanding of the meanings of the terms 'sex' and 'gender' is time-bound: for example, we can refer to a time and place (e.g., France in the early 1800s) when there were two sexes and three genders, and identify the moment (roughly the time of Herculine Barbin, a particularly well-documented case of transgender) when the French system of constructing meaning *vis-à-vis* desire underwent a change to the present one of two sexes and two genders. This shift in a local system of meaning surrounding the terms 'sex' and 'gender' was in some degree precipitated by the legal debates over the case of Barbin. To a certain extent, and particularly in bourgeois discourses, the concept of dwelling place or domus was articulated in relation to domestic ideals which depended upon mutually understood concepts of gender. There are many models for the concept of dwelling space in virtual communities, many of which observe conventions borrowed from real life (RL), some of which do not. The earliest examples are conventional, such as the multiple-user social domain called Habitat. Most of the later elaborations of graphical-based virtual communities – Palace and WorldsAway come to mind, though there are many – share Habitat's conventional representation of domestic spaces that recall well-worn bourgeois sentimentalities. Simultaneously in the laboratories of such architects as Marcos Novak, there have been evolving models of habitation which bear no resemblance to anything customarily thought of as habitation; structures which could have no existence anywhere but in cyberspace. Both models express powerful lessons. The readily accessible graphic-based virtual worlds play upon images of convention, bourgeois expectation, nostalgia, visual (and coding) economy, and commercialization. On the other hand, experimental cyberspace architectures are attempts to develop new visual languages which at first may appear unintelligible.

However, at this time there is no question that participants in virtual worlds still prefer those that are text-based rather than graphic-based. This is because text-based worlds require participants to engage their imaginative faculties much more deeply than do graphic-based worlds. Since almost all of the action in virtual worlds concerns constructions and reconstructions of identity, the greater part of my studies of virtual worlds has been concerned with understanding how identity works in virtual spaces.

I wish to pause here to define a term I will use in the next part of this discussion. I find it useful to use 'Ordinary Space' (OS) to refer to what is generally termed 'the real world' or 'physical space'. In employing the term 'ordinary' I am articulating my search for a grammar of method for analysing cyberspace discourse. In the course of this effort I feel it is important to avoid reifying the

binarisms which come into play so easily when the terms under discussion have already been so resolutely binarized in other discourses – terms such as *physical* and *virtual*, *human* and *machine*, *inside* and *outside*. Of course I play with those terms too; I use them and repudiate them alternately at various points in the work. For our purposes here, in using the term 'ordinary space' I am implying ordination as quantification, Foucauldian 'gridding', or map-making of both a physical and epistemic kind. In other words, we are considering the shallow level of perception at which spatial and epistemic quantification is the mode of common understanding. In addition, the term also refers to what the anthropologist Carlos Castaneda's 'native subject' Don Juan Matus calls 'ordinary and nonordinary reality' in Castaneda's early experiments with anthropological representation. And finally it is homonymous with the computer science term 'Operating System', referring to both machine codings and epistemes, without which neither ordinary spaces nor cyberspaces would exist.

So let us now examine three facets of identity in cyberspace. Fiduciary identity is warranted by computer accounts and the assumption (partly valid) that those accounts are issued by 'responsible' system administrators. However, this is true only for large institutions and companies. Moreover, several blind remailers already exist for the express purpose of preserving the anonymity of account owners. The combination of a fiduciary identity and a biological body to which it is warranted produces what is generally called a person. For our purposes we might call it an OS persona. The perspicuous quality of an OS persona is its stability, since powerful political forces, acting through social legitimation, are continually at work to bound and delimit it.

For this reason, contingent or local identity is the usual variety found on the Net. In the contingent or local mode one persona deals with another persona at face value, without much attempt to warrant the persona to a specific OS persona. There used to be such attempts, until their futility could no longer be overlooked. However, there are other cases in which one or both parties disclose their fiduciary OS identities.

This, then, brings us to the question: How do identity structures arise in virtual interaction?

We have evolved rapidly through a period when persons in the Net treated cyberspace (CS) discourse much like they treated OS discourse, as expressed in a tacit assumption of the facticity and obduracy of a stable person whose identity was merely reflected in their Net persona; i.e., Net persona as mirror or projection screen for an absent agency. With the first recorded case of a Net cross-dresser in 1985 (although the phenomenon extended back in time much farther than that), and the shock it produced in the Net community within which it occurred, came a new understanding of Net persona as something more than a mirror for absent agency, if

something other than a *doppelgänger* for that agency. We now find ourselves at a time when the Net persona is tacitly the real persona – when participants have become used to the idea that a Net identity cannot with absolute assurance be grounded in anything. So what we are observing is really a period of adjustment to unexpected consequences of innovation. And still some participants seek a physical reality beyond the Net persona, and occasionally find it. OS relationships do grow up and sometimes survive off the Net.

Most naive participants in Net discourse take their social conditioning with them into cyberspace, just as they take their spatial conditioning. They tend to assume that there are two genders, and usually spend some effort in trying to determine what the genders of their conversational partners are. Some of the more advanced multiple-user social environments provide for four or five genders; in one example male, female, neuter, troll, and multiple. Most of these systems also contain non-human agents called bots, which emulate human agency and can interact with human agents. However, we have not yet observed participants constructing desire in relation to genders other than the usual and customary binary pair. This step will require, first, a willingness to abandon a sexual history which has been imbued with all the permanence of divine command; and, second, a willingness to surrender the idea of person as it is commonly understood, along with the idea of structure, architecture, and home – all of which are baggage carried over into cyberspace from older and irrelevant contexts. Nostalgia and routine are the inertial constant of epistemology. We need look no further than the nearest gay or lesbian, not to mention transgender, relationship for models of desire that do not operate on principles of difference. Such relationships demonstrate once again the plasticity of attraction and the breadth of human capacity for desire, as well as foregrounding the political and social forces which attempt to control it.

Recently I was asked to participate in a discussion of the nature of housing in cyberspace. Since I tend to avoid the use of the term 'house', or for that matter 'home', in connection with cyberspace, this presented something of a challenge. Either descriptor is misleading because of the meaning structure already associated with it. Houses exist for specific reasons in a universe in which walls and roof are necessary for privacy and to protect against weather. From a purely utilitarian perspective, furniture exists to support the body and household objects against the force of gravity. In a political frame, the frame of location technology, houses provide stable identifiable location, and consequently are part of an apparatus of surveillance and control. Weather, privacy, and gravity have no meaning in cyberspace (privacy is meaningless when one can become invisible at will), and the jury is still out on the

persistence of location. Consequently the meaning of shelter is quite different in cyberspace. This requires a rethinking of the meaning of architecture as well. Marcos Novak's 'liquid architectures' are perspicuous examples of what this might mean.

One of Novak's discoveries in this context is the persistence of sensuality and desire in relation to surface, and the ability to engage the visual sense in constructing sensual experience without much need for tactile feedback. This directly affects construction of theories of sensual interaction in cyberspace contexts.

Cyberspace is large; it can contain multiple epistemologies, from traditional concepts of structure and habitation to Novak's multi-dimensional quasi-structures; from traditional conceptions of embodiment to Brenda Laurel and Rachel Strickland's smart costumes. The important thing is to remember that no single definition can encompass the possibilities for constructing 'space' and 'place' in cyberspace.

Since utopian communities do exist in virtual space, of more immediate concern is the fate of cyberutopianism. For most participants, the utopian character of virtual commmunities will last no longer than it takes for access to be sold off to private interests to be milked for profit. We don't have to look farther than radio for an example. In the USA, 'The airwaves belong to the people' is the hollowest of homilies. The golden rule – those with the gold make the rules – will probably eventually apply to cyberspace as well. Also very probably though, rebel enclaves will survive – and since almost any place in cyberspace with enough bandwidth is infinitely expandable, these could remain important if marginalized cultures. Unless it is still possible to take action to keep cyberspace free of commercialization, whatever that phrase may mean, if anything. None of this addresses the issue of the totally disenfranchised, however, which includes a large segment of Third World populations, not to mention of the USA who may not possess the wherewithal, the time, or the interest in what is certainly an elitist discourse, or the discretionary income to achieve entry to cyberspace. At the recent Fourth International Conference on Cyberspace, a representative of First People groups (native Americans) said quite clearly, 'We don't want your cyberspace' – meaning cyberspace as it is already articulated across a broad variety of anglophone discourses. For most participants none of this will ever be an issue, since they will use access devices and software written for them, with its own epistemological and political agendas firmly and invisibly built in. They are the next wave after the cyberpioneers.

It continues to be my distinct pleasure to be present during the early evolutionary stages of virtual communities, because we are now entering the transition from the first generation of software architecture to the second generation. Without exception, first-generation systems have suffered from problems at the system

level. These include such arcana as memory leakage, database
bloat, defective garbage collection, and imperfect permissions.
Unfortunately, space does not permit further elaboration of those
concepts here. These problems will be alleviated with the release of
such second-generation software systems as Muq, which makes
possible distributed non-hierarchical virtual world servers in a
similar way that the Internet architecture makes possible
distributed non-hierarchical internet nodes. This will remove much
of the 'noise' in virtual communities analysis that arises from
software limitations rather than social or psychological ones,
permitting interactional styles to develop more fully and making
possible better data collection. Time will reveal what we learn from
these developments. Personally I'm eager to find out.

Note

This is a longer version of the earlier 'Overhearing Our Own Voices',
Interface3 (Hamburg, 1996). It incorporates sections from my forthcoming
book, *Beyond Human: Tales from the Edges of Identity.*

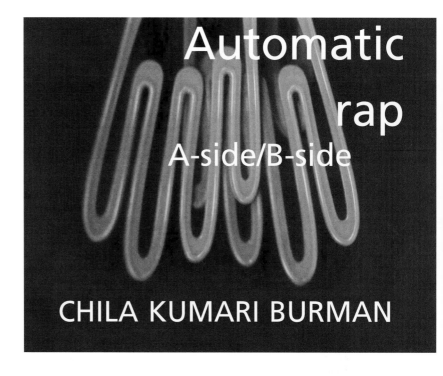

Automatic rap A-side

Me and me Dad having our Roti in Bootle, 1995. Variable size
(A3 – Billboard). Cibachrome/mixed media.

Portrait of my Mother, Sweet Flower, Mummy Ji, 1995. Size:
Passport. Mixed media: heart, liver, kidney, earth, fire, water,
metal.

Fire Ball: Me and me sister in Bootle, 1995. Size: Variable.
Cibachrome print.

Peace, One Love, 1995. Variable size (A3 – Billboard). Mixed media:
anger, rhythm, voice.

Automatic rap B-side

Don't get me started. Gida Pa.

SO much to say, to say, this is the hardest thing in the world, Fire,
 fire, fire, Agg, Agg, Agg,
One struggle after another, one fight after another,
FREEDOM what's that? Woz, IZ, DEAD hard, Stereotypes reinforces
 MYSTERY.
NO art books on are shelves at home. NO paper to draw on. Just
 making ice cream 99s
Tiger nuts & toffee apples and millions of toffee walking sticks – ART
 sister art
NO one listens, suppose they must all think it's Dead easy, they
 haven't a clue.
Making rotis night after night, no time for homework, but loadsa
 sweets to eat from the icecream van,
cornettos, choc-ices & rasberry splits. Flakes and screwballs, shells and
 boats . . .
Who says all working-class Asian girls are quiet, WHA' in are house?
 Wild girls, Punjabi, Bhangra,
Gidha, sticky sweets, sweat, who's wearing the best salwar keemich,
 glittery, satin, & velvet rage,
Gida Pa, Gida Pa goria, Dance english sister Dance. Move that
 body . . .
Roti Dal & beanz & biscuits, Parma violets, hopscotch under the dim
 cobbled street lamp in bare
feet in frilly nylon frocks, tatty hair. Red corduroy dresses, sparkly
 juridar pyjama, white, purple & pink
Indian films every sunday afternoon, all dressed up, tears, nappies,
 playing is in the aisles,
Chocolate, Coke, Jalebi, Ludu, barfi, and syrupy sweet white masala
 tea, Bar 6, toffee crisp, grar
Pakeeza, Mother India, Phoolan devi, Jhansi Ki Rani, Meena Kumari,
 Sita Durga Ma, Kali, where are you
Standing up tall & reaching heights, show 'em whatcha got . . . rebel
 without a pause . . .
Proud brand new grammar school uniform, wrong hat, 11 plus, cyclin
 proficiency, Swim
for the school, act for the school, run for the school, sing for the
 school, long jump for the school
shot put for the school, first class honours, who says were all Meek
 and Mild sharp as a knife . . .
FRAGILE EXPLOSIVE AND SENSITIVE SOULS HANDLE WITH EXTRA
 CARE AND LOVE.
Wish I could go to discos, parties, dances and have girlfriends and
 boyfriends like all the english
girls and posh asian girls, Anyway they're all last those fellas, wimps,
 couldn't handle us anyway

WE'RE too Wild, Sharp, Smart, Fast, Loud, Dynamic, Soft Sexy and Sensitive.

Stay in, study hard, study art, buy a stereo from the catalogue, It hurts so good,

Hibernate To Liberate – Don't get me started . . . let's Laugh and Dance

Work hard in habitat on saturdays, rob all the best stuff, for Freedoms sake, Why work?

Study hard, TWICE as hard, hard, hard, hard, madness, slam, slam, slam, work, work, carrying a heavy load,

STRUGGLE, FIGHT, SHOUT, IZZAT? RESPECT US NOW!

Gotta mek it through the night, warm love, sweetpillow, You know what am sayin Don't cheat us

The World is so cold, ain't do nothing for your soul.

Cockroaches in the fire place, love mashing them up, stir it up little darlin', stir it up . . .

Ther'e must be hundreds of us dying to do art and sing and shout out there,

Why did they have to make it so hard, Go for the BURN, Stretch and Turn

Bad young sister, Reach out and Touch, Let's make this world a better place, We shall OVERCOME

Ain't no stoppin us now, you now, her now, we're on the move and groovin, chulor, lets go . . .

STRENGTHEN and UPLIFT the mind . . . Let's go CRAZY . . .

Roti, Kapar, aur Makaan – Food, clothing and shelter. PEACE.

SPIRITUAL

HE
SAID
LIFE
IS
A
MERE
APPEARANCE
&
BEAUTY'S
AN
ILLUSION

BUT
BENEATH
THIS
POLISHED
SURFACE
HE
WAS
CHAOS
&
CONFUSION.

CONFUSION
&
CHAOS
WAS
HE.
SURFACE
POLISHED
THIS
BENEATH
BUT

ILLUSION
AN
BEAUTY'S
&
APPEARANCE
MERE
IS
LIFE
SAID
HE.

HE
SAID
LIFE
IS
MERE
APPEARANCE
&
BEAUTY'S
AN
ILLUSION

BUT
BENEATH
THIS
POLISHED
SURFACE
HE
WAS
CHAOS
&
CONFUSION.

Cruelty

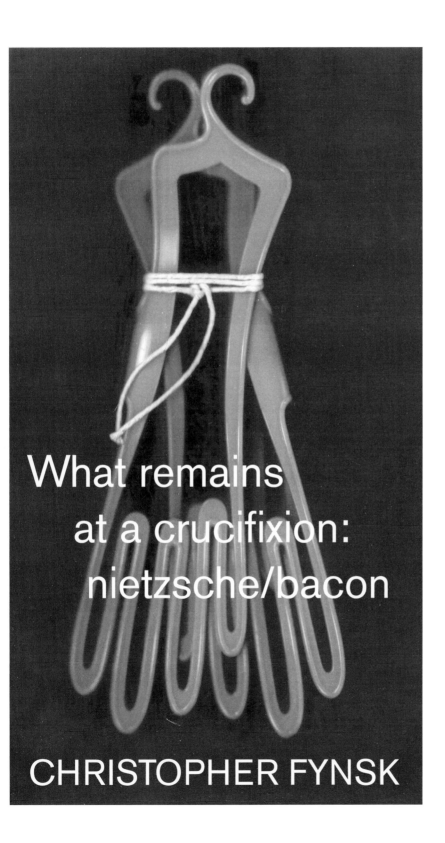

What remains
at a crucifixion:
nietzsche/bacon

CHRISTOPHER FYNSK

What remains at a crucifixion

> And let me confess it: I feel instinctively sure and certain that Lord Bacon was the originator, the self-tormenter of this uncanniest kind of literature: what is the pitiable chatter of American flat- and muddle heads to *me*? But the strength required for the vision of the most powerful reality is not only compatible with the most powerful strength for action, for monstrous action, for crime – it even presupposes it.
>
> We are very far from knowing enough about Lord Bacon, the first realist in every great sense of that word, to know everything he did, wanted, and experienced in himself. (Nietzsche, *Ecce Homo*)

Michel Leiris reports that Francis Bacon would appeal to Nietzsche in conversation, a fact for which he accounts by pointing to a will to power in Bacon's painting.

The supposition is a bit surprising at first, but it is certainly not inadmissible if we pause to consider what the phrase 'will to power' might hold in this context – that is, if

A Preface on Cruelty

Nietzsche begins the preface to *Ecce Homo* with the words, 'Seeing that before long I must confront humanity with the most difficult demand ever made of it, it seems indispensable to me to say *who I am*' (*EH*, 217).[1] He must say who he is, he explains, because he has not been seen or heard, and would not be confused with anyone else. But he will go on to add in *Ecce Homo* that he has not been heard because he constitutes a beginning, an *event* in the history of humanity that marks a complete break with the past – he *could* not have been seen or heard by his contemporaries. And he will suggest that he is not to be confused with anyone else because his identity is absolutely singular, incomparable; he is absolutely different. This alterity is what Nietzsche proposes to present in *Ecce Homo*. Indeed, his task demands this paradoxical self-presentation because he embodies, in himself, the passage beyond nihilism to which he calls humanity. He is the self-examination he will demand of humanity, and his demand will be inseparable from this self-presentation.

'*Revaluation of all values*: that is my formula for an act of supreme self-examination on the part of humanity, become flesh and genius in me' (*EH*, 326). After him, he goes on,

> The concept of politics will have merged entirely with a war of spirits; all power structures of the old society will have been exploded – all of them

1 F. Nietzsche, *On the Genealogy of Morals and Ecce Homo*, ed. W. Kaufmann, trans. W. Kaufmann and R. J. Hollingdale (Random House, New York, 1967; Vintage, 1989). I will use the abbreviations *EH* and *GM* to refer by section to the individual texts in this edition.

we recognize in it a fundamental affectability and open it in such a way as to allow the extremes of 'self-animal-torment' to coexist with a creative or inventive drive. Bacon clearly understood such an uncanny turn of the will (and a finitude of the will) to be the condition of his own form of realism, the groundless source of his own active attempt to 'translate man back into nature' via art, via a will to power as art. To be sure, there are other compelling reasons for Bacon's interest in Nietzsche: Bacon's profound grasp of everything Nietzsche named with the term nihilism (for which phrases such as 'we now know that life is a game' can convey only a hint of the historical and philosophical understanding involved), or his abiding attention to what might be at stake in a return to the 'birth of tragedy'. But Leiris is perhaps not far from the essential in referring to a will to power to account for Bacon's references to Nietzsche – not far if we take the phrase to name what drove Bacon to proclaim himself a 'realist': an acutely exposed sensibility transposed by the cruel humour of an exhilirated *amor fati*, a love for what is given (violently), and an active impulse to render it. Something of the passion and sensibility, (the same *Stimmung*) in other words, that prompted Nietzsche to celebrate Shakespeare's 'truly diabolical cynicism' (Bacon's phrase) to the point of attributing the plays to Lord Bacon and aspiring to no less of a creation.

> are based on lies: there will be wars the like of which have never yet been seen on earth. It is only beginning with me that the earth knows *great politics*. (*EH*, 327)

It would be easy to pass over hyperbolical declarations like this, were it not for the fact that someone like Heidegger took them seriously, and to the point that he even attempted to engage the 'great politics' of which Nietzsche spoke by taking over the task of provoking a general act of self-examination on the part of the German people. Heidegger, of course, spent quite a bit more than a decade trying to come to grips with this deluded gesture, and initially tried to have done with the issue (though he never had done with it) by telling us who Nietzsche's 'sovereign subject', the subject of great politics, might be. His answer was: the subject of modern metaphysics. But this answer effectively disavowed the results of his earlier meditation on eternal recurrence and the will to power ('as art'), on the Dionysian and Nietzsche's contribution to an understanding of the tragic essence of the human *Dasein*. Everything Heidegger said in the early and mid-1930s about Nietzsche's understanding of the tragic would indicate that he found in Nietzsche's text a meditation on human finitude, and not, or not simply, a bringing to completion of the metaphysics of the subject.

In returning to the question of 'who' the Nietzschean subject might be (or become) via the motif of cruelty, I will rejoin the substance of Heidegger's first answers concerning the finitude of the will, but will not be

One last line from *Ecce Homo* by way of transition – but only to set the stage, not to mark a point of reference (my interest lying in Bacon's 'realism', not in his possible sources; 'will to power' does not name the truth of the movement I want to follow). If Bacon knew Nietzsche's words about the 'self-animal-torment' of his supposed forebear, then he undoubtedly knew these last words of Nietzsche's self-presentation: 'Have I been understood? – Dionysos against the Crucified.' The echo would have been haunting, for crucifixion is Bacon's privileged figure for 'self-animal-torment', his primal scene for self-examination. It also happens to be a privileged figure for the exercise of what Leiris termed a 'will to power'. Where these figures pivot (where the thematic motif becomes a figure for the artistic practice itself), we take a turn even Nietzsche might not have anticipated: it is via crucifixion that Bacon approaches the Dionysian. In the pages that follow, I will try to take this path to Bacon's 'realism'.

1 The motif starts with the first *Crucifixions* of 1933 and the *Three Studies for Figures at the Base of a Crucifixion* of 1944 (Bacon's real 'beginning', he suggests), then continuing up to at least 1988 with the second version of the triptych of 1944.

A cruel usage

First the theme. The motif of crucifixion punctuates Bacon's work from its beginnings to its final period.[1] Its persistence is especially striking for the fact that

seeking a return to the possibility of 'great politics' (or certainly not as Heidegger understood the phrase). I may well be touching on the possibility of a politics, if by that last term we intend a practice that proceeds from and answers to an experience of the ethico-political, an engagement with that an-archic ground of the social where the question of political and ethical meaning *opens* in all its historicity and materiality (and if this is in fact part of what Nietzsche meant by 'great politics', then perhaps 'great' can be salvaged). Foucault was clearly attending to such a ground of possibility with his meditations on the question of *askesis* in his project on the history of sexuality, and I may in fact be exploring one essential trait of Foucault's own personal and philosophical practice, one of his own forms of *askesis* as the subject of an exemplary ethical and political undertaking.[2] Foucault knew well the cruel turn of the will that Nietzsche considered the condition of any 'sovereign' exercise in politics or in any other domain, indeed of any invention of the self, of any creative overcoming and self-fashioning. But cruelty, as a dimension of self-reflection (and its disruption), defines no more than a way of access – among others – to that non-ground I have termed the ethico-political, and the latter is also the ground of *im*-possibility for any rational foundation of the political order (which is not to affirm the 'irrational' in politics, but to recognize that any politics, like any political order, however rational or just, is without a ground). It would therefore be inappropriate to project a determinate politics on the ground of this structure of reflection, or to seek one that might be adequate to the experience to which it opens. It was not through discretion that

2 A phrase I use especially in light of David Halperin's impressive treatment of this topic in *Saint Foucault: Towards a Gay Hagiography* (Oxford University Press, New York, 1995). Among the virtues of this book is the way it brings home to us the very material character of cultural invention (not to speak of the severe challenges involved). If I have anything to add in this context to Halperin's evocation of Foucault's 'usage' of the

Francis Bacon, *Painting 1946*. Museum of Modern Art, New York. Reproduced by kind permission.

Bacon strips it of any Christian resonance, or brutally subverts that resonance by linking the motif to more archaic mythological themes. And since Bacon denies to his figures any allegorical significance beyond a rudimentary allusion to the 'ways things are', we are cautioned from taking it as merely a grim or bitter parody, an ironic statement of some kind.[2] We are offered a scene, and the more its meaning is undone, the more it insists. This makes Bacon's only two remarks about its significance for him (there are others about its formal possibilities) all the more poignant.

The first of these comes in Bacon's first interview with David Sylvester. In response to a question about Bacon's motivations in regard to the triptych of 1962, *Three Studies for a Crucifixion*, Bacon responds:

> I've always been very moved by pictures about slaughterhouses and meat, and to me they belong very much to the whole thing of the Crucifixion. There've been extraordinary photographs which have been done of animals just being taken up before they were slaughtered; and the smell of death. We don't know, of course, but it appears by these photographs that they're so aware of what is

2 Needless to say, our reading of the motif need not be a function of Bacon's declared intentions – even his intention to disrupt the structure of 'reading'. But I will not pursue here the extraordinary historical density of the motif in its Christian and pre-Christian forms, and will cite only Lacan's evocation of its place in Christian thought in order to point to what I take to be the essential in its historical resonance. Speaking of the Sadean object as the power of a suffering, itself the signifier of a limit, Lacan writes:

Foucault made only the sparest political assertions from the basis of his meditations on the practices of the self, ancient and modern; for he was seeking in them an *opening* to new forms of political relation, not defined structures. The present, rather modest treatment of the question of cruelty can hardly pretend to be more than the sketch of a possible form of access to the ethico-political.

But it is perhaps appropriate to point to what such a form of experience does *not* allow for political and ethical reflection (and thereby indicate a large measure of its significance): namely recourse to a notion of self-appropriation in the sense of an auto-formation (*Bildung*) or auto-production, any elaboration or stylization of experience directed to its subsumption in meaning or form (either along the aesthetic lines proposed by Nehemas, or in the more pragmatic mode defined by Rorty).[3] 'Becoming what one is' through an art of existence is not an aesthetic elaboration of the self, not a *poiesis* in the sense of the modern metaphysics of production. Likewise, the entity that would proceed from a 'war of spirits' is not an organic artefact. There is creation and art in the practice of the self Nietzsche envisions (not to speak of style[4] [cf. 95, 290]), but it passes by way of a disruption and disappropriation that can never be subsumed. It is a *usage* of the self that involves an exposure of/to a dimension of existence that is properly 'useless', resistant to any *work* of meaning. There is a 'truth' to be found in such a (dis)appropriating usage, as Foucault suggests in the very beautiful preface to the second volume of the *History of Sexuality* (*The Use of Pleasure*), but this is the truth of a becoming that does not conform

self, it concerns the structure of reflexivity to which he alludes, and the 'ontological' dimension of this usage. I would like to take a notion of the 'use' of the self beyond any model of linguistic constructivism or any pragmatics that does not engage that *pragma* that is the concern of 'being in the world'.

3 I refer here to the influential reading of Nietzsche proposed by Alexander Nehemas in *Nietzsche: Life as Literature* (Harvard University Press, Cambridge, Mass., 1985), and statements such as the following: 'To be what one is, we now see, is to be engaged in a constantly continuing and continually broadening process of appropriation of one's experiences and actions, of enlarging the capacity for

going to happen to them, they do everything to attempt to escape. I think these pictures were very much based on that kind of thing, which to me is very, very near this whole thing of the Crucifixion. I know for religious people, for Christians, the Crucifixion has a totally different significance. But as a non-believer, it was just an act of man's behaviour, a way of behaviour to another. (*Interviews*, 1981, 23)

These words clearly rejoin other references to the link Bacon establishes between an experience of mortality and a knowledge of the flesh – the flesh in its most raw manifestations. Bacon will go very far with such a physical 'translation' back into nature – as when a discussion of the cry leads him to speak of the mouth's beauty and reminds him of colour plates of diseases of the mouth to which he has turned for inspiration. (Though this is anything but a mere reduction to the physical, since he will immediately refer to his dream of painting a mouth like Monet would paint a sunset (*Interviews*, 48–50).).

So the Crucifixion is in large measure about the exposure of mortal flesh in its most irreducible, but also vulnerable presence. Its aesthetic analogue is the hanging

'Suffering is conceived of as a stasis which affirms that that which is cannot return to the void from which it emerged. Here one encounters the limit that Christianity has erected in the place of all the other gods, a limit that takes the form of the exemplary image which draws to itself all the threads of our desire, the image of the crucifixion. If we dare, not so much look it in the face – given that mystics have been staring at it for centuries, we can only hope that it has been observed closely – but speak about it directly, which is much more difficult, shall we say that what is involved there is something that we might call the apotheosis of sadism? And by that I mean the divinization of everything that remains in this

85 a preface on cruelty: nietzsche/bacon

to any aesthetic ideology (or its political translations), or lend itself to the *telos* of an *oeuvre*. As Foucault understood (after Bataille and Artaud, and with quite a few others) sovereignty is not about self-production and self-possession in a totalizing form. Sovereignty, for Nietzsche, presupposes a measure of cruelty towards the self and is therefore constantly disappropriating.

With these words of introduction, I do not mean to overdramatize the notes on Nietzsche to follow.[5] I want merely to suggest that my topic speaks to something more than prurient interest and that this generally neglected motif has significant import for contemporary reflection on the ethics of the self. But let me turn now to Nietzsche's text and his 'sovereign subject', namely 'Nietzsche', in so far as he claims he is the subject of an accomplished self-examination, 'the proud and well-turned out human being who says Yes, who is sure of the future, who guarantees the future' (these are nearly the last words of *EH*, 335). This claim implies that Nietzsche's genealogy (of which *Ecce Homo* is in part the presentation) is that of the sovereign philosopher who has emerged from the cocoon of the ascetic ideal, having carried the logic of asceticism to its extreme limit by carrying the value of truthfulness to the point where truthfulness itself comes into question and a creative decision is required concerning the 'Why' of existence in its totality. *Ecce Homo* describes the singular configuration of 'great health' and some of the forms of *askesis* that have allowed Nietzsche to become what he is, but his type is that of the 'sovereign individual' described in 'the beginning of the second essay of *The Genealogy of*

assuming responsibility for oneself which Nietzsche calls "freedom"' (p. 191). Elsewhere Nehemas speaks of 'that relegation that transforms melancholy and misery, passion, pain and effort into experience and knowledge, into the material of the future' (p. 162). For Nehemas, the latter is material for an essentially aesthetic construction equivalent to a Proustian artefact. Nehemas tends to avoid the motif of cruelty (cf. p. 192), and, when he must face it, he produces a rather scant discussion that immediately veers towards the spectre of 'physical cruelty of the worst sort' (p. 218). Needless to say, his reading of *The Genealogy of Morals* suffers considerably (see p. 206, where he fails to recognize how the philosopher as 'sovereign subject' differs from the 'barbarous noble'). As for Rorty, his famous distaste for cruelty has a

sphere, namely, of the limit in which a being remains in a state of suffering, otherwise he can only do so by means of a concept that moreover represents the disqualification of all concepts, that is, the concept of *ex nihilo*' (Jacques Lacan, *The Seminar of Jacques Lacan, Book VII 1959-1960: The Ethics of Psychoanalysis*, trans. Dennis Porter (Seuil, Paris, 1986), 261–2).

carcass. But the passage I have cited also suggests, however, that there is another exposure of the mortal body that is indissociable from this knowledge of the flesh, and perhaps its condition. And here we return again to the cry (powerfully latent in Bacon's references to the animal reaction to the smell of death). Deleuze is in fact drawing on these lines, I believe, when he attempts to define what Bacon seeks to paint in the cry: namely the communication of an extreme bodily affectability (Deleuze, 1984, 41). Deleuze proposes that the *presence* so frequently attributed to Bacon's figures derives from what they communicate (as *figures*, in paint) of a quite bodily being in the world, which Deleuze describes as the affectability of a 'being without organs'. The latter notion permits a compelling account in material terms of the rhythmic components of the exposure in question – a rhythmic dimension of experience that exceeds what a phenomenological account will allow. But Deleuze also entertains the relation between the body and what he terms the invisible forces of time, or death: a bodily ecstasis. He effectively rejoins a transcendental reflection (though in the manner of Irigaray's attempt to describe a 'transcendental sensible') when he proposes that we understand the cry of Bacon's figures from the locution, '*crier à*' – these figures *cry at* the presence of what is

delightful resonance here, even if he is concerned with something quite other than a form of self-relation (but then one could hardly count on Rorty to pause over the form of self-relation I am treating here). I have discussed the persistence of the metaphysics of subjectivity in Rorty's pragmatism in 'Community and the Limits of Theory' in *Community at Loose Ends* (University of Minnesota, Minneapolis, 1987).

4 F. Nietzsche, *The Gay Science: With a Prelude in Rhymes and an Appendix of Songs*, trans. with commentary W. Kaufmann (Random House/Vintage, New York, 1974), section 290.

5 It should also go almost without saying that a number of counter-citations can be preferred against the general line I am taking here. I am following a logic

Morals. To grasp his full genealogy, I would suggest that we need to follow the emergence of this type as it is described in the latter volume.

The sovereign subject, Nietzsche tells us, is one who has achieved the right to a future and the right to affirm itself. It is a subject capable of forgetting, and thus capable of a healthy present unburdened of the past (thus the opposite of the creature of *ressentiment* who cannot free itself of painful memories), but also a being capable of a future in that it wills for itself a future and *guarantees* that future. It is a being who commands a *memory of the will* and whose will commands authority. The sovereign subject is one who has the right to make promises – a self-established right because its word stands as guarantee for itself, imposes itself as law. Its word is not empowered by a law that would pre-exist it in any way. Rather, this word freely affirms itself as the law (it is 'autonomous and supra-moral', Nietzsche says [*GM*, 59]). It gives the law, it imposes a measure of value – in this sense it is creative – and it *authorizes* itself. The sovereign word *speaks for itself*. In this sense it comes like lightning: Nietzsche's privileged image for the creative word that institutes its own authority.[6]

The history that makes possible this development (that is, the creation of a memory of the will, and with it a notion of responsibility, a conscience) is the long history of asceticism: millennia of conscience-vivisection and self-torture: *Selbsttierquälerei* ('self-animal-tormenting'), as Nietzsche puts it near the end of his second essay [*GM*, 95]). It is a history that has its mainspring in cruelty – in the sometimes noble, sometimes 'sick' pleasures of cruelty. Cruelty, as we will see, is one of the crucial traits distinguishing

coming in that moment when they apprehend their mortality. The cry thus captures a kind of pure relation to what comes, drawing out in this way its invisible presence (*débusquer* is the word he uses for what occurs in this futural *ecstasis*). 'It is expressed in the formula "crying at". Not crying *before*, nor *from* [it is not a matter of relating to an object, some*thing* that is terrible], but crying *at* death [*crier à la mort*], in order to suggest the coupling of the sensible force of the cry and the insensible force of what makes cry out' (*Logique*, 41). Bacon does not paint in his cries a violent reality that causes the cry, he paints the *relation* to reality of an agonized and sometimes ecstatic body. The cry that Deleuze attempts to describe captures that relation at its purest – though the relation in question is a purely . material one.

We are undoubtedly 'very, very near this whole thing of the Crucifixion' only if we grasp the full movement of the passage from which we started – from the reference to meat to the apprehension of death – and conceive of the way Bacon links a relation to flesh in its most brutal presence (and transfigured beauty) with the extreme of relationality that he portrays in the cry. And we can perhaps grasp this relation only in something other than a narrative or logical manner (where the

the philosopher who undertakes the task of self-examination – in fact, a healthy cruelty turns out to be the condition of any sovereign yes-saying. The philosopher, or what Nietzsche calls the 'seeker after knowledge' in *Beyond Good and Evil* (BGE 229), says 'No' where the basic inclination of the spirit would like to say 'Yes'. He is thus an 'artist and transfigurer of cruelty [*Grausamkeit*]' – a concept Nietzsche develops in section 230 by describing how the will of the seeker after knowledge counters what I might call the appropriative drives of the will to power. The spirit, Nietzsche explains here, naturally wants to be master in its own house and feel that it is master: it simplifies, falsifies, and excludes in its dealings with the external world in order to incorporate the other and to grow. The same goals are served by a wilful ignorance and a delighted self-deception. Even the will's dissimulating, creative and form-giving force, its play with masks and with surfaces serves this appropriative drive. But the spirit's simplifications and dissimulations are *countered*, Nietzsche says, by a 'sublime inclination', a will in the seeker after knowledge 'which is a kind of cruelty of the intellectual conscience and taste'. He goes on:

> Every courageous thinker will recognize this in himself, assuming only that, as fit, he has hardened and sharpened his eye for himself long enough and that he is used to severe discipline, as well as severe words. He will say: 'There is something cruel in the inclination of my spirit'; let the virtuous and kindly try to talk him out of that. (*BGE*, 161)

implicit in Nietzsche's reflections on the finitude of the will, and attending to Nietzsche's thought of difference (which I take to be a version of *ontological difference*) over against pragmatic versions of Nietzschean perspectivism and will to power which avoid any real questioning of the subject. Needless to say, there is a strong strain of metaphysical thinking in Nietzsche's text (Heidegger's demonstrated this powerfully); he leant himself easily to what Lacoue-Labarthe named a 'national aesthetism', or to softer, humanist versions of self-cultivation.

6 I would note here, however, that the lightning wielded by the sovereign subject (cf. Nietzsche's words in *Ecce Homo*, 'I speak no longer with words but with lightning bolts' (*EH*, 281)) is not the same as the lightning of the violent acts

hanging carcass would translate something like the meaning of 'crucifixion' via its result) if we grasp it in the unity of an experience. Bacon offers it in this manner in the second statement to which I have referred. Sylvester asks, 'In painting a Crucifixion, do you find you approach the problem in a radically different way from when working on other paintings?' (*Interviews*, 46). Bacon: 'Well, of course you're working then about your own feelings and sensations, really. You might say it's almost nearer to a self-portrait. You are working on all sorts of very private feelings about behaviour and the way life is.' Crucifixion, in other words, is Bacon's privileged scene for portraying his own experience of being in the world, his scene of 'self-animal-torment'. To be is to be exposed at this extreme limit of suffering. From here, from this evocation of experience, Bacon can add after another connection to the butcher shop and 'this great beauty of the color of meat': 'Well of course we are meat, we are potential carcasses. If I go into a butcher shop, I always think it's surprising that I wasn't there instead of the animal' (*Interviews*, 46). Bacon's surprise is what should be retained here – his surprise at the uncanny presence of the hanging carcass.

To be, for Bacon, is to know an exposure like that of a crucifixion – a pain of

of the 'blond beasts' that Nietzsche describes in the first and second essays of *The Genealogy of Morals*. And it is not the same thing as the lightning character of the deeds described in the very important section 13 of the first essay where Nietzsche explains how the man of *ressentiment* interprets the act of the strong by dividing the doer from the deed, and positing a 'good' subject who would be capable of not acting. Nietzsche's sovereign subject comes at the end of a long history in which the will has temporalized itself, so to speak, and has acquired a memory. Nietzsche may well explain in *Ecce Homo* that the sovereign creator *has no choice* in the act of creation, and is one with his deed, thus attributing to the creator the immediacy of thought and deed that Nietzsche ascribes to the strong noble type. But this

Nietzsche goes on to suggest that it might be in the philosopher's interest to let this cruelty go under the name of 'extravagant honesty' (*BGE*, 161); but I suspect that even this term would stand convicted of what Nietzsche terms in the third essay of the *Genealogy* a 'tartuffery of words' (*GM*, 138). We psychologists are 'still "too good" for our job', Nietzsche exclaims there. Honesty dictates that honesty be called cruelty.

The Genealogy of Morals thus explores the original manifestations of the trait that is 'spiritualized' in the philosopher – that trait by which the will turns against itself, interprets itself, and creates for itself a temporality and a conscience. Cruelty is in fact the one thread (though it is hardly a *single* thread) that ties together an extraordinarily complex and perhaps even wilfully contradictory piece of speculative history-writing.[7] It serves, first of all, to account for the possibility of that primitive form of exchange by which punishment comes to serve as an equivalent for an unpaid debt. At the beginning of the second essay, Nietzsche explains that promising and memory have their possibility in a long mnemotechnics by which a memory to pay what is due is burned into the subject – first of all the legal subject, and then the political subject, the member of a community. Nietzsche argues that if punishment is allowed as satisfaction for an unpaid debt, it is because the cruel pleasure taken in punishment is seen to be sufficient compensation for material loss.[8] It is an *active* pleasure, Nietzsche argues:

It seems to me that the delicacy and even more the tartuffery of tame domestic animals (which is to say modern man, which is to say us)

exposure, we must add now, that is inseparable from guilt, for the violence to which the existent being is delivered seems almost always to take a vengeful form (hence the frequent presence of the Erinyes). I would not presume to judge this experience of existence without *justification* by rushing to link this with a Christian notion of original sin; for, once again, Bacon is occupying a limit where the Christian experience resonates with archaic echoes as it reaches its end in nihilism. I would merely pick up here Bacon's oblique reference to 'man's behaviour, a way of behaviour to another' as part of 'the way life is' and note that the exposure to which I have referred cannot be thought outside its ethico-political dimension (which does not make the exposure in question any less material, or any less acute – on the contrary). But I would emphasize that crucifixion is hardly one conduct among others for Bacon, for it appears to touch on the very grounds of human relation, on its limits: at the site of an irreducible experience of affliction. That we might identify this as an essentially human, essentially 'social' experience of the pain of existence, does not belie a reference to 'self-animal-torment' or deny that we reach here a zone of 'indiscernability' between the human and the animal, an animal presence of the suffering body. Because at this point we are touching on

resists a really vivid comprehension of the degree to which *cruelty* constituted the great festival pleasure of more primitive man and was indeed an ingredient of almost every one of their pleasures . . . something to which the conscience cordially says Yes. (*GM*, 66)

Shortly after these words, he speaks of the manner in which primitive men were 'unwilling to refrain from *making* suffer and saw in it an enchantment of the first order, a genuine seduction to life' (*GM*, 67). But we might pause to ask here whether a pleasure in watching the other suffer is not tinged with a certain passivity.[9] Moreover, there is little question that such pleasure is fuelled by *ressentiment* (or is caught up in that turn) if it is part of an economy and a direct function of the punisher's social position: 'The enjoyment will be the greater the lower the creditor stands in the social order', Nietzsche asserts (*GM*, 65). In the next section he speaks of it again as 'a genuine *festival*, something which, as aforesaid, was prized the more highly the more violently it contrasted with the rank and social standing of the creditor' (*GM*, 65). Nietzsche appears to recognize the problem when he adds: 'This is offered only as a conjecture; for the depths of such subterranean things are difficult to fathom, besides being painful' (*GM*, 65). Should we presume that if things have gotten a little out of hand here at the outset, it is because Nietzsche is enjoying the pain? But 'genealogy', in any case, is not concerned with essences. We should not look to cruelty as a unitary phenomenon over time.

act of creation is of a different, more complex structure than that of the deed of the blond beast.

7 'Speculative', or *interpretive* inasmuch as it is devoted to the prehistory of the will that could write such a history: the will that is endowed with a memory and the capacity to promise. Werner Hamacher develops this point quite powerfully in his unpublished essay 'The Promise of Interpretation: Reflections on the Hermeneutical Imperative in Kant and Nietzsche'.

8 It could be worthwhile to explore Nietzsche's argument that the origin of all social relations lies in exchange, in the relation of creditor and debtor, and to explore more fully from this ground the rather un-sovereign pleasure that the creditor (or thinker!) takes in pain. See, for example, section 8, where Nietzsche

something like the relation between the human and language, which is all that distinguishes the human from the animal. Which is to say, also, that we are at the limit of the human and the animal, or what Nietzsche called the Dionysian.

I introduce language now because of the second way in which crucifixion figures in Bacon's remarks, namely as a means of representation and ultimately as a figure for representation or figuration itself. To evoke in the broadest sense what I would like to develop here, I would draw an analogy to Bataille. For just as we can say that writing *is* sacrifice for Bataille,[3] we could say that painting, for Bacon, is crucifixion.

3 See the opening words of 'The Jesuve', collected in *Visions of Excess: Selected Writings, 1927-1939*, ed. Allan Stoekl (City Light Books, San Francisco, 1989), 73: 'I have acquired over what happens to me a power that overwhelms me.'

First, the cross, for Bacon, is a frame, an armature, as he puts it, for 'hanging all sorts of feeling and sensation' (*Interviews*, 44). He evokes in this context a special resonance afforded by the history of the motif: 'Perhaps it's only because so many people have worked on this particular theme that it has created this armature . . . on which one can operate all types of level of feeling' (*Interviews*, 44). But as a formal device, it works most essentially to raise, isolate, and suspend the figure, offering the flesh in the manner Bacon so admires, for example, in the painting by Degas entitled *After the Bath* (*Interviews*, 46). Of course, one of the predominant

describes the relations between buyer and seller, creditor and debtor, as 'the oldest and most primitive personal relationships', the first site of encounter between individuals and the origin of all social relations. The preoccupation with exchange at these early stages of humanity constitutes 'thinking *as such*', Nietzsche declares. He then adds that the relations founded in buying and selling are 'older even than the beginnings of any kind of social forms of organization and alliances: it was rather out of the most rudimentary form of personal legal rights that the budding sense of exchange, contract, guilt, right, obligation, settlement, first *transferred* itself to the coarsest and most elementary social complexes' (*GM*, 70).

9 To address this question properly, we would have to

Let us move from these ambiguities to the second historical account: Nietzsche's description of that historial perversion he names 'bad conscience'. I speak of a second history because it starts catastrophically, even though it overlaps with the first, since it is part of that history by which humankind is tamed through such devices as punishment. But here the punishment is not part of an economy, at least originally. Rather, it comes suddenly, and with such a fateful character that it precludes all struggle and all *ressentiment*. This is an important point: in both of the histories from the second essay to which I am referring, *ressentiment* has no place (or so Nietzsche claims – we have seen how problematic this claim is in the first case). Cruelty, Nietzsche tells us, is originally the expression of an active, joyous will, even when it initially turns upon itself and opens the paths of bad conscience. Of course, this latter turn can have occurred only in so far as there has been a lapse of the will of some kind – the will does not struggle with an external force, it folds, so to speak; but nevertheless, even in turning upon itself it remains active. Nietzsche figures the catastrophe that produces this turn as a conquest. A 'conqueror and master race' (*GM*, 86) lays its claws upon a formless or nomad populace and imposes upon it a tyrannical 'state' machinery that moulds and forms that populace. The latter is described as an 'artistic' process, a kind of natural *poiesis*. The blond beasts of prey are 'artists of violence and organizers who build states', Nietzsche says, and these states are described as organic social formations where every part has its meaning in relation to a *living* whole (*GM*, 86–7). The primitive state is a work of art formed by a violent, appropriative will to power.[10]

traits of Bacon's painting is the use of such an armature; the cross is just one example to be linked to all the chairs, the cages and the rails that prefer the figure in the way I have noted. But the crucifixion also lends itself in a striking way to Bacon's description of the act of figuration itself.

This dimension of the motif appears furtively for us in a passage in the *Interviews* that follows a powerful evocation by Bacon of the link between sexuality and death. Sylvester remarks that Bacon tends to evoke the behaviour of friends in extreme situations and adds, 'It seems to me that that preoccupation of yours is very relevant to your work, overtly or implicitly. Overtly when you paint the scream . . . and the Crucifixion, and people violently coupling on beds, and single figures in convulsive attitudes, and nudes injecting drugs into their arms' (*Interviews*, 78). Bacon, as though to interrupt any suggestion that his interest lies in the portrayal of extreme situations and an evocation of the pathos associated with them, reacts abruptly in formal terms:

> I've used the figures with a hypodermic syringe on beds as a form of nailing the image more strongly into reality or appearance. I don't put the syringe because

91 a preface on cruelty: nietzsche/bacon

The *same* will to power is at work in the populace whose 'instinct for freedom' has been repressed. But here, it works internally (this is the origin of human depths, of the 'soul'): the inhibited will turns upon itself. Nietzsche's figure for this process is a caged animal that maltreats itself for want of any external discharge, turning itself, Nietzsche says, 'into an adventure, a torture chamber, an uncertain and dangerous wilderness' (*GM*, 85). But this self-torture takes on in its turn an artistic character:

> Here the material upon which the form-giving and ravishing nature of this force vents itself is man himself, his whole ancient animal self – and *not*, as in that greater and more obvious phenomenon, some *other* man, *other* men. This secret self-ravishment, this artist's cruelty, this delight in imposing a form upon oneself as a hard, recalcitrant suffering material and in burning a will, a critique, a contradiction, a contempt, a No into it, this uncanny, dreadfully joyous labor of a soul voluntarily at odds with itself that makes itself suffer out of joy in making suffer – eventually, this entire active 'bad conscience' – you will have guessed it – as the womb of all ideal and imaginative phenomena, also brought to light an abundance of strange new beauty and affirmation, and perhaps beauty itself. – After all, what would be 'beautiful' if the contradiction had not first become conscious of itself, if the ugly had not first said to itself, 'I am ugly'? (*GM*, 87–8)

take up the entire question of spectacle as it figures throughout the *Genealogy*. Does the spectacle that justifies existence, or at least makes it interesting, not serve to distract a will that is otherwise exposed to a senseless suffering and its own 'basic fact' (*GM*, 97)? Can spectacle, in this perspective, belong to a Dionysian affirmation? Hasn't such a will already fallen from the tragic (or not yet attained it)? But the spectacle offered by life (its old trick to justify its evil [*GM*, 68]) or by the philosophers (to entertain their gods [*GM*, 69]) differs from the one offered by the birth of bad conscience, or rather the *interest* afforded by such a spectacle differs from that of the former instances. For the birth of bad conscience holds an engaging promise (*GM*, 85).

10 Here we meet a question I touched upon at

of the drug that's being injected, but because it's less stupid than putting a nail through the arm, which would be even more melodramatic. I put the syringe because I want a nailing of the flesh onto the bed. But that, perhaps, is something I shall pass out of entirely. (*Interviews*, 78)

The syringes may have been a passing fancy (though they lasted at least a decade, to my knowledge), but the nailing certainly was not; and the link made here between these motifs was clearly not a casual one, because we find an explicit evocation of the intention Bacon describes in a canvas of 1968, *Two Studies for a Portrait of George Dyer*, where one of the two images of Dyer, the one of Dyer in the flesh, we might say, is nailed to a surface over against a seated Dyer – both figures powerfully drawn, in their gaze, to the right side of the canvas.

So what is the function of, or what occurs with this fixion of the image? He used the hypodermic syringe, he said, '*to nail the image more strongly into reality or appearance*'. Reality or appearance. We could spend pages with this conjunction and its onto-phenomenological implications. It names, first of all, what Bacon

the start: does a developed social complex – a complex of sovereign subjects – recover in some way this 'natural *poiesis*' which produces a highly articulated but organic social structure? Many of Nietzsche's political declarations seem to point in this direction – and this is the Nietzsche that leant himself to the mythopoieic ambitions of German fascism. I think we will see, however, that the concept of sovereignty points to a different conception of the grounds of social relation: the 'sovereign' pathos of distance does not lend itself to *one* political space or offer a ground for such a space.

11 In 'The Promise of Interpretation', Hamacher links nicely the first and second essays of the *Genealogy* by suggesting that the will of moral (and supramoral) humanity is the

Two points should be underscored here. First, a *self-interpretation* is identified as the origin of the will (both moral and 'supramoral') that is capable of the promise.[11] It begins with the howl of the frustrated animal and then takes shape in a process of self-contradiction that is finally directed and interpreted by the ascetic priest. The caged beast suffers from its own strength, its own affects, and turns this strength upon itself as the cause of its suffering ('Thus began the gravest and uncanniest illness, from which humanity has not yet recovered, man's suffering *of man, of himself* – the result of a forcible sundering from his animal past' [*GM*, 85]). The ascetic priest merely interposes a concept of sin and gives a figure to the desired transcendence of that suffering. Secondly, and I am again reiterating a point I have made, this self-contradiction does not originally take the form of *ressentiment*. In *ressentiment*, a will suffers passively what it cannot fight off or digest. It suffers from its inability to rid itself of what affects it, and proceeds to negate that which it considers the cause of its affliction. It *suffers* the other and proceeds to define itself in relation to that other, positing the other as evil, and itself as good.[12] Bad conscience takes, originally, the opposite form. It does not negate the other in order to posit itself (mediately). It *negates* itself and posits an other. 'I am ugly, therefore there must be a beautiful.' *Ressentiment* will eventually develop out of this uncanny process. And it may simply be the product of a will that does not have the strength for this process – a kind of supplementary development of the will's turn against itself and its self-interpretation. Bad conscience and *ressentiment* have the same origin: there is an inhibition and lapse of the

claims frequently to be reporting: a presence whose force seems almost to require on occasion that he render it after the fact (*après-coup*), but that gives itself as fact – at however many removes of meaning and representation – in what Bacon most frequently terms an image,[4] an image whose facticity or 'objective value' frequently derives from a poignant juxtaposition of tensions like those Bataille attributes to the 'tragicomic oppositions' defining the 'real presence' of a flower (Bataille, 1985, 10–14). The portraits hold a special status here, for the reality they convey, in however compelling a fashion via their own forceful presence, is frequently immediately attributable to that of their subject (particularly through the presence of the gaze).[5] But where a *scene* is constituted in such a way as to define what Deleuze terms a 'matter of fact' (*Logique*, 10), the referent of this portrayal cedes to a 'reality' or appearance that is proper to the painted figure. And this is undoubtedly the principal direction of Bacon's words when he speaks of nailing the figure into reality or appearance. He nails it down (the implication being that it will 'drift off' otherwise – namely, into illustration), and thereby nails it *into* reality or appearance – transitively, we might say. He nails it down to bring it forth in such a way as to produce the 'that' of Being – the 'that' of 'that there are beings

4 Bacon uses the term 'image' rather freely to name what he is attempting to render. It is what is given in appearance ('the appearance that you see at any moment, because so-called appearance is only riveted for one moment as that appearance' (*Interviews*, 118)), what is offered by the 'slight remove from fact' that is achieved by the photograph ('Through the photographic image I find myself beginning to wander into the image and unlock what I think of as its reality more than I can by looking at it' (*Interviews*, 30)) or via an imagination that seems entirely unbound by

will. At a certain moment, the will is not able to affirm itself against the other; but the caged beast turns upon itself – and this is the origin of the ascetic priest who actively interprets – whereas the man of *ressentiment* turns against the other, economizes on his pain by biding his time and cultivating his revenge.

The ascetic priest, as Nietzsche describes him in the second and third essays, is one who controls and channels *ressentiment*. In fact, the priest is said in section 11 of the third essay to embody *ressentiment* himself to an unparalleled degree, and in the succeeding section of the same essay the sickness treated by this sick doctor turns out to be *ressentiment*. Nevertheless, the perverse interpretive craftiness of the ascetic priest has its origin in an *active* bad conscience – the will's cruelty towards itself. And the priest's active will to power is said to be the condition of man's self-overcoming. 'The ascetic priest', Nietzsche writes, 'is the incarnate desire to be different, to be in a different place, and indeed this desire at its greatest extreme, its distinctive fervor and passion' (*GM*, 120). The ascetic priest works out of bad conscience – he *works ressentiment*. But *ressentiment* is a will that has lapsed and become reactive. The ascetic priest has an active will and is pregnant with a future.

The wicked philosopher, in turn, is nothing but the priest's own self-overcoming. He is a healthy priest (therefore something other than a priest). While the priest will tend the sick (and is therefore sick himself, the philosopher, out of his fundamentally healthy nature, will take his

will *of interpretation*: an interpretation that is made possible by grammar (the first essay) and carried out in language (as we see with the motif of branding in this passage). The will (at least the will of human history) exists only as its own explication. It is not the *subject* of interpretation; rather, interpretation belongs to its structure. I will add in what follows that the cruel turn that is proper to the will (part of its structure, but also such as to undo any self-possession) carries the will to the limits of language.

12 Cf. *GM*, 36–7. Deleuze offers a very precise and strong account of *ressentiment* in relation to the active and reactive structures of the will in *Nietzsche and Philosophy*.

reference and offers images like 'slides' that fall in one after another (*Interviews*, 21). The remove from reference is nowhere better evoked than in his explanation of the inspiration he took from a photograph of grass so trampled and torn that it took on the shape of grass (*Interviews*, 162). As regards portraits, Bacon notes that his recording involves memory in an essential fashion: '(DS) You prefer to be alone? – Totally alone. With their memory. – Is that because the memory is more interesting or because the presence is disturbing? – What I want to do is to distort the thing far beyond the appearance, but in the distortion to bring it back to a recording of the appearance. –

rather than nothing'. The nail itself (or the syringe) figures this act of figuration, this in(x)scription by which the figure is brought into emergence and 'reality' is ex-scribed (to use Nancy's term)[6] in such a way as to produce the 'that' (*Dass*) that a work of art *says* in its createdness, according to Heidegger. All of Bacon's figures, as Deleuze recognizes, have a certain presence, more or less of the presence that conveys the 'that' of existence. But the nail also remarks the cruci-fixion or ex-scription by which existence is given in Bacon's paintings.

Bacon employs other forms of 'nailing' than the ones we have seen. Figures are worked by surfaces (flattened, for example, as against the photographic plate of an X-ray machine), refracted, or even divided by walls, mirrors, and canvases in such a way as to be fixed in representation in a manner that is perhaps consonant with the nailing we have seen. (Twisting is another way of intensifying the image, forcing it into reality or appearance – all of these motifs, including an evocation of the Erinyes, appear in *Seated Figure, 1974*). 'Nailing down', or fixing and piercing in representation, is a constant preoccupation with Bacon. And I would be tempted to draw a link here with all of the figures of sexual coupling. But before pursuing other dimensions of this brutal usage, this rough trade with the image, I want to

distance from the herd. He knows what's good for him. And unlike the priest he does not want to become different: he embraces his fate, as Nietzsche says in *Ecce Homo*. I will return to this claim shortly, but I want to complete my overview of the theme of cruelty in *The Genealogy of Morals* by noting simply that the philosopher's health manifests itself initially in a heightened form of cruelty. The philosopher overcomes asceticism by pushing it – cruelly – to its limits. Nietzsche explains that this animal begins in asceticism and under the garb of the priest, not only in order to acquire the power and respectability of the priest but because he must turn against his own natural impulses. The philosopher began 'with an evil heart and often an anxious head' (*GM*, 115) and had to fight against his own initially healthy instincts. 'As men of frightful ages,' Nietzsche writes, 'they did this by using frightful means: cruelty toward themselves, inventive self-castigation.' They entered the cocoon of the priest, cultivating everything that makes of the priests 'interesting animals' – their depth and evil ('The two basic respects in which man has hitherto been superior to other beasts' [*GM*, 33]). But then, out of 'sublime wickedness, an ultimate, supremely self-confident mischievousness in knowledge that goes with great health' (*GM*, 96), they take their flight. They turn away from the ideal, and, by a superbly perverse gesture, wed bad conscience to any ideal aspirations. In their extravagant honesty, they attempt to translate man *back into nature* as Nietzsche puts it at the end of the long passage from *Beyond Good and Evil* from which I started. This turn, this translation, is not the turn of science. The

pause a bit more over the jump I have made from the reality (or appearance) of the referent to the reality of the figure.

The jump is Bacon's, and it is made in a veritable assault on his own illustrational talent. If there is a 'will to power' in Bacon's treatment of the image, it passes by way of a wilful disruption by which Bacon suspends his attempt to capture the reality of his subject (or the 'image' he has in mind) and gives his efforts over to chance. It is not simply that he welcomes accident with the brush or a toss of paint. Rather, the need to render the reality in question ('the fact you are obsessed by') at the level at which it strikes the 'nervous system' prompts a desperate passage through what Deleuze aptly names after Maldiney a 'catastrophe' (*Logique*, 67). In fact, this disruption is anything but wilful (though Bacon seems to have learned to modulate it), because Bacon emphasizes repeatedly words like 'exasperation', 'hopelessness', 'frustration', 'despair', 'impossibility' and 'abandon' to describe what drives him to this passage. He must *destroy* illustration to release the image latent in sensation or offered to 'instinct' in this moment of passage by what may not be quite the limit-experience portrayed in the crucifixion, but certainly an exposure to a presubjective dimension (a rhythm perhaps? – in any

Are you saying that painting is almost a way of bringing somebody back, that the process of painting is almost like the process of recalling? – I am saying it. And I think that the methods by which this is done are so artificial that the model before you, in my case, inhibits the artificiality by which this thing can be brought back' (*Interviews*, 40).

5 On this point I must disagree with Deleuze if I understand his argument correctly. For Deleuze asserts that Bacon paints *heads* (the head of a 'body without organs'), not visages. I would concur that he often paints in the portrait the body's *suffering* of forces, but one also finds in his human figures

95 a preface on cruelty: nietzsche/bacon

Genealogy of Morals ends with an unmasking of the scientific ideal as the final avatar of the ascetic ideal. The scholar and the scientific labourer, even when they appear as 'hard, severe, abstinent, heroic spirits' (*GM*, 148), heroes of intellectual cleanliness, remain nevertheless captivated by a faith in the absolute value of truth and in the grips of a contempt for man. They refuse interpretation inasmuch as 'forcing, adjusting . . . falsifying [are] of the *essence* of interpreting' (*GM*, 151 – as in the case of this wilful piece of history-writing), and inasmuch as interpretation is always an act of the will to power, always a function of drives and affects. They still suffer from their own affects, we might say, and seek an escape of some kind – or they lack the conviction of their affects, the will of their affects (the will to will); they do not create values and cannot bring into question the value of 'truth'. The presupposition of this movement, again, is great health, and the courage that goes with it: a resurgence of affect and the courage of a sublime wickedness by which the will *turns against itself* in such a way as to open the possibility of a creative deed. *Ecce Homo* describes that movement and its conditions.

The passages in *Ecce Homo* in which Nietzsche describes his 'health' and his practices for its cultivation are among the most delightful in his work (I refer principally to 'Why I am so Wise', and 'Why I am so clever'). To be sure, he knows sickness, as he tells us, and in this he has the experience of decadence. This is the gift from his father. But this gift is also accompanied by an enlightenment about *ressentiment*. Because he has 'one foot beyond life', he is not predisposed against others or against

a compelling gaze. I would take as one particularly strong example Bacon's preferred portrait of Leiris (the portraits of 1976 and 1978 are reproduced in *Interviews*, 146–7).

6 I draw this term *exscription* from Nancy's essay on Bataille. It captures powerfully the metaphor of writing that Heidegger employs to capture the manner in which a work of art draws out difference as a material relation of world and earth, but it also introduces in an important way the problematic of existence. See 'L'Excrit', in *Une pensée finie* (Galilée, Paris, 1990), pp. 55–64.

case, a kind of spatio-temporal opening wherein an entirely different measure opens and a visage can offer itself like a landscape or a mouth like a sunset). Nietzsche, as we have seen, would suggest that only one who has known the extremes of self-animal-torment can practise such a schize by which the image is as much created as discovered – invented, let us say. As for Bacon, if we can say that he is practising a cruel usage of the image, it is only via a cruel usage of his own will – a usage, in fact, that one can barely call 'his' and by which any ownership of the image is suspended.

A number of motifs lead me to draw on this Heideggerian notion of 'usage' (*Brauch*) to address Bacon's practice as a painter, starting with the interruption of the will we have considered – the exposure to which Bacon delivers himself in disrupting his considerable illustrational talent. Bacon lends himself to the birth of the image in such a way as to enable precisely the kind of 'free use of the proper' Heidegger describes in his essays on language when he speaks of a 'use' of the human in what is proper to it *bodily* for the advent of language – a use that is not attributable to any subject or to language, but that belongs to an event (*Ereignis*) from which language and any subject proceed, and which defines the (non)ground

13 In describing Zarathustra, Nietzsche declares, 'In every word he contradicts, this most Yes-saying of all spirits; in him all opposites are blended into a new unity' (*EH*, 305). This would be an example of the kind of counter-citation I

himself, he does not allow injury to fester but responds with either sweets, thanks, or a rude response. And when his vital energies are at their lowest ebb (this is the very definition of sickness in Nietzsche's case), he instinctively practises what he calls Russian fatalism: he avoids all those stimulations of reactive affects that the ascetic priest uses to manipulate the herd. When weak, he accepts himself as fated: at such moments he knows a kind of quiet *amor fati*. And because he has one foot beyond life, he tells us, he never postures, is never tempted by the poses that accompany pragmatic interests. Never having striven for 'honors, women, or money' (!), never having prematurely interpreted what he calls his task with a pragmatic goal of any kind, Nietzsche is free of all false posturing – all of the postures of the ideal which he describes as 'pathological' (*EH*, 257). This is why he says, 'Life was easy for me.' He has never wanted anything to be different. And out of this profound self-love and 'disinterest' (with one foot beyond the pragmatic concerns of life, accepting his fate), he has allowed his multiple, normally irreconcilable, capacities to grow and join in a unity that is not the product of an organic synthesis, but none the less such that these singular traits of the will mutually condition one another.[13] No-saying and yes-saying, for example (perhaps this is the pre-eminent example), are indissociable. And great health names not only the possibility of this coexistence but the condition of the passage between them, their articulation, or better the opening of one to the other.

Nietzsche tells us near the end of *Ecce Homo* that he chose Zarathustra precisely as a figure of the self-overcoming of morality: 'The self-overcoming

for all human usage or 'handling', that is to say, *all praxis and poiesis*. That Heidegger ascribes an erotic dimension to this ground of relationality and recognizes a form of violence in it (the step Bataille makes in linking usage and *jouissance* is anything but abusive)[7] only makes it seem more pertinent for describing the 'handling' to which Bacon submits the image once it appears in the process of creation. This handling itself seems to recover the unity of praxis and its object that Heidegger grasps in Pindar's use of the term *pragma* (a unity of an aletheic comportment of unconcealing – *prattein* – and that which is unconcealed). Indeed, *pragma* may be the perfect term for defining the 'matter of fact' conveyed in Bacon's paintings. Most importantly, this 'handling', governed, as Heidegger emphasizes, by the essence of the hand, is directed to the essence of what is addressed – it *answers*, and in such a way that its hold is not a utilizing but a delivering. It is from this basis, I believe, that we should understand the 'injury' Bacon does to his subjects. The latter term seems to cause Bacon some discomfort, but only because there is a profound fidelity behind this usage, not to speak of love.[8] If we do not grasp this ground of Bacon's 'cruelty' and his devotion to the object, we will not grasp his realism.

7 See, for example, 'The Use-Value of D. A. F. de Sade', in *Visions of Excess*, pp. 91-104.

8 At a particularly poignant moment of the *Interviews*, and in the context of a discussion of his portrayal of coupled figures, Bacon alludes to new possibilities for painting the human body and remarks, 'I can see now that I can start in another way altogether now, now that I feel exorcized – although one's never exorcized, because people say you forget about death, but you don't. After all, I've had a very unfortunate life, because all the the people I've been

97 a preface on cruelty: nietzsche/bacon

of morality, out of truthfulness, the self-overcoming of the moralist, into his opposite – into me – this is what the name of Zarathustra means in my mouth' (*EH*, 328). In the immediately succeeding section, he writes, 'Negating and destroying are the conditions of saying yes' (*EH*, 328). Once again, the dialectic of morality, pushed to its extreme in a joyous and extravagant cruelty, is the condition of Zarathustra's affirmation. But it should also be emphasized that the 'no' is not simply an uncompromising critique of ascetic ideals (a destruction of 'idols'), and a form of self-discipline (as Nietzsche's words might suggest when he defines the task of translating man back into nature in *Beyond Good and Evil*). It involves an extravagant cruelty that allows an opening on to what Nietzsche terms the abyss or the terrible, also the forbidden – an exorbitant form of critique that is something quite other than a 'scientific' knowledge of *homo natura* (cf. *BGE*, 161).

Nietzsche points to this dimension of cruelty and its intimate relation with creation in the fourth section of the chapter in which he explains why he is so clever. While discussing Heine's 'divine malice', he remarks: 'I estimate the value of men, of races, according to the necessity by which they cannot conceive the god apart from the satyr' (*EH*, 245). He then goes on to compare himself to Byron and to Shakespeare, of whom he says, 'The great poet dips *only* from his own reality – up to the point where afterward he cannot endure his work any longer' (*EH*, 246). Nietzsche cites here his experience with *Zarathustra*, and then returns to Shakespeare:

referred to above. But we might also recall Nietzsche's reference in the *Genealogy* (*GM*, 99) to 'those well-constituted, joyful mortals who are far from regarding their unstable equilibrium between "animal and angel" as necessarily an argument against existence'. The character of the unity in question remains difficult to grasp, but it is clear that the Yes and the No are not dialectically related and that no mediation gathers this unity. The peculiar form of the will's drive towards its own limit (which I will describe shortly) is not subsumable in an economy.

really fond of have died. And you don't stop thinking about them; time does not heal. But you concentrate on something which was an obsession, and what you would have put into your obsession with the physical act you put into your words. Because one of the terrible things about so-called love, certainly for an artist, I think, is the destruction. But I think without it they could probably never have ... I absolutely don't know' (*Interviews*, 76).

9 'Well, very often the involuntary marks are much more deeply suggestive than others, and those are the moments when you feel that anything can happen.' – 'You feel it while you're

Deleuze emphasizes a kind of *technical* moment in the genesis and development of the image that emerges from the violent interruption we have considered, and this too may be an important component of Bacon's usage (as of the notion of usage itself, which must be linked to a notion of custom, but also to a thought of instrumentality or operativity). If the latter interruption is translated by a free movement of the hand, the constitution of the image itself proceeds from Bacon's elaboration of the *operative* character of traits left by this involuntary manual movement, traits that belong to a kind of schema or graph.[9] As Deleuze argues in a powerful passage on aesthetic analogy that develops his sense of the link between Bacon and Cézanne, the work of painting lies in the fluid interplay of hand and eye that elaborates the 'factual possibilities' suggested by the 'operative ensemble' of line and colour. The argument is compelling for Bacon and for an understanding of the haptic character of the painted figure in general. It accounts beautifully for the strange poise and power of Bacon's figures, particularly in the sculptural compositions, and it opens an invaluable access to Bacon's lyricism. But Deleuze may be too rapid in suggesting that this understanding of the 'pictural fact' should carry us beyond the reality evoked so insistently by Leiris, for between the fact for

I know no more heart-rending reading than Shakespeare: What must such a man have suffered to have such a need of being a buffoon? Is Hamlet understood? No doubt, *certainty* is what drives one insane. – But one must be profound, an abyss, a philosopher to feel that way. – We are all afraid of truth. And let me confess it: I feel instinctively sure and certain that Lord Bacon was the originator, the self-tormentor [*Selbsttierquäler*] of this uncanniest kind of literature.(*EH*, 226)

'*Selbsttierquälerei*': we are back to the very origin of moral humanity. But this particular cruelty towards animals (indulged in by the great poet or great philosopher – any great realist) does not lend itself to an ascetic turn. If the will is 'interpreting' in this 'uncanniest kind of literature', this 'theater of cruelty'[14] by which it maliciously turns its suffering back upon itself, it does so not in order to burn a form into itself but rather in order to translate itself (in an almost transitive sense) back *into* nature and to know further the pain of existence. It does not open itself to a charge of guilt – it ex-poses itself to the terrible and the questionable (*EH*, 331) – what Nietzsche called in *The Birth of Tragedy* the 'Dionysian'. This is what Nietzsche means when he speaks of striving for the forbidden (*nitimur in vetitum*). Such striving, Nietzsche says, requires courage and it requires strength (cf. pp. 218, 272, 290): the measure of a spirit's value, Nietzsche reiterates, is how much of the abyss (what he sometimes calls 'truth') it can dare and endure – how far it can go in opening to what is

14 Is *Selbsttierquälerei* the condition of this literature (a necessary, prior exploration), or is the literature itself the cruel practice in question? Nietzsche's first words in this passage might suggest the latter: it is because he is practising this cruelty in his work that he cannot endure it.

which Bacon 'grasps' in Leiris's account and its virtual sublation in the figure constituted by the 'haptic' vision described by Deleuze there is something that Bacon persists in seeking to *capture* in his subjects – what he calls a residue of reality, or an 'essence'. I believe we need to hold to this residue if we are to appreciate Bacon's 'realism', and for this purpose I will attend by way of conclusion to Bacon's *operation* on this image and consider a last avatar of the formal meaning of crucifixion.

I speak of 'operation' on the basis of Bacon's explanation of the way he uses cages or frames to isolate the image and fix it: 'I use that frame to see the image – for no other reason . . . I cut down the scale of the canvas by drawing these rectangles which concentrate the image down. Just to see it better' (*Interviews*, 22–3). And if I am struck by the insistence of this motif of trapping, it may well be in recollection of that 'cage' that holds the self-lacerating animal that Nietzsche describes in *The Genealogy of Morals*, that figure of animality at the threshold of 'moral' humanity. But trapping, as Bacon uses the figure, is generally not about 'self-animal-torment'; it defines the entire process of capturing a 'living' reality by 'artificial' means.

making those marks?'
– 'No, the marks are made, and you survey the thing like you would a sort of graph. And you see within this graph the possibilities of all types of facts being planted. This is a difficult thing; I'm expressing it badly. But you see, for instance, if you think of a portrait, you maybe at one time have put the mouth somewhere, but you suddenly see through this graph that the mouth could go right across the face. And in a way you would love to be able in a portrait to make a Sahara of the appearance – to make it so like, yet seeming to have the distances, of the Sahara' (*Interviews*, 56).

99 a preface on cruelty: nietzsche/bacon

strange and questionable in existence, how far it is capable of a Dionysian affirmation.

This does not mean simply recovering the 'natural' strengths of the ugly primitive affects (lust for power, sexual drives, joy in cruelty, etc.) for the purpose of sublimating them and using them in a more powerful, higher deed of the creative will than what Christianity has allowed hitherto. Nietzsche does in fact have frequent recourse to a model of sublimation or spiritualization and the majority of Nietzsche's readers have felt comfortable with Nietzsche's cruelty (when they recognized it) because they have understood it as leading to a kind of *Aufhebung*: one taps the evil in oneself in order to become stronger, if only spiritually. But Nietzsche goes farther; this is precisely why he speaks of the terrible, the sublime, the questionable, the strange and the forbidden. What the cruel will of the philosopher does in translating the will back into nature is force the will to undergo a meaningless suffering. This is what makes the philosopher's will so uncanny, so wicked. The will not only punishes itself, it pushes itself into a void where willing becomes impossible – and that, according to Nietzsche, is the cruellest suffering of all (if not simply intolerable). As he says at the beginning and end of the third essay of *The Genealogy of Morals* (the lesson was obviously important), the will would rather will nothingness than not will. This latter tendency is what made possible the ascetic ideal; this is what ultimately allowed the suffering animal to lend itself to the interpretations of the ascetic priest and to turn its earthly life into a hell in the name of a desired transcendence. To reverse the direction of bad

Let me cite just two passages regarding this capture – two passages that will convey something of *what* is captured. Referring to the difference between film or photography and painting as regards the capture of 'fact', Bacon remarks:

> What can you do [as a painter] but go to a very much more extreme thing where you are reporting fact not as simple fact but on many levels. Where you unlock the areas of feeling which lead to a deeper sense of the reality of the images, where you attempt to make the construction by which the thing will be caught raw and alive [obviously, we are not far from crucifixion] and left there, and, you might say, fossilized – there it is. (*Interviews*, 66)

'There it is' – Bacon may be punctuating, but he also seems to be saying something about what happens when he captures the thing 'raw and alive, fossilized'. He is talking about the surprise of appearance, the 'magic' of the act of rendering, but also about the *character* of the presence involved, a presence Bacon attributes to the special texture of paint in its address to sensation. 'Fossilized' expresses what

conscience as it has unfolded thus far – to punish the will by destroying all ideal goals, all mystifications, to turn the will upon its own interpretations (in general), is to push itself back into a meaningless suffering and to make it experience again its 'basic fact', its foundation – a *horror vacui* (*GM*, 97). The cruelty of the philosopher consists in pushing the will back to its originary exposure to a becoming that offers no meaning, no *telos*. The reference to Hamlet in *Ecce Homo* is telling in this regard if we think back to his appearance in *The Birth of Tragedy*. Indeed, Hamlet's problem is not doubting, it is certainty: he knows the abyss. The philosopher's (or poet's) divinely cruel turn of the will involves forcing the will to confront the impossibility of willing something beyond a meaningless becoming, in making it suffer the pain of unjustified existence. We could speak here, perhaps, of an ecstatic 'being towards death' inasmuch as the confrontation in question is a confrontation with mortality. But we would have to add that this is also a being-between-two-deaths, an experience of the real that exceeds any tragic subsumption.

But how could the will drive itself into the impossibility of willing in this cruel devotion to its 'truth' (its 'basic fact')? And how could such an experience be the condition of a creative affirmation, of a Yes-saying; how would the experience of the *nihil*, or, even more radically perhaps, the Dionysian inseparability of life and death (the void is still somehow more comforting, in a philosophical perspective, than the Dionysian), *release* the will to an affirmative act? How does the event of such ex-posure *free* the will? Must not great health (which is Nietzsche's only answer in the pages

he elsewhere terms '*endurance*' (*Interviews*, p. 58), a quality he links to a certain materiality, a sedimented character that belongs to the painted trait (all the more inevitable and enduring the more arbitrary and non-illustrational it is). There it is – he means by this 'life', 'reality or appearance' as brought forth in the medium of his 'operation': the medium of a usage that does not sublate its material base in a process of signification, but rather brings it forth in its physical character, *arresting* mediation for the sake of another mediality, another communication. The 'that' of Being, as Heidegger demonstrated in his meditation on art and poetry, is conveyed by the fact of language itself (taking language in a very broad sense). Deleuze has perhaps captured the essential character of Bacon's language with his notion of aesthetic analogy, but I would add that part of the force of Bacon's painting, of his 'pictural fact', lies in his presentation of the fact of this language.

 A second citation will underscore that what is communicated here is not simply 'language', as my last words could suggest. In the course of a discussion of realism in the eighth interview with Sylvester, Bacon's focus turns to the arbitrary or artificial means of the trap, and Sylvester alludes in this regard to the structure of the triptychs. He says:

101 a preface on cruelty: nietzsche/bacon

we are reading – his only way of accounting for the passage into the No and into the Yes), harbour a 'Yes', a Yes to the will's finitude, even to that extreme of exposure that is its 'basic fact'? The will must know (have known) its 'truth' to turn upon itself as it does – only a knowledge of finitude could make this turn possible. But at the same time, it can know its limit experience only in affirmation, only as it affirms its existence as an opening, a reiterated opening to what exceeds its hold. The 'No' is indissociable from a 'Yes'. But the Yes does not subsume the No, precisely because the affirmation of eternal recurrence is also an affirmation of the finitude of the will. Yes and No are joined as the two poles of a passage that is at once the opening to an alterity and the creative affirmation that proceeds from it, the latter leading back into this alterity even as it overcomes it. The will of 'great health' is *cruel and creative*, and in its creation it is cruel. It is of its nature to carry itself into an encounter with alterity, to open to the other, and to draw out this otherness in a creative act: to draw it out in such a way that the creative act is an ongoing exposure to that otherness. And because the will is cruel even in its creation (Nietzsche repeatedly characterizes Zarathustra in these terms), the will's creative transfiguration cannot be thought as a subsumption of that to which the will opens. The terrible, the forbidden, the uncanny, is not overcome. It becomes more terrible; this is why the Dionysian affirmation is tragic and why its affirmation is ecstatic.[15]

 I started by suggesting that Nietzsche posits himself in *Ecce Homo* as the sovereign subject he describes in *The Genealogy of Morals*. He claims

15 It is in these terms that I read Nietzsche's description of 'what Zarathustra wants': 'This type of man that he

– It seems to me from all you've been saying that in the end what matters most to you is not an immediacy in the work's reference to reality, but a tension between juxtaposed references to different realities and the tension between a reference to reality and the artificial structure by which it is made.

– Well, it's in the artificial structure that the reality of the subject will be caught, and the trap will close over the subject matter and leave only the reality. One always starts work with the subject, no matter how tenuous it is, and one constructs an artificial structure by which one can trap the reality of the subject matter one has started from.

– The subject's a sort of bait?

– The subject is the bait.

– And what is the reality that remains, the residue? How does it relate to what you began with?

– It doesn't necessarily relate to it; but you will have created a realism equivalent to the subject matter which will be what is left in its place. You have to start from somewhere and you start from the subject which gradually, if the

conceives conceives reality *as it is*, being strong enough to do so; this type is not estranged or removed from reality but is reality itself and exemplifies all that is terrible and questionable in it – *only in that way can man attain greatness*' (*GM*, 331).

to embody the type of the philosopher who is the master of a free will, who has the right to make promises and stand guarantee for its future. He is the subject with 'sufficient will of the spirit, will to responsibility, freedom' (*GM*, 116) to emerge from the cocoon of asceticism and to create new values. *Ecce Homo* leaves no doubt, in fact, that Nietzsche considers himself the first sovereign subject. As he says in his description of *Twilight of the Idols*, 'I am the first to hold in my hands the measure for "truths"; I am the first who is *able* to decide' (*EH*, 314). And it is clear that he stakes this claim on the basis of his creation of Zarathustra. The 'supreme deed' that is *Zarathustra* represents a new determination of Being. Everything he says about the linguistic nature of this event (beings, he says, offer themselves to his language, and they offer themselves as language, whereby his language returns to the original nature of imagery), everything he says about the experience of rhythm, about the measure opened with this event ('Till then one does not know what is height, what depth; one knows even less what truth is' [*EH*, 305]) and about its absolutely singular character ('There is no moment in this revelation of truth that has been anticipated or guessed by even one of the greatest' [*EH*, 305]) – all of this points to the eventful character of this creative act. If Nietzsche insists hyperbolically upon his singularity and greatness, it is because he is claiming to have achieved a radically new determination of the Being of what is: no prior creative act can compare to his precisely because his act is incommensurable and sets entirely new standards. Everything Nietzsche says about this solitude and about the fact that he cannot be heard follows from his sense that he is, as

thing works at all, withers away and leaves this residue which we call reality and which perhaps has something tenuously to do with what one started with but very often has little to do with it. (*Interviews*, 180–2)

Bacon is clearly attenuating to an extreme degree the referential character of the process of mimesis, despite his insistence throughout the *Interviews* that he is painting after the fact, recording the fact. But then, the point, as Leiris noted, is to paint not the thing but its 'fact', the fact of its existence (which for Bacon frequently becomes the experienced fact of existence itself). When he says elsewhere that his aim is to record the essence,[10] he means essence in the sense of the way a thing is *given* in its materiality. He is thinking of the mode of essence to which Heidegger refers with his meditation on the phrase *es gibt* or *il y a* (once again: 'there it is . . . '). That this thing is already lost to illustration (or simply signification) forces us to speak of no more than a residue, the trace of a reality, so to speak. But the trace is compelling enough, material enough, to oblige us to recognize this 'referential' dimension of the image – its force in *drawing out* existence as it is given in its fact. It does so, again, *après coup*, after the fact, and

10 '[FB] For me, it's just a jet of water. – Perhaps I see it as something else as well because for me this picture, like the one of grass, has a sort of animal energy, not an elemental, macrocosmic energy but an energy that has an animal, even a human, scale. – What I would like those things to be would be an essence,

he says, a destiny: something *happens* in his text: a new law is given that speaks in his word.

We may well balk at such a claim (would this be the place to confess my reserves about *Zarathustra*?). But the important point for my purposes is that it is predicated upon the possibility of a radical suspension of all prior interpretation, indeed, a reopening of the question of the meaning of existence in its totality. It is predicated upon a transcendence, if only in the manner of an ex-posure to the nothing named in Blanchot's phrase: 'Nothing is what there is, and first of all nothing beyond.'[16] Cruelty, as I have traced it here, is the enactment of this exposure. But I would also add immediately that Nietzsche thinks this exposure as inseparable from an experience of the Dionysian. I am hesitant to fill in this term as enthusiastically as Bataille does in his 'Nietzschean Chronicles' in referring to the chthonic powers called up in communal religious experience,[17] but I believe we do well to attend to Nietzsche's insistence upon the relation of death and sexuality when he returns to the notion of the tragic in *Twilight of the Idols*, and to recognize that the experience of the Dionysian is a bodily experience of alterity, a translating of the human *back into nature* that is not a simple dissolution of the human in forces that exceed it (though it becomes problematic to speak of subjective experience, and indeed of a 'psychology of tragedy' [*EH*, 273]), but the baring of another 'basic fact' where the human will is concerned: the bodily affectability of human existence and its singular materiality, what Haver has named so powerfully 'the body of this death'.[18]

16 From *The Writing of the Disaster*, trans. Ann Smock (University of Nebraska, Lincoln, 1986), 72.

17 See the translation of this essay in *Visions of Excess*, 202–12.

18 The phrase is from the title of William Haver's book: *The Body of This Death: Historicality and Sociality in the Time of AIDS* (Stanford University Press, Stanford, 1996).

you might say, of landscape and an essence of water. That's what I would like them to be' (*Interviews*, 168). Here is Bacon's very 'Shakespearian' conclusion after Sylvester's evocation of another instance of such an essence: 'Perhaps that is why painting is an old man's occupation, and perhaps, so long as one can work, one may be able to get nearer to a kind of essence of these things.'

via considerable transformation. This fact, this 'that' of what is in all its facticity – has never really *been* before its ex-scription; it is both singular and originary. But 'that it is' marks relation, the fact of an event. It trails relation, so to speak. This relationality is part of what 'touches' our gaze and carries it back constantly in a reference to 'reality'.

So the residue of these paintings, 'this residue that we call reality', is what Leiris calls 'the sheer fact of existence', ex-scribed in a singular presentation. In the fixed density of Bacon's images and in the fixing tension of their reference, we have existence written apart and asunder (*auseinandergeschrieben*, to borrow Celan's term in recollection of the grass that appears throughout Bacon's work), or splayed and nailed to appearance in such a way as to offer this existence. What is left is reality. If we are to read in our seeing, *that* is what we must learn to read in such figuration.

References

Bataille, Georges (1985) 'The Language of Flowers', *Visions of Excess: Selected Writings, 1927–1939*, trans. Allan Stoekl (Minneapolis: University of Minnesota Press).
Deleuze, Gilles (1984) *Francis Bacon: Logique de la Sensation* (Editions de la Différence, Paris), chapters 6–8, especially 41.
Sylvester, David (1981) *Interviews with Francis Bacon* (Thames and Hudson, New York), 23.

In short, Nietzsche's sovereign creative act (and in general any self-styling or self-invention) is creative because it entails exposure to a dimension of experience that is irreducible to any work of meaning or totalizing initiative, even in the 'aesthetic' form of giving a shape to one's existence. 'Self-examination' and the 'revaluation' that proceeds from it is an open-ended, an-archic play of creation that constantly engages what of the human is resistant to any ideological formation (or 'idolization'). It is 'cruel' not simply by virtue of a cruelty latent in the very structure of the will's self-affection but because it undoes any surety of identity, ex-posing the self constantly to the exigency of new initiatives. Of course, since this exigency can be truly known only in affirmation, the task is a light one. And since the exposure in question *communicates* itself (as Bataille understood), it does not have to be undertaken alone. But here we reach a dimension of the ethico-political (its an-archic ground) where Nietzsche, in his icy solitudes, is of relatively little help, or even inhibiting: the thought of the pathos of distance as a relationality. The task that opens here is perhaps a 'queer politics' of a kind. But even with that joyful epithet, we psychologists may still be too good for our job.

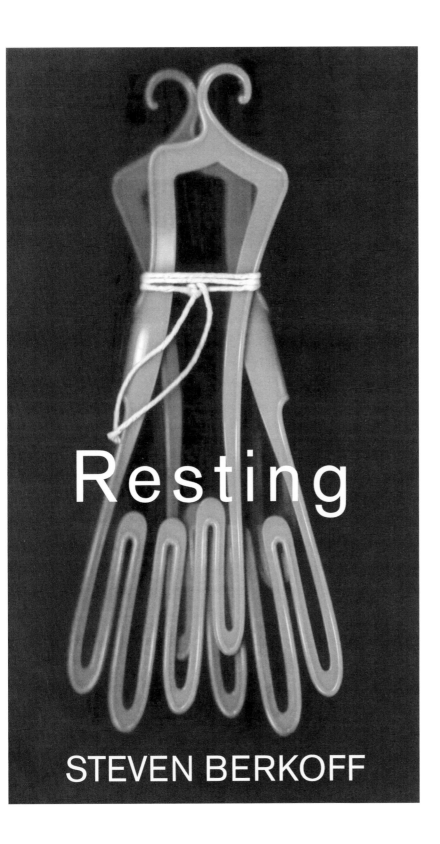

Resting

STEVEN BERKOFF

Tired, he was always tired lately . . . not during the day when the city's population flowed through the streets, as if a tide had been let loose on parched fields, and H. could be carried like a piece of flotsam on the back of the throng. There he had a purpose, could browse around the bookshops, slip through the labyrinth of streets designated as Soho, idle in the National Gallery, sip a coffee in Patisserie Valerie, a favourite coffee shop in Old Compton Street, scour the antique stalls of Camden Passage, Islington's sixteenth-century backstreets, visit the YMCA if in the mood, sign on at the Labour Exchange, call a chum and have a breakfast natter in the local greasy spoon or nag the agent. There were a thousand and one other things an unemployed actor in London can do, swept along on the stream of human activities, and at any of these places there might occur a chance meeting with some lonely and eminently desirable woman.

Even, and this was always an option, visit the Astoria Dance Hall in Charing Cross Road, where each afternoon an event quaintly called tea-dancing took place. The hours were from 3 p.m. to 6 p.m. and, when you entered, the outside world vanished and the band played the current hits of yesteryear that housewives, widows, couples and au pair girls might find appealing. Yes, the Astoria Dance Hall was the last hope café, the refuge and sanctuary for those who did not have a large role to play in helping to keep the great metropolis going round and, like H., who literally did not have a role to play, it was a way of turning away from the accusing light of day and basking in ersatz night. Here H. could purge his frustrated energy and translate it into pure fevered lust in the pursuit of some desirable, interested, fascinating piece of female flesh. This not only took one's mind away from the fevered world outside but seemed an alternative and worthwhile pursuit for which he, for some reason, had no guilt. Yes, today he would go tea-dancing. So he took the Tube, changed at Holborn for the Central Line and exited when the train stopped at Tottenham Court Road, stared with almost unseeing eyes at the brassière ads that moved past him on the escalator and blinked with pleasure as he entered the bustle of Oxford Street.

After the claustrophobia of the Tube, the sudden shock of the city never failed to surprise him and he took his familiar walk around the corner to Charing Cross Road and descended the stairs into the warm, amber subterranean cavern, which was also womb-like since it was a warm, reddish velvety room where sperm-filled men pursued egg-filled ladies in a furious dance and maybe one or more lucky spermatozoa would eventually penetrate. As he trod the thickly carpeted stairs he felt he was descending slowly into a bath of warmth and music which gradually enveloped him, covered him and swallowed him up, filling his ears and then his eyes as he took in first the syrupy music and then the blur of moving bodies sweeping around the floor, and finally his nose detected their combined scents sweetening the atmosphere with its erotic mix. They were at present swirling around the floor in a waltz, tightly held females of all shapes and sizes, making their ritualistic perambulation, moving anticlockwise but why this was always the fashion one never knew. He grimly observed that it seemed to be a mostly older lot today, middle-aged ladies from North

London swathed in taffeta or flowing floral dresses, hair frozen into a wave of candyfloss and just as stiff, as he had noticed on one occasion when desperation made him charter one of them for a short but choppy voyage round the floor. The experience, combined with the penetrating odour of her hair lacquer, made him positively sea-sick.

Apart from H., who had arrived early, there was the usual gaggle of hirsute men in suits, pushing their live baggage around like they were porters at King's Cross Station. These were mostly waiters and kitchen staff from Soho who had just come off the lunch shift and had a couple of hours to kill. Some went to the betting shop, some idled their time chatting in a coffee bar in Greek Street, a few went home, and some ended up at the Astoria to see what they could find to fondle and squeeze for the two or three hours of freedom they had before once more grovelling in front of the tables at Kettners, L'Escargot, or the Gay Hussar. Waiters and chefs were notorious womanizers, since this was for them a chance to get a grip on what they had to dance around and cater for at the table, a kind of act of revenge. Some were remarkably seedy, he noticed, as a swirling, moustached dancer had protruding from his tight and ill-fitting jacket a folded copy of the *Evening Standard* open at the racing page.

H. sat and calmly surveyed the room, waiting for it to fill up a little and, like a predatory animal watching the single woman sitting alone, he would pounce. He quite liked the young ones, the French au pair girls for whom loneliness and desperation for some human comfort had driven them to ride on this carousel of the flesh. The dance ended and a couple who seemed entwined as if joined at the hip like Siamese twins, parted suddenly, each exploding off in different directions since there was no music to glue them together any more or to give justification to the act of suddenly being able to embrace a complete stranger. Each wandered off into the gloom from whence they had emerged, and then the bandleader, looking bored under his grinning mask, made an effort to bare his teeth and announced that the next dance will become Latin American, in fact a samba. There was about as much resemblance to Latin America in this faded English dancehall as a holiday poster – just an image – a shadow, as the group of balding sweaty musicians smiled happily as is expected from those of Latin temperament and shook their tambourines. A few stalwarts got up, albeit sheepishly, since the rhythm demanded a floss more energy than was required for the grope waltz or foxtrot. H. would sit this one out too, but nevertheless made his trajectory around the floor in the affectedly casual way men have of pretending that they are just taking a leg-stretch round the room. Here in the dance hall, the genetic signals are reaching back into the inner coils of the brain, echoing a time when the predator would be circling its prey on the open savannah in some vast Africa at the dawn of time. In the shimmering distance was a young deer grazing and H. concealed himself in the long grass. Here there was an attractive dark-haired young woman standing alone, smoking a cigarette. H. would have liked to ask her to dance and lingered somewhat, trying to be inconspicuous, and turned his head this way and that as if not in the least interested in making a pounce, but, as he looked back at her with almost indecent longing, she allowed

herself to be whisked off by a gent of somewhat Italianate appearance. She danced without too much expression but held the steps. He was now able to study her lithe figure which acquitted itself well in a sheath-like dress which hugged her form a little too possessively. She did move gracefully, anguished H., and was about five foot seven which he liked. She performed the side to side motions of the dance with ease and while the Italian kept attempting to draw her closer to his needy flesh, she was able to keep her pelvis at a good distance from his, H. was satisfied to note.

H. moved around the room observing the general melee of peroxided ladies who seemed to be in couples, and there were the usual devotees who loved the art of dance and were amongst the few who came expressly for that reason and knew their favourite partners. These flowed around the room with athletic abandon and the women could be seen changing their shoes as soon as they entered the dance hall, removing the tatty, old, battered street shoes and donning elegant pumps with pointed heels. The old ones they placed in a carrier bag. Now, like Cinderellas, they were transformed by the shoes, since shoes can do strange things to people, and turn a dowdy housewife into this flying, spinning, whirling confetti of flesh. Yet in spite of their expertise they danced stiffly and reminded H. of stick insects. The woman held the man by the shoulder and as she was swept along by the wave of energy she looked away, as if all this was being done to her against her will, but still managed to follow each step and every change of her partner's body. She mustn't reveal that she enjoys the seduction. There were a few Jewish-looking matrons there since they loved to natter and dance and here they can accomplish both at the same time, but H. did notice an exotic-looking Jewess of probably Middle Eastern extraction, who was about late thirties and wore her jet black hair in two thick braids that she had twined into snakes and then pinned to her skull. She seemed to be on her own.

Yes, things were looking up as H. marked out his potential territory; the Jewess and the younger, rather sad, but healthy-looking dancer of five and seven, the oily concoction of medleys pouring in his ears, the confluence of scents and body odours sucked into the nose, the potential female flesh waiting, or moving, being drunk up by his eyes kept his sensory functions on high alert, and, without consciously thinking it, H. was glad that his otherwise under-employed senses were able to extract some nourishment. He was a predator in some distant, far place, watching, listening, sniffing, each sense tuned to its highest degree of reception and was interpreting automatically all the information coming in and deciding what to do with it. He was following an instinct as old as time, even in the seedy Astoria Dance Hall, Charing Cross Road. His shoulders relaxed, his stomach softened its protective tightness, his head moved side to side with the music, a little bobbing, a touch of the hips changing weight. Hey, he was relaxing, his body going with the sound of the music and the room swam before him in a roundabout of bodies, flowers and swirling dresses. A tight skirt, with a slash that allowed one leg to be forced out, swam past and the shining domes of the band nodded to the rhythm and passed little private smirks to each other and to the bandleader who was nattily dressed in a

polka-dotted shirt. Meanwhile, the off-duty waiters were hanging on grimly to their prey and trying to push their pelvises closer, hoping for a response which wasn't forthcoming, and a thin haze of cigarette smoke was beginning to spread through the room. The women sitting in threes and fours giggled energetically as if released from the bondage of a possessive spouse, and relished the variety of male flesh that they could be scornful of.

H. studied himself in one of the many mirrors that lined the walls. Yes, fine. A thin, roll-necked sweater under a jacket . . . very smart but casual, hair newly shampooed and flopping over his forehead, a little on the thin side but not bad. No. Just a slight angst . . . the quiver in the heart and the tremor in the bubble of his oh-so-fragile confidence. He must ask the dark, saturnine, healthy-looking woman with a sad face for a dance, for she is already his in the fast-forward motion of his fantasy. His projection into the unseeable future might give him the confidence of a gambler who bets to win and is empowered by hope. His future is with her and he now watches intently the movement of her body, the curve of her leg, so tantalizingly shaped by her dress, the sweet, strong wave of her hips which swept in at her waist which was held by a large, elasticated belt, and her blouse, short-sleeved, gathered and puffed out at the end revealing healthy, tawny arms. Oh how he ached for those arms, those strong legs, those clean, powerful hands unadorned by nail polish, her pale lipstick, swept-back hair fixed by a brooch holding the thick tresses in place. He fantasized but did not wish to hover, so circled slowly around the floor, still nonchalantly jogging his head to the music while his heart was beating a different drum. Meanwhile she was dancing the samba and hardly looking at her partner. But no, now he's talking to her, she smiles, which suddenly lights up her whole face, and now she giggles as if he has said something witty or smart and thus the swine is weaving the first of his webs around her while all H. can do is *fantasize*. She must like him! H. stopped obeying the rhythm of the music, stopped resembling seaweed being pulled this way and that by a tide, stopped to feel the stomach tightening again, the head heating, the jaw tensing, the teeth grinding, and felt he must move away from the source of his discomfort.

He strolled round, scanning the room, but the other potential victims were dancing and there was nothing else there he wanted, he desired, he fantasized as much as she. He liked her strong-limbed body, so buoyant and confident of itself and that was HIS match. She was his style, quality, form, and H. felt that he was in the same league that contained her. The waiter was *not* and never would be, and can't even be thought possible of being so, and yet damnably he was holding her and dancing with her. H. turned away again and strolled as if to try and relax and noticed a brunette wallflower, rather Irish-looking, glance at him and then quickly turn away again, as if to pass him a signal saying 'I would not be reluctant to dance with you'. H. glanced at her again and decided that she looked a trifle dowdy, although she had a pleasant face and certainly caused no crisis of confidence like the other, but if he danced with her he would be confirming that he was in her league and hence would be forever damned to remain in that division, since it was H's dearest wish TO CRAWL OUT OF THAT

PLACE FOREVER! But H. has to ask the beauty to dance, even at the cost to his nerve. He passed the Irish and gave her a warmish glance, rewarding her with some false sense of hope which at the same time kept an ember going for an emergency, but again swivelled his eye momentarily to the dancer and then raked the dance floor, allowing the blurred figures to momentarily distract him from his obsession. Yes, he felt better now and was optimistic on the whole, and would be patient and wait.

H. was a result of a million years of evolution and must now pass on his genetic material and, whether or not H. was aware of these things, his billion cells were, felt a distinct pull and were now in an uproar. Does one instinctively know one's own genetic worth that drives you to mating with those of your own 'value' and to avoid those whose 'physical' attributes seem to overwhelm yours? H. could see that she didn't much care for the man and probably his hands were sweaty, horrible thought, nails none too elegant, and didn't like the way he would sometimes try to push her thigh with his. Dancing can be so intimate, yes, what a strange ritual that gives you permission to put your arm around a complete stranger and feel their body, hold their hand in yours, smell their odour, brush their thighs and then leave. Like it's a test for both of you. A sniffing out in a wide-open prairie under a hot sun when two animals slowly circle each other, sniffing, examining, sensing by the highly-tuned mechanism whether the smell is strong, good and suggests virility and health, since it has to be of equal value. Is H., for a second, questioning his own value and therefore his hesitancy in some basic, deep acknowledgment of his worth and does that mean that H.'s genetic bank cannot afford her? No. His hesitation is merely that being so right for him, she becomes a challenge that he must face and not just run off with the weakest deer in the pack. Do you know what happens then? Self-disgust. The dance stopped and the figures were absorbed back into the territory from whence they came as if they marked it out; the chair, that particular patch of wall, this table. Now, ah yes, a slow waltz . . . good time to talk, easy to move together over the landscape like we were taking a journey, the end of which would find us reborn as a couple.

H. would be able to give good chat, he would be sensitive to her. She was adjusting her dress . . . the waiter had left, but no, he was HOVERING, so as to be quick off the mark for the next, the pig! H. decided. Yes. Now. He walked over to her but in a way that pretended he wasn't. He strolled, so as to appear casual, but really would have liked to run across the room, snatch her hand, pull her up, and the velocity of such a gesture would throw her strong, lithe swimmer's body into his arms, yes, feeling all that body against his; legs, thighs, her divide as his thigh moves a fraction of a second forward before hers can retreat and locking his fingers into hers like a nest of snakes, and then weightlessly whisking her off, her lips facing his, her eyes his eyes, nose to nose, smile to smile and breathing in each other's breath . . . yes. She would 'sniff' him as potential genetic material. This is what H. had somehow, in a quick flash, formed in his mind as he casually walked and yet was he expecting rejection or half-expecting it and is he prepared for that half and has he got back-up, and can he DEAL WITH

THAT FEELING WHEN YOU HAVE CROSSED THE FLOOR, WALKED UP TO A
WOMAN AND ARE REJECTED AND FOR A MOMENT YOUR LIFE, YOUR MOST
PRECIOUS LIFE, HAS A NULL MEANING. FOR A SECOND YOU ARE IN LIMBO
SINCE YOU ARE EITHER ON THE THRESHOLD OF CREATING A THOUSAND NEW
GENERATIONS OR YOU ARE WITHOUT PURPOSE.

But you must deal with it and the message that rejection implies is that
your material's not suitable to mix her chromosomes with. Your smell is not
right. My signals are not attracted. Sorry. Yes, you deal with it, smile and
walk away and since victims are interesting, other eyes will be watching
you, FASTENED ON YOU. They wish to see what you will do with the egg
sliding down your face! But there is no chance of that since she danced
with Mr Greasy and now H. offers her a division higher and step by step is
getting closer . . . she, still sitting, relaxing after the more strenuous samba,
crosses her legs, throws back her hair with a toss of her head . . . she is
settling. H. is on his way over. His destiny is at the end of this walk. But
why? Why place so much importance on the outcome? It's only a dance,
but in H.'s case the dance was HIS dance. The roles he didn't get and the
work that never expressed his ability, the hours that sat upon his head, the
hunger in the soul, the pain in the gut, the shrivel in the balls when they are
not needed for work. You *wish* to use them, to challenge them, to show you
have them and here is a place where that particular rotund receptacle is at
least to be used, or could be . . . and can be, and so he carries them along
with his diminishing sense of self-worth, the result of dozens of rejections.
Thus like the conditioned Pavlovian dog, poor H. approaches the object of
his hunger with the accompanying fear of receiving an electric shock, which
does not make for secreting those sexual odours that women are supposed
to find so attractive. So carrying both hope for the future and angst of the
past, and weighed down by both, like an old Chinese water-seller with the
yoke across his neck, H. valiantly reaches the object of his desire and of
course there was too much riding on this one, let alone that this be the test
before the Goddess of Fertility.

The waltz was in the first phase and figures were darting here and there
like fish in a tank that have just had their seed thrown in. Figures seemed to
be extricated from their dark corners, peeled themselves away from the
wallpaper and danced away into the distance. Sometimes they reminded H.
of sailing ships waiting for that sudden gust of wind that would take them
off into the far horizons and when the music stops the wind subsides, and
the ships would sit quietly waiting for another gust. He continued to make
his way as casually as possible and slightly off-angle as if he might just
make a trajectory past the moon, meanwhile taking in the waiter who was
still hovering inclined to capitalize on his gain. Admittedly, the Italian did not
dance badly and in fact quite well, but H. would now show her how HE
danced, what care he expressed in his motions, what sensitivity he
possessed, she would and must pick up from the way he would handle her,
concern, poetry in motion, dry hand, warm actor's voice, strong but gentle
movement. Yes, he was there . . . he had arrived at the promised land but
she appeared not to have noticed this vehicle of human aspirations coming
towards her, at a slight angle of course, and didn't even look up as he

arrived by her chair, but now his voice pulled her head up to where he stood, waiting in all his glorious hope, a modest grin uncomfortably attached to his face.

H. stood there for an eternity, the clocks stopped for a few seconds and she turned her head. It was a routine request that he had made dozens, if not hundreds of times and sometimes they do and sometimes they don't, but on average he'd scored far more yes's, so what's the big deal. Perhaps it was that this one was a touch rarer than any of the others and more exotic, what H. had always hoped for, with whom he would be proud to be seen, to wait for, to look forward to seeing, to dream about, to yearn for and not like recent pick-ups, quickly steered across streets when he saw friends from his neighbourhood walking his way. So H. stood there in this state and how could she possibly know the layer upon layer of crumbled hopes that formed the foundation of his request. Upon the ancient ruins of disappointment were the foundations of his new church, whatever that may be but now it was . . . 'care for a dance' . . . she looked up, making that split-second assessment that girls have to make, and smiled. H. moved his weight a fraction towards the ball of his foot so as to be expectantly ready, as if the request was a formality . . . 'No thanks', she said, still smiling, warding off the sting of rejection with the balm of goodwill. She was tired, the previous dance had made her hot and she wanted one dance off, that's all. Perhaps there was nothing more than that which in normal circumstances would be the most likely interpretation, and anyway if a man can pick and choose why not grant a woman the same privilege. So spin on your heel, walk on, stroll past others, go to the bar, have a coffee, survey the rest, pull yourself together, and maybe even try one more time. But for reasons already well-established and that are too deep, numerous and complex, this 'No thanks' was like a karate blow to shake the brain inside its fluid, causing it to knock on the walls of its cage. For H. it was not just another 'no' after the thousand and one 'no's' he expected in his chosen calling; it was from whom the 'no' came. 'NO' – AND AFTER SHE HAD DANCED WITH THE GUY WHO WAS OBVIOUSLY A WAITER AND THUS HER 'NO' RELEGATED H. TO A STATION LOWER THAN THE LOWLY AND HE SENSED THAT THE WAITER WAS WATCHING HIM AND SMIRKING WHILE STILL HAVING HER PERFUME ON HIS HAND!

H. smiled in acceptance and turned swiftly away as if this was of no great import and for some reason couldn't stay in that hall any more, which contained the woman who would be a permanent *accusation*, and welcomed the cool air on his cheeks as he surfaced in Charing Cross Road. He wanted his temperature to lower but now felt sticky and hot and his hair stuck to his temples and his roll-necked sweater irritated and he didn't feel so . . . confident. Fuck her, H. thought, trying by demeaning his Goddess, to de-mystify her. How could she reject me and dance with that greasy, disgusting man . . . it was unforgivable. It's enough, and anyway I don't think I want to go there again ever, decided H., and the long, metal tongue of the escalator at Tottenham Court Road swallowed him up and deposited him into the depths of the city, where he was transported through its dark intestines to a distant destination where the line stopped.

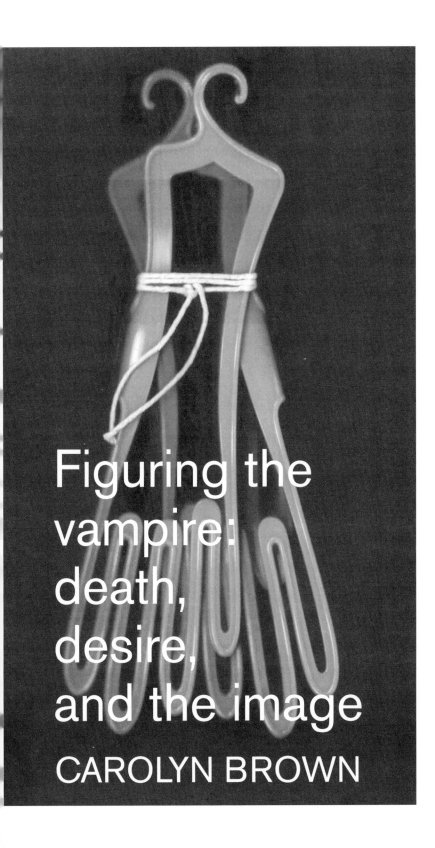

Figuring the vampire: death, desire, and the image

CAROLYN BROWN

Vampires, as we know, cannot be seen in mirrors. Jonathan Harker's suspicions are aroused when he cannot see his host's reflection. In Anne Billington's *Suckers* her protagonist has a terrible time in the ladies' loo at the Vampire bar in Canary Wharf, hiding from the mirror that would indicate her human status. This 'myth' is refuted, along with others, at the start of Anne Rice's *Interview with the Vampire*. Nevertheless the myth of the inability of vampires to be reflected in a mirror is always present, even if – especially if – it is refuted. It would seem that the absence of the mirrored self/image rather than designating an authentic self-hood, or simple lack thereof, designates a mingling of the self with image, within the figure of the vampire itself. As the vampire is both dead and dying for a drink, it serves therefore as a point of condensation for the configuration of the image/desire/death. 'The body' in vampire lore serves as a mutating metaphor for the mobility of shape, substance, and desire. Thus, in Rice's *Chronicles of the Vampires*,[1] it is hyper-aware and yet literally statuesque, but also as (only?) good for a drink, as meat. It is a construct which cannot be thought outside of the genealogy of the image – a phantom which is haunted by 'the monstrous maladies of the dead'. For Roland Barthes, the photograph

1 Anne Rice's series of novels will, following convention, be referred to hereafter as the *Chronicles*.

> is the way in which our time assumes Death: with the denying alibi of the distractedly 'alive' . . . for Photography must have some historical relation with what Edgar Morin calls the 'crisis of death' beginning in the second half of the nineteenth century; for my part I should prefer that instead of constantly relocating Photography in its social and economic context, we should also enquire as to the anthropological place of Death and the new image. For Death must be somewhere in a society; if it is no longer (or less intensely) in religion, it must be elsewhere; perhaps in this image which produces Death while trying to preserve life.
> (Barthes, 1988, 92)

Dorian Gray and Dracula are key myths of the twentieth century articulating images/desires/death: emerging from the space of the library – almost specifically the British Library in Dracula's case or des Esseintes' guide to Western literature in *A Rebours* in Dorian's case – they also emerge from the Theatre, as important a mode of re/presentation, or rather performance. In their hybridity, they join Blanchot's figure of Don Juan and the Commander as figures of desire and death, as they do Marx's austere capitalist and his *Doppelgänger*. The movement of desire and the image, the puppet, the statue, is inextricably linked with death; in Susan Sontag's evocative phrase, one becomes 'embalmed in a still'. The construction of death is to be considered as inhuman – that is, beyond the individual, for whom it nevertheless waits. Death, like the image, becomes a powerful mode of individuation in this period. Between death and the image the soul becomes desire; the human begins to be thought differently, beyond the 'self', in an alternative schema drawn from the gothic. 'The drawing back before what dies is a retreat from reality. The name is stable and it stabilizes, but it allows the unique instant

already vanished to escape; just as the word, always general, has failed to capture what it names . . . We thus find ourselves caught in the treachery of I know not what trap' (Blanchot, 1993, 34). The energy of the language of death, hauntings and possession in the writings of Wilde and Foucault becomes a force for transfiguration, a way of becoming *otherwise*.

One. The vampire trap

> Depending on its placement, the vampire trap made the actor alternately body and spirit. The trap propelled the vampire either up or down through the stage floor . . . or through invisible doors in the flats, allowing him to make imperceptible, phantomlike intrusions into or out of domestic space. (Auerbach, 1995, 23)

The concept of identity within the postmodern condition is one of apparent paradox. On the one hand, the argument is that the postmodern has opened up places for the articulation of marginal voices (usually indicated as black, gay, women). On the other, the questioning of the liberal concept of the unified subject, it is argued, takes away the claim of self-knowledge, of authenticity, of the identity from which those from the margins are permitted to speak. There is a tension between a political language which uses a rhetoric of community and authenticity, of domesticity, and the apparently dispersed, fragmented subject of postmodern discourses. The tension between potential multiplicity and plurality and the limitations of our existence, between the heterogeneous desires which traverse our bodies, and our abilities to perform those desires is no recent occurrence. Dorian Gray

> 'used to wonder at the shallow psychology of those who conceive the Ego in man as a thing, simple, permanent, reliable, and of one essence. To him, man was a creature with myriad lives and myriad sensations, a complex multiform creature that bore within itself strange legacies of thought and passion, and whose very flesh was tainted with the monstrous maladies of the dead.' (Wilde, 1989, 154)

As Richard Ellman makes clear, Wilde's *The Critic as Artist*, *The Decay of Lying*, and *The Picture of Dorian Gray* deconstruct the idea of the unified self. Wilde elaborates the paradoxes with which identity and desire present us. The construction of 'the subject', or 'man' as 'creature' whose multiple possibilities are juxtaposed with the finitude of the flesh, solidifies, elaborates upon the abstract or domesticated subjects of so many debates. These 'myriad lives' emphasize not only the varying relations of time and space (what Bakhtin usefully terms chrono-topes) which are constructed in our legacies, but how 'the body manifests the stigmata of the past experience and also gives rise to desires, failings, errors' (Foucault, 1977, 149).

Richard Dyer, in an essay entitled 'Children of the Night: Vampirism as Homosexuality, Homosexuality as Vampirism', has argued that there is a correspondence between the gothic and specifically vampire-lore and gay identity, that 'vampirism represents something about homosexual desire that remains stubbornly marginal, unruly, fascinating and indispensable' (Dyer, 1988, 70). 'Analogous with the shift, and insistence upon it, from lesbian and gay men as persons who speak for themselves' (Dyer, 1988, 65) is the shift to first-person narration in vampire stories. Dyer suggests that 'Dorian Gray, the archetype of gay male existence, is a fundamentally vampiric creation' (61) and furthermore that 'vampirism can now be celebrated as the most exquisite form of sexual pleasuring' (67), specifying the *Chronicles*. Dyer's account indicates yet evades some of the more disconcerting aspects of the copulation of lesbians, gay men, and vampires, by prioritizing the 'real' categories of lesbian and gay men who find the vampire an appropriate vehicle to describe ('imagine?') their existences and desires. Thus, while he registers Anne Rice's *Interview with the Vampire* and *The Vampire Lestat*, as 'two of the cult novels in US gay circles in the 1970s and 80s . . . though not written by a gay man . . . in which [male] gay love is an inherent part of the ecstasies of vampirising' (Dyer, 1988, 48), he considers neither Rice's gender nor the multiple other 'ecstasies' of vampirism in these texts. The *Chronicles* construct the fantasy of *being a vampire*, and homoeroticism is an integral part of this play with the archives of gothic and pornographic literatures – those twin discourses which affect the reader more than cerebrally. The *Chronicles* offer a postmodern yet nostalgic phantasmagoria of desire and death, of the demonic which offers 'the violent transgression of all human limitations and social taboos prohibiting the realisation of desire (Jackson, 1981, 57). The 'cult' nature of the *Chronicles*, like the demonic, transcended the categories of gender and sexual orientation by which we are too often domesticated. Nina Auerbach's *Our Vampires, Ourselves* reinforces Dyer's point by drawing attention to the moment of Dracula's conception in the 1890s in the wake of the Wilde trials – 'Dracula's silence recalls the silence forced on the voluble Wilde . . . ' (Auerbach, 1995, 84). She further elaborates on the 1980s moment of the embracing of the vampire by Queer Theory – in the performance work of Sandy Stone, and the writings of Christopher Craft and Sue-Ellen Case. The rhetoric of death, desire, and deviance works both ways, as Jonathan Dollimore argues strongly. 'The connection of homosexual desire and death is made by those who want literally homosexuals to die', but crucially 'this death/desire connection is part of our history, . . . the sexually dissident have always tended to know more about . . . the strange dynamic which, in western culture, binds death into desire' (Dollimore, 1995, 36). Elisabeth Bronfen's discussion of death, femininity and the aesthetic argues that 'the Other is semantically encoded as the site on to which anxieties about loss of control and boundary distinctions are projected' (Bronfen, 1992, 190) and thus 'the Other is always connected with death' (1992, 191). The connection between death/queer/vampires/other others, is very much an historical *a priori*, and it is aspects of that dynamic and its intimate link

with the ideas of identity, the image of, the soul of identity, that we will explore here.

That 'identity' is multiple, phantasmal, is very much part of the tradition of what James Donald has usefully termed 'the vulgar sublime'. In this terrain, 'desire' traverses the 'body', and gender is but one source of perverse and multiple pleasures. The continuing legacy of the vulgar sublime is a place of performance – hardly surprising when one considers the complex interaction between theatre, cinema and literature in this genre. When the vampire Lestat awakens in 1985 into the postmodern condition, it is to find, among other things, vampire bars, many located (of course) on Castro Street. These are frequented not merely by 'real' vampires, but also by wannabe vampires – vampire simulacra if you like. The use of subcultures and their bars not only inscribes the text in an intersection of specific discourses and social relations, but indicates the complex intertextuality and performativity of the 'vulgar sublime'. As texts such as *The Addams Family* and *The Rocky Horror Picture Show* demonstrate, the 'vulgar sublime' operates with an audience which is both ironically aware of the intertextual references and yet identifies with and enacts these as self-dramatization. Vampires, as with so many other creatures of the gothic imagination, are the creatures of the night of the Enlightenment, dwelling in that area which 'lies within closed systems, infiltrating, opening spaces where unity had been assumed. Its impossibilities propose latent "other" meanings or realities behind the possible or the known' (Jackson, 1981, 23).

Two. Capital bodies

Whereas in William Gibson's *Neuromancer* the body is 'meat', and the language of addiction and desire is linked to 'jacking into' cyberspace, despite the sexual connotations of the language, the body is transcended by mind, in the *Chronicles* the vampire-body is hard, statue-like, and generally an improvement on the human condition. It clears the skin, improves the condition of the hair, diminishes wrinkles and tones the body shape. It is an ideal image of the human body. It is also a demonic body – the body of the addict – possessed by 'the hunger', literally dying for a drink. As in Bram Stoker's *Dracula*, Whitley Strieber's *The Hunger*, the 'explanation' of the vampire is in terms of 'blood' – albeit recast as DNA/viral – sharing a discourse of invasion, of possession, and engendering an impressive taste for cruising. Stephen Neale has indicated 'the special fascination with the body which characterises the fantastic – an ambivalent and highly erotic compound of attraction and repulsion' (Neale, 1989, 222). It is the insertion of the body – or, better, differentiated bodies – into discourse which the gothic enacts with a particular vehemence. The self, as Jackson points out, suffers an invasion, a metamorphosis, or fusion with another being (1981, 58). The body is located as liminal, between life and death, between 'self' and 'other', between image and desire, but also oscillating between the terms to achieve a special density of the spirit and the flesh, the 'I' and the 'non-I'.

The fascination of the gothic with the portrait, and the 'death of the subject', is long-standing: for example, Edgar Allan Poe's 'The Oval Portrait'. The portrait in its mimicry doubles, yet questions, the 'self' of realism. Susan Sontag indicates how the inscription works:

> A person is an aggregate of appearances, appearances which can be made to yield, by proper focusing, infinite layers of significance. To view reality as an endless set of situations which mirror each other, to extract analogies from the most dissimilar things, is to anticipate the characteristic form of perception stimulated by photographic images. (Sontag, 1980, 159–60)

The disjuncture between the assumed, imaged 'self' and the desires and eventual decrepitude which inhabit that being is an articulation of themes that Kathleen Woodward has seen as a part of a postmodern paranoia. She argues that

> The surgically youthful body is the post-modern version of Oscar Wilde's haunting tale of Dorian Gray, the man whose body never visibly aged. From this perspective, the post-modern body is not, as Arthur Kroker and David Cook suggest, the body disfigured by what they call post-modern diseases (aids, anorexia, herpes). It is rather the surgically youthful body, the uncanny body-in-masquerade. (Woodward, 1988/9, 136)

It is perhaps more useful to see the two terms as conflictually entwined, as operating across the ways in which the body becomes *unheimlich*. While the body as ideal-image produced through surgery, exercise, cosmetics seems attainable, death, disease, age mark it as vulnerable, as mobile, as not-self. As Aschenbach admits cosmetics, so too does he admit desire and death. Both fixed image and death/desire mark the *unheimlich* nature of the body.

The rhetoric of the modern vampire as a creature of desire and transgression, as dynamic, demonic, uncontainable, works across a network of multiple forces. Firstly, the exploitative aspects are allied to the mobility of capital – which as Christopher Frayling points out, was a link made from the early nineteenth century, particularly with regard to Ireland – on which is then superimposed the Byronic image, of dissipation masked under English 'cool' which was aligned in France at least, with an image of 'the City'. The comforting rhetoric of the vampire as *revenant* aristocracy ignores that class's control of finance capital. It is a similar 'image' which André Gide locates as the attraction of the English homosexual in his *Journals*. It is possible to read a fairly straightforward repressed homosexuality in the texts of late nineteenth-century England – such as Elaine Showalter's entertaining reading of *Dr Jekyll and Mr Hyde*. Christopher Craft with regard to *Dracula* argues for a suppressed and mediated homoeroticism of Dracula's opponents and that 'Victorian culture's anxiety about desire's potential indifference to the prescriptions of gender produces everywhere a predictable repetition and a predictable displacement: the heterosexual norm repeats itself in a mediating image of

femininity – that displaces a more direct communion among males' (Craft, 1989, 238). Craft correctly argues that 'Stoker's vampirism . . . imagines mobile desire as a monstrosity, and then devises a violent correction of that desire' (224).

Michel Foucault's schematic construction of the nineteenth-century sexual figures of the hysterical woman, the Malthusian couple, the masturbating child and the perverse adult, indicates the absence of those who draw up the classification system. There is no place for an acceptable male bourgeois sexuality other than as the (dominant) half of the Malthusian couple, fraught with danger as union with the 'hysterical' woman, who may well mutate into the *femme fatale*. (George Eliot in *Middlemarch* considers the problem for Casaubon and Lydgate.) Vampires are among the many figures of the sexual – dehumanized, as sexuality is displaced on to the objects of desire who become sexualized-beings-in-themselves. In the archaic discourses of biology, the symbolic importance of blood empowers the vampire as a threatening figure from the margins (geographically and historically) who as virulent capital/body enters, corrupts, destroys, 'the physical vigour and moral cleanliness of the bourgeois body' (Foucault, 1981, 54). Showalter's work on models of syphilis is clearly relevant here, and one must consider too those gentlemanly groups of H. G. Wells and Joseph Conrad. Like Kurtz, Dracula is a gorging and engorged phallus, a massive projection of nineteenth-century Bourgeois Man.

The vampire serves, then, as a figure for the double displacement of his desires; having displaced 'sexuality' on to others, he seeks to recover those desires by possessing them. This is a fantasy of possession, in both senses. The bourgeois individual man is a position (nearly as phantasmal as that of the vampire) of sadistic control. Terry Eagleton extrapolates this movement from Marx's 'Economic and Philosophical Manuscripts':

> Capital is a phantasmal body, a monstrous *Doppelgänger* which stalks abroad while its master sleeps, mechanically consuming the pleasures he austerely forgoes. The more the capitalist foreswears his self-delight, devoting his labours instead to the fashioning of this zombie-like *alter ego*, the more second-hand fulfilments he is able to reap. Both capitalist and capital are images of the living dead, the one animate yet anaesthetized, the other inanimate yet active. (Eagleton, 1990, 200)

We can also locate this *alter ego*, this *Doppelgänger*, as a vampire. The energy of the vampire seems more aligned to the consumption of pleasures, a more fitting mirror; indeed it may be that the capitalist is more fittingly seen as the zombie, the puppet of the larger desiring machine. We can further indicate Marx's literary archive of Goethe and Shakespeare, and his imaginative grasping after the metaphysics of capitalism, of the conjuring trick which is money: 'everything which you are unable to do, your money can do for you: it can eat, drink, go dancing, go to the theatre, it can appropriate art, learning, historical curiosities, political power, it can travel, it is *capable* of doing all these things for you' (cited by Eagleton, 200). Marx's language of the phantom draws it into the realisation of desire in inverted

Andrew Lowe

form. 'Money, which is the external, universal *means* and *power* derived not from man as man and not from human society as society – to turn *imagination into reality* and *reality into mere imagination*, similarly turns *real human and natural powers* into totally abstract representations, and therefore *imperfections* and tormenting phantoms, just as it turns *real imperfections and phantoms* . . . into *real essential powers and abilities*' (Marx , 1981, 378). A magic mirror indeed – or perhaps a portrait.

Dorian Gray's 'choice' is to refuse the fate which Lord Henry outlines for him, as future bourgeois man: 'The pulse of joy that beats in us at twenty, becomes sluggish. Our limbs fail, our senses rot. We degenerate into hideous puppets, haunted by the memory of the passions of which we were too much afraid, and the exquisite temptations that we had not the courage to yield to' (Wilde, 1989, 65). The vampire articulates multiple nightmares of capitalism, of the genie-like mobility of capital, seemingly answering to whoever rubs the lamp, of the degeneration of the self into the 'hideous puppet' of the bourgeois capitalist, of invasion, not least by those marginal peoples associated with an earlier mode of existence, of peasants and feudal lords, whether in Transylvania or Ireland. Vampires combine the 'related categories of exhaustion, excess, the limit and transgression – the strange and unyielding form of those irrevocable moments which consume and consummate us' with the parody of the 'form of thought that considers man as worker and producer – that of European culture since the eighteenth century – where consumption was based on need, and need based itself exclusively on a model of hunger' (Foucault, 1977, p. 49). Parenthetically, we might recall that in his introduction to the essay on 'The Sexual Aberrations' Freud elaborates his ideas on sexual desire in terms of the libido, which he explains in terms of an analogy with 'hunger'.

Three. Soulless sex

The vampire, and the homosexual, emerge in the space of the gothic, of the literature of terror, which emerges as a 'twin' of Sade's 'impossible book'. For Foucault, the emergence of sexuality in our culture was an 'event' of multiple values. In part, it made possible and enforced the construction as a space from which to speak – in relation to the Law, it is a movement of, a language of, transgression. Between desire and need, the vampire incarnates the space *between* these models – and that it, too, becomes a space from which to speak is a legacy of the configuration of sexuality and the gothic genre. The gothic, the literature of the erotic, of transgression, Sade's 'obvious pastiche of all the philosophies of the eighteenth century' raises, like postmodernist discourses, the problem that 'On the day that sexuality began to speak and began to be spoken, language no longer served as a veil for the infinite; and in the thickness it acquired on that day we now experience finitude and being. In its dark domain, we now encounter the absence of God, our death, limits and their transgression' (Foucault, 1977, 51).

 This complex formulation indicates the impossibility of the self-presence of desires to identity. The in/human creature is no escape into the Disneyland of synchronic roles but an entry into the *inconnu*, the uncanny of the vulgar sublime; the fractured histories which assemble our fantasies and existences, the complex assemblages by which we conceptualize and enact ourselves. Rice's vampires declare their knowledge of their archives, from which they cannot be released. Wilde constructs for Gray a sublime library in which he finds himself reflected, and therefore being. Dorian Gray, like the vampire, has since his inception existed in the 'the space of language' which 'is today defined not by Rhetoric, but by the Library: by the ranging to infinity of fragmentary languages . . . within itself, it finds the possibility of its own division, of its own repetition, the power to create a vertical system of mirrors, self images, analogies' (Foucault, 1977, 67).

 It is thus entirely appropriate that the vampires constructed within Rice's novels are postmodern creatures, as desiring un/dead, and that the complexity of the vampires is such that, unable to be seen in mirrors, they are yet dispersed throughout the world, and into the heart, like the looking glass which the demons break in Andersen's 'The Snow Queen'.

 Language, in the literature of terror is a movement of desire in language, through the 'thinness and absolute seriousness of the story' (Foucault, 63). This opens a mode of language which 'permits' us to speak, to be spoken of as individuals, and sexual beings – to escape in some ways, that dominant mode in 'our stories' which retains the form of the confession, the injunction to save the soul – or at least to 'find oneself'. It is a literature which is always involved in 'the things recounted', yet always with an ironic doubling. It is

 the questioning of language by language in a circularity which the 'scandalous' violence of erotic literature, far from ending, displays from its first use of words. Sexuality is only decisive for our culture as spoken,

and to the degree it is spoken . . . In this sense, the appearance of sexuality as a fundamental problem marks the transformation of man as worker to a philosophy based on a being who speaks. (Foucault, 1977, 50)

The emergence of 'sexuality as a fundamental problem' is also, as Philippe Ariès has indicated, the moment of the macabre eroticism of the eighteenth century, where the 'confusion between death and pleasure is so total that the first does not stop the second, but on the contrary, heightens it. The dead body becomes . . . an object of desire' [Ariès, 373]. By the late eighteenth century, 'in the world of the imagination, death and violence have merged into desire' [Ariès, 375]. This is the time of the vampire and his/her companions – Polidori's *Vampyre* and Coleridge's *Christabel*. Thus the uncanny nature of the vampire as an incarnation of desire – transgressive and potentially infinite with desire as need, as hunger – both as all-consuming; death as marking the finitude of the self in the absence of God, juxtaposed with death, and the phantom, as erotic pleasure. Its image as masculine, but not Man, as feminine, but not Wife, renders the vampire a mirror image, produced for consumption, returning as consuming production – dwelling within the bourgeois *heimlich*, their children of the night – their phantoms springing through the vampire trap into the domestic space.

Yet this phantom 'Desire', itself emerging and dwelling in the interval between the living and the dead, reinforces the construction of the flesh while apparently paradoxically becoming inhuman, as it operates in excess of the body and its limits. As Blanchot writes.

Desire is [the] turning back when in the depth of night, when everything has disappeared, disappearance becomes the density of the shadow that makes flesh more present, and makes this presence more heavy and more strange, without name and without form; a presence one cannot then call either living or dead, but out of which everything equivocal about desire draws its truth. (Blanchot, 1993, 188)

Four. Effigies

I remembered it; it was a small picture, about a foot and a half high, and nearly square, without a frame; but it was so blackened with age that I could not make it out.

The artist now produced it, with evident pride. It was quite beautiful; it was startling; it seemed to live. It was the effigy of Carmilla!

'Carmilla, dear, here is an absolute miracle. Here you are, living, smiling, ready to speak in this picture. Isn't it beautiful, papa? And see, even the little mole on her throat.'

. . . I was more and more lost in wonder the more I looked at the picture.

'Will you let me hang this picture in my room, papa?'
(Le Fanu, 1993, 272)

Those who cannot, or do not want to, share in the construction of the Individual Man and Wife are then empowered to speak, but it is a gift which locates them in a particular position, with a particular essence, to reveal their 'truth' – their selves, their souls, their sex. The 'democratization' of the notion of the individual is combined with their construction as commodity, – in part labour, in part image. This doubling of the self is also a splitting. Ariès notes that

> The strong individual of the later Middle Ages could not be satisfied with the peaceful but passive conception of *requies*. He ceased to be the surviving but subdued *homo totus*. He split into two parts: a body that experienced pleasure or pain and an immortal soul that was released by death . . . the idea of an immortal soul, the seat of individuality . . . gradually spread from the eleventh to the seventeenth century, until eventually it gained almost universal acceptance. (Ariès, 1983, 606)

The origins of the portrait from the death mask and as coin, as currency, is to be revived with the enforced stillness of the subject by the technology of early photography. The photograph belongs, as Baudelaire noted, to the aesthetic of realism, and its illusion of 'every degree of exactitude'. Realizing that his wish has come true, Dorian Gray reflects that 'This portrait would be to him the most magical of mirrors. As it had revealed to him his own body, so it would reveal to him his own soul' (Wilde, 1989, 126). Thus, on the portrait is caricatured every sin, every thought, every desire. Photography had made the portrait available to all but the poorest, and indeed they too suffered the indignity of the camera through the growth of mechanisms of surveillance. As John Tagg convincingly argues, the portrait is

> a sign whose purpose is both the description of the individual and the inscription of social identity. But at the same time, it is also a commodity, . . . ownership of which confers status. . . . The history of photography is, above all, . . . a history of needs alternatively manufactured and satisfied by an unlimited flow of commodities; a model of capitalist growth in the nineteenth century. Nowhere is this more evident than in the rise of the photographic portrait. (Tagg, 1988, 36)

Both of these movements offer the democratization of 'the self' previously possessed only by the aristocratic/clerical/bourgeois classes. The 'double' emerges in this space created by the soul and the portrait, a ghostly self, located across cultural dislocation (cf. *William Wilson, Melmouth the Wanderer*). Photography too was used as evidence of another world, beyond the dissolution of the body, of the existence of the 'soul'. Functioning as a double self, the soul returns in corporeal, or at least representational form. If the (mortal) body is seen as endangering the (immortal) soul – the soul, that which can be known only by representation, comes to function as the preferred image. As sex comes to function as a major force for the (fictive) individuality of the self, it is in tension with, as it

re-places, the soul. Access to the self becomes a movement of possession, of representation, opening the gap between process and image; through the body as process and as imaged persona emerges one's sex. Sexuality, like the speech of the mystics, becomes the mode by which those who are not 'Man' are enabled to speak of their 'being', possessed, as it were, by a force beyond their control. Emerging then from the death of God into language, these phantom perverts, children of Judge Schreber, multiply, haunt the real, as they are conjured up by it. Expelled from the domestic space of Man and Wife, they are categorized, classified by the sexologists; the deviants breed prolifically, promiscuously, endlessly.

The legibility of the body was a commonplace of nineteenth century moral-scientific discourses. 'Sex', like 'race', existed as the deployment of a 'fictitious unity as a causal principle, an omnipresent meaning, a secret to be discovered everywhere: sex was thus able to function as a unique signifier and a universal signified' (Foucault, 1981, 154). With the 'new persecution of peripheral sexualities', photography was a crucial part of the apparatus which made possible 'a new *specification* of individuals' facilitating their classification. Thus

> the nineteenth century homosexual became a personage, a past, a case-history and a childhood, in addition to being a type of life, a life form, and a morphology . . . Nothing that went into his total composition was unaffected by his sexuality. It was everywhere present in him: at the root of all his actions because it was their insidious and indefinitely active principle; written immodestly on his face and body because it was a secret that always gave itself away. (Foucault, 43)

Process, body, and actions are manifestations of an essence, and the appearance of, the image of the self is constructed wholly by this essence. It is in part the refusal of this transparency, this legibility, that makes the parable of Dorian Gray so attractive, so uncanny. His sins, his acts, his desires, are inscribed not immodestly on his person but with parodic exactitude upon his portrait, effecting a displacement, allowing the body to exist as its ideal self-image, and undoing the practices of science and of realism. Auerbach points out the classificatory apparatus which van Helsing brings to bear upon the case study of Dracula, reducing him to silence and an easily administered death. 'The British 1890s were haunted not only by the undead, but by a monster of its own clinical making, the homosexual' (1995, 83). *The Picture of Dorian Gray* uses motifs from the discourses of the fantastic both to mirror 'reality' and to refuse, confuse that act of mirroring. This is not merely a tactic to refuse the labelling, the fixing, of the sexologists but simultaneously an inscription of the (ideal) self, as a commodity within the logic of consumer capitalism, of the society of the spectacle where people feel 'they are images and are made real by photographs' (Sontag, 1980, 161). *The Picture of Dorian Gray* is a parable both of the contradiction between 'image' and 'process' and of the refusing by the fixed image to be 'read' as 'pervert', or to enter into the maturity/ degeneration of full Victorian manhood.

Meanwhile his image/body permits ever more consumption, ever more desires. It is not the body of mythical 'biological' origins but the body poised between image and decay, seeing age as 'horrible and dreadful' (Wilde, 1989, 67).

There is a constellation of points which overlap and confound any simple entry into the complex construction of the self/portrait. Both the desired body ideal – and estranged from that as it is experienced as 'image' – becoming the self through that image; desiring process as the consumption of beauty, art, literature, and yet fearing, refusing process as the consumption of one's life. Dorian Gray becomes perhaps not so much his picture but his statue. It is uncanny in that it operates, not so much as reflection nor as (mis)-recognition, but as a double-in-time, a counterpart, which declares what one was, the transience of one's [mortal] being with no compensatory fantasy futures. The picture, the portrait, transfixes the subject as object while promising to 'mock . . . horribly'. Having exchanged the soul for the body image, the image becomes a *memento mori*. Thus, for Roland Barthes the portrait photograph combines this sense of becoming an object and death. Posing for the portrait,

> represents that very subtle moment when, to tell the truth, I am neither subject not object, but a subject who feels he is becoming an object; I then experience a micro-version of death (of parenthesis). I am truly becoming a spectre . . . when I discover myself in the product of this operation what I see is that I have become Total-Image, which is to say, Death in person. (Barthes, 1988, 14)

But it is also the moment of the realization of desire; in the triangular exchange between Basil Hallward the painter, Lord Henry the spectator/critic, and Dorian Gray the subject/object is a realization of decrepitude, of limitations, of mortality, but also of possibilities. Carmilla's already considerable charms are reinforced by the discovery of her image/effigy. We can further elaborate upon this dynamic by recalling the encounter of Don Juan with the Commander. On the one side, the desiring being of Don Juan, in whose Catalogue 'joyful desire recognizes itself in numbers, and in these recognizes what is stronger than eternity since eternity could no more exhaust desire than it could succeed in ending its count with a final figure . . . Don Juan is the man of the possible. His desire is a force, and all his relations are relations of power and possession; that is why this is a myth of modern times' (Blanchot, 1993, 188). Yet his desire is not that of conquest but of desire. 'He desires – that is all' (ibid.). It is a rapturous desire, desire as ardour, as a constant *being*. The Commander is beyond the 'extreme of the possible', beyond negation, 'the abyss of non-power, the icy, frozen excess of the *other* night. At the bottom of the myth there remains the enigma of the stone statue, which is not only death but something colder and more anonymous than Christian death: the impersonality of all relation, the outside itself' (190). He is 'desire's nocturnal face' (188). As statue, as image, he is beyond the 'lover of universal life, . . . the mirror as vast

as the crowd . . . [the] "I" with an insatiable appetite for the "non-I"'
(Baudelaire, 1986, 9).

Five. Terrible shadows and critical spirits

The debates on identity have, when not silencing the body, incorporated it
as an abstraction, have when considering desire, too often remained
unproblematically within a discourse of the political or the medical. Yet how
we experience our existences, our sex, our images, our selves is intimately
connected with the experience of our bodies and their limits, of how these
become thought, of how the 'inhuman' which is desire possesses us. 'A
heavy silence has fallen over the subject of death' noted Philippe Ariès,
asking 'If there is no more evil, what can we do about death?' (1983, 613).
It is here that we can rejoin the vampire Lestat in the vulgar and
postmodern sublime. 'Pure evil has no real place. And that means, doesn't
it, that *I* have no place. Except, perhaps, in the art that repudiates evil, the
vampire comics, the horror novels, the gothic tales – or in the roaring
chants of the rock star' (Rice, 1986). Different locations of 'evil' are
however all too easily made – and there is nothing then very new either with
the location of queer as evil or, as Jonathan Dollimore indicates in his
discussion of homophobic representations of Aids, in the association of
homosexuality and death: 'homoerotic desire is construed as death-driven,
death-desiring and death-dealing' (1995, 27). Reversing this figure, Linda
Ruth Williams has seen in vampirism as the 'realm of the undead, a liminal
space within which the subject . . . ceases to define itself according to the
either/or choices of the binary waking world' (Williams, 1995, 163) where
to speak as post-mortem is 'to counter the negatives of living by embracing
the positives of an unterritorialized zone' (172).
　　Vampires are creatures of the library, of a vast cultural archive of novels,
poems, plays, films, and visual images. They derive their energy from the
gothic, the literature of terror, the aesthetic of ruins, chasms, darkness,
dungeons, death. Dorian Gray's 'poisonous book' (we should of course
recall the *pharmarkon* here) was itself a dwelling within the library of
precious books – notably Poe and Baudelaire. This literature which merges
death with the erotic so effectively is also, as Adorno, amongst others, has
observed, a literature which in/formed the constructions of modernism, of
modernity. In this genealogy of vampires, death, desire and the image, the
zones of 'high' and 'low' are also transgressed. As 'Carmilla' and *Dracula*
indicate, the hybrid languages of science, medicine, technology, folklore
and Christianity made for a particularly dynamic ensemble of terms in the
late nineteenth century of evocation and repression, and arguably it is this
which renders them so potent a field for our postmodern vampires and their
companions. The *Chronicles* assemble these motifs within a logic of
consumer capitalism: perfect-body-image fired with an insatiable desire
tinged with melancholy, cruising their victims as much for the experience as
for a drink. Within the postmodern world of shopping arcades, of
subcultures, they function as figures of the past, drawing their energy, their

wealth, their life-blood from the present, dwelling within the apparent homogeneity of the present, shadows within and without the culture entitled 'the West', 'the Modern World'.

Within the library dwells Wilde's 'terrible shadow', which

> comes to us . . . with many gifts in its hands, gifts of strange temperaments and subtle susceptibilities, gifts of wild ardours and chill moods of indifference . . . and passions that war against themselves. And so, it is not our life that we lead, but the lives of the dead . . . the soul that dwells within us is no single spiritual entity, making us personal . . . and entering into us for our joy. It is something that has dwelt in fearful places, and in ancient sepulchres has made its abode. It is sick with many maladies, and has memories of curious sins . . . It fills us with impossible desires, and makes us follow what we know we cannot gain. (Wilde, 1989, 276)

The library is not only from whence monstrous desires emerge but also, or as a necessary corollary, the site where the 'critical spirit' develops, with which 'we shall be able to realize, not merely our own lives, but the collective life . . . and so to make ourselves absolutely modern, in the true meaning of the word modernity . . . To know anything about oneself, one must know all about others. There must be . . . no dead mode that one cannot make alive' (Wilde, 1989, 276). In this way Foucault's demands for a 'historical sense, free . . . from the demands of a suprahistorical history' may be as much represented by the vulgar sublime, the popular postmodern, as the earnest labourings of historians. The study of history makes one 'happy, unlike the metaphysicians, to possess in oneself not an immortal soul but many mortal ones' ('The Wanderer', cited by Foucault, 1977, 161). Foucault's celebration of Nietzsche's genealogy indicates the potential of this idea of 'modernity'. There now will be 'the identification of our faint individuality with the solid realities of the past, but our "unrealization" through the excessive choice of identities' (161). There we will realize that 'this rather weak identity which we attempt to support and unify under a mask is itself only a parody: it is plural; countless spirits dispute its possession; numerous systems intersect and compete' (Foucault, 1977, 161). For this perhaps is the most optimistic reading of the *Chronicles*, and the archives of the vampires: that it revives elements of these fragmentary languages by which we interpret our being and our finitude – as image – as process – and may make possible 'the life that has for its aim not *doing* but *being*, and not *being* merely, but *becoming* – that is what the critical spirit can give us' (Wilde, 1989, 277). It may be the transfiguration of the vampire into a figure celebrated by both Sting ('One of the most wonderful, erotic, sensual, books ever written') and *The Catholic Herald* that marks a movement into a celebration of Dorian Gray as a complex, multiform creature, rather than as 'a sparkling, agreeable surface masking a hidden depravity' (Dyer, 1988, 61). Perhaps through the vulgar sublime, through the echoes of the gothic, through the archives in which we exist as postmodern creatures, we can begin to consider the materiality of, the finitude of, the body as we also consider the body as image, as

simulacra, as mask – as the flesh which makes possible and refuses our desires, which sets a limit, which inserts us and defines us not merely within the social but within our physicality as creatures. Perhaps then we will move beyond the tyranny of the image as the mockery of process, the revealer of the soul, the inscription of the self, to a constellation of desiring figures who as phantoms of the library emerge through books, films, texts, and bodies. In the performance of the hybridity of our desires we will enquire how 'the body' can be 'out of place', celebrate how the languages of phantoms, of images, make possible a movement of transformation, of transmigration: 'Genealogy [as] history in the form of a concerted carnival' (Foucault, 1977, 161). For 'life and death are mysterious states, and we know little of the resources of either' (Le Fanu, 1993, 271). After all 'Girls are caterpillars when they live in the world, to be finally butterflies when the summer comes' (Le Fanu, 270).

Bibliography

Ariès, Philippe, (1983) *The Hour of Our Death* (Peregrine/Penguin, Harmondsworth).

Auerbach, Nina, (1995) *Our Vampires, Ourselves* (University of Chicago Press, Chicago).

Barthes, Roland, (1988) *Camera Lucida: Reflections on Photography*, trans. Richard Howard (Fontana, London).

Baudelaire, Charles, *The Painter of Modern Life and Other Essays*, (1986) trans. Jonathan Mayne (Da Capo Press, New York).

Blanchot, Maurice, (1993) *The Infinite Conversation*, trans. Susan Hanson (University of Minnesota Press. Minneapolis).

Bronfen, Elisabeth, (1992) *Over Her Dead Body: Death, Femininity and the Aesthetic* (Manchester University Press, Manchester).

Craft, Christopher, (1989) 'Kiss Me With Those Red Lips', in Elaine Showalter (ed.), *Speaking of Gender* (Routledge, London).

Dollimore, Jonathan, (1995) 'Sex and Death', *Textual Practice*, 9: 1 (spring).

Donald, James (ed.), (1989) *Fantasy and the Cinema* (British Film Institute, London).

Dyer, Richard, (1988) 'Children of the Night: Vampirism as Homosexuality, Homosexuality as Vampirism', in Susannah Radstone (ed.), *Sweet Dreams: Sexuality, Gender and Popular Fiction* (Lawrence and Wishart, London).

Eagleton, Terry, (1990) *The Ideology of the Aesthetic* (Basil Blackwell, Oxford).

Foucault, Michel, (1977) 'A Preface to Transgression' (pp. 29–52), 'Fantasia of the Library' (pp. 87–112), 'Nietzsche, Genealogy, History' (pp. 156–98), in *Language, Counter-memory, Practice: Selected Essays and Interviews*, ed. Donald Bouchard, trans. Donald Bouchard and Sherry Simon (Basil Blackwell, Oxford).

— *The History of Sexuality*, (1981) Vol. 1, trans. Robert Hurley (Penguin, Harmondsworth).

Frayling, Christopher, (1991) *Vampyre* (Faber, London).

Jackson, Rosemary, (1981) *Fantasy: The Literature of Subversion* (Methuen, London).

Le Fanu, Sheridan, (1993) *In a Glass Darkly*, (Oxford University Press, Oxford).

Marx, Karl, *Early Writings*, (1981) trans. Rodney Livingstone and Gregor Benton (Penguin, Harmondsworth).

Neale, Steve, (1989) 'Issues of Difference: *Alien* and *Bladerunner*', in James Donald, *Fantasy and the Cinema* (British Film Institute, London).

Rice, Anne, (1986) *Interview with the Vampire* (Futura/Macdonald, London).

—— *The Vampire Lestat* (1986) (Futura/Macdonald, London).

Sontag, Susan, (1980) *On Photography* (Penguin, Harmondsworth).

Tagg, John, (1988) *The Burden of Representation: Essays on Photography and Histories* (Macmillan, Basingstoke).

Wilde, Oscar, (1989) 'The Picture of Dorian Gray' (pp. 47–216) and 'The Critic as Artist' (pp. 241–98), in *Oscar Wilde*, ed. Isobel Muray (Oxford University Press, Oxford).

Williams, Linda Ruth, (1995) *Critical Desires: Psychoanalysis and the Literary Subject* (Edward Arnold, London).

Woodward, Kathleen, (1988/9) 'Youthfulness as Masquerade', *Discourse* 11: 1 (fall–winter).

Appetite

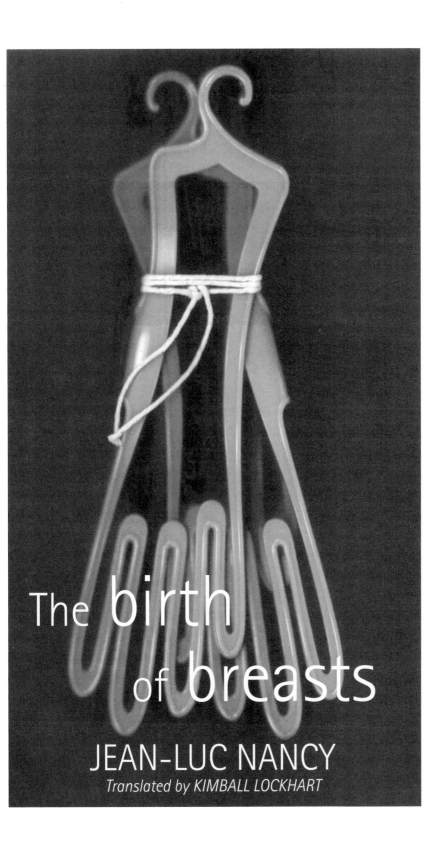

The birth
of breasts

JEAN-LUC NANCY
Translated by KIMBALL LOCKHART

Excerpt from *La Naissance des seins*. Unless otherwise noted, all translations of citations are by Kimball Lockhart.

At this moment, the softness of nudity (the birth of legs or breasts) touched the infinite. (Bataille, 1971a, 110)

Ah, that I were dark and obscure! How I would suck at the breasts of light! [. . .] Oh, it is only you, obscure, dark ones, [who] drink milk and comfort from the breasts of light! (Nietzsche, 1969, 129–30)

A never-ending elevation, dull but ready without hesitation, a swell, a gentle, supple tension all the way to its own end that does not stop it but brings it back up and suddenly draws it back in, which colours it and grounds it, which gathers it in and striates it meticulously to resolve its swell in the closed symmetrical replica of an outstretched open mouth, released to pronounce the word which lets go only from itself – the breast – like naked presence, outside and very far from all language, from the elevation itself in itself simply accomplished, appeased, with a slight and restless weight.
 – neither the cool roundness of the sphere of being, nor the insidious curve of the symbol, neither the one nor the other, but their parallel division, mutual and catalytic, the one and the other undoing the other, their reciprocal disagreement in their gracious alternation, together, futile and rhythmic of a double elevation, the one and the other a perpetual thing sent and movement – stirring that owes nothing to muscle – impeding the coming to an end, putting to end the reign of ends, always newly offering weight and its opposite, a résumé of elementary physics and the soul of the world,
 – neither grand heroic form, nor lyric gush, nor even more the circles and angles of the concept, but the need more pressing than ever finally to return language back to what it has touched upon, toward that which it has loosened far beyond all language, toward that which escapes it, to return hands toward what, to begin with, hollowed and filled their palms, lost their contours along the curves, vases, sketches of things,
 – not to return in the direction of a beginning nor suckle some nostalgia, but to the contrary to learn how it is, itself, the beginning, even more new, in advance, unknown, exposed, by a difference which is not that between words and things, nor that of one sex and the other, nor that of a nature and a technique, but rather indeed the difference by which each of these comes before the other indefinably, in turn, allowing no rest, creating a disturbance,
 (creating enigma and mystery, calling forth the divine hermaphrodite, Tiresias with women's breasts, with his knowledge, at the bottom of the belly – guess what)
 – forcing us again, differently, not to let reason seek rest, just as Kant did not let himself believe that to find it by taking credit to demonstrate and present the necessity in itself of being itself, or God, forcing us thus to carry on without him (without God, without Kant too) the elevation of reason toward a finish that will take it to term without speaking nonsense, both confident and self-mocking, a reason that does not explain itself, that does not give in,
 – that also does not exalt in this elevation, but comes back down just as well, that falls back not from a fall but of a quenching which remains without rest, that after all allows
 – a little joy in the breast of aridness.

I broach my subject without proving its importance. This is because it has no importance. At least it does not have the importance of a subject that would merit a discourse, in other words, a discourse worthy of an object. I do not here want to consider an object. I initiate a movement, I am an emotion, I let myself be led by the presentiment of a slow failure of writing, of thought – in other words by writing or by thought itself.

'I am an emotion': in French, the statement *Je suis une émotion* compels this ambiguity. I go forward following an emotion, pursue it, I lag behind, follow it in its wake – or rather ('me'?) is an emotion, is nothing but just that, *ipse* is the incandescent, vanishing point of a momentary disturbance.

> I felt like throwing up the first time I saw a woman's two completely naked breasts. (Flaubert, 1925, 121)

No treatise, then, no book on breasts. Some exist, I could cite them, I'll cite a few. I went through all of the bibliography it was possible for me to peruse. There are wise books and grotesque books, medical and voyeuristic ones, some gallant, others salacious. All is said, of course, and one either comes too late or too early.

> It is in no way different, in this house, for the room of breasts. By the crack, under the closed door, there is milk everywhere and from the keyhole comes an insipid, white odour which makes me sick to my stomach. Nothing can be heard in this room, where the silence of a nursery prevails. I know this soft and profound silence well, by the memory of times past. At the time I would have preferred that it last for ever. But today everything has changed terribly and this is why the room of breasts inspires in me nothing but despair. (Zürn, 1971, 184)

This would be, if you will, a pretext. This subject which is not one is a pretext to speak of something else. Of what: that, however, about which I have no idea. There is an allure, an attraction toward something which is in no way designated – and in no way designable either – a dangerous and necessary thing. Toward a tongue's limit, but a limit to be touched, a fragile skin. For this would not be like a pure absence. This would not be an inaccessible mystery, rather this would be, like any mystery, like mystery itself in general and absolutely, the very movement of its own revelation, that which reveals itself by itself and which has nothing other to reveal but this movement, this presentation or this offering of self. Pretext: that which is put up front, that which is woven in the front, the bordering of a fabric, lace, braid, straps or fringe – that which would border and would embroider a thin garment of self [*un mince vêtement de soi*],[1]

1 Translator's note: 'un mince vêtement de soi' puns on 'un mince vêtement de soie', a scanty garment of silk.

> The bulging of her breasts
> Under her tunic. (Bonnefoy, 1975, 24)

'Self' being, for its part, nothing but that: carried in front, preceding itself, a

presence that comes before any existence and which thwarts meaning and desire, the palpitations of being, the slippage of words outside of their matrix. 'Self' consisting precisely in the distance which separates self with itself, and in the return upon self which crosses the distance by running up against it irremediably, for the one preceded the other and the other knew nothing about it – blind bosom [*poitrine aveugle*], buttons closed, thus forward, upright station, opaque torches brandished in front of nothing. Exposed, put up front, put on view, behind storefront glass and for sale – *prostitutum* – and by this very fact *protectum*, protected by a breast-plate or a shield, of a pectoral, a bosom in front of the bosom, covering the core, that which shows the core of breath or of the heart, *ab imo pectore*, an extroverted autism.

Pretext, then, perhaps, for that for which any other book or treatise would have itself only been the pretext? The writer is always the most modest and the most immodest of men. But that itself, each – the modest and the immodest – is as such, without writing, inasmuch as the writer appears before others, in the simple ordinary coming into contact of the being-of-the-ones-with-the-others.

> But the agora is actually a little plaza. At Olynthus, for example, it occupies the space equivalent to eight *insulae*, and similar proportions are found at Miletus, at Pirene, in all of the most theoretical cities. The map thus speaks clearly and tells us of the importance of these places, but what is even more obvious, and what links the one to the other, is their anomalaic quality or, rather, of the event, in the space of the city. Now what in this way creates the event is not properly speaking a construction, a monument, but a void, a hollowing out of the urban fabric. Much more than a slot, a field freed in its heart [*sein*] and which, far from removing itself from it, tightens it, magnifies it and resolves it (Bailly, 1994).

How naked we are! But what is it that thus borders and carries our nudity in front of everyone and everything? What betrays (as one says) always and cease-lessly, the most secret judgements and outlines of our intimate diagrammatics, and which we do not even know? What is it that opens what to us is closed to us, like this scar between my breasts, underneath which I am told a heart has been grafted?

Before forming an image, 'the birth of breasts' should describe or indicate nothing other: a reserve, a withholding that carries the possibility, and perhaps the necessity, of a withdrawal, of an abstention, the withholding that makes the venture [*la lancée*] possible.

How to speak without speaking of any object? How to pass from the side of the thing – there where it always comes before us, always already there, carried up front – how to pass from its side and to its side, in order to espouse its movement, the exact mode of its presence, not its representation? How to pass, consequently, with language [*la langue*] as far as the thing itself, how to touch it, hold it, feel it, weigh it, and preserve it so as to give it to itself, so as to leave it, the thing, itself finally nude – but a nudity which is identical to its saying [*dire*]?

There is nothing other at work in what takes the various names such as 'literature', 'poetry', 'song', and even, simply, 'language', if we could only stop there: very simply the double genitive of an expression such as this one: 'the saying of the thing'. And this is why behind all books there is the hidden book, the intimate excrete [*excrit*] that demands its due, a deaf, profound utterance that rises from nudity itself, and as nudity. The book is the only possibility of books, of their delivery. The book that we would save out of all other books, from their disarray splattered with significations, that would do justice and thanks to the exasperation at one point deep in the bowels, or in the head, the very point of the joint and of the rupture, the soul/body split, the pineal gland in an unsupportable state of alertness [*intimation*] and intimidation. Me at the height of nerves. The (at least) double meaning of the word 'breast' [*sein* in French: 'breast' and 'core' but also 'heart' (Tr.)], takes nourishment from this torsion, which it excites and in turn chafes: from the deepest place, from the heart, from the loins or from the womb, to the most superficial, to the double gallant escutcheon through which milk can still flow. A double mystery of a rise and of an exposition of the thing itself (nothing less, if one thinks about it, than the proper hysteria of the thing), the coming of the ground and of the origin, produced on the surface and as surface, as an exorbitant elevation of the human body erected upright and there, even further beyond, erected in front of it, a sensible and visible precedence of this soul/body division which is nothing other, finally, but the rising forth or the start [*tressaillement*] of language. No mystery, as well, but a laughable, touching, futile agitation.

Presentation itself – its failure.

The tiger approaches the two martyrs. It rears up and, sinking its claws into the flanks of the son of Lasthentes, its teeth tear up the shoulders of the intrepid confessor. As Cymodocia, still pressed to the breast of her husband, opened to him eyes full of love and terror, she glimpses the bleeding head of the tiger next to the head of Eudora. (Chateaubriand, *Les Martyrs*, XXIV (Paris, 1810)).

The rhythm of being – and even more, being itself as rhythm. The meaning of being, as they say. Lifting, palpitations, beat, relapse, cadence. Resistance, abandon. Birth, separation of the two sides of a united body gently split in two. Areality: that which is neither thing, person, subject, object, but between two –
– even identification, and like the eye without vision of a sameness that positions itself different, indefinably different – a substance not substantial, a desire without lack, a tension of a nude nature toward even more nudity but toward no secret, by no transgression. Budding or long withered, young or old, swollen or flabby, this nudity is the same: always at the conjunction:

There is nothing I do not dream
There is nothing I do not cry
further than the tears death
higher than the ground of the sky
in the space of your breasts.
(Bataille, 1971b, 88)

And I have seen the human phallus, the heart of Cecilia beating between
her breasts,
 in this bone rack slot,
 where the soul to be confirmed smells of a dead woman.
 (Artaud, 1978, 19)

 – because it is necessary that there be disjunction, and separation, but not
because there would be incompletion, nor lack, or finitude, as they say, but because
nothing is valuable alone, simply.
 Why is it so difficult to be heard? Even more difficult than the bitterness and
melancholy of the being-alone, who, says nothing other, perhaps?
 You never know where nor when knowledge . . .
 All elegance is of . . .

The look – (the discourse) – the contact of hands – the kiss – the contact
of breasts – the grip of sexual parts – the embrace – such are the scales of the
ladder – upon which the soul climbs – to this scale is opposed that
upon which the body climbs – all the way to the embrace. Feel – smell – possess.
(Novalis, 1966, 236)

 – still the conjunction between the other and the same, still this disturbance of
identity stronger than the identical, since one has in fact to be a little to the side of
self to be to the self, always next to, never there, neither other, nor same.
 The destabilization of a time immemorial immobility, that of the bust or the
hieratic torso, of sculpture that is the monument and the ruins of origin, arms
crossed back over the impassive, marbled bosom of a divinity without a face and
even without abyss, without breath, without emotion. The stirring in place of almost
nothing.

I was a high wall.
my breasts were like towers,
and thus I was in this light
like those who have found peace.
(Pound, *The Cantos*, 8: 10)

 Birth, upheaval, inclination, slope: identification with nothing other than the
unidentifiable, with a shaking that spreads and which gains ground, and which
feeds off itself. One cannot distinguish between a joy and a pain, between an accent
and an other. It comes, and loses itself, passion, compassion – equivocal for the one
and the other.
 This is how one touches on truth: by turning away from it to observe its silence,
its breath and its birth. There is truth, since I am not alone and since it moves next
to me, in front of me.

Passion to know, compassion for non-knowledge. Pushed simultaneously toward
contact and toward the intact. Excitement by what escapes an organic body and by

what is incorporated by the body nearby, always nearby. The newness of each inflection, of each joint, the unforeseeable lifting of a cheek, of a hip, a palm or neck. The unknown toward which this rises and moves.

Thought is attained by rising, swelling [*le soulèvement*] as such, and without appeasement – for as such it is nowhere alike to itself, never as such. The agitation of thought, its unbearable susceptibility to being itself and to truth, to birth, death, and contact, comes from thought's profound taste for emotion that causes it to be born and for which nothing is more important than to intermingle in a single, subtle, and divisible trace.

This presents itself here in such a way that, as soon as that which appeared first as the object falls away for consciousness on the level of a knowledge of the latter, and that the in-itself becomes: a being-for consciousness of it, in-itself; this, then, is that very thing which is the new object, in the company of which a new figure of consciousness arrives upon the scene – for which essence is another thing than what was the essence for the anterior figure. It is this factor that guides the entire series of figures of consciousness in their necessity. Only this necessity itself, or the birth of a new object which presents to consciousness without the latter knowing what is happening to it, is what for us happens so to speak on its back. In this way in its movement there occurs a moment of being in self, or for us, which does not present itself for consciousness, which is busy having the experience in question; but the content of what is born for us is for consciousness [in French: *elle (la conscience)*: 'her'], and we conceive only of the formal dimension, of pure birth: for 'her', what is thus born, is just like an object; for us, it is at once a question of a movement and of a becoming.[2]

2 Hegel, *Phénoménologie de l'esprit*, trans. Jean-Pierre Lefebre (Aubier, Paris, 1991, 90). [Tr.: I have decided to translate directly from the French translation to acknowledge that the author cites this passage as much for the specificity of its language *in translation* as for its concepts.]

The difficulty is overwhelming, because the identity of the becoming, which it is a question of touching by an apprehension that follows the contour in movement of the thing itself, has no other presence than that of the curve which precedes itself infinitely according to the advance of a leaving of self – in other words, of nothing. This is why consciousness sees nothing there and guesses nothing, thus embracing the very movement that gets around it and passes it.

Yvonne was sitting up half reading her magazine, her nightgown slightly pulled aside showing where her warm tan faded into the white skin of her breast, her arms outside the covers and one hand turned downward from the wrist hanging over the edge of the bed listlessly: as he approached she turned this hand palm upward in an involuntary movement, of irritation perhaps, but it was like an unconscious gesture of appeal: it was more: it seemed to epitomize, suddenly, all the old supplication, the whole queer secret dumbshow of incommunicable tenderness and loyalties and eternal hopes of their marriage. (Lowry, 1965, 87)

But what happens so to speak on the back of consciousness – 'so to speak', since consciousness has no back, has no thickness, it is itself only its point extended in contact with experience – this itself is for us before us: in front of us, coming to our encounter and at the same time preceding us, we who are not consciousness, but thought itself, which is to say the redeployment of being in the swelling of birth, the recovery in self of its whole outside – this birth which consequently is not, or is not born, except for us, not however according to a relation or an intentionality, but to

us ourselves and how this 'us', to our rhythm which is the rhythm of birth itself and is nothing but birth, infinitely, to rise infinitesimally before us, us before ourselves like a heart-rending softness opening incomprehensibly our night to even more night, opening the universe to its own curvature everywhere folded back and everywhere reopened, traversed in all directions by thin webbed veins and long trails of galaxies.

The point of view of thought is the blind clairvoyance from which tears flow, and the laugh, at the heart [*sein*: 'breast'] of this immense outside.

> Even though night might fall and the carriage travel quickly, in the country, in a town, there is not a feminine torso, mutilated like an antique sculpture by the speed we maintain or the sunset that darkens it, that does not pull from our heart, from each corner of the street, from the back of every shop, arrows [*flèches*] of Beauty, of Beauty of which one would sometimes be tempted to wonder if there is in this world anything but the complimentary part that to a fragmentary and fugitive passer-by is added our imagination overexcited by regret. (Proust, 1954, 713)

> This notion of calm comes from him. Without him I would not have it. Now I'll wipe out everything but the flowers. No more rain. No more mounds. Nothing but the two of us dragging through the flowers. Enough my old breasts feel his old hand. (Beckett, 1974, 60)

> But The Egyptian, her breast bare, her joints stiffened
> from fatigue, is seated in the forest, near the fire,
> Singing unceasingly. (Hölderlin, 1967, 800)

Note

The breast image is from the private art collection of sue golding.

References

Artaud, Antonin, (1978) 'Suppôts et supplications', *Oeuvres complètes*, vol. XIV (Gallimard, Paris).

Bailly, Jean-Christophe, (1994) *Théâtre et agora*, Cerisy Colloquium on 'public space'.

Bataille, Georges, (1971a) *L'Impossible*, *Oeuvres complètes*, vol. III (Gallimard, Paris).

Bataille, Georges, (1971b) 'L'Archangélique', *Oeuvres complètes*, vol. III (Gallimard, Paris).

Beckett, Samuel, (1974) 'Enough', *First Love and Other Shorts* (Grove Press, New York).

Bonnefoy, Yves (1975) *Dans le leurre du seuil* (Mercure de France, Paris).

Flaubert, Gustave, (1925) *Mémoires d'un fou*, *Premières oeuvres*, vol. II (Paris).

Hölderlin, (1967) *Oeuvres* (Gallimard, Paris).

Lowry, Malcolm, (1965) *Under the Volcano* (Random House, New York).

Nietzsche, Friedrich, (1969) *Thus Spoke Zarathustra*, part 2, 'The Night Song', trans. R. J. Hollingdale (Penguin, New York).

Novalis, (1966) *L'Encyclopédie*, trans. M. de Gandillac (Minuit, Paris).

Pound, Ezra, (1955) *The Cantos* (Faber & Faber, London, 1964).

Proust, Marcel, (1954) *A l'ombre des jeunes filles en fleurs, A la recherche du temps perdu*, vol. I (Gallimard, Paris).

Zürn, Unica, (1971) *L'Homme-Jasmin* (Gallimard, Paris).

Slavery/sublimity
ADRIAN RIFKIN

One of my problems is the banal nature of quality, the high-serious quality of reflections upon matters of sex and ethics. It's all too difficult to escape from the shadow of Genet's trivially ecstatic treacheries in *Funeral Rites*, Sade's exquisite grammar in any of his writings, or Liliana Cavani's elegant framings of desire's disjunctions in *The Night Porter* (1974); acting them out once again risks being even less than banal; perhaps just naughty, or, even worse, theoretically correct. Nor for that matter is there any shortage of academic discussion on the legitimacy of all these cathexes that cut across the boundaries of political acceptability on the one hand and the need for what we loosely call 'love' on the other, though sex and love are all too rarely named as such. What follows is inescapably a repetition of what has come before, but, I hope, in a fresh order, or maybe just a fresh disorder and perhaps without too much concern for legitimacy or its sinister twin, legitimation. It proceeds by quotation, invention, conjunction and commentary.

source 1

Léonore, separated from her lover Sainville, is more than twenty times attacked, and finds herself more than twenty times in the most critical situations for her virtue, without ever giving it up, her lover who is separated from her and who seeks her, finds her three times without recognising her, and himself gives her up three times to those who are hunting her, without that the unfolding of the situations, artistically if naturally arranged, allows Sainville to act otherwise, and without that Léonore much more reduced by these conjunctures, all the less finds the means to escape from the imminent perils that surround her. (Sade, *Aline et Valcour*, 1198)

Sade's need to outline his longest text in one sentence unexpectedly offers us an extraordinary erotic of the subclause as the vector for a cruel deferral of conventional sublimation as the very substance of entertainment. Stripped of the apparatus of Enlightenment ethnography that characterizes this novel, and its intricate comparison of societies and civilizations, it is as if Sade had already overtaken Adorno's and Horkheimer's critiques of Enlightenment, at the same time showing how narrative itself might reduce complexity to a simple system of equivalences. A system in which Léonore escapes with her virtue, or, rather, on account of which her pleasure escapes her. In *The Night Porter*, in the long scene where the lovers sense one another's presence in the Vienna Opera to the performance of Mozart's *Magic Flute*, Cavani allows a glimpse of a desublimation through the rite of passage that leads from Enlightenment Masonic fantasies to the Holocaust as a wound that might be imagined healed only through a sexual acting-out. Léonore could yet be saved from loss and for desire.

'I want to be your slave'. The voice was hoarse with desire, just as you might expect in a pornographic story. Neither too heavy nor light toned, its richness cut by the breathless sigh, a slight Berlin accent in his English. David was struck by this, by the man's ability to be so direct in another language, immediate in his response to the question that had just been put to him.

'What do you want?', he had asked, 'what do you want?'.

source 2

Had the man replied 'I want to be free', it would have made no sense at all.

David pulled out of his absorption and asked himself what the question had really meant to do, what kind of an answer he had indeed required to hear. It had seemed natural enough that he should have put it. For the play had reached a turning point or perhaps an impasse; the impasse of strangers who have begun to confide their body to each other, wordless, but have not yet matched, and perhaps never will quite match such highly coded desire with the involuntary movements of their flesh.

For, after all, their actions derange and unsettle the Freudian theory of the fetish. Rather than a disavowal or imaginary replacement, the elaboration of this acting-out of fetish is the site for a subtle yet dramatic unfettering of cognition.

Around them the spaces of the club are wrapped with sounds and filled with lights, the dance-floor techno muted in this distant corner of the concrete bunker, beating off the attracting shield of leather, tongueing latex and lashing round tattoos.

The guy is crouching at David's feet, slightly askew against the sweating wall, his head swung round against his torso's twist, and looking up. He is neatly trussed, not to immobilise him, but to ensure that each and every movement reminds him of the purpose of his bondage, which is the character and construction of his pleasure. Rawhides spider geometrically across his body, held by knots and clamps, linked to his hands, and his hands to each other, so that each response to one of David's machinations pulls his balance out with sharp and transient pains, a gradual crescendo of isolated elements into an abstract, formal map of the desiring body, at once immanent and within. Now they have been together more than an hour, and up to now the scene has been going well. But now it has reached its limits for the place, for the dark; it needs a fresh turn, or perhaps more space, regular lighting, clarity. A change.

In an ordinary pornographic story, they would find the quickest path to *jouissance*.

David admires the man, his motions, the way he folds into a pain, taking control of it, amplifying it without recoil or hesitation. But it is David now who hesitates; his concentration slips; the reply is not what he expected, and has caught him off his guard. It should have been something more local, the expression of a parochially specific preference to enable a new stage in their play. Indeed, as a prompt, he had indicatively slipped the man's belt free of its loops, and even now still runs it between his fingers.

But then the man said: 'I want to be your slave'.

David has been a fool, he's betrayed the master's discourse. In this secretly most intellectual of encounters, he has let up on the fiction of elemental passion guided by unflinching reason, broken the subclausal chain.

What passes through his mind, and makes his attention drift so completely, is a reversal of the image that the two of them are making in their shadow-play. Here it is the man, above medium height, Germanic without caricature, who is standing, booted in his leather, feet apart in a classic posture of dominance (the fantasy is quite detailed, slightly differing from the real man); his fists are stretched down, halfway between a disco gesture and a menace, between succour and repression; and before and beneath these fists there kneels another man. This figure is evidently Jewish, at the refined end of the stereotype, some ten years older than his companion. From his mouth comes a misshapen bubble in which these same words have hastily been scrawled:
'I want to be your slave.'
A little dazed by this unexpected, yet far from uncanny figuration, David now tries to think his way free from it.

I suspect that something along these lines, perhaps, passes through his mind, moves his lips slightly, like someone half-literate reading aloud under his breath: 'I need to run this without Deleuze, the humanist paradigm just won't do, neither the manipulative pleasure of the masochist nor theory of victim complicity. I need to run it without the help of Bettelheim or Theweleit.' Possibly David is frightened by his own desire, his unabashed virtuosity hatching symptoms of the endless passage of repression and its returns.

David wrenches himself from the fantasy of inversion, which already, in its single replication, threatens to universalise this wish. He looks down at the man, who seems far, far away. 'Let's go for a drink', he whispers. He stoops and deftly frees the other, raising him and at the same time asking him his name. Threading through the beat of sounds and bodies, they make their way to the bar. In a simple gesture of welcome to the city, the man buys the beer, and then they talk.

David's dilemma, his dilemma of intensity and distraction, strikes me as having a special pathos. This is not to say that I have any pity for him. On the contrary, I emphatically regret that the young German was not to get his way, and reproach David that he left him soon after they had returned to one of the cage-areas where they had first cruised one another; angry too that he has thus deprived me of another glimpse of the city's byways that he could have shared with me. No, rather it is that I feel a certain sense of despair that their plight might not get the exegetics it deserves, simply because it happened in a nightclub, solely because it overtook them at the level of the pornographic. At the same time I have come to believe that this dialogue, generically that is to say, offers one of the only possible exorcisms of the Holocaust. To write about its deferral of the indentification in self and other, to rescue and to cherish their aporia, I have two choices.
One is to reach for a theory of power and sexual identity. You will imagine the scenario; deposits of the socially and historically evolved forces of domination and shame manifesting themselves in the deepest structures of individual gesture and enunciation; gay subversion at play with performative sexuality in a non-resolvable

conflict with individual and collective fascism – see and rerun Leo Bersani's critique of Judith Butler in his *Homos* (1995) for the latest version of this one. And perhaps a discussion of *The Night Porter*, skilfully referenced to Califia's and Rubin's long-past defence of S/M in the pages of *Body Politic*. I'm not happy with this if only because it repeats the problem as a problem and not as an opening. 'Yes, it is a nazification of the personal . . . ' versus 'No, it's not, it's an acting out as finally harmless of the politically dangerous . . . ' and so on.

The other is to seek a tracing of the borderlines, the interferences of experience and representation, precisely in the pornographic, in its quest for a sublime transcendence of these two men's predicament. That is to say, I must refuse theory's offer of a safe sublimation for another fantasy, that of the desublimated moment that the best porn alone has the freedom to envisage. A borderline, for example, where the lovers in an adventure story cross from the safety of their dungeon to the 'real world' of villains, and experience the dissolution of their expectations of pleasure, of its politics and limits. For me this is to envisage the breaking of a law not so much as the subversion of the social as the refusal of our theoretical currency itself. For can we not argue that it is the pornographic imagination that wills the distinction between the possible and the permissible to break down, and that even as the story might be quite 'literal' this occurs at the level of theory, at the level of an abstraction that reconciles the elements of a contradiction under the auspices of an ethical longing?

But here, for just a moment, let us imagine another scene in a similar space.

There is a large St Andrew's Cross fixed against a brick wall, and, with his back to us, a man is fastened to it with ankle and wrist restraints. His leather is a ripple of highlights in the shadows, shifting as the heavy belt-blows fall across him. His master who, from David's odd perspective, appears below him and the cross, and so as if in fact a servitor, unleashes a closing salvo, then soothes the man, relaxing him into the restraints, which he carefully detaches from the iron rings. One weary arm falls in a diagonal, slow sweep, rising to crook backwards around the master's head, pulling it to nuzzle at his nape as the master, in turn, reaches ungainly up and over to release the other arm. The flagellant's second hand falls to his crotch, he folds back against the other's chest, into his arms, concave, not quite enraptured.

source 3

It's a special expression of contentment, one of those moments that confuses the order and expectations of the story's outcome. A queer combination of the deposition and the flagellation, an earthly mingling of the flagellator and the mother, the lover and the son.

David thinks that this is a sort of mental amniosis, this unique, polymorphous flow of energies in a low blue-green light, and that it also has very little to do with a sentimental or maudlin humanism of the genre 'even they', or even 'especially they' are attentive to each other's needs.

No. It's as if the humanist tropes which might be used to speak the scene, to excuse it, are undone. Vaguely they point, but they fail to name or offer a connotation that doesn't underline their own inadequacy. As a social relation it's both terribly practical and at the same time inventive. Inventing from moment to

moment its own ethical balance between two others, whose subject is sovereign on the terrain of sameness. Its outcome is unpredictable and subject to an excess of witness in the collective space of the bar. Its witness strips of the right to a narrowly individual satisfaction, to a singular interpretation.

source 1

Stop, he said to me, I'll forgive the disgust due your manners and national prejudices; but it's too much to give yourself up to them; give up making a difficulty of things here, and know how to adapt yourself to situations; repugnances, my friend, are nothing but weaknesses, little sicknesses of the organisation, whose cure has not been worked on in youth, and which master us when we yield to them. In this respect it is absolutely as it is with many other things; seduced by prejudice, the imagination first suggests refusal . . . one tries . . . one finds it good, and the taste sometimes decides itself with a violence that is all the greater the stronger estrangement had been in us. I arrived here like you, mad with stupid, national ideas; I blamed all . . . I found everything absurd; the practices of these people alarmed me as much as their customs, and now I do everything as they do. (Sade, *Aline et Valcour*, 561)

Sade's narrator has adapted to a moral climate that puts all judgement in question. Yet the responsibility of judgement is thereby heightened, and, in the frame of the Enlightenment, the subtlety of Kant is revealed as this sublime space between the absolute and the absolutely contingent. Yet the worst of all possible eventualities would be that you all learn to act like those two men, or like David and his German trick, as a substitute for dealing with your own contingency.

source 2

Back home for the summer, David is at the annual festival, and is chatting with his friends outside a marquee. The usual mix, the informal, ageless grouping of his scene, refined by leather. Another German, younger than the Berliner, charming if a little cool and detached, sips a cola. David knows of his reputation as a master, and admires the manifest elegance of his judgement. He panics. How can he know it, other than as an other to himself?

I'm sure that one reason for his panic is tied up with his residual allegiance to religion. A Jew may prostrate himself, but must never kneel.

His panic seizes him as if desire. He faces the young man, half raises his hands, flapping, and then drops to his knees, controlling the hands that he folds behind his waist; his head inclined. No words are needed, his posture speaks them, 'I want to be your slave.' In what must look like a gesture of benediction the young man gently adjusts the incline of David's neck.

This is a beginning, of being other. Yet there is no need for panic.
However elevated the moment, it's nothing more than a subclause, and, indeed, no less.

source 4

Les *tortures* sont différentes, suivant les différentes pays; on la donne avec de l'eau, ou avec le fer, ou avec la roue, avec des coins, avec des brodequins, avec du feu etc. (Diderot and d'Alembert, *L'Encyclopédie*, Neufchâtel, 1765)

Readings

Bersani, Leo, (1995) *Homos* (Harvard University Press, Cambridge, Mass. and London). See especially chapter 3, 'The Gay Daddy', for the refutation of Foucault's position on S/M and hence of my romantic utopics.

du Bois, Page, (1991) *Torture and Truth* (Routledge, London).

Preston, John, (1987) *The Love of a Master* (Alyson Publications, Boston).

— *The Arena* (1993) (Badboy, New York).

Sade, Marquis de, (1990) *Oeuvres* 1, édition établie par Michel Delon (NRF Gallimard, Paris). The epistolary novel of 1795, *Aline et Valcour*, pp. 387–1109. The first citation is from the editor's documentation of the novel and is drawn from a description made by Sade in 1788. The second is from the body of the novel.

Townsend, Larry, (1993) *Run no More* (Badboy, New York).

07/02/96 13:04 ☎416 978 5566 U of T POL SCI ☒001

Department of Political Science University of Toronto

100 St. George Street Toronto Canada M5S 1A1 Telephone 416/978-3343 F x 416/978-5566

FACSIMILE TRANSFER COVER SHEET

TO: DR. S. GOLDING	FAX#: 011·441·71·4342941 Press #. 8 or *
LOCATION: London	# OF PAGES: #23 (INCLUDING THIS PAGE)
FROM: G. HOROWITZ Toronto	Tel: (416) 978- 5566

DATE: July 2 '96 **TIME:**

REFERENCE: _____

MESSAGE:

The Syllabus is the Message.

ACKNOWLEDGEMENT REQUIRED: YES (✓) NO ()

(For office use only:

Please see over for billing information.)

UNIVERSITY OF TORONTO
DEPARTMENT OF POLITICAL SCIENCE

POL 427Y THE SPIRIT OF DEMOCRATIC CITIZENSHIP

COURSE SYLLABUS 1996–97

Introduction and overview: Toward a democratic quantum leap

PART ONE: No One Truth. Language and Reality.

1. The map is not the territory – and all we have are maps. The general-semantics movement.

2. Levels of abstraction in the construction of reality. Korzybski's "structural differential" (a map of the mapping process).

3. Critique of the 'is' of identity and the 'is' of predication. E´ (E-Prime: English without the verb 'to be').

4. "Consciousness of abstraction" and practise at the silent levels.

5. The inherent circularity of human knowledge.

6. The devices of general semantics.

7. The metamodel (another model of the modelling process).

8. Case study: "racism" or "rational bias"?

9. Multiordinality and paradox.

PART TWO: Evoking the Others. Non Violence. Deep Democracy.

1. What is "self" and "other"? How the self emerges out of relationships.

2. The self as self-fulfilling prophecy.

3. Experiencing multiple perspectives: evoking the other.

4. "Justify my hate": the projection of evil: the face of the enemy.

5. Gandhi's Satyagraha. Nonviolence: Listenting to All.

PART THREE: The Spirit of Equality. Resisting Internalized Oppression.

1. The spirit of inequality: the discourse of individualism; "fair play" versus fair shares.

2. Critique of "self-esteem"; stepping out of worthlessness; transcending self-rating.

3. How oppressive self-rating depends on confusion of multiordinal levels of 'self' and 'worth'.

4. Is a person with less – less of a person?

5. Radical democratic critique of the individual therapy of worthlessness.

6. Mapping "individual" problems in social space.

READINGS:

Part One: A. Korzybski, *Selections from Science and Sanity*, General Semantics Readings.

Part Two: E. Sagan, *The Honey and the Hemlock: Democracy and Paranoia in Ancient Greece and Modern America.*

M. Snyder, "On the Self Perpetuating Nature of Social Stereotypes."

Z.D. Gurevich, "The Power of Not Understanding: The Meeting of Conflicting Identities."

C. Becker et al, "Fostering Dialogue on Abortion: A Report from the Public Conversations Project."

Part Three: W. Ryan, *Equality*.

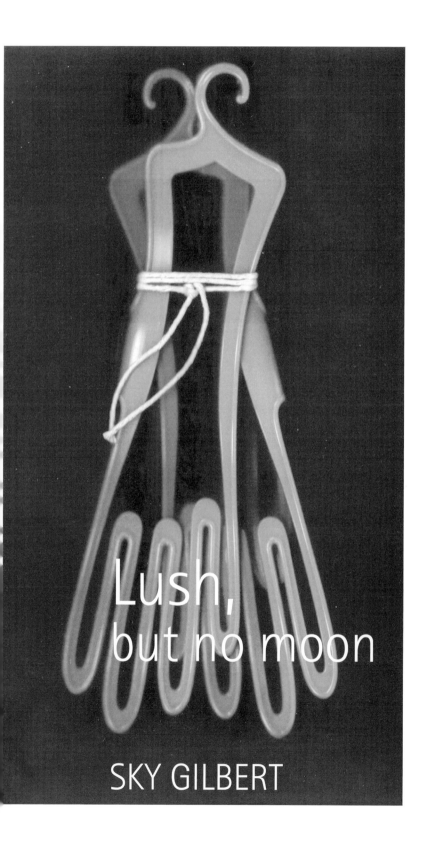

1. Okay, let's get this cleared up right away. His name. Okay I'll just say it. I'm as ashamed of his name as I am of having lived in Buffalo at one time – another B-word. Okay it's Brent. Yes Brent. Let's face it, if it's 1995 and you're sleeping with someone in their early twenties they are going to be called the B-word; Brent, or Bartley or Brandon. It's very difficult to get poetic and effusive about somebody named Brent. So let's just get this whole Brent thing out of the way now. Okay, everyone say it with me, and if there's any laughter we'll have to say it again: Brent.

2. So I walk into this bar in Key West called Bourbon Street, the name is an excuse to have Mardi Gras parties at the slightest provocation. There's Brent sitting on a bar stool. And he keeps looking at me. And I keep looking at him. And so we pick each other up. More detail.

3. He's got short spiked hair. He looks like your average beautiful teenager, dark, with bright eyes. You look at him and think; he'll be hard. Everywhere. You just know it. Some boys you just look at them and know. They're hard. And his T-shirt said LUSH.

4. So he comes over and asks me for a light and of course I know this is a come-on and I ask him about his T-shirt and it's here the generation gap begins. LUSH is a band, he looks at me incredulously. Well of course I should know it's a band but I'm forty-three years old and the last three CDs I bought were musicals by Kander and Ebb and Chita Rivera was in two of them but of course I'm not going to tell him that. I'm going to try and bluff it so I do. LUSH, hmm I've never heard of them, what kind of music do they play, anyway – which is a dangerous thing to say but I really want this kid and he rhymes off three other bands I don't know and finally mentions the Red Hot Chili Peppers (you don't have to be hip to know them every old faggot knows them because they've been around for eons and they perform with socks on their cocks) and so I get all political about The Red Hot Chili Peppers because it's one of the only things I know how to be, political, and I say gee when is Flea going to come out of the closet anyway, and he says oh he has, he's said he's bisexual. Well I'm not going to argue the point, for me saying you're bisexual doesn't actually constitute coming out, but that just shows how old-fashioned I am and I'd better not say it cause it's contentious so I don't. Thank the LORD I've actually heard of one of the bands he knows. So now we can get off the bands and it doesn't matter anyway 'cause as far as I'm concerned Lush isn't the name of a fucking band it's his name. I never liked Brent anyway and lookit him just lookit he's so LUSH.

5. So we talk about this and that who knows what I came up with to entertain him and he says let's go sit with my friend and I think oh here comes the dumpster this is the dumpster line I'm going to end up in the scrap heap with all the arthritic whining there's too much ice in my drink and I'd like a table near the window please, honey ancient homosexuals. But no, he actually wants to get rid of his friend and he goes with him off to the 801 and I sit and wait.

6. Oh God it's endless. I am this close, this close to having LUSH but of course he could get away still he could disappear into the piano stylings of the 801's never ending cocktail hour and never return. And so I think I'll just finish this drink and if

he doesn't turn up, I'll go to the video store and wank off with some sexy stranger from Kalamazoo. But I'm pretty certain he'll come back. And I'll tell you why.

7. It's this weird thing. He was listening to everything I said and I was talking a lot, but he wasn't really interested. And as I watched him, not listening to me, I thought about all the times I'd sat with people and not really listened to them, but pretended I was. And the reason I did it was because I simply desperately wanted to fuck them and it didn't matter what they said. And I couldn't believe this kid, this beautiful American boy in a LUSH T-shirt was so fucking horny for me that he could not listen to me for so long, with such intensity.

8. Yea, he comes back. And then I touch his knee and say hey, if you sit this close to me any longer I've just got to kiss you and I do. This does not seem to bother him. I'm going crazy so next I try so do you want to go back to your place or my place or, and he had told me he lives around the corner and he knows I'm staying in a gay guesthouse called the Lighthouse Court which is kinda like a bathhouse. So he says, do you want to go skinny dipping and I say well sure are you crazy I think of course I want to go skinny dipping with you let's relive an adolescent memory I never even got to have while we're at it why don't we circle jerk and read playboy. So then I say, you mean skinny dip at Lighthouse Court and he says no that would turn into a group scene, and he's right it would and I'm so glad to hear he doesn't want that, and then he says let's go down to Atlantic Shores and I say is it closed now he says yes and then he says we can just jump the fence.

9. So we walk down. But let me tell you a little bit about Atlantic Shores. It's this motel right on the water with a pool in it and a pier that goes way out into the ocean and it's like under the stars it is. And so I know he's talking about sex under the stars on the pier in Key West. Fuck.

10. I cant remember what we talked about on the way down. I remember I talked a lot and he was intently not listening. It made me very horny.

11. So then we jump the fence and walk no run to the end of the pier and he's already taking his clothes off and fuck he's got a big hardon shit, my hardon is never big and I don't even know if I can get one. This intimidates me terribly and then I think Sky try not to see his instant hardon as intimidating try and see it as a compliment. And we're about to step into the ocean naked and I'm thinking this is crazy and I laughingly say 'Are there sharks?' but I kind of really mean it and Brent I mean Lush laughs and says we'll find out. And then I think fuck we don't really want to go skinny dipping we want to fuck which was my first really rational thought of the evening and I drag him onto the pier again and start sucking his cock. And things go crazy and I sort of won't tell you the details except that he seemed to love holding me, this big guy and kissing me and it was fabulous and he didn't come but I did but that was okay because I could tell he could have come about five times and I actually started having fantasies that he didn't want to come with me because it might be just too big a thing for him, which shows you how crazy I was.

12. So what does this all mean anyway? It means that like every other gay tourist I went down to Key West feeling like a lonely undesirable lump and came back

fulfilled and sexy as hell. Which makes it an ideal resort. Of course we won't discuss why did I have to go all the way down there and find Lush and discuss Flea and get out on a pier 90 miles from Cuba to experience all this.

13. And it means one final thing. That I'm still romantic about promiscuity. And that is a very important part of me. I mean to a lot of people promiscuity is simply having a lot of sex that's why I don't understand couples, there are a lot of couples in Key West looking for sex which is fine but it's not my thing because how can you have a romantic fantasy about a couple you're having sex with, I mean you're obviously never going to fall in love with a fucking couple and buy a house together it's just sex and it may be too many Kander and Ebb musicals but I need the romance of promiscuity and And oh I forgot to tell you at one point we looked up at the sky which was huge and big and I don't mean me I mean the actual sky which was filled with stars it looked like you could see the whole universe except there was no moon, which was weird because we knew there was a crescent moon the night before and Lush and I thought hmmm, no moon. And I thought that was significant, yes I spent my night on the pier under the constellations with Lush but there was no moon.

14. And I had one final question, is that the way it's always going to be for me, Lush, but no moon? And sometimes I think that's a stupid sad question and I shouldn't think it and then other times I think you're forty-three years old and you've gone through a lot of shit and thank god I still ask questions like that, thank god I still ask. You know?

My mother liked to fuck

JOAN NESTLE

This piece was first published in Joan Nestle, *A Restricted Country: Documents of Desire and Resistance* (Pandora, London, 1987), 109–12. Afterword original to S. Golding's *The eight technologies of otherness*.

My mother, Regina, was not a matriarchal goddess or spiritual adviser. She worshipped at no altars and many times scorned the label mother. She was a Jewish working-class widowed woman who, from the age of fourteen, worked as a book-keeper in New York's garment district. My father died before I was born, when my mother was twenty-nine, and left her with two children to raise. My mother liked sex and let me know throughout the years both the punishments and rewards she earned because she dared to be clear about enjoying fucking.

Regina was in my mind that October afternoon I sat in the front row of 1199's union auditorium to tape the panel discussion on pornography and eros. When my mother died, she left no money, no possessions, no property, no insurance policies. She left me only a sheaf of writings, scrawled letters and poems written on the back of yellow ledger sheets. I have written a longer piece about her and me incorporating these, letters[1] but for now I only want to talk about the courage of her sexual legacy and the sexual secrets I found in her writings and how she stood in my mind, the mind of her lesbian daughter who has loved women for over twenty years, the afternoon of the panel.

At age thirteen my mother allowed herself to be picked up on a Coney Island beach and have sex with a good-looking Jewish young man who was in his twenties; three weeks later he invited her to his apartment where she was gang-raped by three of his friends. She became pregnant and had to have an abortion at

1 'Two Women: Regina Nestle, 1910–1978, and Her Daughter, Joan', *A Restricted Country*, 67–88.

age fourteen. The year was 1924. Her German father threatened to kill her, and she left school in the ninth grade to go to work. When my mother writes of these experiences she tells of her sexual passions, of how she wanted sex.

> I remember as a little girl, the impatience with my own youth. I recognized that I was someone, someone to be reckoned with. *I sensed the sexual order of life.* I felt its pull. I wanted to be quickly and passionately involved. God, so young and yet so old. I recognized my youth only in the physical sense, as when I exposed my own body to my own vision, saw the beautiful breasts, the flat stomach, the sturdy limbs, the eyes that hid sadness, needed love – a hell of a lot of grit and already acknowledging this to be one hell of a life.
> I was going to find the key. I knew the hunger but I did not know how to appease it.

She goes on to speak of her shock, pain, and hurt, and later of her anger at the rape, but she ends the narrative with a sexual credo: she would not let this ugliness take away her right to sexual freedom, her enjoyment of 'the penis and the vagina', as she puts it.

Respectable ladies did not speak to my mother for most of her widowed life. She picked up men at the racetrack, at OTB offices, slept with them, had affairs with her bosses, and generally lived a sexualized life. Several times she was beaten by the men she brought home. In her fifties, she was beaten unconscious by a merchant seaman when she refused to hand over her paycheck. My mother, in short, was both a sexual victim and a sexual adventurer; her courage grew as the voices of condemnation and threats of violence increased against her. I watched it all, and her belief in a woman's undeniable right to enjoy sex, to actively seek it, became a part of me. But I chose women. I wanted to kill the men who beat her, who took her week's pay. I wanted her not to need them and to come into my world of lesbian friendship and passion, but she chose not to. We faced each other as two women for whom sex was important, and after initial skirmishes, she accepted my world of adventure as I did hers.

The week before she died, she was sexually challenging her doctor in the hospital, telling him he probably did it too quick for a woman like her. He, red-faced and young, drew the curtain around her hurriedly. At sixty-seven, my mother still wanted sex and made jokes about what she could do when she didn't have her teeth in. My mother was not a goddess, not a matriarchal figure who looms over my life big-bellied with womyn rituals. She was a working woman who liked to fuck, who believed she had the right to have a penis inside of her if she liked it, and who sought deeply for love but knew that it was much harder to find.

As Andrea Dworkin's litany against the penis rang out that afternoon, I saw my mother's small figure with her ink-stained calloused hands, never without a cigarette, held out toward me, and I saw her face with a slight smile.

> So *nu*, Joan, is this the world you wanted me to have, where I should feel shame and guilt for what I like? I did for all the years of my life. I fought the rapist and the batterer and didn't give up my knowledge of what I liked.
> I looked at those dirty pictures, and I saw lonely people. Sometimes I did those things they do in dirty pictures, and wives would not speak to me. Their husbands fucked me first and then went home for *Shabbas*. I made lots of

mistakes, but one thing I never did – I never allowed anyone to bully me out of my sexual needs. Just like you, Joan, when in the fifties I took you to doctors to see if you were a lesbian, and they said you had too much hair on your face, you were a freak, and they never stopped you either. They called you freak and me whore and maybe they always will, but we fight them best when we keep on doing what they say we should not want or need for the joy we find in doing it. I fucked because I liked it, and Joan, the ugly ones, the ones who beat me or fucked me too hard, they didn't run me out of town, and neither can the women who don't walk my streets of loneliness or need. Don't scream *penis* at me, but help to change the world so no woman feels shame or fear because she likes to fuck.

Afterword

Since my discussions with Barbara Cruikshank, I have been thinking about the fem–woman connection in a different way. In my introduction to *A Persistent Desire: A Fem-Butch Reader* (1992), I naively suggested that the decade of the fem was upon us. I was wrong. I had not counted on the tremendous appeal of lesbian masculinity; I should have known better.

In the last year, at two 'cutting edge' events on the subject of lesbian genders, it soon became clear that only one 'gender' was in sight, the one I had taken delight in for so many years – butch and all its versions. At one of the events, a participant echoed a familiar belief that a fem image by itself does not read as lesbian; it would only be perceived as a 'woman'. Now I have read many pages of Butler and Case, and do accept performance as a profound expression of mutability, but somehow the more things change, the more they stay the same, at least where fem is concerned.

When I tried to speak about what is missing from the post-modern discussions of lesbian genders I found I have no language that feels comfortable, given all I now know. For me, 'fem' has a very problematic relationship to 'femininity'; perhaps because I spent many years being a butchy-looking fem, perhaps because I was never initiated into the mother–daughter performance piece called 'how to make your daughter a girl', perhaps because I spent my entire adult life within a lesbian community. For whatever reason, 'femininity' carries a heterosexual marker that does not signify what I mean when I speak of my femness. 'Woman' does. And it is precisely this that I have no word for. I know I do not mean the word 'woman' as in 'woman-identified woman', or as in 'lesbian woman'. I mean the word *woman* as in lesbian *fem*, the full bodied, big breasted, big assed woman who stands firm on her feet and takes on her lover and what ever else life has to offer. This body description I mean to be symbolic of a mental and emotional stance – age and illness can change the physical outline, but the surge of feeling remains.

I do not see fem as a parody of a woman. At my age, life is too short to act as if it has no meaning. The clear message from the public discussions I have attended, and many of the texts that I have read, is that the fem woman is not a transgressive persona in her own right. She only becomes visible when she is brought into the world of lesbian masculinity on the arms or stomach or fist of her 'butch-daddy-boygirl-gay mangirl – baby butch' lover. How ironic that this is a positioning that I helped to create.

The construct of 'woman' that I explored with Barbara is not the same one I am speaking of now. The 'woman' who moves in the straight world has become for me almost synonymous with worker, the employed being who must earn her way in the world. Barbara made me think about the interaction between woman and fem in a way I had not before; it was fun to separate out the strands of performance, but in the aftermath of the last year's discourse, I see that womanness is the sticking point. What to do with her? Do I accept that fem is the performance, woman the essence? No. Do I accept that fem is the parody, woman the false original category. No. Something is wrong with this whole discussion. Have I fallen in love with the womanness I see in some fems? Yes. Is James Dean my screen hero? No. I eat up Bette Midler. Do I want to spend the next ten years taking photographs of lesbian fems all by themselves? Yes.

My most basic concern now is that behind all the sophisticated discussion of lesbian genders is a devaluing of the fem woman, not because she is fem, but because she is a woman.

I was kindly asked for a last word, but to paraphrase Leah Albrecht, it is time for a new story.

DRINKING SONG

HE WALKED BACK
INTO THE ROOM.
HE SAID:

"I WANT YOU DRUNK
BUT NOT TOO SOON."

HE WALKED BACK
INTO THE ROOM.
HE SAID:

"I WANT YOU DRUNK
BUT NOT TOO SOON."

HE WALKED BACK
INTO THE ROOM.
HE SAID:

"I WANT YOU DRUNK
BUT NOT TOO SOON."

"I WANT YOU DRUNK
BUT NOT TOO SOON."

"I WANT YOU DRUNK
BUT NOT TOO SOON."

HE SAID:

"I WANT YOU DRUNK
BUT NOT TOO SOON."

HE WALKED BACK
INTO THE ROOM.
HE SAID:

"I WANT YOU DRUNK
BUT NOT TOO SOON."

HE WALKED BACK
INTO THE ROOM.
HE SAID:

"I WANT YOU DRUNK
BUT NOT TOO SOON."

HE WALKED BACK
INTO THE ROOM.
HE SAID:

"I WANT YOU DRUNK
BUT NOT TOO SOON."

"I WANT YOU DRUNK
BUT NOT TOO SOON."

"I WANT YOU DRUNK
BUT NOT TOO SOON."

HE SAID:

"I WANT YOU DRUNK
BUT NOT TOO SOON."

Skin

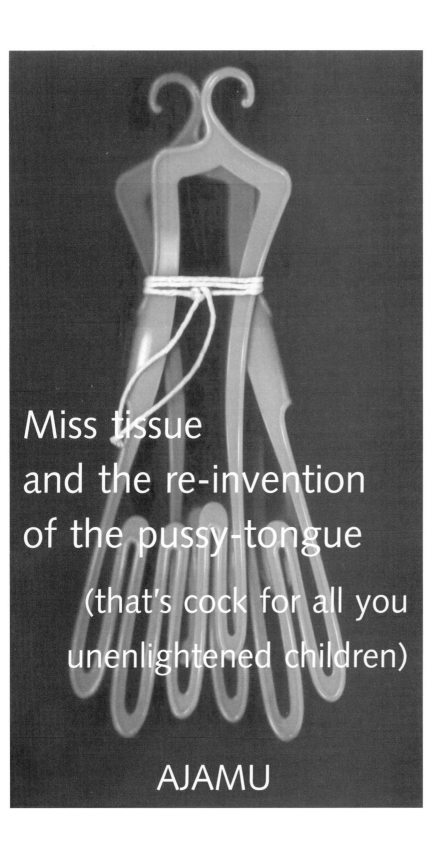

Duppy Writer: Ms Precious Rhourbourgeua (Trevor Hinds)
Images: AJAMU
Text: *Miss Tissue and the re-invention of the pussy-tongue (that's cock for all you unenlightened children)*
Model: Ms Precious Rhourbourgeua

WARNING: Black queer irreverence – Don't even think about it!

Dear Children,

She stands in front of a wonderful example of Rococo craftsmanship. A gilt-framed full-length mirror, that is said to be the once property of a certain lady of high standing who dared to let slip the words, and I quote, 'Let them eat cake', how do I know this, well if you're shagging a director of a contemporary arts auction house it becomes pillow talk. Sorry, children, I digress.

She is seductively putting on her *haute couture* drag for a mixed audience of aristocratic, bourgeois and plebeian perverts. She whispers to her reflection.

What great words of wisdom should I impart on to all you beautiful children out there.

The first thing that came into this pretty little head of mine was something or other on The Black Body, but then those kind of discourses are way above my legs Miss Thing.

But then inspiration hits her like a hot flush on a cold Novembers night.

It put me in mind of those old-time Christian visions Mama used to get when I attended the First Born Child of the living God Pentecostal Church on WASP Nest Road . . . Miss T then turns her back on the mirror while looking back at herself dressed in her long slinky black frock. She runs her hands down from her pert prosthetics over the curvy contours of her body. *Maybe I'd be better off talking about what I know best . . . Me.*

I could never understand the eclectic musical taste of Miss T. Talking Heads was in the background playing on her battered old gram (she was so tragically faded. Often I'd ask her hadn't she heard the wonderful reproduction that CDs now offered), the sexy white husband David Byrne was singing . . . **ONCE IN A LIFETIME** . . . Picking up her phallic-shaped flesh-coloured dildo like some dweeb at karaoke night in an East End pub.

She did her terribly irritating parody of one of those white boys trying to be all black and so terribly funky.

So what can I say . . . I come from a long line of Diasporic queens. 'Miss T always laments one queen per country is a crazy concept.'

On a good day I dress like a man, or let's say I give it my best shot. Masculinity was never my strongest point back in the day. Sex . . . yes . . . whenever someone is willing to give me a good two minute shag . . . no seriously . . . I simply refer to my self as a cock-sucking sodomite . . . though when those old heterosexual urges start playing up, I go for pussy big time, like those fine but uneducated straight children who abuse me

in the shadow of my Dior scent, that one uses to mask the reality of life on the frontline.

I've mentioned Sex and I've mentioned Gender As for Race I wear it like a mask. Miss T does a fierce Angela Davis circa 1970 act. In the words of my she/ro Miss J (Michael Jackson), It doesn't matter if you're black or white, did I say that (That's two snaps in a double circle for revolutionary thinking, honey).

Miss T is a little faded by time and yes she's extremely frivolous with her thoughts; trapped by the boundaries of body and mind I once dared to accuse her of being nothing but a drunken old Queen looking at life through the bottom of a champagne glass. Her answer to this was – Precious, life is never that simple. As a drunken Queen one will always speak with a sober mind.

Miss Tissue

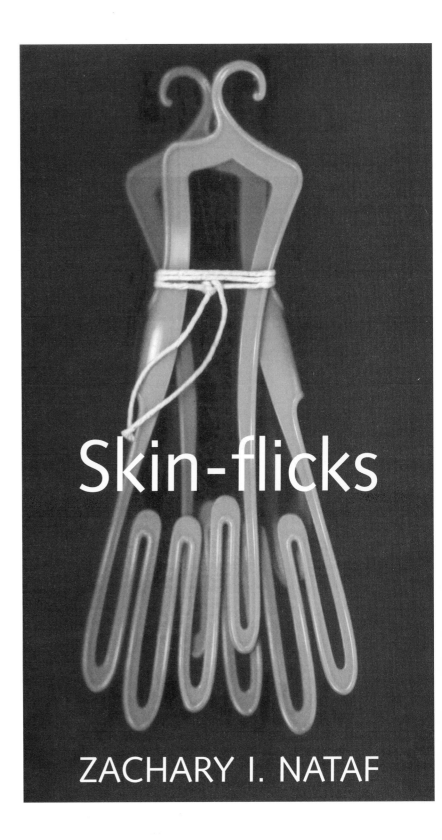

I. The body transgendered – angel or monster?

The metaphors 'angel' and 'monster' represent familiar, if containable, ways of imagining the sexed or gendered body exceeding the normative. But also they point to the limits of language in describing and naming the range of sex and gender expressions and phenomena beyond the binary male and female.

The angel represents an escape from sex and gender altogether, in that it transcends the body. The angelic entity is pure spirit. The sex of angels is often portrayed in art as an androgynous unity of the essences of both genders and so beyond sexual difference and duality as to be corporeally neuter.

The monstrously sexed body on the other hand is transgressive and mutating, blurring boundaries in its ambiguity and indeterminacy. The monstrous speaks of the alien, the Other, the as yet unimagined and unnamed potential hybrids and simulacra.

Transgender begins to give a framework and language, in the late twentieth century, with which to begin and to speak about and name some of the existing varieties of non-normative sexes and genders as well as representing potential new ones which can be achieved through the body's encounters with technology.

Embodying these conceptions of other genders and sexes I am currently reconfiguring my body using the sex-reassignment technology of hormones and surgery. For at least a period of time, if not as a goal in itself, the transgendered/transsexual body in transition is unstable, mutating and intermediate in its sex/gender attributes.

I call my dick a clitoral-penis when I speak about it in a formal way. But it is monstrous for a clitoris and non-normatively micro for a penis. It is in my view neither a clitoris nor a penis but the genitals typical of a not-woman, transsexual man whose brain is wired for a penis and testicles (whether biological factor or description of psychical experience) but whose natal anatomy was female. Using the medical technology I am shaping the material of my body to express my gender identity and contribute to the variety of genders and sexes in the world.

II. The natural body

In the mythology about the body it is seen as nature as opposed to gender which is accepted more easily as culture. The natural body in this formulation exists somewhere in a pure state, is pre-cultural, or somehow impervious to culture.

But, of course, the body is not impervious to culture and is discursive. Is itself a text. Our apprehension of it is historically derived and culturally relative. So the notion that there are only two sexes and they are distinct, opposite, closed and immutable is an ideological leftover from the nineteenth-century institution of the 'two-sex model' paradigm for which

1 See Thomas Laqueur, *Making Sex: Body and Gender from the Greeks to Freud* (Harvard University Press, Cambridge, Mass., 1992).

2 Michel Foucault, *Herculine Barbin: Being the Recently Discovered Memoirs of a Nineteenth-Century French Hermaphrodite*, trans. Richard McDougal (Pantheon Books, New York, 1980).

3 Aimée Waddington, 'Herms, Ferms, Merms and the BioPower of the Surgical Shoehorn: A Critical Review of Anne Fansto-Sterling, 'The Five Senses: Why Male & Female Are Not Enough" (*Sciences*, March/April 1993)', *Dyscourse*, 5: 4 (July/August 1993); Bernice L. Hausman, *Changing Sex: Transexualism, Technology and the Idea of Gender* (Duke University Press, Durham and London, North Carolina, 1995), 204, n. 32.

scientists of the Enlightenment claimed biology provided evidence and that gender followed naturally from biological sex.

According to Thomas Laqueur,[1] before that time, from antiquity through the Middle Ages and the Renaissance, from Aristotle and Galen and up to the time of Freud, the 'single-sex/flesh' model was in circulation. It allowed for more unstable, mutable bodies, with gender being the fixed marker of difference and social status. Contemporary notions of gender are not solely derivative of biological sex. Sex is seen to be the universal system of differentiation, and gender has both a motivated and arbitrary relationship to sex. Gender is culturally relative and changes over time.

In the 'one-sex/flesh' model the female body was simply an internalized inversion of the male body. They were otherwise exactly the same. The male anatomy externalized due to a higher level of heat. (Not as far fetched as it may seem, as testosterone was later found to raise the temperature of the human body, perhaps affecting the body's thermostat in the hypothalamus.) Representations of dissected and studied human anatomy during the Middle Ages and the Renaissance confirmed that theory of the body.

Later, in the eighteenth and nineteenth centuries, studies of embryology echoed this view of human anatomy, as it was found that the structures that would become the testes and those that would become the ovaries and fallopian tubes coexist until the eighth week and the penis and clitoris, labia and scrotum, the ovaries and the testes began from one and the same embryonic structure.

But by the 1860s scientific, legal, and religious discourses intervened to drive society into two sexes even amongst hermaphrodite people (now known as intersex), for whom this single sex was difficult to determine truly. According to Foucault in his introduction to the memoirs of the nineteenth-century French hermaphrodite Herculine/Abel Barbin,[2] until that time, during the Middle Ages and Renaissance, intersex people who were assigned a sex by the father or godfather at birth were allowed to change that assignment at the time they came to marriageable age if they felt it was mistaken. But they couldn't switch back thereafter, under pain of the sodomy laws.

From the end of the nineteenth century only medical professionals could legally assign sex. Now all children born with intersex conditions (an estimated two per cent of all births)[3] are surgically corrected into only one sex.

Contemporary scientific investigation of the components which determine biological sex reveal a more complex picture than indicated by the nineteenth-century 'two-sex' model. The determining factors include chromosomal sex, gonadal sex (testes/ovaries), hormonal sex, internal reproductive organs (uterus/prostate), external genitalia, secondary sex characteristics (voice pitch, facial and body hair, etc.).

This complexity makes sex even less reliable in determining gender than ever. Not only does gender not correspond directly to sex but the interrelated biological factors determining sex are not always fully

congruent between themselves. For example, a person with the male chromosome pattern XY may have an intolerance to testosterone and so be anatomically female because her body cannot use the hormone. Biological incongruence is most evident in intersex people, but current scientific thought supports the findings that all people fall somewhere along a continuum.

External genitalia becomes, as a result of biological complexity and despite contradictory evidence sometimes, the primary factor for assigning and attributing sex and gender. Culturally and legally people aren't allowed to be a woman with a penis and a man with a vagina, although this actually does occur in reality. Transsexuals are a good example of that phenomena. Recent scientific findings by the Dutch researchers Swaab, Hofman and Gooren indicate that there is a structure in the hypothalamus of transsexuals which means their brain sex is different from their anatomical, natal sex.

Historically, cross-gendered people have always existed and across all cultures. Early examples are the Native American *berdache*, recorded by European explorers and anthropologists in the 1600s. The Gay American Indians History Project has documented accounts of the special social role (third and fourth gender) of male to *berdache* in 150 North American societies and female to *berdache* in half these.

Accounts in the Ayurvedic medical literature in India, dating from oral traditions in the second millennium and written down between 600 BC and AD 100, describe transgender people corresponding to the modern third sex caste, neither man nor woman, referred to by the modern term *hijra*. This term covers a vast range of gender-transposed expression and includes intersex and transsexual people.

Although gender dysphoric and gender-transposed people have always existed, transsexualism is seen as a twentieth-century invention because it couldn't have existed until hormones were synthesized in the 1920s and 1930s, phalloplasty and vaginoplasty were developed between the 1930s and the 1960s and a diagnostic category with sex reassignment surgery as the treatment to 'cure' gender dysphoria was established in the *American Psychiatric Association Diagnostic and Statistical Manual for Mental Disorders* in the 1980s.

III. Skin technologies: skin art

Those who benefit from gender oppression may still cling to the old gender system, but its obsolescence will become evident. It ceases to have the authority of reality. It is one system amongst others. The two-sex gender system was invented for the social/political control of biological reproduction and inheritance in bourgeois hetero-patriarchy during the Industrial Revolution. The technological means to reproduce the species will replace the primacy of the human reproductive function at the *fin de siècle*, and hopefully as a result the outmoded sex/gender system as we know it now will become extinct.

The need to interrogate gender – the fact that someone doesn't know or has to ask themselves, can't tell, can't decide, fails to be able to fix someone in gender, the mere existence of gender innovation, gender indeterminacy and gender ambivalence, defying the binary – demonstrates the failure of the gender system to describe observable reality fully.

The making visible and the representation of the transgender body, for the sake of other trans-people as well as for society at large, helps to put paid to the myth of only two sexes/two genders.

The important thing for me to do is begin to make visible the lives and experiences of trans-people who have crossed beyond gender apartheid and to attack the gender system at its roots, digging up its deep structures and exposing them. I want to contribute to the creation of language – vocabulary and images, stories and aesthetics which celebrate the living possibilities born from daring to imagine that gender is not natural, fixed, binary.

The film/video treatments which follow were written prior to and during the early phase of my transition from butch-lesbian/not-woman to female-to-male (FTM) transgendered man, and so deal more with the struggle to escape the pull and hold of gender. After the hormones, surgery, living in the male social role and evolving my identities as a queer, black, pansexual FTM transgendered man, different perspectives, new vistas, experiences and stories unfold.

These Skin-Flicks use violence/horror/porn images to re-produce the visceral experience associated with Otherness. Skin here is the pivotal modality of Otherness. Identity's fluidity and the body's mutability, the method and apparatus.

Structurally and narratively in this work, boundaries dissolve. What was limited and distinct is revealed as more richly varied and complex. Black/white becomes hybridity, male/female transgender, hetero/homosexual becomes polymorphous pansexuality and other techniques of queer.

IV. In extremis

I burst apart. Now the fragments have been put together again by another self . . . [A]ssailed at various points, the corporeal schema crumbled, its place taken by a racial epidermal schema . . . it was no longer a question of being aware of my body in the third person but in a triple person . . . I existed triply . . . I was responsible at the same time for my body, for my race, for my ancestors. I subjected myself to an objective examination, I discovered my blackness . . . completely dislocated . . . I took myself far off from my own presence, far indeed, and made myself an object. What else could it be for me but an amputation, an excision, a haemorrhage that splattered my whole body with black blood? (Frantz Fanon, 1970)

Treatment 1: The Ordeal – a performance and video installation, June 1992

In a 99-minute Installation, three video montages across nine monitors of fragments of footage from documentary and fiction films showing the worst possible result of colonial control, racial scapegoating, stereotyping, fetishized fascination and negrophobia. On one screen short segments in a slow, seamless flow emphasize the grotesqueness of these events. The next screen shows a detail from that image which is emblematic of the horror. On the last screen, that detail is abstracted through close-up, etc. to the sensual quality of light, colour, texture, or movement of patterns, to relieve the interminable assault, distancing the unbearable.

The piece explores some of the ways and reasons why the black body has become so tied up with violence and its representations. By presenting or reproducing the effects of the experiences in this storehouse of projected violence by showing these images in conjunction with an actual, present 'suffering' black body whose ordeal can be directly witnessed by those gathered. (Publicity should target black audiences.)

This process of witnessing is important in the black communities to preserve the sanity of its individual members by mutual recognition, especially where instances of institutionalized racism – difficult to pin down, yet effectively undermining – are dismissed as imagined by those not affected by it.

Witnessing is also a tradition in the black Christian church where the personal, subjective experience of the felt existence of God, the 'Holy Ghost', or other powerful spiritual feelings are expressed by 'shouting'. One or more participants demonstrates an ecstatic state of religious transport by wailing, speaking in tongues, shaking, dancing, or swooning. This allows the other members of the congregation to witness proof of the existence of a great spiritual force directly through the body and being of someone known and present amongst them. The whole congregation can be uplifted and transformed (converted or confirmed in faith) by this experience.

Besides the effect of the sheer physicality and endurance of the live performance and the tone created by repetition and extended duration, the particular gestures or actions themselves resonate with further connotations. These are reinforced or framed by the video images and sound track.

A non-synchronous sound track will weave sampled natural sounds into sparse, fusion-jazz music. Unusual instrumentation and disharmonics will create cacophonies which appear and then dissolve like smoke-rings or soap bubbles. The vocals, against the grain of the music, will give a sense of crisis, singing sometimes coherent but minimal and repetitive text-fragments from Zora Neal Hurston, Frantz Fanon, etc.

On a raised platform, the performer is attached by the wrists to a cross and by the ankles to a suspended pulley system weighted by sandbags

which are pierced and slowly emptying. The actions are, principally, the presentation of an exposed (unclothed) body, a crucifixion, falling, hanging, burial and drowning/suffocation.

Each of these brings up fears of death, annihilation of the self as we know it. There are other associations, for example crucifixion with the scapegoat who is a victim because a threat as the 'Other' within the group, whose destruction is seen as necessary to maintain the cohesion, that is, homogeneity of the group, but who is also the exemplary sufferer by whose sacrifice the group is redeemed from the guilt of its crime. In place of the scapegoat's Otherness, a 'universal humanity' emerges and reflects them back their own.

Some preferred readings of the gestures include the body as *gestalt*, the existence of the body by its reality in space/time, the authentic subjective and kinesthetic experience (sensation of position, presence, and movement) through the body as positive in inter-relationship to the world as against the body as negative, because skin or biological sex are significant through a reductive displacement.

The performance in relationship to the video montages points to difference fixed by mapping the mythic and stereotype on to the body. Falling and repositioning of the crucified body is a self-immolation striving to liberate self, as identity and not just epidermis from the psychosis of the 'colonial fantasy' in which the raced body is trapped as in a collective nightmare.

The hanging associated with the lynching of black men in the American South after the Civil War and through the 1950s in an effort by some white men (e.g., Ku Klux Klan), to control what they designated as the excessive and otherwise uncontrollable sexuality of black men and their threat to white woman and the annihilation of the white race through miscegenation. Both documentary and fiction representations in the montages encourage this reading of hanging.

Other associations are the measurements and comparisons employed by early European anthropologists in documenting, classifying and determining the status of non-white human specimens using the photographic method of anthropometry. Images, sound texts and gestures will also comment on the nineteenth-century practice of dissecting and studying anomalies or 'errors' in black (Hottentot) female genitalia which were then used to theorize blacks as inherently different from Europeans and of an inferior race as well as of female sexuality as pathological.[4] Accordingly, abnormal 'excesses' like lesbianism and prostitution in European women were thought to reveal anatomical irregularities in these women similar to those found in black women.

The nakedness of the performer's body here, exposed under the surveillance of the camera, under the gaze of the audience, brings up questions about notions of measuring and comparing of parts in isolation in order to control and acquire knowledge; to make the whole knowable by its parts or the parts whether epidermal or sex parts, the only knowledge. Although exposing certain visible signs of herself, the performer remains strangely unknown and unknowable.

4 Sander L. Gilman, 'Black Bodies, White Bodies: Toward an Iconography of Female Sexuality in Late Nineteenth-Century Arts, Medicine, and Literature', in *'Race', Writing, and Difference*, ed. Henry Louis Gates, Jr (University of Chicago Press, Chicago 1985).

Knowledge here is replaced by the innumerable signs, anecdotes, fragments, and surfaces of historicity and racist/sexist stereotypes. The performance can only deconstruct this overdetermined colonial perceptual reality of the performer's present physicality. Kinesthetic perceptual reality of the performer's present, presence. Buried by the crumbling debris of racist myth, the performer struggles to excavate her body from the sand-fall. The ordeal may be a catharsis and exorcism of the victim-impulse for this black woman performer. For both the audience and performer, much that has been repressed or disguised about the issues treated has returned to be examined. The intention is for the performer to come to a point where her body is no longer a self-effacing or empty sign filled with the ideology or master discourses of white male supremacy and the Oedipal Law and language of male subjectivity. So, what body will, can emerge from the ordeal?

The performance is an effort not to arrive at the ideal body but to dislocate the body from the stereotypes and myths on the one hand and the symptoms of negotiated and internalized oppressive racism and gender constraints on the other.

What is hoped for are gaps opening up in the narrative. So the body after the ordeal is not perfect or whole as in a narcissistic fantasy. It is not innocent or outside of history, ideology. The intention is to experience and to show the process in which, between the body and the world and between the various competing signifying contexts and contents, identity and black female subjectivity constructs and transforms itself constantly in the moment.

V. Orgasm

With the cutting of the umbilical cord, the new-born child, like the androgynes [in Plato's *Symposium*], finds itself separate from a part of itself, torn from the mother's internal membranes. Birth causes it to lose its anatomical complement . . . The libido, the instinct, will be maintained within corporeal limits and will henceforth be unable to flow completely other than by way of 'erotogenic zones', which are rather like valves opening towards and by the outside.

As Lacan makes it clear, the delimitation of the erotogenic zone has the effect of canalising the libido . . . and transforming it into a 'partial instinct'. The erotogenic zone is a cut or aperture inscribed in a suitable anatomical site: for example, the lips, the gap between the teeth, the edges of the anus, the tip of the penis, the vagina, the palpebral slit.

Having previously taken only the whole area of the skin, the mucous membranes and the orifices to be erotogenic, Freud, in the name of hypochondria, extends to all the internal organs, the possibility of becoming a site of excitement of a sexual type. The whole body can thus be said to be erotogenic. To be more accurate, it is a set of possible erotogenic zones. (Anika Lemaire, 1977)

Treatment 2: Working title: In Search of the Ideal Orgasm, 1993

In Search of the Ideal Orgasm is a queer lesbian film in which Zina, a black lesbian performance artist, is keeping an interactive CD-ROM diary of all her sexual exploits in order to create a 3-D interactive model of the lesbian orgasm on the screen.

The narrative takes a specific direction after Zina decides to undertake the task of making a visible representation of the female orgasm, which, unlike the male come shot, cannot easily be seen, shown, or represented, only implied. Parallel with her search for a representable state of lesbian desire Zina makes a commitment to attempt the complete dissolution of the constructs (social, ego, subjective, sexual) that make up her own identity.

Zina's process of deconstruction of gender and race conditioned subjectivity pushes her toward a zero-state which she believes will be a more authentic self. The video-disc diaries become more fragmentary, contradictory, difficult, taboo and dangerous (identity threatening). Found-footage, images borrowed from TV, film, documentary, fiction, pornography, art, advertising are mixed with home movies, samples of experiences, recorded surveillance of her own bed and grow organically into a bricolage/collage which are intended to evoke, to stimulate and simulate the responses of ecstasy.

The following three scenes capture how the interactive and editing aspects of the technology in these scenes, give a sense of pushing back the boundaries of discourse, to hint at what might become utterable or conceivable beyond the conditioned. We witness the computer/mind interface expand to an almost tangible matrix, a habitable landscape of information and the imagination, a cyberspace.

Scene 14
Interior night. Zina's multi-media bench

Zina at home with her technology looks at still more women and their orgasms which she has added to her collection (a catalogue of lesbian sexual practices focusing on the details of various whippings, spankings, penetrations, tribadisms, rough play, arseholes, cunts, lips, fingers, fists, dildos, vibrators, latex gloves, K-Y lube, condoms, dental dams, exhibitionisms, voyeurisms, fetishism, leather, rubber clothing, make-up, skin, etc.).

She uses the various functions of her CD-ROM and computer database to author various versions of the raw material possessing and controlling the women in her technology, exploring the erotic quality of repetition in the editing process. As much because of her personal lovers' crisis as because of the pressure she is putting on disintegrating identity as she knows it, Zina takes deeper refuge in the web of cyber-space reality she is creating with her technology. Attaching herself with probes and wiring, goggles and gloves, she both stimulates herself by a remote flow of imagery and interactively records a quasi-bio-medical-

type virtual display of the biochemical and neural results of her stimulated body.

Is this real or a simulation devised by electronic alchemy, a representation which strives to become an entity whose only concrete existence is impulses and sensation? Zina makes love to herself inside the virtual reality cyberspace and comes. The orgasm is pictured by 3-D computer animation.

> I was pursuing the idea of a more abstract body than that of an individual afflicted by hysteria, because the text was about the proliferation of bodies in the one body, many voices articulating it in a constant motion of dissolution. (Laleen Jayamanne interviewed by Anna Rodrigo on her film *A Song of Ceylon*)

Scene 15
Dream 4. Interior day. Sunlit room in a Moroccan house

A dance with veils inspired by the photographs of Clérambault, a French psychiatrist in Morocco at the end of the nineteenth century, who treated and photographed female 'hysterics' who fetishized the cloth of their veils so that a diffuse eroticism of touch and envelopment displaced sexual pleasure from the genitals, remapping it on to the surface of the body.

Scene 22
Dream 5. Black & white. Interior

Slowly out of the black fade up to reveal grainy texture of bodies moving in slow motion, entwining on a surface in a darkened room (dark as in the recurring nightmare of turning on the light but achieving no brightness). Bodies in 'black light' with a chiaroscuro edge of light which traces the outlines of a side, a belly, a scoop of shoulder or buttocks. What might have been one or two bodies appears a writhing mass of four then six then ten or more anonymous shapes (all races and ambiguous genders). Out of the indistinguishable mass, two pairs of lips kiss (optically printed subtle speed change). Zina's body arches with tension into the light then merges back into the darkness again. Black.

Envelopment by a second skin, cloth, leather, or rubber, for example, or in the case of *In Search* by the technology or by the orgy (or darkness), is like a return to the womb. Orgasm here is more *jouissance* as the equilibrium of an eternal undifferentiated pleasuring than *jouir* (to come), the difference between tension and its release associated with the paroxysm of genital orgasm.

Envelopment dissolves the boundaries between self and other, body and environment or inside and outside. The charge flows freely between the partitions creating an osmosis. This is like the paradisic state before parturition. Languid, smouldering, the w(hole) body rendered ecstatic.

This piece is also about the splitting, splintering and proliferation of voices, bodies, identities seen as hysterical by the practitioners of psychoanalysis as much as by practitioners of ritual exorcism for the treatment of those possessed by demons. But it is this instability of identity and productive proliferation of subject positions, a fluidity, that refusal to be fixed, which some confuse with madness. Forever pushing, penetrating boundaries, transgressing the social rules and one's own limitations. Breaking down dualities, dwelling in the unfolding flow of reality or vibrating like a thread in the web connecting all things, all separateness of forms revealed as superficial, common connective life-force being the truth.

VI. Möbius Strip

Why are we overwhelmed by the need to destroy everything, change everything to consecrate all to the transitory? Behind that necessity, reality resurges . . . The only thing left to do . . . is turn the iconoclastic force against one's own body to accomplish the crossing over of that other channel: oneself. Open one's body to the theatre of emptiness, to the representation of the void, beginning the ceremony by three ritual strokes: sep-pu-ka. (Severo Sarduy on Yukio Mishima and *hara kiri*, 1981)

Treatment 3: ZED (working title), 1995 – synopsis

ZED is a fifty-minute experimental narrative film shot on 16mm black and white and colour and on Hi-8 video black and white and colour.

The film is located entirely in London's East End, where Zed, the main character, shares an artist's loft with Sammi, a white skinhead lesbian punk guitarist. Zed, a video artist and a black female-to-male transgenderist, cross-dresses and lives full time as a man. His ease at passing as a man is partly due to the self-administering of synthetic male hormones acquired on the black market. He began taking the testosterone as an experiment to alleviate his sense of gender dysphoria and his persistent belief that he was a man in a woman's body. Instead of going to see a shrink at the gender clinic in order to come truly to terms with his transsexual desires, he abuses testosterone as a recreational drug. Taking the drug gives him an adrenalin buzz, but he also gets this from being seen as a man in the streets. This psycho-chemical cocktail has opened an old wound and begins unleashing a deadly self-destructive rage. The testosterone leads to an increase in aggression and uncontrollable sex drive which enhances Zed's gender confusion but also aggravates his alcoholism.

Zed constantly wears a penile prosthesis (which doubles as a urinary device and a dildo when made erect): this ceases to be enough, and a series of bizarre dreams of having and not having a penis increases Zed's castration anxieties. In some of his dreams he tries to reconcile his

relationship with his father who was found dead under mysterious circumstances while in the custody of military police and was purported to have committed suicide, shooting himself in the mouth with his own revolver. Zed was ten years old.

In an effort to run away from his pain and confusion Zed instead plunges deeper into emotional crisis and chaos. His bisexual promiscuity – sexual encounters with ultra-femme lesbian bombshells and stunning black drag queens culminates in a triangle with heterosexual journalist Ruth and lesbian actress Jez. Zed's bid to prove the authenticity of his manhood by his sexual conquest of Ruth is thwarted when she is unimpressed by his compulsion to act out the worst macho stereotypes, his abuse of power, his irresponsibility in the sexual exploitation of others and his provocative occupation of the zone between genders.

Zed, who was taught as a child how to shoot, has begun to spend time at a local shooting range with the intention of carrying a gun for self-protection against the increasing threats of queerbashing and racist attacks he's experiencing on the street in the East End and the hostile reaction generally to his gender ambiguity.

As his crisis deepens, the combination of alcohol, a gun, testosterone and a violent rage over which he is losing control causes the events of Zed's life to take on more and more the surreal quality of his dreams until his sense of the boundaries of what is real and the power he has over events becomes as confused as his gender identity.

In the final scenes of the film Zed, driven headlong down an irreversible path to his own destruction, betrays Jez, who although she is a lesbian is learning to love Zed's masculine gender identity. In a desperate act Zed castrates a would-be sexual harasser in a sadistic game with his father's revolver on an empty underground train. After this Zed rapes Jez with the gun and then abandons her in the rainy night streets of Whitechapel. The police effortlessly trace Zed to his loft and swarm into Zed's bedroom destroying everything in the room. There they act as judge, jury, and executioner, beating Zed to death with their truncheons.

Act 1, Scene 1
Interior night. Opening scene. A dream sequence in black and white

The sound is surrealistically amplified and distant as if heard from the other end of a tunnel. A naked light bulb in a hanging ceiling fixture is swinging back and forth overhead making shadows which alternately obscure and illuminate Zed's face. Eight armed white policemen raid Zed's loft in East London, breaking down the door. They find Zed in bed with his gun resting on his crotch over the sheets. They bludgeon him to death with long black, phallic police truncheons, first knocking the gun from his hand. They take turns battering Zed as he struggles futilely to protect himself.

Scene 2
Interior night. Colour. Zed's loft bedroom, East London

Zed wakes from the dream. A naked light bulb in a hanging ceiling fixture is swinging back and forth overhead making shadows as during the struggle in the dream. He pours a glass of bourbon and drinks it muttering to himself.

> **Zed**: Heavy thought policing going on, or what?

Zed turns off the light and gets back into bed.

Scene 12
Dream sequence, interior. Hammam day, black and white

Four veiled women in a hammam masturbate under their chadors. Two women open their veils to kiss each other. One woman stands in the doorway lamenting in Moroccan Arabic. Check-patterned tiles show highlights of the beams of sunlight filtering through the corridors and through the arched doorway (the intensity of light stands in for colour here). Zed hanging naked in an S/M sling, as if in a hammock, clearly has a penis. His body, suspended sensually, is stretched and straining in the leather constraints as he gives his body to gravity and to the women. One of the women squats and urinates on a cloth. We see the cloth absorb the water and then become saturated. She goes over and as if to wash Zed, she touches his body with the wetted cloth, first his cheek, then chest and then the genitals which seem to be erased or absorbed in the cloth.
 The cloth becomes bloody and Zed's wound drips blood a drop at a time on the floor. Zed groans and then cries out. The doorway is empty now, the sound of footsteps running down the corridors. Over this scene on the sound track women's whispering voices echo as if from the past. Also on the sound track the distant voice of a child is calling its father.

> **Child**: Father please take me with you. Take me away from the women. Father I beg you.

In a cobblestone street a father stops, turns, and picks up the child of indeterminate gender running after him.

Act III, Scene 16
Zed's loft. Interior. Night

Zed gets ready to go out. He is clearly drunk and the bottle of bourbon is nearly finished. Zed, undressed, dances in front of the video camera and then binds his chest, puts on the penile prosthesis and dresses in leathers. At one point he decides to take his gun, aims at the camera, aims at himself in the mirror then in the video monitor and sings from a Prince song[5] as he points the gun at himself pretending to fire it.

5 Prince and the New Power Generation, 'Papa', on *Come* album (Warner Bros, 1994).

Zed: Oh Papa, Papa, boom, boom.

He then puts the gun in his pocket and leaves. The streets are wet and shining from a drizzling rain. Zed hops on a bus. Jez, who has been sitting in her car outside Zed's house watching the comings and goings, follows the bus.

Scene 17
TV/transsexual club 'Travestie', Bromley-by-Bow. Interior night

Zed meets his FTM transsexual friend Mike for a drink and in order to get his supply of black market testosterone. Mike gives him a vial, needle, and syringe. Zed knocks back a shot of bourbon and goes into the men's toilet and stands at the urinal peeing through the prosthesis. He then goes over to the sinks, lowers his leather jeans and self-administers the injection in the hip. Jez, who has been standing outside the toilet, bursts in. A white transvestite follows Jez in and in full drag goes over to the urinal, lifts her dress, and pees. Jez picks up the empty vial.

Jez: What's this? Crack?

Zed laughs and kisses her tenderly and drunkenly.

Scene 18
Outside the club. Exterior night and interior. Tube Bromley

Zed leaves the bar with Jez following behind.

Jez: Hey, Zed, come on I've got my car here, let's go back to my place and get you sobered up a bit.
Zed: No, that's no fun. You come with me. I want to fuck you on the Tube.

Jez follows Zed into the Tube reluctantly. They get on to an empty train carriage from a deserted platform and Zed begins to ravish Jez. He has taken one of Jez's breasts out of her dress when a white man in a black leather jacket gets on to the train. He begins to interfere and touches Jez's breast. Zed goes berserk and pulls out his gun. Together Zed and Jez taunt him, making him pull his penis out and wank it until it gets hard. He whimpers from fear. Zed shoots the man's dick off, showering them all with blood.

Scene 19
Tube station and Whitechapel streets. Interior/exterior night

Stunned, they get off the tube at Whitechapel and run through the passages. They appear for a brief moment on the video surveillance monitors and they run past the cameras. Out in the street they turn a few corners and down an alley where they stop to catch their breath. They start kissing each other wildly. Zed in a rabid frenzy turns on Jez, forcing

her to suck on his gun and then fucks her with it. Jez, paralysed with fear and disbelief, stumbles away vomiting and collapses in a heap on the ground as Zed, frightened by what he has done and the sound of police sirens, runs off into the night.

Scene 21
Zed's loft. Interior night. Later

The police, seen through the video monitor (and so in black and white as if in a dream), break into Zed's room where he is sleeping with his gun held on his crotch. In full colour the police descend on Zed, who wakes in time to raise his gun. It is knocked from his hand with the blow of a truncheon. The police, who are all white, proceed to beat him to death, the video camera as sole witness. The monitor screen goes black as the tape finishes and rewinds in the machine. One policeman takes the tape from the machine. Another policeman smashes the screen.

● ● ●

It is difficult to escape the gravitational pull of gender. But, like the gravity-defying play of the dancer or the rock climber, one can begin to discover the elasticity of its boundaries, to push one's body against the constraints moulding the material of gravity like clay, the tension between body and this force yields fluid response reshaping the body as the body momentarily makes an impression which reforms/deforms the boundaries, testing the resistance and penetrability of gravity or gender.

The Möbius strip metaphor is evoked here because skin with its inside and outside surfaces is understood to seal off and divide these continuous but flipside surfaces from each other. The tug and tension in the struggle to escape the gravitational pull of gender implodes gender, causing a collapse and twist in the surface so that it no longer separates but like a Möbius strip has restructured the topology of gender to occupy only one continuous surface.

The film is visually packed with phallic references. It is about who has or doesn't have the phallus. In the Lacanian sense of the word, no one has the phallus. No one escapes gender, although Zed is struggling to do so, in order to access language, the symbolic, that also means that no one escapes castration, which is the same as gender. Zed is branded with gender as he dies (is himself castrated).

The film ends pessimistically in that the phallic power which survives his demise is conflated with the penis not of the order of the mythical, ungendered phallus which transcends bodily sites on either the male or female anatomy and is thus represented as beyond gender.

In his struggle to escape gender Zed tries to destroy the signs of man and woman, to castrate them by the shooting and the rape. But castration in the Lacanian sense is what creates gender. Zed is caught on the Möbius strip and cannot escape beyond the system, is compelled to repeat the

effort of acquisition of the phallus, the perpetual erection (afforded by the artificial dick, better than the 'real' thing) and eternal *jouissance* by his promiscuous exploits which he records on video to preserve and repeat again. This is a tragedy, a suicide.

Zed fails to transcend the body and succeeds only in sacrificing it to the quest for the phallic order which consumes him to prevent unleashing a utopian, impossible, differently gendered being. The castration/rape scenes indicate a war waged against the gender system. His ultimate act of trying to destroy the signs of binary gender are a desperate last resort but do not reconcile his confusion of the phallus with the penis, which prevents his arriving.

VII. Poly-morphous and Perverse

The Dogon are a Malian, West African people, who in their cosmology[6] invented a story which has similarities to the psychoanalytic model of the gender narrative with omni-gendered figures akin to the Freudian phallic mother and the primal father of *Totem and Taboo* (Freud, 1950), who represent pre-Oedipal polymorphous perversity and impossible *jouissance* and power.

In the story Ama, god, created the stars and the sun by scattering bullets made of clay into the sky along with a white ball encoiled by copper. The earth he created stretching her out supine beneath the sky. Because he was alone he desired to join with her, the coupling troubled however by her resistance. Her clitoris stood up and barred Ama's entrance. Refusing to be deterred, he excised her clitoris. In a primal rape, this show of force designated the superior organ and the castration suppressed the possibility of a masculine, rebellious organ in the female anatomy.

The expected twin births which should have resulted were thwarted by the difficulty encountered by Ama. Instead a single, unique being sprung from the earth, a jackal with both sexes and with incestuous intentions toward its mother. Before the jackal could re-penetrate mother earth and throw all things into chaos, Ama coupled with her again, without any obstacles this time, and she gave birth to twin 'Nommos', half-human with the belly and tail of a snake.

Each of these Nommos, unlike their elder sibling, had a single sex, one male, one female – together they re-entered the earth to propagate the human race. The humans born were hermaphroditic like the jackal. In order to restore the order of things the female foreskin was circumcised to create the male human which, when tossed away, became a lizard; the male clitoris was excised to create the female human, the clitoris becoming a scorpion. It is a cutting away by castration and construction of specific genital forms which creates gender in the story, a cultural management of the flesh.

As with Freud's and Lacan's erotogenic zones, the libidinal instinct's tendency towards excess (the attempt to return to the prenatal state of

6 Marcel Griaule, *Dieu d'Eau: entretiens avec Ogotemmeli* (Librairie Arthème Fayard, Paris, 1966).

complete union with the mother by incestuous coupling with her) is constrained within corporeal limits via the cut and canalization. Biology is made more suitable for its social outlets. Cutting/castration is the requirement for access to gender, culture, language, and the symbolic order. In psychoanalytic theory as in the Dogon system neither the male human nor the female human has the powerful phallus of Ama and of the earth before she was castrated, nor the dangerous double sex of the exiled jackal, but are subdued as was the earth, finally, under a patriarchal, heterosexual orderliness of procreation.

Transgender people can easily identify with the jackal in this story, as they are not beyond gender like the mythical primal parents but differently, multiply and dangerously gendered like the jackal. And although the jackal is other and ostracized from the society of the Nommos' human offspring, the jackal is invested with shamanic powers of ritual and prophecy. From its privileged perspective on society's activities, and ability to have insight into human fate, the jackal is sought out by the diviners of the society.

The threat according to psychotherapy is that one risks madness by trying to escape gender or binary sex difference altogether. The social contract regulates one's gender obligation to conform to the binary by threat of marginalization, pathologization, or violence. This and the lack of language, structures or representations (validated visibility) of other options produce fear and shame which keep people silent about their own actual gender experiences.

The material being worked in these texts is the skin/flesh/body which is suggestive, open-ed to resignification. In pansexuality the apertures are truly interchangeable and equal in the giving and receiving of pleasurable sensation and associative charges. Lips, anus, vagina, the slit of the penis or fold of the foreskin are equal and interchangeable in the libidinal economy of pansexuality.

S/M or non-genital eroticism captures the charge and diffuses it across the surface, causing the whole of the body to resonate. Surgical mutation can create new orifices or types of genitals. A proliferation of new erotogenic zones can be made available simply by cutting and stitching the flesh, piercing, tattooing. branding, with prosthetics to increase and enhance the receptivity of the body's surface and interiority.

Gender identity, like all subjectivity, is unstable. Gender must be constantly re-established socially through performance of gender codes and roles and anchored by language and the body's forms. If the body does not suit one's self-determined gender identity/stories then technological intervention can redesign the body to approximate more authentically to the gender expression of the subjective identity experienced. Gender is a social, psychic, political category which is not fixed in or guaranteed by nature. Biology is ideological. What we often take as natural sex or gender is always culturally constructed. Sexual anatomy as an empirical, common-sense evaluation has only a contingent, arbitrary relation to gender reality.

References

Fanon, Frantz (1970) 'The Fact of Blackness', in *Black Skin White Masks*, trans. Charles Lam Markmann (Paladin Frogmore, St Albans, Herts).

Freud, Sigmund (1950) *Totem and Taboo*, Standard Edition (The Hogarth Press and The Institute of Psycho-Analysis, London), vol. 13.

Lemaire, Anika (1977) *Jacques Lacan*, trans. David Macey (Routledge & Kegan Paul, London).

Rodrigo, Anna (1985) 'To Render the Body Ecstatic', *Fade To Black* (Sydney College of the Arts Film Group).

Sarduy, Severo (1981) 'L'hidalgo et le samourai', *magazine littéraire*, no. 169 (February), Paris.

Tisseron, Serge (ed.) (1990) *Gaetan Gatian de Clérambault: Psychiatre et Photographe* (Collection les Empêcheurs de Penser en Rond, Paris).

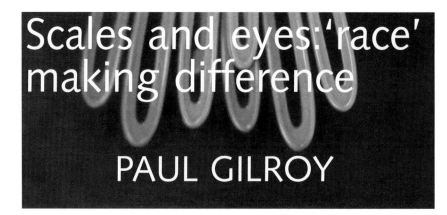

Scales and eyes: 'race' making difference

PAUL GILROY

As we peer into the darkness of the transformations taking place
in that great flowing stream of human physicality, our sight fails as
we contemplate a future for which it has been determined that
though no prophet shall pierce its veil, it may be won by the most
patient man. Here flows the dark stream that for the most noble
may prove their predestined grave. The only bridge that spans that
stream is the spirit. Life will pass over it in a triumphal chariot, but
perhaps only slaves will remain to be harnessed to it.
(Walter Benjamin)

The reason for assuming the Negroes and Whites to be
fundamental races is self-evident. (Kant)

Several years ago, Stephen Lawrence, a young black man, was brutally
murdered by several young white men at a bus stop in south-east London.
His tragic death was the third fatality in a sequence of racial attacks that
had been perpetrated in the same area. The others to die, Rolan Adams
and Rohit Duggal, had been killed in comparable circumstances. All the
murders were unsolved. All the killers passed unpunished.

The whole story of political action around these deaths cannot be
recapitulated here. For these limited purposes, it is enough to say that a
small but dynamic movement grew up around these tragedies and that the
actions of the bereaved families and their various groups of supporters
took place both inside and outside the formal institutions of government,
publicity, and legislation. Tactical actions were intended to project anger,
to amplify grief, win support, change consciousness, and raise money for
legal fees. Political initiatives included a demand for the justice that had
been effectively denied where police, courts, and prosecutors refused to
act with speed and diligence against the attackers. They also encompassed
a demand for sympathy for the plight of the families in their loss and their
sadness. These actions articulated a further sequence of supplementary
demands: for recognition of the seriousness of the offence, for
acknowledgement of the humanity of the victims and the distinctively

unwholesome nature of the brutal offences that had left them to die on the pavement while their blood drained away.

Most aspects of the forbiddingly complex case of Stephen Lawrence cannot be explored here but that does not mean they have been forgotten. There are also solid moral and political reasons why that bitter episode should not be used as illustrative material on the way towards a more general and inevitably speculative argument. Nevertheless, that is what I wish to do.

The British National Party – an openly neo-fascist grouplet – had been very active in the area where Stephen Lawrence was murdered. Their national headquarters was close to the spot where he had died and it was unsurprising when the group's presence in the neighbourhood and possible role in creating a local climate in which this form of terror was possible and legitimate became the focus of political activity directed towards the police and the local state. In the names of anti-fascism and anti-racism, the demand was raised that the party's well-fortified headquarters should be shut down. There were tactical divisions within the campaign as to how this might be achieved. One group favoured localized direct action, another preferred to pursue more familiar patterns of protest. Rather than march against the building, they chose to make their public demands in the central area of the city where government buildings are located and where the media would attend. Another local demonstration was called around the same aims. It marched directly to protest outside the building. This action was animated by the suggestion that, if the authorities were unable to move against the group and their building (which had become powerful symbols of the malevolent forces of racism and fascism), this urgent task would be undertaken by anti-racist demonstrators themselves acting in the name of their ideals and the prospect of multicultural community waiting to be born in that area. This demonstration, also held on Saturday 16 October 1993, pitted a large number of protesters against a considerable formation of police in riot gear that had been deployed to protect the neo-fascists from the wrath of the anti-racists.

The details of the violence that followed are interesting but not essential to the points being explored here. The physical confrontation between these groups resulted in forty-one demonstrators being injured. Nineteen police were treated for their injuries. Four of them were detained in hospital overnight. Conflict over the behaviour of marchers erupted after the event. This was something more than the routine cycle of mutual denunciation. In particular, the police claimed that anti-racist marchers had singled out black officers and made them special targets for hostility and attack. One policeman, Constable Leslie Turner, said he had been attacked because he was black. He told the newspapers, 'It was white demonstrators. There were no black people there that I could see. They singled me out as being a traitor.' Whatever his thoughts to the contrary, it is possible that PC Turner's plight might well have been worse if there had been larger numbers of black protesters around that day. On the scale of human suffering which ends with brutal murder, his experiences may

seem slight, even trivial. His story of victimage may even have been fabricated to win new legitimacy for a dubious police operation. But I want to proceed as if, almost irrespective of what really happened, there was indeed a measure of truth in what he said about that demonstration. What if he *was* attacked as a traitor? What if he *was* assaulted by angry people on the basis that by being a black police officer he had somehow violated the political position that they imagined to match his body? What if the mob was not alive to the irony of his being deployed in defence of neo-Nazis? What if they too succumbed to the vicious logic of racial typology?

This tale is being told here in order to conjure up some of the substantive problems lodged in the way that people conceptualize and act upon racial difference. If dedicated anti-racist and anti-fascist activists remain wedded to the most basic mythology of racial difference, what chance do the rest of us have to escape its allure? If the brutal simplicity of racial typology remains alive even in the most deliberate and assertive of anti-fascist gestures, then perhaps critical, avowedly 'anti-essentialist' intellectuals are asking too much when we inquire about the renunciation of 'race', or when we aspire to polychromatic and multi-ethnic utopias in which the colour of skin makes no more difference than the colour of eyes or hair.

Recently, it has become commonplace to remark that, however noble, the idea of anti-racism does not communicate any positive affirmation. What, after all, are anti-racists in favour of? What are we committed to and how does it connect with the necessary moment of negation that defines our political hopes? There are difficulties in framing those objectives, utopian and otherwise. I see this as a small symptom of a larger, chronic problem. The history of racism is a narrative in which the congruency of micro- and macrocosm has been disrupted at the point of their analogical intersection: the human body.

The order of active differentiation that gets called 'race' may be modernity's most pernicious signature. It articulates reason and unreason. It knits together science and superstition. Its specious ontologies are anything but spontaneous and natural. They should be awarded no immunity from prosecution amidst the reveries of reflexivity and the comfortable forms of inertia induced by capitulation to the lazy essentialisms which postmodern sages inform us that we cannot escape. To cut a long story short, what does that trope 'race' mean in the age of molecular biology? Today, we have been estranged from anatomical scale. We are more sceptical than ever about the status of visible differences which do not, for example, tell us everything we need to know about the health-status of the people we want to have sex with. On what scale is human sameness, human diversity now to be calibrated? Can a different sense of scale and scaling form a counterweight to the appeal of absolute particularity celebrated under the sign of 'race'? Can it answer the seductions of self and kind projected on to the surface of the body but stubbornly repudiated inside it by the proliferation of invisible differences that produce catastrophic consequences where people are not what they seem to be? In the instability of scale that characterizes our time, how is

racialized and racializing identity being imagined? Is there still place for 'race' on the new scale at which human life and human difference is contemplated?

The modern idea of race belonged to a certain scale. It operated within the strictest of perceptual limits. For argument's sake, let's call that distinctive ratio the scale of comparative anatomy. The idea of 'race' leaked out from those lofty confines, but always worked best through their ways of looking, enumerating, dissecting, and evaluating. More than this, the idea of 'race' defined and consolidated their typologies. It (re-)produced their methods, regulated their aesthetics, and de-limited their parochial ethics. Their truths were produced 'performatively' from the hat that 'race' provided like so many startled rabbits in front of a noisy crowd. 'Race' made sense within those novel historical conditions. It inspired the colonial anthropologies that succeeded them. Can we agree that these perceptual regimes have now been left behind? The microscopic has yielded comprehensively to the molecular. To be blunt, this means that much of the contemporary discourse producing 'races' and racial consciousness is an anachronistic and even vestigial phenomenon. Where screens rather than lenses mediate the pursuit of bodily truths, 'race' is best approached as an after-image – a lingering symptom of looking too casually into the damaging glare emanating from colonial conflicts at home and abroad.

On their journey away from modernity's inaugural catastrophes, racial ways of organizing and classifying the world have retained a special baggage of perspectival inclinations, perceptual habits, and scalar assumptions. Their anthropologies depended and still depend upon observations that cannot be wholly disassociated from the technological means that have both fostered and mediated them. This is where anatomical scale was first broken. Long ago microscopes transformed what could be seen, but the new technologies of seeing on smaller and smaller scales changed the threshold of visibility and have contributed to an enhanced sense of the power of the unseen and the unseeable. The eugenic ravings of Francis Crick, the Nobel-prizewinning co-discoverer of DNA, demonstrate exactly how the change of scale involved in the founding of molecular biology and the redefinition of life in terms of information, messages, and code was recognized as having cataclysmic moral and political consequences. Bio-politics laid the foundations for and was superseded by what can only be called 'nanopolitics'. This successor system not only departs from the scalar assumptions associated with anatomical difference but accelerates vertiginous, inward movement towards the explanatory power of ever-smaller scopic regimes.

Scientific and biological, historical and cultural, rational and irrational, skin, bone, and even blood are no longer primary referents of racial discourse. If the modern episteme was constituted through processes that forsook the integrity of the whole body and moved inside the threshold of the skin to enumerate organs and describe their functional relationship to an organic totality, the situation today is very different. The same inward direction has been maintained and the momentum increased. Forget

totality, the aspiration to perceive and explain through recourse to the power of the minute, the microscopic, and now the molecular has been consolidated.

In a space beyond comparative anatomy, the body and its obvious, functional components no longer delimit the scale upon which assessments of the unity and variation of the species are to be made. The naked eye was long ago recognized to be insufficient to the tasks of evaluation and description demanded by the condition of everyday extremity and the eugenic answers to its manifold problems. It is more than technological changes which make what was hitherto invisible not only visible but decisive also.

Nuclear magnetic resonance spectroscopy is one of several innovations to have transformed the relationship between the seen and the unseen. Whether we are spelling out the IBM logo with atoms of xenon or dreaming of gaining control over the big world 'by fiddling with the nanoscale entities of which it is composed', the movement is always in one direction: downwards and inwards. Our question is this: where does that leave racial difference, particularly where it cannot be readily correlated with genetic variation? Current wisdom seems to suggest that up to six pairs of genes regulate skin 'colour'. They do not comprise a single switch.

Michel Foucault, whose early work explored useful historical precedents for the contemporary shift towards nano-scale, is a frustrating guide to these problems. He seems to have been insufficiently attuned to the significance of protracted struggles over the unity of 'mankind' that attended the emergence of bio-politics and appears disinterested in the meaning of racial differences in the context of anthropology's presentation of the species as a unified object of knowledge and power. To put it simply, though he identified 'man' as both the pivot and the product of the new relationship between words and things, he moved too swiftly towards a sense of modern humanity unified by its immiserating passage from sanguinuity to sexuality. He failed, for example, to consider how the idea that Africans and their New World descendants were less than human might have affected this transformation and it epistemic correlates. Perhaps he was not haunted, as I have been, by the famous image of an orangutan carrying off a Negro girl that comprises the frontispiece of Linnaeus's A Genuine and Universal System of Natural History. The central, inescapable problem in that picture is the suggested kinship between these species rather than the fact that their conflictual interrelation is figured through the idea of rape. The extensive debate as to whether Negroes should be accorded membership of the family of 'mankind' (a group whose particularity was inaugurated, proved, produced, and celebrated by the transformed relationship between words and things that crystallized at the end of the eighteenth century) is more central to the formation and reproduction of the modern episteme than Foucault appreciated. I raise this, not to pillory him nor to reopen discussion of how that process has been reconstructed by historians of science, but rather because his study of that fateful change is an important resource in our own situation where similar processes are observable.

Nobody fills old skulls with lead shot these days. It bears repetition that the truths of racial difference are being sought by other means and produced by technologies that operate on other, smaller scales. The semiosis of anthropology has been transformed several times since the high point of skull-filling activity. Here we must acknowledge the power of vernacular race codes that have an ambivalent relationship to racial science proper. There are 'one drop of blood' rules with their unsentimental disjunctions between insides and outsides, 'pencil tests' and other shadowy technologies of alterity that discover symptoms of degeneration in the special tones of pink and red to be found at the base of fingernails. However, with Kuhn in our bookpacks, we comprehend the contingencies of truth-seeking, the pressures of institutional location, the active power of language to shape enquiry and the provisional status of scientific enterprises. Let me propose that the dismal order of power and differentiation – defined by its intention to make the mute body disclose the truth of its racial identities – is best apprehended through the critical notion of 'epidermalization' bequeathed to our time by Frantz Fanon. That idea was born from a philosopher-psychologist's phenomenological ambitions and their distinctive way of seeing, as well as understanding the importance of sight. It refers to a historically specific system for making bodies meaningful by endowing in them qualities of 'colour'. The term has a wider applicability than its colonial origins would suggest. Emmanuel Chukwudi Eze and Christian M. Neugebauer have reminded us recently, that Kant's *Physische Geographie* said more than his contemporary celebrants like to admit, about the qualities of Negro skin and the practical problems it presented when pain had to be inflicted with a split bamboo cane.[1] Like Hegel's well-known opinions on the Negro and the limitations he placed upon the African's capacity for historical development, these sentiments can be thought of as exemplifying epidermal thinking in its emergent form.

 In an era where colonial power had made epidermalizing into a dominant principle of political power, Dr Fanon used the idea to index the estrangement from authentic human being in the body and being in the world that colonial social relations had wrought. Epidermalized power violated the human body in its symmetrical, intersubjective, social humanity, in its species being, in its fragile relationship to other fragile bodies and in its connection to the redemptive potential inherent in its own wholesome corporeality. Fanon's notion supplies an interesting footnote to the whole history of racial sciences and the exclusive notions of colour-coded humanity that they specified. Has anyone ever been able to say exactly how many 'races' there are, let alone how skin shade should correspond to them? Buffon had counted thirty races of dogs. Initially, Linneaus thought that *homo sapiens* included four varieties while the other species that comprised the genus *homo* (*homo monstrosus*) had its own numerous affiliates including *homo troglodytes*. Kant identified four races of man: the white, the black, the Hun and the Hindustani. All dealt differently with the question of whether the differences within races were as significant as the differences that might exist between them. In the

1 'Alle Bewohner der heissesten Zonen sind ausnehmend träge. Bey einigen wird diese Faulheit noch etwas durch die Regierung und Zwang gemässigt' (Kant, *Physische Geographie*, 1802, quoted by Christian M. Neugebauer 'The Racism of Kant and Hegel', in H. Odera Oruka (ed.), *Sage Philosophy: Indigenous Thinkers and Modern Debate on African Philosophy* (Brill, New York, 1990). Emmanuel Chukwudi Eze, 'The Color of Reason: The Idea of "Race" in Kant's Anthropology', in Katherine Faull (ed.), *Anthropology and the German Enlightenment* (Association of University Presses, London).

period since, distinctively modern racisms with their scientific flavours joined hands with common-sense perception by making the external surface of the body the focus of its gaze. With the body figured an epiphenomenon of coded information, this aesthetics is now residual. The skin may no longer be privileged as the threshold of identity. There are good reasons to suppose that the line between inside and out now falls elsewhere.

Revenge

SUE GOLDING

As I come from a military world, I do so hesitate to take the name
of violence in vain. (Master Johnny-Boy, *Memoirs and Sayings*)

[But] how could you *not* do that? (Nietzsche, *Beyond Good and Evil*)

Is 'living well' life's best revenge?

11e. I started thinking about revenge as if a practical solution to a
problem: someone in the world of theatre had done something humiliating
and brutal, which I knew about (indeed, was the very target of those
stings) – a person who was not only *not* being seen as having done the
deed but was being credited with uprightness and in the full bloom of
glory. I was amazed; I seethed. And I thought.
 As if to consult the oracles, I went back in time to the Babylonian
moment of the Judeo-Muslim desert world, a world whose coinage 'an
eye for an eye, a tooth for a tooth' wildly comforted a blood-boiling rage.
And it is written:

> *Of retaliation short of life.* If a person wilfully strike off the hand of
> another, his hand is to be struck off in return because it is said in the
> Qur'an (Surah v.49), 'There is retaliation in case of wounds.' If a person
> strike off the foot of another, or cut off the nose, retaliation is inflicted
> in return. If a person strike another on the eye, so as to force the
> member, with its vessels, out of the socket, there is no retaliation; it is
> impossible to preserve a perfect equality in extracting an eye. If, on the
> contrary, the eye remain in its place, but the faculty of seeing be
> destroyed, retaliation is to be inflicted, as in this case quality may be
> effected by extinguishing the sight of the offender's corresponding eye
> with a hot iron. If a person strike out the teeth of another, he incurs
> retaliation: for it is said in the Qur'an, 'A tooth for a tooth.' (Surah
> v.49) . . . There is no retaliation for the tongue or the virile member.[1]

1 T. P. Hughes, *A
Dictionary of Islam* [1885]
(Lahore, 1996), 481–2.

Revenge, as it is written: Tracking the footsteps of an enemy; rightfully
getting one's [self? pride? self-as-pride?] back. The law – not the rule –
the law of retaliation. *First crisis of conscience.*

12e. I would like to state at the outset that I am not the slightest bit

interested in purity or any of its related paraphernalia: the perfect, the flawless, the pure event, pure transcendence, pure object, pure subject, pure lack, pure violence, pure morality, pure identity, pure mastery. I dislike the subject of purity; probably dislike even more those who try to achieve it; and I do so with a honed and malevolent vehemence reaching, almost, the pure itself. But it does not reach it; and it never will. For this is the lowly, warped flight path of cruel humiliations we so lightly call 'spice of life'. *Second crisis of conscience.*

13e. Today I want to speak – no, shout – in a monstrous tongue, whose monstrosity lies precisely in the neither/nor-ness of its calling. I want to sport the language called revenge, but there is a certain difficulty. For revenge seems but a sign of life writ large only in the middle distance of time – the seeable horizon sitting just a little over there, picking its teeth and beckoning; the evenning of odds almost within one's grasp. But consider this: could you, would you, accept its terms? Are you physically, mentally, spiritually, emotionally, dedicatedly prepared – to sign on the dotted line? Bonus consideration: Do you have the right outfit? Answer first this skill-testing question: What is the condition of the unconditional? *Third crisis of conscience.*

14e. I will start again; this time borrowing from Paul Monette's *Borrowed Time*:

> If every minute of the nineteen months was worth the struggle, reclaiming a corner from death, some moments were the most exalted of my life. The sheer gratitude after coming through fire is so profound, so first-things-first, it makes you laugh inside when people say you are brave . . .
>
> The protocol for the dressing change was an enormous responsibility, but I champed at the bit to learn it. Finally, something to *do*. And when you do this part you come to see there's something nearly sacred – a word I can't get the God out of, I know – about being a wound dresser. To be that intimate with flesh and blood, so close to the body's ache to heal, you learn how little to take for granted, defying death in the bargain. You are an instrument, and your engine is concentration. There's not a lot of room for ego when you're swabbing the open wound of the eye.[2]

2 Paul Monette, *Borrowed Time: An Aids Memoir* (Abacus, London, 1996), 263.

Sad. I am very sad. So very very sad. And a little exhausted too. Just a little. Sometimes I am merely a stain of the blood I once was; sometimes, just the spectre of that stain. Revenge: a certain luxury in an Aids-drenched world; a certain property of the 'bigger picture'; a certain stylistics of existence. *Fourth crisis of conscience.*

15e. Actually, I'm one with Monette: I have oceans, galaxies, salty harsh tidal waves, of unresolved rage. But towards whom? And is there a 'statute of limitation' for how long a grudge can be held? Revenge, responsibility and justice: assumption that they are mutually

exclusive, especially if there is no pin-pointable enemy. *Fifth crisis of conscience*.

16e. When identity becomes a physical, biological ticking of the T-cell time-bomb count, when space becomes the floating border of the doctor's (prison) sentence: HIV positive, says Monette, but non-symptomatic; or symptomatic but borderline treatable; when time and space collide, mutate, become the virtual-but-not-quite-sustainable virtual matter: you run with all your might and go exactly nowhere.

It varied a great deal from case to case, we were told: 'Two months, three months, six months . . . ' I longed for him to go on and fill in the ellipsis and give us longer, but in fact it was all guess work. I remember bargaining in my head when he said [it], hungry for the whole six months. He went on to reassure us that the most important element was how treatable the infections were, with progress being made all the time. But time itself becomes so pregnant when it's hardened into a number . . . Time is the number you fight – two, three, six, all these laughable integers. Where had the tens and hundreds gone?
 . . . The fact is, no one knows where to start with AIDS. Now, in the [sixteenth] year of the calamity, my friends in L.A. can hardly recall what it felt like any longer, the time before the sickness. Yet we all watched the toll mount in New York, then in San Francisco, for years before it ever touched us here. It comes like a slowly dawning horror. At first you are equipped with a hundred different amulets to keep it far away. Then someone you know goes into the hospital and suddenly you are at high noon in full battle gear. They have neglected to tell you that you will be issued no weapons of any sort. So you cobble together a weapon out of anything that lies at hand, like a prisoner honing a spoon handle into a stiletto. You fight tough, you fight dirty, but you cannot fight dirtier than it . . .
 I have friends who will not be tested at all because they know how shamefully glad they'll be. Their gut instinct is they're negative, so who are they trying to kid? . . . My own consistent opinion is selfish enough and sounds suspiciously Orange County. I want the two million – or the five million, depending on whose scenario piques your fancy – to have themselves tested and know, so I will have people to talk to . . . I want to tap into the rage of the positives so we can throw buckets of sheep's blood on the White House lawn and spit in the faces of cops with yellow gloves. (Monette, 1996, 118, 2)

Identity as diseased rant playing hard at charades – sounds like: revenge, now as a spot of sameness tinged with difference steeped in honour. But to whom does this matter *really* matter? *Sixth crisis of conscience*.

17e. And as she sat there, watching relentless waves slapping unspoilt sand and rock, singing of sirens and shipwrecks and blue-bottled vipers, the poison flowed silently from all her (semi-bandaged) wounds. The salted beat beatings, strangely reverent and cruel and rhythmic, clothed

her, and the darkness gave her life. A seagull eyed her for quite some time; they exchanged a knowing glance. Caught as she was, between the calmness of its wings and the violence of the crashing, watered sense of rough, she remained there, wrapped in the oddly comforting surface of her – absurdity. A rather bewitching aloneness: she could not, would not budge. Immobilized, riveted, she laughed out loud and for the first time, in a very long time, she relaxed, on holiday from the usual banalities of rape and blood, and senseless stabbings of her soul and its mates. Revenge, as a kind of leisured memory, writ tiny tiny in the ironic mutiny of it all. *Seventh crisis of conscience*.

18e. So now I want to play a game. Let it not be doctor or house. This game will have no known rules; well no rules, except one. The players will be issued seductive little chits of many colours, though none of them primary. The game will stretch well into the night with plenty of liquor for all. Hairstyles are secondary, though not unimportant. As it will be taking place worldwide, telematically sported on satellites everywhere, thousands, no millions, will be able to place bets on their favourite players. Timing – not time – is (to be) everything, and indeed is the bottom line. The one rule: revenge must hold out the possibility of hope. *Last crisis of conscience*.

Note

Probable excerpt from the English version, in my *Commentary over Theory*, vol. II (New York: A-B Press), pp. 12–15. Reality: variations on this piece have been presented at the kind invitations of: Professor Christopher Fynsk, Chair, Comparative Literature Department, and Professor Bill Haver, History Department, Binghamton University, New York (April 1996); Professor Barry O'Neill, School of Organization and Management, Yale University, Connecticut (May 1996); and Professor Penny Siopis, Chair, Fine Arts Department, The University of the Witwatersrand, South Africa (August 1996).

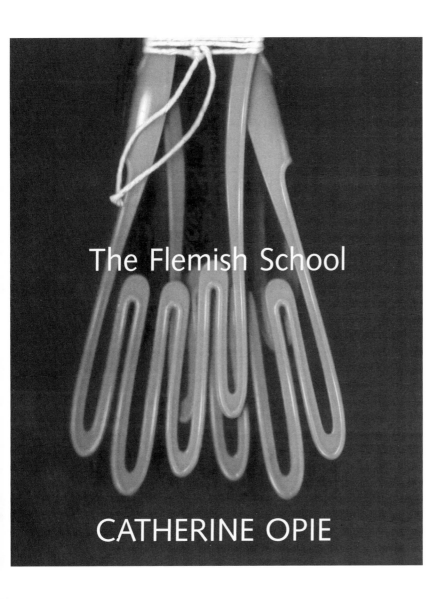

The Flemish School

CATHERINE OPIE

Mike and Sky, 1993. Chromogenic print, edition 7 of 8, 20" × 16".

Mitch: Race, Class, Gender, 1994. Chromogenic print, edition of 8 20" × 16".

Darryl 2, 1993. Chromogenic print, edition 1 of 8, 20" × 16".

Self-portrait/Pervert, 1994. Chromogenic print, edition 6 of 8, 40" × 30".

LETTER TO THE EDITOR

RAZOR.
STATION.
MUM.
BACON.
STRIKE.
CABLE.
BROLLY.
CODEINE.
TELLY.
TRACKS.
MIRROR.
DRAIN.
"VICTIM".
YESTERDAY.
DOLLY.
HEAVEN.
BABE.
MAZE.
YOUNG.
SPECTRE.
SIN.
EXCISE.
"BIRDIES."

RAZOR.
STATION.
MUM.
BACON.
STRIKE.
CABLE.
BROLLY.
CODEINE.
TELLY.
TRACKS.
MIRROR.
DRAIN.
"VICTIM".
YESTERDAY.
DOLLY.
HEAVEN.
BABE.
MAZE.
YOUNG.
SPECTRE.
SIN.
EXCISE.
"BIRDIES."

Nomadism

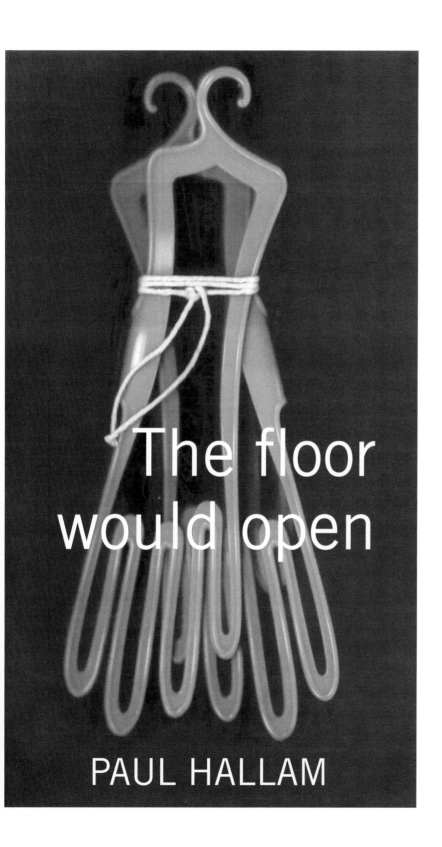

The floor
would open

PAUL HALLAM

Red in the face and riveted. Caught out, caught short. Put on the spot. Momentarily blocked. The need to be someplace else, or better still, invisible.

Embarrassed, single *r* or double *r*? I have a word book, usually on the desk. My own private dictionary. *Embarrassed* is high on the list of words I frequently misspell. Words that worry me. In a note, or a diary entry (the diary – a refuge from embarrassment), I might shorten it to 'embd' or refer to my 'embnt'. Abbreviate to avoid the double *r*, double *s* problem. I don't like to misspell, even to myself.

Embd: In the past year, my reference library, the word book included, has been in storage. I've had to manage without. This in a year when the word has come to obsess me. *Obsess* or *obssess*? Another on my personal spellcheck. It isn't rare words I can't spell, it tends to be the words I use and think about often. Embarrassed, I look it up in someone else's dictionary to discover its Spanish root. *Embarazar*, an obstacle on the way, an impediment. Something that stops the journey short.

I've been wandering from place to place, with next to no money in my pocket. Financially embarrassed. Usually house-sitting and dealing with unfamiliar forms of ansaphones, faxes, coffee makers and washing machines. So many kinds of window locks, all manner of keys and security concerns. Acutely aware of every mark I make, fresh stains, the tear in a well-worn duvet. My blots on other people's landscapes. Some friends use place mats, others relish the worn look of rings on wood. Are the plugs kept in or tugged out? Left switched on at the socket or always switched off? Entering each home, half of me feels like a guest, half like a thief, groping my way. I locate the light switch, approach warily the 'welcome' notes. From 'make yourself at home' through to detailed essays on rules concerning.

Setting up camp in a corner. My own things, a few bags excepted, locked away in 'Self-Storage', a business that thrives in converted Victorian factories and under railway arches in run-down parts of the city. My books are piled floor-to-ceiling in an unmarked steel room, on an upstairs landing, behind a padlocked door, overseen by a bank of security cameras. The man laughed at my security insecurities. It wasn't likely to be my books any burglar would be after. My room one of hundreds of identical rooms, hiding multiple and doubtless dubious stored-away selves.

Curious and awkward, once the basics of each new home is mastered, strange sounds identified and the corner shop found, there's a relief. The joys of other people's possessions. Touching and tasting. Their records and books, their clothes and their porn. Traces of sex. In most of the gay

households, at least, it's palpable. Toys and tapes, treasured porn mags kept for years.

Dislocated and tired, the shoulders ache from the bags. Usually, once settled, in silence at a strange table or in a strange bed, I'm content. Not that everyone needed sitters, sometimes the tenants were still home. Other people's sounds as they wake, their anxieties, their routines and rituals, their bills, family habits and rows. I've stayed in all manner of homes in the past year. As a temporary guest I want to be near-invisible. Broke, I'm conscious of every bulb that goes, every battery gone flat. My every class, food and eating habit exposed. The hosts must feel much the same. Hosts and hospitality, the simpler the better. Minimal embnt.

It's all very well, this moving on, and it began with a genuine optimism. A desire to put away my books, to be mobile, a portable Paul Hallam. I had no real address. It would be a relief to be away from the post, the shower of bills and demands. They'd even phone you at home, it shocked me that they could. A rent I couldn't afford and a social security system I couldn't and didn't want to handle (a system devised to discourage, a guarantee of insecurity).

I'm easily embarrassed in the face of authority. Escape isn't easy. On the move, no fixed abode, can I register to vote? Am I 'eligible' for Council Tax? I'm trapped. Do I complicate my life and risk complicating the lives of friends, register at each short stop? How many days can you stay somewhere without registering? I couldn't bring myself to ask. For a short while I joined the non-persons, the millions of the unregistered.

This is hard for someone who, faced with a bus conductor will wave my hand and fare in the air, 'you've missed me'. Out of fear more than honesty. Disproportionate fear. The penalty perhaps for being 'brought up right'?

When London Transport put up photographs of people caught, fare-fiddling, frozen in the glare of fellow passengers, I wanted to tear them down. The ad agency responsible knew about embarrassment. How the consequences of the odd misdemeanour could suddenly become mortifying.

Authorities and forms and uniforms. Travel, wandering, I thought I might take a break. Well, they didn't go away, the inspectors. I conjured up scenarios of future repercussions. Future embnt. Just where were you exactly between June 1995 and June 1996, Mr Hallam?

Wandering. It's odd that travel books are marketed as tales of the intrepid. My suspicion is that the embarrassed move on more often than the brave. When I'm lost, trapped in lies, mostly around money, it's then that I need to leave. There is a whole history of fraudsters and bankrupts changing names, changing places. Should you choose not to jump off the financial tower, or into the sea, what option is there but to set up someplace else? When you can't afford the bill, let alone that flustering and universal cause of embarrassment – the tip – take off. Get out fast, leave, exit by the back door, under the proverbial cloud.

Go someplace else, where at least the embarrassments will be fresh. Head for the hills, no not the hills, grand landscapes disturb me, demand attention and appropriate awe. Escape to the sea. Escape entanglements, leave everything that threatens to last for ever. Break the circles and the seals. Staring out to sea, as unsociable as you can get, and as unembarrassed. But it's all very well, this staring at the sea, the wandering, the loose uncommitted eroticism, the unproductive joy. But I've missed the detailed pleasures of my own place. Every crack and corner. Home as a place to hide, unblushing. Home, traditionally communal, for me at least, a relief from community.

Constantly exposed, in this year of wandering, to other people. A nomad, dependent on the next oasis. Reliant on friends, friends of friends, and sometimes total strangers. Surrounded too by their attention-demanding plants and pets and pests. Moths, mice, dogs, cats, ants. Creatures to be kept, creatures to be killed. Even a displaced duck, nesting at a friend's, off the Mile End Road. Not a pond in sight. Me watching her watching over a nest of nine. A rabbit headed for the bolt-hole. Do rabbits slow their pace once secure inside the warren? Camel-like I keep going for days. Hedgehog, tortoise, snail or a duck out of water. For someone not enamoured of animals, there was a lot of identification going on.

Losing a sense of refuge, of home not just as hearth but as a place to look out from. I set out confidently asserting that an address was not entirely necessary. Not with a mobile phone and a laptop. I should have known.

The mobile phone, for me, was neither a plaything nor a pressing need. Just somewhere for people to drop off messages. Few did. I hate using the phone in public, though I enjoy hearing others on theirs. The unembd. Phone, computer, clothes, current projects, the odd book. I prefer to move my bags by bus. A taxi would relieve the shoulder, but cabs necessitate cost and, worse, conversation. Just when you need quiet. I'm at home on the bus, once the awkwardness of squeezing the bags by the fold-away pushchairs is complete. The anonymous passenger.

Embd. The desire to disappear. On the move. It must look mad and suicidal at times to those more settled. To be not exactly in the world, but not out of it either. Unnerved, unhinged.

The portable computer. The laptop, light enough. But the printer altogether too heavy for one on foot or bus. Without the printer the words feel illusory, files of air. If I wrote, it was mostly notes. On the move, but pressed to present a front of hard work. Crowded with new impressions, I welcomed less than ever the question, 'Have you managed to work?' or 'What are you working on now?' Fear maybe. Losing face. Losing in front of the home crowd. The glare of contemporaries. 'New project?' Yes. How to get from A to B and back again. Will I manage without the correspondence files, the old project notes, the warm jacket? I'm embarrassed by the work question. I'm also quietly livid. A sense of failure in the embarrassing present. Seeking refuge in the past, old resentments and rejections, and the occasional success.

Refuge in invisibility. Moving in, amongst, around, through. Unnoticed, watching, undemanding. Not drawing attention. But every so often falling over, hitting that awkward embd moment, I feel found out.

In strange territory. I might not wear the T-shirt, speak the language, but I can still enjoy it. Family language, a foreign language, a technical language. I can read almost anything with pleasure. Old textbooks, educational part works, encyclopedias, dictionaries. I love to dip in. Books on mining for example. I collect them. Son of a miner, whole seams of mining books, now in self-storage. Dad had just the one, *Safety At Work*. I've got a library. A project came up, a kind of competition for a film on the changing nature of the Nottinghamshire coalfields. Where I'm from. I suppose I was a bit embd, back in my home town, by my never having been down the pit. And I couldn't deal with going back, in a year with no home, to the subject of home. Ended up trashing it.

1. INT. MINE – DAY.

JOHN and JIM, two older miners, work, stripped to the waist. Rippers, hacking away at the coal-face. In water and in dust. The din of a mechanical cutter in the background.

The miners look like pin-ups from a *Soviet Weekly* Hunk of the Month socialist realist calendar.

They break for 'snap', tuck into thick-sliced white bread. Sandwiches from ancient, battered metal snaptins; water swigged from flasks.

They're joined by MARK and JEFF, two younger miners, in their second-best torn Calvins. MARK and JEFF carefully unwrap what look like takeaways from Prêt à Manger. Croissants and Evian water.

A sad faced and studious STEPHEN watches them. Caught in the light of his helmet lamp, a tear trickles slowly down his cheek.

JOHN wraps an arm round STEPHEN's shoulder.

<div style="text-align:center">

JOHN
Cheer up, scholar.

</div>

Didn't get the job. Perhaps I'll return to it. Couldn't quite face it. Comedy and porn, the old refuge. I started the story, it just wouldn't shift. Embd: as a writer struggling with narratives. Stories, I envy the skills of good tellers. I keep going back to the 'I'. Here for example. It's embarrassing.

Perhaps the most effective, if retrospective, 'cure' for embarrassment (the memory of embarrassment) is comedy. Look back, make a joke of it. If it's comedy with a sexual twist then so much the better. Competitive and comic self-exposure is increasingly popular on TV. Home video mishaps; all manner of talk-shows; dating games; actors' blunders and slow-motion sporting disasters, endlessly replayed. Cheap TV, and the audience is vast.

Embd: by the clumsiness of conversation, and this year full of them (exposed to conversation). Embnt: forever going over what was said, things left unsaid. Write, in part from impatience with speech. The relief of research, the desk, or more precisely, the relief of a bath, once the work is done. I'm not at all sure about the writing bit.

Embd: Little done in this year of wandering. What does failure look like? Red in the face. Embd/angry. Raw. Blocked, skidding. Skid Row.

Minor embnt. Returning goods to shops. Arguing terms. Contracts. Clothes with holes. Undesigned rips. Awkward posture. Not being able to say 'no' easily or clearly. Food and money habits, made public. And smoking. Smoking. This year I've smoked in the streets and on porches, hung out of windows, wandered the rooftops, often in rain. I've sprayed fresheners, opened windows, left fans on for hours. But still I've been caught in smokeless zone homes. Totally broke, but I smoke. Paranoia. Suspect people are saying, 'if he can afford to smoke . . . ' England full of such grudges, moans, resentments. Well, I love it, love the futile smoke. Love it in others. But Smoking Causes Embarrassment and I suspect I will stop in the end. Not easy now, three burning minutes of peace.

Embd: sometimes by my very existence. Hello, I'm here. Sorry.

Excuse me. Mind if I . . .

Pardon me for breathing.

Times when I feel like a giant adolescent spot, redness erupting.
Suspect most people do. Mortified by the bad haircut, the wrong
clothes. Embd: by snoring, or rather by attention drawn to the snore.
The body and its imperfections. And, like an adolescent, when the skin
cream fails, there's always retreat. Maudlin music, sad poems. Eternally
adolescent. Relief in music. And in dance – after a drink, that is, after
the initial embnt. Taking the step. Adolescent moods, mortified verging
on murderous.

Embd by my 'negative' (I think, I've not tested) HIV status faced with the
'positive'. And the symptoms that must embarrass. Think of the
adolescent spot. Think of Kaposi's. Wearing your sex life on your face.
Think of all those embng moments. Refs to death. In front of HIV friends.
Or worse, the avoidance. Self-censoring. Save us from safe speech.
Emnbt: trying, with HIV friends, to sound 'optimistic', and wondering
who's kidding who. A friend (HIV himself) talks of Aids and kitsch, Aids
as kitsch. Aids and safe-sex campaigns have been round long enough for
people to feel, if only secretly, superior. Aids and distaste, Aids and bad
taste – look at much of the art, the excruciating cheer of fund-raising
events.

Embd by forgetting what others are going through, even with best friends.
Can you remember exactly what it was to them, when those close to them
broke up, broke down, or died? What happened? How old were they at the
time? What was that rare cancer? Details of grievances and anniversaries
of grief. In a city, with so many stories, and without reminders (names
you never had a face for, places you can never quite picture). Sorrows
and angers confided, perhaps once over whisky. It's assumed you'll
remember. It's easy to forget, and hard to admit to forgetting. The embd
bluff.

Another friend laughs at all news of death. He can't seem to find the
'appropriate response'. He'll go bright red. Embd by death. Embd to
death.

Embnt: in the face of beauty for as long as I can remember. In recent
years, many of the beautiful 'positive'. Working out, on diets and
proteins, supplements and pills.

The Unembd. Those who have no vices to be embd by. The fully fit.

There's an attraction to the unembd. I saw a group of handsome thugs on the front of a Sunday paper. I stopped to look and read the caption. A march through Auschwitz in 1996, a protest against the Jewish 'monopoly' of the Holocaust. Fascinating fascism, maybe. For a few seconds, then fury.

Unembd politicians, except when caught, pants down. A boy in the bed. Or photographed, with the public, pressing flesh they'd clearly prefer not to press.

Pub bores. Easy moralists, purveyors of proverbial wisdom. Fundamentalists of all kinds. Loud voices in restaurants, making a meal of complaint.

Embnt: curse/charm and its element of envy. I relish confidence, fuck-you styles and 'attitude' in others. Embd because you care what people think, or think you do. Worried about your image in their eyes. Small wonder the anarchically unembd create such delight. I might prefer a more furtive approach, but the punk and pervert on the pavement, the sight always pleases me. In a club, at home, they'd be part of a scene. Out in the streets, I love their never-ending game, the unnerving of the unembd norm.

The unembd. Face painters, community artists and clowns. Fret-free, never red. Buskers who try to catch your eye as you look away. Those who trap and trip, demand attention or, like death, an 'appropriate' response. They catch you, these characters, deliberately in broad daylight. Embd by them? Face it. You're embd on their behalf.

Back to the night. Theatres, safely seated in the auditorium dark. No participation. Laughter and tears, anonymous. Or the private entertainment. The unhurried pleasure of porn, or of gossip and friends' stories of sex. I might be embd by my own drunken revelations, I'm rarely embd by other people's. Those who fuck quickly and often. Not my style, I admit. But a style I approve. I'd be embd in the park, in the cottage. Fail in the quick fuck stakes, I know it. Sorry – I want to linger awhile, there'll be trouble turfing me out in the morning.

Couldn't believe my luck that night. A new kind of first time. The boy, whose neck my eyes had followed turned, smiled and then stated the price. Back-alley rates or bed? I wanted time. He wanted a taxi. We talked at a bus stop, I said they were frequent. We waited, I wondered. Was travel time included? He was hungry. I imagined the food bill. He said a sandwich would be fine. Quick trick or talk? He seemed happy to talk, and nothing, but nothing was quick. All kinds of embarrassment entered and ended.

Move on. Take a break, go on holiday. Give those guide books a miss. Guides to gay sex in seven languages, a new breed of books, extra baggage. Just what you don't need, more weight on the shoulder. Words you want away from. Useless at languages? Enjoy the strangeness of new sounds, play guess the meanings.

Do I want refuge from embnt? Or revenge for it? Red rarely forgotten. Put it to use? In bed for example. Ease the embnt of need, whatever you want, no need to hide here. Any means necessary, give it a try.

Enjoy, unabashed, the spying and the solitude. What matter? Take time. Hold back on announcements. Wait and see. Relish too the next fiver in your pocket, brief respite, when confidence and comedy return. Graze the surface or go underground.

Book a seat in a darkened room, where surprise can be welcome. No one will catch your reaction. Repetition. Go back to the porn, tried and tested. Dates and diaries, calendars, collections. Write it down, get a grip. Copy and steal. Revisit. Think of the achievement. Three makes of coffee machine finally mastered. Well it's some kind of start.

Embd. Exhausted. This effort to do right, worse, the need to be seen to do right. Sod the concern about what others might think? Then again, imagine no concern at all. Embnt. What to avoid, what never to repeat. Don't bother them, don't let them bother you. You don't affect them as much as you think. Withdraw awhile, stay put.

I think I've found a place to live, though I doubt it will be the form-demanded 'permanent address'. A bit embarrassing, the name, Brodlove Lane. Formerly, more fetchingly, Cut-throat Lane.

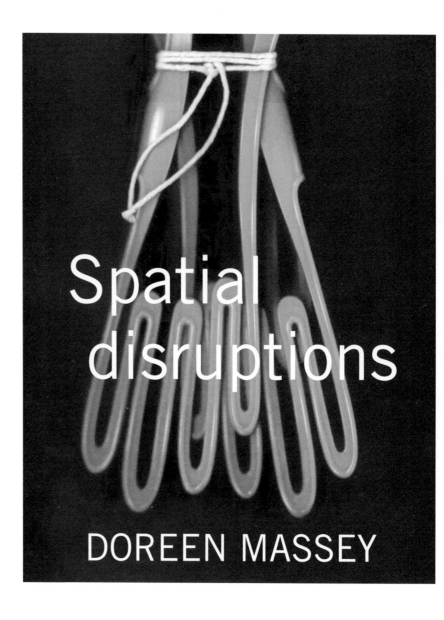

There is this notion that space is orthogonal to time. You take a cross-section through all the movement and flux and development . . . a slice through time . . . and there you have it – *space*.

Space as the layout of things, caught in a moment
or space as the structure of the whole, held in an a-temporal synchrony.

Space as cross-section
or space as the structures of the structuralists.

Space as representation, as the fixation of meaning.

The contemporaneity of the instant
or the a-temporality of the structure.

It is a view (or a set of views, actually) authorized by an assumption so deep it seems impertinent to mention it.

I arrived in this new city (new to me, there's been some vital meeting and mixing of people on this site for centuries) quite abruptly. Emerging out of the railway station almost at its heart. How to know where I was, how to find my way around? Obvious. I go to a kiosk and buy a map. In the station café I open it out. The map (official/tourist)
 is a cross-section of the city
 it holds the city still for me while I sort out where I am
 it shows its links and interconnections
 it is a representation of the city
 (it is, of course, a *particular* representation, but right now (a) I don't care, and (b) it's the one I want. I'm tired, dirty, and I need to find my hotel).
 And sure, the map helps me get around. I pay, and set out to where I'll be staying.

*

A static cross-section exhibiting to view the interconnections between things. *A slice through time.* A map of the order of things. It is thus that many think of space.

> . . . "the (voracious) property that the geographical system has of being able to transform action into legibility, but in doing so it causes a way of being in the world to be forgotten." (de Certeau, 1984, 97)

> . . . "any representation of a dislocation involves its spatialization. The way to overcome the temporal, traumatic and unrepresentable nature of dislocation is to construct it as a moment in permanent structural relation with other moments, in which case the pure temporality of the 'event' is eliminated . . . this spatial domesticization of time" . . . (Laclau, 1990, 72)

But a map is not space.
And the spatial is not representation.

> [There is a queerness – or not – anyway in this designation because space is so often understood as Time's other, its subordinate negatively-defined support (Massey, 1992). Time as the privileged dimension: space as a lack of temporality. Space as immanence, Being, female.
> Or so they say, usually without saying.
> A classic binary.

[Aside]

> Yet here is 'space' as the dimension of comprehension, whether that is positively understood (the classic structuralists) or by suggestion denigrated as (necessary) ideological closure. Space, the subordinate term, seen as having the power to break Time's flow.

> . . . "modern accounts of history and temporality have been guided by attempts to capture the passing moment within a spatial order" (Walker, 1993, 40–5)

. . . "temporality must be conceived as the exact opposite of space. The 'spatialization' of an event consists of eliminating its temporality" (Laclau, 1990, 41)

. . . "A strategy assumes a place that can be circumscribed as *proper* (propre). . . Political, economic and scientific rationality has been constructed on this strategic model
. . . "The 'proper' is a victory of space over time" (de Certeau, 1984, xix)]

Any view of space implies a view of time. If space is a slice through time then history is impossible. This kind of space implies a homogeneous linear progression, a time dimension which 'is infinitely divisible, so that spatial reality may be chopped up into instantaneous slices of immobility [my map, indeed] which are then strung together again with the "time line"' (Ho, 1993, 171). Louis Althusser said much the same thing about Hegel's '*coupes d'essence*'. Space as the binary opposite of Time makes history no more than a sequence of snapshots.

*

It is possible to find, in second-hand bookshops, old maps of the city. Other cross-sections, other slices through time. The city as a tiny cluster of houses around a fortification at the river's mouth. The same city become a medieval market town, a cathedral built from agricultural surplus, and the very beginnings of urban sprawl. A sequence of maps. You can sit and stare at each in turn, but they won't tell you how the city made it from one to the next. Maps (these kinds of maps) are representations in which temporality is repressed. Space as the absence of time.

[*Aside*]

["This kind of map represses temporality." (Note: represses – in fact even these have a temporal code [Wood, 1993], both a tense and a durational thickness/depth. How, for instance, do you decide what's long-lived-enough to put on it?) But anyway there are other kinds of maps. On both sides of the Atlantic – and more than half a millennium ago – maps bore witness to a pre-Columbian integration of space and time. *Mappae mundi* told a story, in the Ebstorf map (constructed circa 1240, destroyed in the Second World War) time and space are indivisible (Harley, 1990, 11). Toltecs, Aztecs, Mixteca-Puebla integrated location in time and space.

(Of course they got their distances wrong, and the shapes look most peculiar. . . "Such world maps (*mappae mundi*) used to be dismissed by geographers for their lack of realism. But today we read the Ebstorf map as a Christian metaphor in which time and space are indivisible" [Harley, 1990, 11].)

"unscientific", "metaphorical", "religious". . . but they do not separate time and space. Here it is not the spatial which is assumed to fix the temporal, but representation which fixes space-time.

These maps, too, though, were ways of placing oneself in a universe. The cognitive mappings of five hundred years ago. Attempts to grasp, to invent, a vision of the whole; to tame confusion and complexity, to bring them within one story.]

*

. . . "Newtonian time, in which separate moments, mutually external to one another, are juxtaposed in linear progression, arises from our attempt to externalize pure duration – an indivisible heterogeneous quality – to an infinitely divisible homogeneous quantity. In effect, we have reduced time to Newtonian space, an equally homogeneous medium in which isolated objects, mutually opaque, confront one another in frozen immobility." (Ho, l71)

Space must be temporal; must incorporate process.

*

What's more, the map-which-is-assumed-to-be-the-same-as-space is concerned with links and interconnections. (I can find my way to the hotel.) And these links and interconnections are (a) *instantaneous*

"The 'solution' to a juxtaposition – Alaska, Lebanon– that is not yet even a puzzle until it is solved – Nasser, Suez! – no longer opens up historiographic deep space or perspectival temporality of the type of a Michelet or a Spengler: it lights up like a nodal circuit in a slot machine . . .
. . . "history has become spatial, . . . " (Jameson, 1991, 374)

This is orthogonality again. Time as an arrow. Space as instantaneous interconnection. And you can have either one or the other. Each excludes the other. Each invalidates the other. It's not on.

[*Aside*]

[You end up with exactly the problem Plato faced in *Timaeus*
. . . "We must in my opinion begin by distinguishing that which always is and never becomes from that which is always becoming but never is" (Plato, *Timaeus*, 40) . . . precisely the mutually exclusive orthogonality presumed of space and time. "*Chora*", then, would be that same excluded term in search of which have gone Heidegger, Benjamin, Ricoeur (thoughts of *jetztzeit*, and durational now) in their attempts to mediate what had previously been separated.]

The connections are also assumed to be (b) *complete*. The synchronies of the structuralists, the spatialization of dislocations, Hegel's essential sections . . . are all tied up in total instantaneous (timeless) interconnections, *a coherent system*. Discourses of closure indeed.

> . . . "all the elements of the whole revealed by this section are in an immediate relationship with one another, a relationship that immediately expresses their internal essence" (Althusser, 1970, 94)

> . . . "spatiality means coexistence within a structure that establishes the positive nature of all its terms." (Laclau, 1990, 69)

With these maps/space you never lose your way, are never surprised by an encounter with something unrelated. Never – come to that – make *new* connections. Connections/relations *without* temporality?

> . . . "the occasion . . . has been controlled by the spatialization of scientific discourse . . . scientific writing ceaselessly reduces time, that fugitive element, to the normality of an observable and readable system. In this way, surprises are averted" (de Certeau, 1984, 89)

In this kind of space you never run into alterity, never stumble across the unknown. If "space" is an "instantaneous completely interrelated system" (like they say) then "time" is allowed only one narrative. There can be only one storyteller.

Connections (symbioses or antagonisms, egalitarian or oppressive) have to be created. There are moments before they happen. "Space" is constantly disconnected by new arrivals, constantly waiting to be determined (and therefore always undetermined) by the construction of new relations. If you really *were* to take a slice through time it would be full of holes, of disconnections, of tentative half-formed first encounters, littered with a myriad of loose ends, a *geological* map (if you must) of fault-lines and discontinuities, bringing different temporalities hard up against each other. A discourse of closure it ain't.

With time to spare before the conference (title: *Another academic get-together on the city*) I wander out. I have often been suspicious, or at least reticent, about the terms on which "the urban" is carved out as a distinct object of analysis. Not the fact of specificity but the nature of it. But it takes only a couple of blocks to convince me yet again. The criss-crossing of a myriad "stories so far". A hoarding blares that a new migrant group, fleeing another history somewhere to the east, is the latest to arrive. Histories jumble on the streets. You can live this by tolerating "unassimilated otherness" (Young, 1986); diversity does not necessitate interaction. Worse, you can read it as exotic, a setting for your (privileged

but not exotic) life (May, 1996); I wonder uneasily about the conference (will there be any papers which dare *not* to be marked as exotic in some way?). Or you can argue/hope for something more than non-interactive toleration – a more active engagement with difference (Sennett, 1994). But you can't interact with everyone. Again, the totally connected system is out of reach (should you have wanted it). But in this – I must insist – the city (and especially the "postmodern" city) is no more than (though that is quite a lot) an advanced case of what is true of "space" in general.

[Maps again. There *are* cartographies which try to capture this kind of space. Maps which do not lay down an order of things. Situationist cartography sought the opposite end: to defamiliarize, temporarily to disorient. To expose the incoherences, the fragmentations. To leave openings for something new. [*Aside*]

The opposite of the synchronies of the structuralists. The exposure not the occlusion of the disruptions inherent in the spatial.

Breton, in *Nadja*, had written of "a new space – . . . a relation without unity" and a space "from which . . . the *unknown* announces itself and, outside the game, enters into the game" (Blanchot, 1967, 307–8, cited in Lechte, 1995, 109). The spatial, here, as an arena of potential, and situationist cartography a mimesis of productive incoherence (Levin, 1989; Pinder, 1994). Maps which resist cartographic enclosure. Experiments with rhizomes are after much the same thing. Attempts to "map" dislocation, to leave possibilities open.

So, for sure, space is not equivalent to a map, but even maps do not have to be "essential sections".

In Paris, in Parc de la Villette, Bernard Tschumi tries to produce a space which is like space – "superimposition", "dissociation", "dispersion", a strong infusion of chance, a "heterogeneous non-relation between elements" (Lechte, 1995, 109), the intersection of the previously barely related . . ."Tschumi's *folies* are an adventure in non-determination and undecidability . . . Parc de la Villette is perhaps emblematic of the city today" (Lechte, 1995, 110).

Or even more than that: "emblematic" not so much of "the city today" (a phrase which anyway tends to signify – without saying so – *our* cities: Paris, Los Angeles, London . . . what of Bamako?) so much as of *all* cities, *all spaces*. Dislocation and happenstance are inherent in the spatial.]

<div align="center">*</div>

"Space is essentially dislocated". The specifically spatial within space-time is produced by that – sometimes happenstance, sometimes not – arrangement-in-relation-to-each-other. In spatial figurations otherwise unconnected narratives may be brought into contact (or connected ones wrenched apart). The dimension of the juxtaposition of the dissonant, spatiality disrupts the possibility of a single narrative, one

voice. The singular universal presupposes the essential section. But in the city – in any place, as a fact of spatiality – different temporalities must find means of accommodation. (Note to Foucault: surely *all* spaces/places are heterotopias?)

Happenstance juxtaposition, finding yourself next door to alterity . . . in the formation of the spatial new narratives are born. "Time", which takes itself to be self-generating, in fact needs spatiality to set itself in motion. Temporality as a product of process, interaction. Spatiality as productive of those indeterminations which are necessary to the existence of the political. Temporality requires spatiality. Space and time were born together.

The city lives forever unfixed, always in the making, never fully achieved . . . the never finished creation of a time-space.

*

This city I'm lost in now is not a place on a map. From the tiny settlement on the estuary, through the domination of church and farm, through plague and prosperity, from the far-flung trade to the intimate quotidian intersections with the known and the unknown, it's *a spatio-temporal event*. A constellation of social relations held in a precarious and open specificity. It's like all cities, all places.

*

The encounter with the unknown is precisely both that much-proclaimed characteristic of the urban metropolitan cosmopolitan and the more general meeting of temporalities in the spatial.

We could call it (we could *think of it as*) space-time.

Note

Thanks to Ernesto Laclau and Sue Golding for long conversations about all of this.

Bibliography

Althusser, L., (1970), 'Part II: The object of capital', in L. Althusser and E. Balibar, *Reading Capital*, trans. B. Brewster (Verso, London).

Blanchot, M., (1967), 'Le demain jouerer', *La Nouvelle Revue Française* (April), 283–308.

de Certeau, M., (1984), *The Practice of Everyday Life* (University of California Press, Berkeley).

Foucault, M., (1986), 'Of Other Spaces', *Diacritics* (spring), 22–7.

Harley, J. B., (1990), *Maps and the*

Columbian Encounter, The Golden Meir Library (University of Wisconsin, Milwaukee).

Ho, M–W., (1993), *The Rainbow and the Worm: The Physics of Organisms*, (World Scientific, Singapore).

Jameson, F., (1991), *Postmodernism; Or the Cultural Logic of Late Capitalism* (Verso, London).

Laclau, E., (1990), *New Reflections on the Revolution of Our Time* (Verso, London).

Lechte, J., (1995), '(Not) Belonging in

Postmodern Space', in S. Watson and K. Gibson (eds), *Postmodern Cities and Spaces* (Blackwell, Oxford), 99–111.

Levin, Y., (1989), 'Dismantling the Spectacle: The Cinema of Guy Debord', in Elisabeth Sussman (ed.), *On the Passage of a Few People through a Rather Brief Moment in Time: The Situationist International 1957–1972* (MIT Press, Cambridge, Mass.), 72–123.

Massey, D., (1992), 'Politics and Space-time', *New Left Review*, 196, 65–84.

May, J., (1996), 'Globalisation and the Politics of Place: Place and Identity in an Inner London Neighborhood', *Transactions of the Institute of British Geographers*, 21, 194–215.

Pinder, D., (1994), 'Cognitive Mapping: Cultural Politics from the Situationists to Fredrick Jameson',

paper presented at the 'Mapping and Transgressing Space and Place' session of Annual Meeting of the Association of American Geographers, San Francisco, April.

Plato, (1977), *Timaeus and Critias*, trans. D. Lee (Penguin, Harmondsworth).

Sennett, R., (1994), *Flesh and Stone: The Body and the City in Western Civilization* (Faber and Faber, London).

Walker, R. B. J., (1993), *Inside/ Outside: International Relations as Political Theory* (Cambridge University Press, Cambridge).

Wood, D., (1993), *The Power of Maps* (Routledge, London).

Young, I. M., (1986), 'The Ideal of Community and the Politics of Difference', *Social Theory and Practice*, 12: (spring), 1–26.

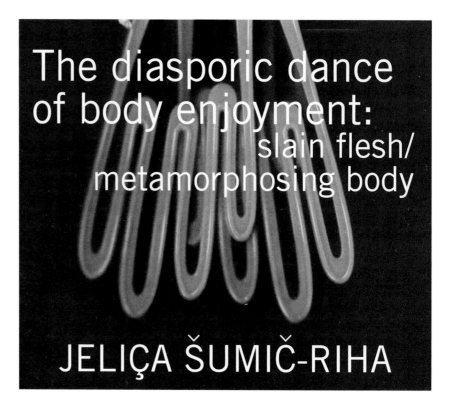

The diasporic dance of body enjoyment: slain flesh/ metamorphosing body

JELIÇA ŠUMIČ-RIHA

The issue this essay will address is that of the enjoyment of the dancing body, a particular kind of enjoyment which, as I will try to show, paradoxically survives the 'death', the 'slaying' of the body. It is from this perspective that dance will be examined as one of the technologies of otherness. First, it will be argued that the dancing body is split between enjoyment and the signifier in so far as dance is nothing other than an oscillation between the body-enjoyment, the enjoyment attached to the flesh, this being the 'body before the body', and another body, the body of the signifier which is the 'dead' body, the body purged of enjoyment. Second, this vacillation between the 'not yet' and the 'no longer' of the body, this splitting of the body will be explored as a staging, proper to dance, of the impossibility of the body as a body. Third, in the process of the 'disembodiment' of the body, that is, the banning of what I have termed body-enjoyment, dance produces a 'surplus of enjoyment', an obscene and unrecognized enjoyment which results from the very foreclosure of enjoyment of the body.

Clearly it is not possible to answer either the question of what dance is (an 'interpretation of a role', a 'visualization and expression of emotions and feelings', a 'pure and abstract language of the body' or an exploration of physical reactions to surroundings, objects, other dancing bodies, and so on) or the question of how otherness is involved in dance until the role of the body in dance is clarified. In considering the

alternative between 'danced discourse', which seems to be incomprehensible, impenetrable but for those familiar with its code, this being 'the language of the body', or something else, and enjoyment of the body, its visualization, I take issue with the spontaneous ideology of modern dance. By claiming that only modern dance is the 'authentic language of the body', this ideology tacitly assumes the identification of the dancing body with the body-enjoyment, thus conflating the above mentioned alternative between enjoyment and discourse. As will be shown, two erroneous conclusions follow from this conflation: first, that the body enjoyment is an invention of modern dance. In contrast with this view it will be argued that fascination, even obsession, with the enjoyment of the body, is not specific to modern dance but is constitutive of dance as such.[1] And second, the idea that the specificity of dance could be defined by reference to its greater or lesser distance from theatre. Contrary to this approach I will defend the view that it is this very comparison with theatre, this attempt at 'theatricalization' of dance, of its measuring by a yardstick that is inappropriate to it, that had led to its failure. As it is well known, for this modern dance ideology the central problem is that of the code: on the one hand, it is by reference to this foundational convention that the identity and consistency of dance as such is constituted, but, on the other hand, the issue of the code is also perceived as the breaking point between classical ballet and modern dance.

Unlike ballet, which was based in a specific code, modern dance problematizes the very interpretative scheme which identifies a certain practice of movement as dance. Thus, for example, in the name of the 'emancipation' of the mobile potential of the body, modern dance negates not only particular conventions, formulae and schemes but the possibility of a master-signifier in the field of movement. But a perverse consequence of the emancipatory imperative of modern dance, that is of the putting into question of the unifying signifier, is the inconsistency of this field, which in return lends urgency to the question, what is dance as dance, what constitutes its 'identity' and consistency.

It is not difficult to show where modern dance, especially modernist experimentation, fails from this perspective, which reduces dance to a code, a rule. For if all traditional dance conventions which have given dance its identity and consistency are deconstructed, then the field of movement which dance is supposed to encompass broadens to the extent that it is no longer possible to construct a frame that would totalize the diversity of mobile practices. The insoluble problem of modern dance is therefore that of synthesis: how, on what basis can manifold heterogeneous, hybrid practices be united into something that can still be called dance? Is it gesture, space or rhythm? Or is dance constituted by oppositions such as motion and immobility, light and darkness, sound and silence, space and time? Is something perceived as dance simply because it takes place in a setting recognized as a conventional place of dance?[2] As could be seen from the beginning, the only way out of this impasse is to appeal to yet another rule or convention. But this

1 By maintaining the centrality of the problem of the body for dance as such, more precisely, by examining the status of the body in dance in the light of the relation between the signifier and enjoyment, I not only deny the 'history of dance', and especially the break between classical ballet and modern dance, but call into question oppositions that are taken for granted today, such as the opposition between Western, European dance, supposedly a denial of the body, and, for instance, African dance, which is held to be fundamentally an affirmation of the corporeality of the body or body-enjoyment.

2 Cf. e.g. S. Banes, *Terpsichore in Sneakers*, Wesleyan University Press, Middletown, Connecticut, 1987.

structurally necessary call for convention is nothing other but the failure of the modern dance project: the putting into question of all conventions. Thus, the lesson to be drawn from the failure of the modernist experiment is that the attempt to eliminate convention leads to an even greater reaffirmation of convention, since it is only by inventing a new foundational convention that modern dance can demonstrate its identity and its existence.

Yet this critique of modern dance is still insufficient in that it does not link the failure of modernist experiments to the issue of the body, to be precise, to the articulation of the body and enjoyment. This aspect of the body is usually neglected by the spontaneous ideology of modern choreographers themselves, for whom dance is a demonstration of the emancipation of the body. But it is precisely in its attempt to put on stage the 'liberated body', that is, the enjoying, living body, since it is only to the living that enjoyment can be attributed, that contemporary dance, in both its modernist and its postmodernist naturalistic guises, fails. And I will argue that the reasons for the failure of modernist experiments cannot be sought purely in the 'revenge' of convention, in its re-entry by the back door. Rather it should be sought in the impossibility of showing that the supposed 'liberated body', a body which is not enslaved by the Other (the convention or institution of dance), exists at all.

Modern dance, it is true, set itself the aim of exploring the mobile potential of the body. Undeniably, the last fifty years have witnessed radical changes in the way the body in dance or dancing corporeality[3] is treated. Thanks to choreographers such as Martha Graham and Merce Cunningham the dancer's body liberates itself from the traditional code of classical dance, from any aesthetic norm and requirement of meaning and becomes a 'pure, organic undifferentiated material,' in Bernard's words, a material for fragmentary, heterogeneous, hybrid choreographies. Following Bernard we could summarize the radical shifts in modern dance as follows.

First, deconstruction of the classical code and oppositions based upon it: pure/impure, homogeneous/heterogeneous, continuity/discontinuity; centre/periphery; balance/imbalance, order/disorder; frontal, all-encompassing perspective/multiple perspectives; space/time.

Second, this deconstruction, on the other hand, initiates a set of corresponding transformations of corporeality such as: the establishment of a 'bodily democracy' (T. Brown) instead of a hierarchy of bodily parts and functions (the use of bodily postures that have previously been regarded as the least noble or most uncomfortable: kneeling, lying down, crawling, etc.); a change in the way in which the body dominates space and masters gravitation (not only upright, but also seated, lying and kneeling postures); minimalism of movement and expressionism, which transforms the face itself or the play of the facial muscles into a choreographic space; the penetration of the silence of dance by voice or the 'theatricalisation' of dance (vocal interventions by dancers, who shout, narrate, recite and sing). The dancing body is apprehended as a

3 The phrase is borrowed from M. Bernard. Cf. his *Le Corps* (Paris, Seuil, 1972) and *L'Expressivité du corps* (Paris, Seuil, 1976). *Corporéité* according to Bernard is a point of encounter of two symbolic fields: cultural history and individual accidental libidinal history.

mobile machine, free of all outer constraint, of any frame (technique, music), the beginning and end of the exploration of bodily and mobile capabilities.

What then did dance modernism show? One of the principle merits of modern dance is to 'exhibit' the truth of dance: once purified of unnecessary trimmings (costumes, techniques, materials, media, etc.), reduced to nothing but a constant defiance of gravitation, dance becomes a self-sufficiency of pure movement. This means that movement in dance has no exterior purpose, since nothing is supposed to exist beyond the system created by the dancing body with its postures, positions and motion. Thus, dance has no exterior, points to nothing beyond itself. Dance moves within itself and within it there is no striving for completion. Dance, then, is by definition inconsistent, in short, an open series. Dance could be said to be a contingent, precarious and paradoxical game of the construction and deconstruction of the body, the search for its unity and identity within the diversity and dispersion of movements, positions and postures. Dancing corporeality constantly decomposes and renews itself in the succession of its instants without being capable of being visualized as one, as a complete phenomenon. For dancing corporeality is unstable corporeality, a series of instantaneous events, a series of uncertain, unpredictable punctuations. These punctuations or events could be defined as a visualization of time in space by means of transpositions, positions, postures of the body, movement and mimicry by which the dancer 'displays his/her mobility'.

But are we any wiser as to the question of what is the dancing corporeality? What is the meaning of these transformations of corporeality, this playing with unorthodox motions and postures, with an unusual use of space, etc., that is so characteristic of modern dance, if not an attempt to expose and, in the final analysis, to produce the corporeality of the body, the Body as such? But is this all that modern dance has to show? My point is different: modern dance does not fascinate merely with new, unorthodox dance structures and an unusual use of the body; rather, the modern dance's innovation is to be sought in the ways in which modern dance by assigning to the body the role of 'principal protagonist' or 'narrator' paradoxically produces an effect of estrangement. This estrangement could be seen, for example, in the dancer's inability to identify with the body and with what the body is doing. Somewhat caricaturally it could be said that not only the spectator but the dancer himself/herself marvels at what the body is doing; or in other words, the dancer's body is 'strange', 'uncanny' to spectator and dancer alike. It is precisely in the dancer's exterior relation towards his/her own body that the radical difference between dance and theatre emerges: whereas for the actor identification with the *dramatis persona* is imperative, the dancer's performance is distinguished by a distance from the function of narrator. Indeed, there is no story to be told because there is nothing to imitate or portray. Furthermore the dancing body does not express any emotions and feelings, in short, there is no interior to be exteriorized. The dancing body expresses nothing, it points to nothing

outside or beyond itself for there is nothing but mere displacement in space.

It can be seen here why the spontaneous ideology of 'natural movement' is of no help at all in illuminating the status of the body in dance, but rather obscures the relation of the body with enjoyment on one hand and the signifier on the other. For what is demonstrated both by modernism's rigorous, clinical study of the dancer's relationship towards his/her own body as a mobile machine, the analysis of an abstract language of dance defined purely through the movement produced by the dancer, and by postmodernist naturalism of movement which rejects all technique and instead reduces the danced event to a bare physical reaction to something (the setting) or someone (dancing partners), is a missed encounter with the body, a living, enjoying body. If the stake of modern dance was to affirm the body through the study of mobile potential, its result – that is an 'instantaneous body' or an 'occurrence of dancing corporeality', as Bernard puts it – is not the presence of an enjoying, living body but a body subjected to aphanisis: an appearing and disappearing body of the signifier, a body, then, that is by definition dead, purged of enjoyment, in short that which Lacan called a 'desert of enjoyment'.

In sum, modern choreography may dissect the smallest movement, the most negligible physical reaction to the surroundings, this does not mean that we are any the wiser as to what the body is. On the contrary, what modern dance demonstrates is that the body remains in a radical sense Other, inaccessible. What is paradoxical about modern dance is its ability to produce the illusory body-enjoyment as a result of playing games with dancing corporeality, that is with the body of the signifier, the dead body. But why is this body-enjoyment illusory? Following Lacan it could be said that we would not even know that we had a body in the most naive sense of the word if language had not conferred it upon us. Yet this body which language confers on the subject is a body already evacuated of enjoyment, and thus a body which 'does not live' or is indifferent to the opposition life/death.[4] But at this point one can ask a simple, naive, yet unavoidable question: If the body conferred upon the subject is 'always already dead', since it is the symbolic body, the body articulated into a signifier, where does the illusion of life come from? The most obvious answer would be to look for life there where 'it enjoys'. According to Lacan 'it cannot enjoy' but in flesh, since flesh, as opposed to the dead body of the signifier, is supposed to be alive and thus figure as the enjoying substance. The only problem is that this 'it that is supposed to enjoy' does not exist or, to be more precise, 'it enjoys' only in fantasy. Consequently, the body-enjoyment is nothing but a myth: a retroactive attempt to account for the impression of life there where no life is possible: in the signifier's body as a 'desert of enjoyment'.

At this point we must ask whether modern dance disproves this statement. Is this obsessive exhibition of movement in modern dance, this frenetic, constant motion, not irrefutable proof of life? Where, then,

4 Cf. J. Lacan, 'Radiophonie', *Scilicet*, no. 2–3, Paris, Seuil, 1970, 61.

does this impression of the moving, living body originate? If the body, as has been shown, is a dead body, dead because it is occupied by the signifier, then the impression of life cannot come from the body itself but paradoxically from what devitalises it, that 'slays' it, that is, from the signifier. Thus it is not the body but the signifier that moves and, conversely, the body itself is 'moved', displaced by the signifier. It moves only in so much as the signifier has taken possession of it. So the endless, continuous movement in dance is nothing but the endless displacement of signifiers. Thus it could be said that it is nothing other than this metonymy of signifiers that creates the illusion of life. But here it could be seen also what the paradox of the metonymy consists of: it consists of this turning of death into life. This paradoxical reversal of the already dead into a proof of life, which characterises the operating of the metonymy in dance, enables us, in addition, to account for a close affinity between desire and dance in so far as both are characterised by continuous 'eternal' movement.

This would not mean that desire is a metaphor of dance. Rather, the opposite is the case: dance is a space where desire manifests itself. Thus, it could be said that desire, which is defined as desire of the Other, is inherent to dance: it occupies, invests dance, transforming it in this way in the domain of the Other. Legendre's famous study of dance[5] relates dance to the Other in its very title: *La Passion d'être un autre.* Following Legendre it could be said that dance as such is animated by passion, or rather desire. Yet what kind of desire, what kind of passion are we dealing with in dance? For Legendre what constitutes dance is the relation between the subject, his/her body and the great Other which he calls the institution, the authority of tradition, the Law. From Legendre's perspective dance is seen as one of the privileged mechanisms of identification or subjectivation. Dance on this view is one of the 'political practices' constitutive of the community precisely to the extent that dance is an 'ideological interpellation', to use Althusser's phrase, which is held to be all the more insidious for the fact that the institution 'addresses' the subject's unconscious desire by (ab)using his/her body.

The crucial question here is how can the body serve as an instrument of the subjection to the institution? Legendre's answer is to a certain extent enigmatic: the subject's unconscious desire is trapped by the institution not by using the body as an unintelligent, dumb tool. On the contrary, dance as a form of institutionalised ritual is based on the assumption that the limbs themselves think and 'speak'. From this institutional perspective, the one that is supposed to think and to know what to do is the body, not the subject. Thus we could say that the subject does not know how the institution entraps him/her since he/she is not the one who 'communicates' with the Other, with the Law: rather, it is the body that 'negotiates' directly with the Law. Dance, then, is in itself 'political', serving the political ends of the institution by creating the space for the realisation of a fantasy. According to Legendre, the body is a fundamental fantasy realised through the dancing. But the

5 P. Legendre, *La Passion d'être un autre. Etude pour la danse.* Paris, Seuil, 1978.

crucial point is that this fantasy is not the subject's fantasy, but the fantasy of the institution itself. And this institutional fantasy could be called fundamental to the extent that it is a fantasy on which the institution itself is grounded. Thus it could be said that it is through fantasy that the institution exists but to realise this fantasy the institution needs the dancing body. Crucial in this respect, to repeat once more, is the fact that the subject is unaware of the ways in which the institution uses and therefore also consumes, enjoys his/her body. Moreover, the subject's ignorance is a *conditio sine qua non* for a successful recreation of the institution.

It is in the light of this constitutive role of the body in the realising of the institutional fantasy that the spontaneity-claim which characterises modern dance exhibits all its ideological character. The ideological core of this modern 'mythic, savage thought', as P. Legendre himself calls it,[6] with which modern dance legitimates itself as a revolt of the body against tradition and institution, lies in the fact that it is a 'savage thought' not of the body, but a 'savage thought' that the institution imagines that the body should have. In short, this 'savage thought' as a revolt against the institution is permitted by the institution, moreover, it is 'staged' by the institution. For this spontaneous rebellion of the body is an invention of the Institution itself, of the Other from which the dancing corporeality is supposed to have liberated itself. What is concealed in this way is the obscenity of the institution: it is the institution, the Law itself, which, under the cover of the 'affirmation of corporeality', 'naturalness', 'stages' the transgression of the Law. Hence it is impossible to answer the question of what dance is unless we demonstrate what the body serves, to whom it belongs and not least who enjoys it.

A key question, then, is how the body is articulated to enjoyment. Who enjoys, and what? Or, recalling the title of Legendre's *La Passion d'être un autre*, whose passion is it? According to Legendre it is the passion of the institution itself, the Law, the Text; in short it is the passion of the Other, while the body is nothing but the object of enjoyment. It is the Other which is presumed to enjoy the body, but not the body as it is, the 'natural' body; rather, the object of the Other's passion is an ideal body, a body that is yet to be constructed. The crucial point here is the division of the body: on one hand, the body as it is, the 'natural' body; and on the other another body, an ideal body. How, then, is this ideal body produced? It is precisely at this point that dance intervenes because dance is the space in which the process of 'transubstantiation' of the body takes place. Put differently, dance serves the institution as the space in which institutional discourse dismembers the body such as it is in order to reconstruct it as a body it likes, a body which does and 'says' what the institution permits or dictates.

But what is it that qualifies the ideal body as the object of enjoyment? We propose the following answer: If it is ideal, it is ideal not because it is physically different from the 'natural' body, since it is

6 *Ibid.*, 150f.

assembled from the fragments of the 'natural' body, but because it is presumed to know nothing of enjoyment. And vice versa: only a body purged of enjoyment, a body from which enjoyment has been evacuated, can be qualified as beautiful, and only as such, that is as the ideal of beauty, can it be the object of enjoyment. Because the body, seen from the perspective of the Other, is the body that does not enjoy (the ideal body), or should not enjoy (the 'natural' body). In short, enjoyment of the body is, for the institution, either impossible or prohibited.

This prohibition of enjoyment reveals a dual relationship towards both dance and the body. On one hand, dance was traditionally associated with debauchery, with the manifestation of an archaic, 'savage' enjoyment of which the 'natural' body is capable, while on the other, it is treated as a practice of 'cultivation', domesticating, schooling, taming of the body and the banishing of 'indecent' enjoyment. This ambiguity characterises the relationship towards the body as well: the 'natural' body is not inert, neutral matter to be manipulated by the institution, rather, it is regarded as a 'bad', 'depraved', 'evil', 'shameful' body, a body that enjoys. The 'natural' body was treated as a worthless and at the same time dangerous object, as a body presumed to enjoy furtively, secretly and illicitly, in short as an evil body that must be destroyed to make of it a 'good', 'decent' body immune to enjoyment. And it is only through dance that this indecent, evil enjoyment of the 'natural' body can be purged. Dance, thus marks the entry of the body into a process of metamorphosis by means of the cultivation, the domestication, of body-enjoyment. In dance the 'natural' body manifests itself as the paradox of a worthless supplement: the 'natural' body is worthless, it counts for nothing, as such it is the remainder, the residue, of a transformation into an ideal body, but is regarded at the same time as a dangerous, terrifying body, capable of contaminating and corrupting the good, ideal, dead body, for which reason the 'natural' body must be submitted to 'subduing', 'disciplining' and 'taming'.

Yet it is precisely in this process of 'taming', of 'purging' the body that a particular mode of enjoyment origins. It is obvious that this enjoyment exhibited through dance cannot be said to be the remnant of a previous enjoyment, enjoyment of the flesh. Of this 'mythic' enjoyment we neither know nor can we know, since it is radically divorced from discourse, the Symbolic. Strictly speaking it is real and, as such, impossible. Consequently the surplus enjoyment (that is enjoyment produced in the process of 'taming' of the body), is not the portion of enjoyment that survives the 'slaying' the body, on the contrary, this 'killing' of the body is the very condition of this enjoyment. Hence dance is not only an ideological apparatus: what dance is about is not, primarily, the constitution of the ideal body and through it the subjugation of the subject to the institution; rather it is the production of surplus enjoyment, of enjoyment that is a result of the very process, the very operation, of purging the 'natural' body.

And it is for this reason that Legendre's analysis, however lucid and persuasive in parts, does not answer fully the question of enjoyment. For this operation of cultivation of the body is not located where it should be according to Legendre, namely in the Other; because of this Other it cannot strictly be said to enjoy. For the Other, whether its name be the institution, the Law or tradition, not only has no body but furthermore does not exist and can therefore know nothing of enjoyment. Yet to this Other, which by definition cannot enjoy, Legendre nevertheless ascribes the capacity to enjoy the object-body. But how can enjoyment be imputed to something which is immune to it?

In response to this question it is necessary to re-examine the origin of enjoyment in dance. So far it has been shown, firstly, that dance, modern and classical, can be conceived as the space in which the 'natural' body is transformed into an aseptic body purged of enjoyment, and secondly, that in this very process of transformation a specific mode of enjoyment is produced. But, this surplus enjoyment, being a result of the very process, the very operation, of purging the 'natural' body of enjoyment, remains evading and errant. And it is at this point that the Other intervenes. It is at this point that the relationship between the Other and enjoyment can be articulated. This relationship could be formulated as follows: the instance of the Other is erected in an attempt to account for a mysterious origin of the surplus enjoyment. Thus it could be said that the Other and enjoyment mutually presuppose one another: the Other exists if it enjoys; enjoyment, on the other hand, 'exists' only in so far as it can be located in and attributed to the Other. But the problem is that the Other does not exist. The only solution to this problem could be the following: the inexistent Other does not enjoy except in fantasy. All fantasy, as is well known, requires a specific setting, a scenario provided by dance. Seen from this perspective dance is nothing but a phantasmatic scenario, an attempt at staging of this enjoyment of the Other.

Yet that is not all. For dance is not only an instrument for the phantasmatic staging of the enjoyment of the Other, paradoxically, it is also the staging of the traversing of the institutional fantasy. Put differently, it is in this staging of the Other's enjoyment, in this phantasmatic enactment of the Other's enjoyment, that the subversiveness of dance lies. And this dimension of the traversing of the fantasy is completely neglected by Legendre. Legendre is right in pointing out the way in which dance serves the institution: it enables the institution to reproduce itself by way of staging a fantasy in which this institution is grounded. He is also right in denouncing the obscenity of the institutional handling of dance for, as has been shown, the rebellion against the institution is nothing but another mask of the institution itself. Yet in his striving to unmask dance as an instrument of the institution, Legendre misrecognises the subversive potential of dance: in order to stage the Other's enjoyment dance, necessarily, introduces a distance from this fantasy. The paradox of dance – that Legendre, by being obsessively fixed on the ideological function of dance,

misrecognises completely – lies in the manner in which dance stages the institutional fantasy: for by organising the necessary setting for this fantasy, dance at the same time denounces, exhibits what fantasy conceals, namely, a specific mode of enjoyment organised as a support of a given social regime. And it is in this sense that dance could be said to be subversive – because in an attempt to stage and sustain the fantasy of the institution dance always already traverses it.

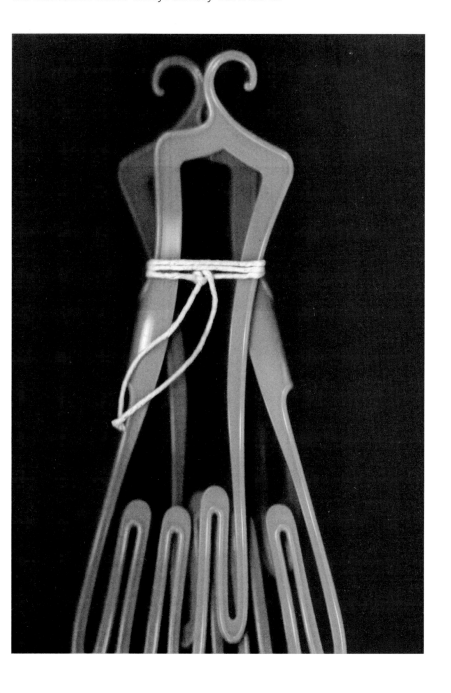

Singing the blues in cyber-city

ARTHUR & MARILOUISE KROKER

Chaos time. It's 6.30 p.m. on Market Street in San Francisco, just down the way from the Virgin Megastore. Business people are fleeing homeward, office towers are shutting down, security guards and cleaners are moving in, coffee shops and stores are locking up their doors, and smokers hurry by, lighting up first cigarettes since the afternoon break.

There are no street people in cyber-city, but there are plenty in SF. They might occupy different worlds, but when chaos time comes, when it's that dusky cusp between light and dark, between cyber-city at work and SF at evening play, sometimes, just sometimes, the two populations meet.

Like on the corner of Powell and Market, we hear a blast from the pre-MTV past. Hard drivin' 1960s R&B tunes are being played by a guy who looks like Fats Domino and sounds like him too, putting down a heavy beat on a set of rusty blue drums, singing with a deep bass voice that puts into song the wail of America that has travelled from the plantations of the southern delta to the slaughterhouses of Chicago, and met futureshock in SF, this city at the end of the western continental migration of the body. He's got two sidemen, both sitting on speakers, the car battery for their electric guitars inside a white plastic garbage can.

A compact, wired guy steps up front and yells: 'Just tell the story, brother, tell the story, tell the story, tell the story . . . ' There was something about the music that just pumped the cynicism right out of the air. And it did tell the story. All of America was there: punks with torn Misfits and Fugazi T-shirts, a homeless white guy with an enormous hunting knife in an aluminum taped scabbard in his back pocket, somebody just to our side is drinking lime-green alcohol straight out of the bottle, a guy with a Cherokee Nation sweatshirt circles around the band, pulls a harmonica out of his pack and begins to play along, the shopping crowd carrying parcels from Macy's and Armani and GAP put their purchases down and listen, and, all the while, those gigantic posters from Virgin of k. d. lang and Tony Bennett look down on us from their multi-million-dollar high-in-the-sky window perches.

But it doesn't really matter. Because for one twilight moment the American song is on the streets of SF, a kind of swirling charged-air energy vector that sweeps its way into your belly and your mind and your eyes, takes you suddenly to places sad and sorrowful and beautiful, and you stand there at this street scene, knowing that for one moment the continent has truly ended here, that it is the end of the road. Now, this is an old story that has been told again and again, in the founding myths of the country, in film, in music, in videos, in idle chatter, and sometimes even in writing. All the energies of the continental American migration are pushed up against the blue sheen of the Pacific. It's as if the massively shifting tectonic plates far under the ground with their eleven fault lines criss-crossing the Bay Area have their fleshy equivalent in the streets of cyber-city. And sometimes, just sometimes, the body plates rub up against the end of the continent just a bit too hard, all that pent-up, screwed-down pressure inside the street bodies looks for an opening, an unstable fault line, and when it finds one, the result is a shuddering music quake. Like this dirt-poor outlaw street band. It has exited normal space, the space of SF that Jack Kerouac once described as a 'police state'. It's a kind of open fault line through which all the rage and the anger and the sorrow and the ecstasy of a street society at the end of the road explodes out of rasping mouths and rusty drums and beat-up Fender guitars.

The R&B sound is a big rumble at the end of the continent, and so when the band flips into Otis Redding's 'Dock of the Bay' with the words: 'I left my home in Georgia . . . Headed for the Frisco Bay . . . Got nothing to live for 'cause nothin's been going my way', we can just feel the keening of the words inside our skin, and when Fats cuts the words down to the naked-edge line of 'Nothin' to live for . . . Nothin' to live for . . . Nothin' to live for', which he rasps over and over again like a mantra of the dead, we know that we have mutated beyond music, and are present at a dirge, SF style: end of the continent, end of the road, end of the body, end of life, end of hope. It's just that moment when a song becomes lament, and the city streets are a dance of the dispossessed.

Sounds crazy? Maybe. But everyone on that dusky corner, punks and grunge and rockers and homeless women and too-poor-to-be-just-down-and-out-guys and destroyed bodies and digital faces and panhandlers' pleas and salaried smiles and American Medical Association conventioneers straight out of the 'internal medicine' show at the Hyatt just down the street, and alcoholics, and tourists and office workers – all the demented and the happy and the sad and the lonely and the tired and the frenzied and the dead – just everyone fell into a common magical spell. You could just see it register in body rhythms. Street people began to dance, sometimes fell down hard on their asses but clawed their way back up to air again, punks dropped the Misfits alien-zone stare for a brief moment, and even the tourist folks just couldn't leave, and just

wouldn't leave, and just didn't leave. For one brief instant, we were listening to those silent tectonic plates shifting inside of our deep-down feelings, really hearing R&B on the hard luck streets of SF as the intense, ancient song of lament that it was always meant to be.

In the usual way of things, all this led to a no-time time and to a no-place place. The darkness came and the group of pilgrims on a dusky street corner in cyber-city dropped some quarters in the box and went their separate ways.

OLD STANDARD

I DROPPED A BRICK.
FROM THE UPSTAIRS WINDOW.
IT WENT THROUGH YOUR WINDSCREEN.
VERY SLOW.
IT WENT THROUGH YOUR FACE.
VERY SLOW.
IT SLOWED YOU UP.
GOING HOME.

IT HAD YOUR NAME ON IT.
THAT BRICK.
IT HAD YOUR NAME ON IT.
THAT BRICK HAD YOUR NAME ON IT.
IT HAD YOUR NAME
ON IT.

I DROPPED A BRICK.
FROM THE UPSTAIRS WINDOW.
IT WENT THROUGH YOUR WINDSCREEN.
VERY SLOW
IT WENT THROUGH YOUR FACE.
VERY SLOW.
IT SLOWED YOU UP.
GOING HOME.

IT HAD YOUR NAME ON IT.
THAT BRICK.
IT HAD YOUR NAME ON IT.
THAT BRICK HAD YOUR NAME ON IT.
IT HAD YOUR NAME.
ON IT.

IT HAD YOUR NAME ON IT.
THAT BRICK.
IT HAD YOUR NAME ON IT.
THAT BRICK HAD YOUR NAME ON IT.
IT HAD YOUR NAME.
ON IT.

IT HAD YOUR NAME ON IT.
THAT BRICK.
IT HAD YOUR NAME ON IT.
THAT BRICK HAD YOUR NAME ON IT.
IT HAD YOUR NAME.
ON IT.

IT HAD YOUR NAME ON IT.
THAT BRICK.
IT HAD YOUR NAME ON IT.
THAT BRICK HAD YOUR NAME ON IT.
IT HAD YOUR NAME.
ON IT.

Contamination

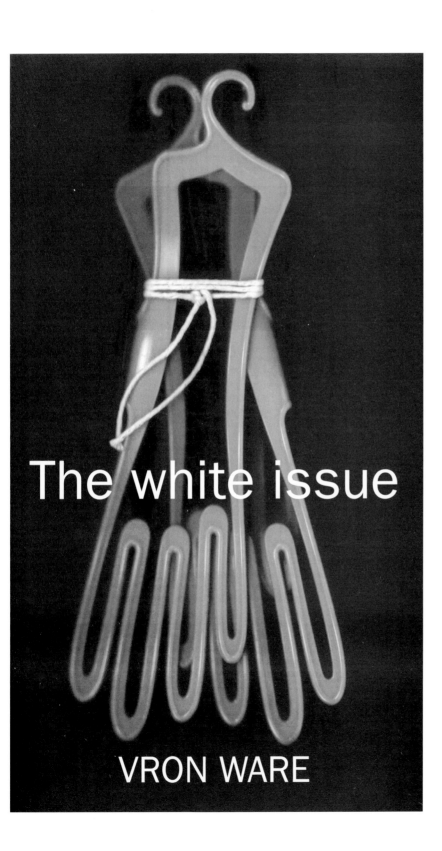

The white issue

VRON WARE

Part I: A meditation on white paint

As I write, I am painting a room white; or rather, as I paint, I find I am beset by voices. And I am in a filthy mood, not just because it is hot outside and the job is harder work than I remembered when I volunteered to do it, but because the ecologically pure paint that I am using is not up to it. Against all advice I chose it because I like the idea that it does not give off secretly toxic fumes as it dries. Since all that stuff about the perils of chlorine bleaching I am even more convinced that the desire for whiteness in the home is pathologically induced by a century of brainwashing. White is modern, clean, and bright, and a white surface is also nothingness, an inability to choose a more interesting colour. But I have no problem with wanting white walls in this particular room, and being able to justify it to myself, at this point.

The hue of my paint, however, seems to me to be near enough to the 'brilliant white' that it claims to be, though it was a half-empty old pot I had found in the cellar. It is when I reach the roller stage and begin in my unsystematic way to apply the paint at the end of a broomstick that I notice to my horror small flecks of orange appearing. As soon as I roll over them they spread and multiply. I stir the paint though I can't see anything to sully the chalky innocence in the pot. As I continue rolling, the orange spots looked ridiculous, but then I notice that even the white bits look off-white next to the faded paint I was replacing. Defeated, I switch to Texas vinyl silk, truly brilliant white and pure, and spend the next three hours straining and reaching and cursing until all the surfaces have been reached by some degree of emulsion.

As I paint, struggling to roll smoothly and evenly, I hear voices. I am surrounded and absorbed by the task of turning this space absolutely white. I ponder the enduring and perplexing appeal of this colour, which, after all, is the sum of all other colours even if it seems to be colour-less. But white paint is nothing but white paint. Its allegorical purity and cleanliness has little to do with the world outside interior decorating. White paint is no more damaging than any other shade of paint. But I am obsessed with the structure of feeling that emerges from whiteness; how this particular way in which light falls on material objects has acquired enduring power to represent terror, greed, innocence, purity, hygiene, luxury, privilege, modernity.

It is so hard to keep things white. White underwear, for example, or white sheets show up body fluids like nobody's business. My mother was proud to see all four children wearing white nappies even though she had no washing machine for the first three. I do a white wash for my own folks even though I hold out on biological soap powder and use old-fashioned Vanish on food stains, sighing when it doesn't work, and the crisp whiteness inevitably turns grey. I know the soil beneath our feet is being slowly poisoned by chlorine bleach, phosphates, optical brighteners, effluents from the process of trying to make and keep natural fibres unnaturally white. I know there are stagnant lakes in Switzerland, rendered lifeless by the industrialization of laundry. Who doesn't, but as long as people buy it, whiteness sells.

So I converse with myself and others as I paint, hating Ralph Lauren for his thirty-five shades of white in the 1996 paint catalogue, little knowing that for those who follow the fads of interior decoration, white is definitely the icing on the cake this year.

Photo image: Vron Ware

Part II: Voices out of time

W. E. B. Dubois: The discovery of personal whiteness among the world's people is a very modern thing – a nineteenth and twentieth century matter, indeed.[1]

Ralph Lauren: (or as his catalogue might say) White is absolutely in this year. So why not choose from the wonderful, extraordinary range of shades that I am offering this year: Aspen Summit, Avalanche, Breakwater White, Candelabra White, Country Stove White, Design Studio White . . . [2]

Charles White: The white European . . . being most removed from the brute creation, may, on that account be considered as the most beautiful of the human race . . . Where shall we find, unless in the European, that nobly arched head, containing such a quantity of brain?[3]

Ralph Lauren: . . . Dover Cliffs, Dune White, Edwardian Linen, Flour Sack White, Garden Rose White . . .

Herman Melville: . . . as in essence whiteness is not so much a colour as the visible absence of colour, and at the same time the concrete of all colours; it is for these reasons that there is such a dumb blankness, full of meaning in a wide landscape of snows – colourless, all colour of atheism from which we shrink?[4]

1 W. E. B. Dubois 'The Souls of White Folk', in *Darkwater: Voices from Within the Veil* (Kraus-Thomson Organisation Ltd, Millwood, 1975), 29–30.

2 *Harpers* (May 1996).

3 Charles White, 1795, Lecture to the Literary and Philosophical Society of Manchester quoted in Peter Fryer, *Staying Power* (Pluto, London, 1984), 168–9.

4 Herman Melville, *Moby Dick*, 1851 (Penguin, Harmondsworth, 1986), 295–6.

Richard Dyer: This property of whiteness, to be everything and nothing, is the source of its representational power . . . The colourless multicolouredness of whiteness secures white power by making it hard, especially for white people and their media, to 'see' whiteness. This of course makes it hard to analyse.[5]

W. E. B. Dubois: The ancient world would have laughed at such a distinction. The Middle Ages regarded it with mild curiosity, and even up to the eighteenth century we were hammering our national manikins into one great Universal Man with a fine frenzy, which ignored colour and race, as well as birth. Today we have changed all that, and the world, in sudden conversation, has discovered that it is white, and, by that token, wonderful (30).

Emile Zola: What caused the ladies to stop was the prodigious spectacle of the grand exhibition of white goods. In the first place, there was the vestibule, a hall with bright mirrors, paved with mosaics, where the low-priced goods detained the voracious crowd. Then there were the galleries, plunged in a glittering blaze of light, a borealistic vista, quite a country of snow, revealing the endless steppes hung with ermine, the accumulation of icebergs shimmering in the sun. One found there the whiteness of the outside windows, but vivified, colossal, burning from one end of the enormous building to the other, with the white flame of a fire in full swing. Nothing but white goods, all the white articles from each department, a riot of white, a white star, the twinkling of white was at first blinding, so that the details could not be distinguished amongst this unique whiteness.[6]

National Socialist White People's Party: Have you ever taken a long close look at the face in the mirror? It's WHITE . . . but the attitude, behaviour and dress seem to be something much different from that of a self-respecting white person.[7]

W. E. B. Dubois: I am quite straight-faced as I ask soberly: 'But what on earth is whiteness that one should so desire it?' Then always, somehow, some way, silently but clearly, I am given to understand that whiteness is the ownership of the earth forever and ever, Amen! (ibid., 30)

Charles White: . . . Where, except on the bosom of the European woman, two such plump and snowy white hemispheres, tipt with vermilion? (ibid)

Joel Kovel: The problem of racism is part of the problem of Western culture. And thus, its central aspect is not . . . blackness . . . , but its cognate, whiteness. For the world is neither black nor white, but hued. A lightly hued people – aided perhaps by fantasies derived from their skin colour – came to dominate the entire world, and in the process defined themselves as white. The process that generated this white power also generated the fear and dread of black.[8]

W. E. B. Dubois: The discovery of personal whiteness among the world's people is a very modern thing – a nineteenth and twentieth century matter, indeed (ibid., 29–30).

5 Richard Dyer, 'White', *Screen*, vol. 29, no. 4 (1988), 45–6.

6 Emile Zola, *The Ladies Paradise* (*Au Bonheur des Dames*, 1883) (University of California, Berkeley, Los Angeles, Oxford, 1992), 352.

7 National Socialist White People's Party, provided by Christian Identity Online, 1995.

8 Joel Kovel, *White Racism: a Psychohistory* (Pantheon, New York, 1970), 95.

Emile Zola: And the white hung from the arches, a fall of down, a snowy sheet of large flakes; white counterpanes, white coverlets floated about in the air, suspended like banners in a church; long jets of Maltese lace hung across, seeming to suspend swarms of white butterflies; other lace fluttered about on all sides, floating like fleecy clouds in a summer sky, filling the air with their clear breath. And the marvel, the altar of this religion of white was, above the silk counter, in the great hall, a tent formed of white curtains, which fell from the glazed roof. The muslin, the gauze, the lace flowed in light ripples, whilst very richly embroidered tulles, and pieces of oriental silk striped with silver, served as a background to this giant decoration, which partook of the tabernacle and of the alcove. It made one think of a broad white bed, awaiting in virginal immensity the white princess, as in the legend, she who was to come one day, all powerful, with the bride's white veil.

'Oh! extraordinary!' repeated the ladies. 'Wonderful!' (ibid., 352–3)

Women For Aryan Unity: Nor are White racialists a new phenomenon. They can cite traditions, facts, and precedents dating from the founding of church and state . . . If Whites could speak out, they would tell thousands of stories of exploitation, intimidation, and political repression.

Ralph Lauren: . . . Journal White, Killington Traverse, Montauk Driftwood, Petticoat White, Picket Fence White, Pocket Watch White, Polo Mallet White, Poncho White, Portico White . . .

National Socialist White People's Party: If that face staring back in the mirror is White, why in the world would you want to act like any other race or people? Why in the world, after being born and raised by a White mother and father – being taught a civilized White language, White values, living as a part of this highly advanced and cultured society would you decide not to be a proud White American and not act your color?

Herman Melville: Though in many natural objects, whiteness refiningly enhances beauty, as if imparting some special beauty of its own, as in marbles, japonicas and pearls; and though various nations having in some way recognised a certain royal pre-eminence in this hue . . . and though this pre-eminence in it applies to the human race itself, giving the white man ideal mastership over every dusky tribe, and though, besides all of this, whiteness has been even made significant of gladness . . . yet for all these accumulated associations, with whatever is sweet, and honourable, and sublime, there yet lurks an elusive something in the innermost idea of this hue, which strikes more of panic to the soul than that redness which affrights in blood.

Ralph Lauren: . . . Resort White, River Rapids, Riviera Terrace, Roadster White, Sail White . . .

Emile Zola: . . . Every article of female linen, all those white under-things that are usually concealed, were here displayed, in a suite of rooms, classed in various departments. The corsets and dress

improvers occupied one counter, there were the stitched corsets, the Duchesse, the cuirass, and above all, the white silk corsets, dove-tailed with colours, forming for this day a special display; an army of dummies without heads or legs, nothing but the bust, dolls' breasts flattened under the silk, and close by, on other dummies, were horsehair and other dress improvers, prolonging these broomsticks into enormous, distended croups, of which the profile assumed a ludicrous unbecomingness. But afterwards commenced the gallant *dishabille*, a *dishabille* which strewed the vast rooms, as if an army of lovely girls had undressed themselves from department to department, down to the very satin of their skin. Here were articles of fine linen, white cuffs and cravats, white fichus and collars, an infinite variety of light gewgaws, a white froth which escaped from the drawers and ascended like so much snow. There were jackets, little bodices, morning dresses and *peignoirs*, linen, nansouk, lace, long white garments, roomy and thin, which spoke of the lounging in a lazy morning after a night of tenderness. Then appeared the under-garments, falling one by one; the white petticoats of all lengths, the petticoat that clings to the knees, and the long petticoat with which the gay ladies sweep the pavement, a rising sea of petticoats, in which the legs were drowned; cotton, linen, cambric drawers, large white drawers in which a man could dance; lastly, the *chemises*, buttoned at the neck for the night, or displaying the bosom in the day, simply supported by narrow shoulder straps; *chemises* in all materials, common calico, Irish linen, cambric, the last white veil slipping from the panting bosom and hips.

Clifford Geertz: Foreignness does not start at the water's edge, but at the skin's.[9]

9 Clifford-Geertz 'The Uses of Diversity', *The Michigan Quarterly Review* (Ann Arbor, Michigan, 1993).

National Socialist White People's Party: We have news for you. The White race has not been nor will it be ever beaten. Sometimes many members of the White race fall asleep at the wheel and temporarily lose control, but our people always regain control when awakened.

W. E. B. Dubois: The discovery of personal whiteness among the world's people is a very modern thing – a nineteenth and twentieth century matter, indeed.

Ralph Lauren: . . . Sailor's Knot, Sneaker White, Snowdrift, Starched Apron, Tennis Court White, Tackroom White, Tuxedo Shirt . . .

National Socialist White People's Party: It always comes back to the mere fact that in this world there are leaders and followers, builders and destroyers. The White race has been, is, and always will be a race of leaders and builders. Non-Whites have always been followers. There is nothing wrong in being proud to be White just as all races should be proud of their heritage. Let us never forget that no race has so much to be proud of as the White race!

Emile Zola: The silk department was like a great chamber of love, hung with white by the caprice of some snowy maiden wishing to show off her spotless whiteness. All the milky tones of an adored person were there, from the velvet of the hips, to the fine silk of the thighs and the shining satin of the bosom. Pieces of velvet hung from the columns, silk and satins stood out, on this white creamy ground, in draperies of a metallic and porcelain-like whiteness: and falling in arches were also *poult* and *gros grain* silks, light *foulards*, and *surahs*, which varied from the heavy white of a Norwegian blond to the transparent white, warmed by the sun, of an Italian or Spanish beauty.

National Socialist White People's Party: . . . healthy White men are discovering that some of their rightful biological partners are becoming hideous to behold. The skin of these women still gleams like ivory, their bodies as voluptuous as ever. The hideousness comes from the male hand intertwined with one of theirs. The hand is black.[10]

Clifford Geertz: Foreignness does not start at the water's edge, but at the skin's.

bell hooks: Socialised to believe the fantasy, that whiteness represents goodness and all that is benign and non-threatening, many white people assume this is the way black people conceptualise whiteness. They do not imagine that the way whiteness makes its presence felt in black life, most often as a terrorising imposition, a power that wounds, hurts, tortures, is a reality that disrupts the fantasy of whiteness as representing goodness.[11]

James Baldwin: As long as you think you're white, there's no hope for you.[12]

10 National Socialist White People's Party, provided by Christian Identity Online, WWW, 1995. This extract first appears in *National Vanguard* 1979, 11 quoted in Abby L. Ferber's '"Shame of White Men": Interracial Sexuality and the Construction of White Masculinity in Contemporary White Supremacist Discourse', in *Masculinities*, vol 3, no. 2 (summer 1995) 1–24.

11 bell hooks, 'Representing Whiteness in the Black Imagination', in *Black Looks: Race and Representation* (Turnaround, London, 1992), 169.

12 James Baldwin in *James Baldwin: The Price of the Ticket*, BBC2 TV documentary, also quoted in David R. Roediger, *Towards the Abolition of Whiteness* (Verso, London/New York, 1994), 13.

Part III: A whitelist

White House
White Race
White Lies
White Power
White Bread
White Supremacy
White Wash
White Skin
Whitewash

White trash

The social construction of whiteness. The total destruction of whiteness.
Elle Decoration (July–August 1996)
The White Issue
Is sent to haunt me.
As if they knew all along what was going on in my head
And wanted to join in,
Au Bonheurs des Dames

This is what it says:

white white white
LIGHTEN UP WITH THE NEW WHITES
MAKE YOUR HOME A PLEASURE ZONE
COOL WHITE HOMES
light and bright

the white issue
All white now . . . clean and cool, white is right. Freshen up with white
linen, white furniture . . . even painting the floor white will make a
difference . . . lighten up. In this issue we have wonderful light white
homes to inspire you . . .

WHAT IS WHITE?

White paint is a grey issue.
Technically there is only one real white – apart from brilliant white, which is chemically
adjusted to make it brighter. Thereafter you're really talking about pale colours; the nearly-
whites.

SHOPPING TREND
white
Buy it white for a look that's space-age, modern, cool
white
clean-lined and easy to live with - it's all white now . . . white

SHOPPING BASICS

Any definition of luxury would have to include

freshly laundered and delicately scented creamy white bed linen and towels.

Air-dried for maximum softness, textured

waffle towels and fine linens

are an absolute must on the beach or in bed

get the look

GREAT ESCAPE
The big freeze
In our dreams the Arctic is clean, ultra-white and absolute – the antithesis of our polluted cities. In reality, travelling to the Arctic is fast becoming a 1990s version of the hippy trail to India.
The wilderness of Greenland is purity in 3D.

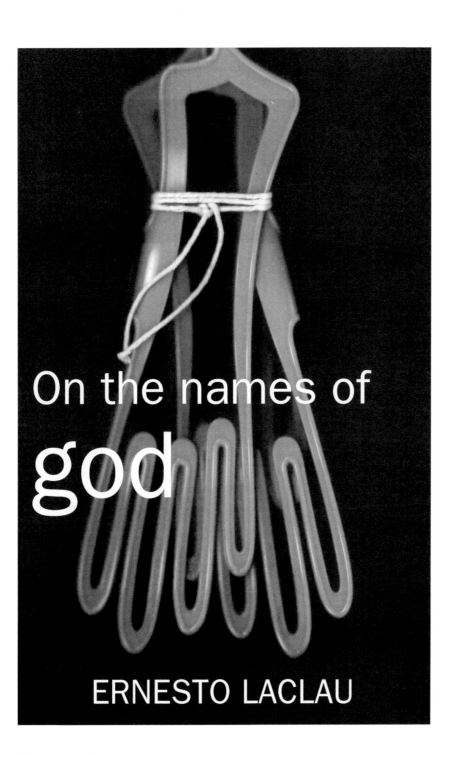

On the names of

god

ERNESTO LACLAU

Eckhart asserts:

> God is nameless for no one can either speak of him or know him
> . . . Accordingly, if I say that 'God is good', this is not true. I am good,

but God is not good! In fact, I would rather say that I am better than God, for what is good can become better and what can become better can become the best! Now God is not good, and so he cannot become better, he cannot become the best. These three are far from God: 'good', 'better', 'best', for he is wholly transcendent . . . Also you should not wish to understand anything about God, for God is beyond all understanding . . . If you understand anything about him, then he is not in it, and by understanding something of him you fall into ignorance, and by falling into ignorance, you become like an animal since the animal part in creatures is that which is unknowing.[1]

1 Meister Eckhart, *Selected Writings* (Penguin, London, 1994) Sermon 28 (DW 83, W 96), 236–7.

If God is nameless, it is due to His absolute simplicity which excludes from itself all differentiation or representational image:

> You should love God non-mentally, that is to say the soul should become non-mental and stripped of her mental nature. For as long as your soul is mental, she will possess images. As long as she has images, she will possess intermediaries, and as long as she has intermediaries, she will have no unity or simplicity. As long as she lacks simplicity, she does not truly love God, for true love depends upon simplicity.[2]

2 Ibid., 238.

The only true attribute of God is Oneness, because it is the only attribute which is not determinate. If I say that God is good, 'goodness' is a determination which implies the negation of what differs from it, while God is the negation of the negation. As such, Oneness, as a non-attribute which involves no difference and, therefore, no negation, is the only thing that we can predicate of Him.

> Oneness is purer than goodness and truth. Although goodness and truth add nothing, they do nevertheless add something in the mind: when they are thought, something is added. But oneness adds nothing, where God exist in himself, before he flows out into the Son and the Holy Spirit . . . If I say that God is good, then I am adding something to him. Oneness on the other hand is a negation of negation and a denial of denial. What does 'one' mean? One is that to which nothing has been added.[3]

3 Ibid., Sermon 17 (DW 21, W 97), 182.

If we call God 'Lord', or 'father', we are dishonouring Him, because those names are incompatible with Oneness – a Lord requires a servant and a father, a son. So, 'we should learn that there is no name we can give God so that it might seem that we have praised and honoured him enough, since God is 'above names' and is ineffable'.[4]

4 Ibid., Sermon 5 (DW 53, W 22), 129.

It seems apparently necessary to conclude, with Dionysius Areopagite, that 'the cause of all that is intelligible is not anything intelligible'. This paves the way for the mystical way, the *via negativa*. God is

> not soul, not intellect,
> not imagination, opinion, reason and not understanding,
> not logos, not intellection,

not spoken, not thought,
not number, not order,
not greatness, not smallness,
not equality, not inequality,
not likeness, not unlikeness,
not having stood, not moved, not at rest.[5]

5 Pseudo-Dionysius
Areopagite, 'Mystical
Theology', in *The Divine
Names and Mystical
Theology*, trans. John D.
Jones (Marguette University
Press, Milwaukee,
Wisconsin, 1980), 221.

Etc. What we are presented with here, through all these negations, is a certain manipulation of language by which something which is ineffable gets expressed. This is a generalized tendency within mysticism: a distortion of language which deprives it of all representative function is the way to point to something which is beyond all representation. In some primitive texts, such as those related, for instance, to Merkabah mysticism, this effect is obtained by giving each organ of the body of the Creator, in their descriptions, such an enormous length, that all visual representation becomes impossible. As G. Scholem points out: 'the enormous figures have no intelligible meaning or sense-content, and it is impossible really to visualise the "body of the shekinah" which they purport to describe; they are better calculated, on the contrary, to reduce every attempt at such a vision to absurdity'.[6] In a highly intellectualized discourse such as that of Eckhart the devices are, obviously, much more sophisticated – they rely on the redemptive nature of language, according to which 'words come from the Word'. But in any case it is a distortion of the normal use of language which is at stake. What is involved in such a distortion?

6 Gershom Scholem,
*Major Trends in Jewish
Mysticism* (Schoken, New
York, 1995), 64.

Let us concentrate for a moment on the series of negations through which Dionysius attempts to approach the (non-)essence of the Divinity. In the first place, all the contents which are negated are part of an enumeration which has no internal hierarchy or structure. They are in a purely paratactic relation with each other. In the second place, the enumeration is an open one: many more contents – actually, all representational content – could have been part of the same enumeration. Now this enumerative operation is crucial to produce the effect of meaning that Dionysius is looking for. If he had just said, for instance, that God is not 'imagination', the possibility would have always existed that He is something else, endowed with a positive content. It is only the location of 'imagination' in an enumerative chain with 'opinion', 'logos', 'number', 'intellection', etc, as well as the open character of the enumeration, that guarantees that God can be identified with the 'ineffable'. But in that case, the enumeration is not just an enumeration in which each of its terms would express the fullness of its own isolated meaning (as when we say, for instance, that the USA was visited last year by many British, French, and Italian people). In the case of Dionysius' text each of the terms of the enumeration is part of a chain which, *only when it is taken as a totality*, expresses the non-essence of that Who is the Cause of All Things. That is, that we are dealing with a peculiar type of enumeration, one whose terms do not simply coexist one by the other, but instead they can replace each other because they all,

within the enumerative arrangement, express the same. This is the type of relation that I call *equivalence*.

It could perhaps be objected that this possibility of an equivalential substitution is simply the result of the negative character of each of the terms of Dionysius' enumeration. But I do not think that this is the case. If the only thing that we had in the succession of negative terms was the negation of which they are bearers, the possibility of expressing the ineffable would be lost. For if all we are saying is that God is not A, not B, and not C, this by itself does not exclude the possibility that He is D, E, or F. That is, if we focus exclusively on the *not* of the negation, there is no way of meaningfully constructing the open-ended dimension of the enumeration (on which the possibility of expressing the 'ineffable' depends). We are apparently dealing with two contradictory requirements: we want to maintain the ineffable character of the experience of the divinity, and we want at the same time to show through language such an ineffable presence. As we said, no pure concentration on the *not* will help us to meet these two requirements. However, the enumeration of Dionysius has another dimension, for what he is saying is not that God is 'not imagination' – paragraph – 'not logos' – paragraph, etc. What he is actually saying is, first that God is something which goes *beyond* the specific meaning of terms such as 'imagination', 'logos', 'intellection', etc, and, secondly, that this transcendence, this going *beyond*, the specific meanings of these terms, is shown through the equivalence that the terms establish between themselves. For it is clear that an equivalential enumeration – as different from a purely additive one – destroys the particularized meanings of its terms as much as a succession of negations. I can perfectly replace 'not imagination', 'not logos', and 'not intellection' by the equivalential succession 'imagination', 'logos', and 'intellection'. In both cases I would be saying exactly the same, for if I have to concentrate – in order to establish the equivalence – on what 'imagination', 'logos', and 'intellection' have in common, I have to drop most of the particularized meanings of each of these terms, and if the chain of equivalences is extended enough, it can become the way of expressing something which exceeds the representational content of all its links – i.e., the 'ineffable'. The advantage of eliminating the *not* from the enumeration is that in that way its equivalential character becomes more ostensible, and its infinitude – its open-ended nature – becomes fully visible. When I enumerate 'not-A', 'not-B', 'not-C', etc., I can incorporate D to that chain, in the fullness of its positive meaning, without any further requirement. But if I have the equivalence between the positive terms A, B, and C, I cannot incorporate D into that chain without the added requirement of reducing D to what it has in common with the three previous terms.

So from the previous analysis we can conclude by saying that God is something different from any particular attribute that we can predicate of Him, and saying that he expresses Himself through the *totality* of what exists,[7] is to say exactly the same. Likeness (= equivalence) between things is the way in which God – actualizes Himself?, expresses Himself?

7 Here, of course, is where different mystical currents start to diverge. Is the experience of the Oneness of God Himself, or that of an expression of God? For our argument in this essay the debate around dualism, monism, and pantheism is not really relevant. Let me just say in passing that, from the point of view of the logic of the mystical discourse, pantheism is the only ultimately coherent position.

Listen to Eckhart:

> God gives to all things equally and so, as they flow forth from God, all things are equal and alike. Angels, men and women and all creatures are equal where they first emerge from God. Whoever takes things in their first emergence from God, takes all things as equal . . . If we take a fly as it exists in God, then it is nobler in God than the highest angel is in itself. Now all things are equal and alike in God and are god. And this likeness is so delightful to God that his whole nature and being floods through himself in this likeness . . . It is a pleasure for him to pour out his nature and his being into this likeness, since likeness is what he himself is.[8]

As far as the experience of the ineffability of God passes through the equivalence of contents that are less than Him, He is both beyond those contents and, at the same time, fully dependent on them for His actualization. Indeed the more his 'beyond', the more extended the chain of equivalences on which His actualization depends. His very transcendence is contingent upon an increased immanence. Let us quote Eckhart again: 'God is in all things. The more he is in things, the more he is outside them: the more in, the more out and the more out, the more in'.[9] As David says in Browning's *Saul*:

> Do I task any faculty highest, to imagine success?
> I but open my eyes, – and perfection, no more and no less,
> In the kind I imagined, full-fronts me, and God is seen God
> In the star, in the stone, in the flesh, in the soul and the clod.[10]

Now, if God is present 'in the star, in the stone, in the flesh, in the soul and the clod', it is clear that mystical experience does not lead to an actual *separation* from things and daily pursuits but, on the contrary, to a special way of joining them, so that we see in any of them a manifestation of God's presence. According to Eckhart:

> Those who are rightly disposed truly have God with them. And whoever truly possesses God in the right way, possesses him in all places: on the street, in any company, as well as in a church or a remote place or in their cell. No one can obstruct this person, for they intend and seek nothing but God and take their pleasure only in him, who is united with them in all their aims. And so, just as no multiplicity can divide God, in the same way nothing can scatter this person or divide them for they are one in the One in whom all multiplicity is one and is non-multiplicity.[11]

This experience of daily involvement as one in which multiplicity is not denied but it is lived as the variegated expression of a transcendent unity is the distinctive mark of the 'unitive life' required by the mystical consciousness. Eckhart gives two metaphoric examples of what is to live multiplicity in unity. The first is the case of somebody who is thirsty: their thirst will accompany all the activities in which they are engaged, irrespective of their variety. The other refers to somebody who is in love:

8 Eckhart, Sermon 16 (DW 12, W 57), 177–8.

9 Ibid., Sermon 4 (DW 30, W 18), 123.

10 Jacob Korg (ed.) *The Poetry of Robert Browning*, (Bobbs-Merril, Indianapolis and New York, 1971), 286. The following are some other examples of a theme which is quite common in mystical literature. Julian of Norwich refers to a small thing that he is beholding, the size of a hazelnut. And he asserts: 'In this little thing I saw three properties. The first is that God made it: the second, that God loveth it: the third that God keepth it. And what beheld I in this? Truly, the Maker, the Lover and the Keeper' (*The Revelation of Divine Love of Julian of Norwich*, trans. James Walsh, SJ (Burns and Oates, London, 1961), 60). In his diary George Fox sees in everything existing the 'hidden unity in the Eternal Being'. Commenting on that passage, Evelyn Underhill says: '"To know the hidden unity in the Eternal Being" – know it with invulnerable certainty, in the all embracing act of consciousness with which we are aware of the personality of those we truly love – it is to live at its fullest the Illuminated Life, enjoying "all creatures in God and God in all creatures"' (Evelyn Underhill, *Mysticism: A Study in the Nature and Development of Man's Spiritual Consciousness* (Dutton, New York, n.d.) 309.

11 Eckhart, 'The Talks of Instruction', 9

his or her feeling will taint the multifarious pursuits of that person's daily life.

A last important aspect to be considered is the mystical *detachment*, whose inner structure is most revealing for our purposes. The detachment in question cannot be that of an anchorite, who lives a segregated existence, for the mystic is not refusing involvement in daily life. The mystic should be fully engaged and, at the same time, strictly detached from the world. How is this possible? As we know, actually existing worldly things – Browning's star, stone, flesh, soul, and clod, Julian's small thing like a hazelnut – can be considered from two perspectives: either in their isolated particularity, in which each of them lives a separate existence, or in their equivalent connection, in which each of them shows the Divine essence. So, the mystic has to love each instance of his worldly experience as something through which the Divinity shows itself; however, as it is not the particular experience in its own naked particularity which shows God but instead its equivalential connection with everything else, it is only the latter connection, the contingency of the fact that it is *this* experience rather than any other than the one that I am having at the moment, which approaches me to the Divinity. Essential detachment and actual involvement are the two sides of the same coin. It is as the formation of the revolutionary will of a subordinated class: every participation in a strike, in an election, in a demonstration, does not count so much as the particular event concerned, but as a contingent instance in a process that transcends all particular engagement: the education of the class, the constitution of its revolutionary will. On the one hand, the latter transcends all particular engagement and, in that sense, requires the class to be detached from them; on the other hand, however, without a serious engagement in the particular event there is no constitution of the revolutionary will. Paradoxically, it is the detached nature of what is invested in the particular action, its purely contingent link with it, which guarantees that the involvement in that action is going to be a serious one. Let us have Eckhart speaking for the last time:

> We must train ourselves not to seek or strive for our own interests in anything but rather to find and to grasp God in all things . . . All the gifts which He has granted us in heaven or on earth were made solely in order to be able to give us the one *gift*, which is himself. With all other gifts He simply wants to prepare us for that gift, which is Himself . . . And so I tell you that we should learn to see God in all gifts and works, neither resting content with anything nor becoming attached to anything. For us there can be no attachment to a particular manner of behaviour in this life, nor has this ever been right, however successful we may have been. Above all, we should always concentrate upon the gifts of God, and always do so afresh.[12]

12 Ibid., 40.

Let us draw two important conclusions from our brief exploration of mysticism. The first concerns the specific problems involved in naming God. Being God the ineffable, we could use whatever name we want to

refer to Him, as far as that name is not attributed any determinate content. Eckhart says that, precisely because of that reason, the best is to say just 'God', without attributing anything to Him. So the name of God, if we are not going to soil His sublime reality (and our experience of it) has to be an empty signifier, a signifier to which no signified can be attached. And this poses a problem to us. Is 'God' such an empty signifier, or is this name already an *interpretation* of the sublime, of the absolute fullness? If the second is the case, to call the sublime 'God' would be the first of the irreverences. To put it in other terms: while the mystical experience underlies an ineffable fullness that we call 'God', that name – God – is part of a discursive network which cannot be reduced to that experience. And, in actual fact, the history of mysticism has provided a plethora of alternative names to refer to that sublimity: The Absolute, Reality, the Ground, etc. There have even been some mystical schools – as some currents of Buddhism – which have been consequently atheistic. If the mystical experience is really going to be the experience of an absolute *transcendens* it has to remain indeterminate. Only silence would be adequate. To call it 'God' is already to betray it, and the same would be the case for any other name that we choose. Naming 'God' is a more difficult operation than we would have thought.

Let us now move to our second conclusion. As we have seen, there is an alternative way of naming God, which is through the self-destruction of the particularized contents of an equivalential chain. We can refer to God by the names of 'star, stone, flesh, soul and clod' for, as far as they are part of a universal chain of equivalences, each of them can be substituted by any other others. *Ergo*, they would all be indifferent terms to name the totality of what exists – i.e., the Absolute. Here we are confronted, however, with a different problem from that of naming God in a direct way – or, perhaps, with the same problem seen from another angle – for, if that operation could be achieved, we would have accomplished something more than obtaining a universal equivalence: we would have destroyed the equivalential relation and made it collapse into simple identity. Let us consider the matter carefully. In a relation of equivalence the particular meanings of its terms do not simply vanish; they are partially retained and it is only in some aspects that the replacement of one term by the others operates. There are some currents of Hindu mysticism which have advocated a total collapse of differences into undifferentiated identity, but Western mysticism has always played around the Aristotelian–Thomist notion of analogy, grounded in an equivalence that is less than identity. A mystic like Eckhart was trying to think 'unity in difference', and that is why the analogic relation of equivalence was crucial in his discourse. The universe of differences had to be brought into unity without the differential moment being lost. But it is here where we find a problem, for, if the equivalence becomes absolutely universal, the differential particularism of its links necessarily collapses. We would have an undifferentiated identity in which *any* term would refer to the totality, but in that case the totality – the Absolute – could be named in an

wealthy 1950s dowager: tight orange cashmere sweater matching a narrow orange and brown chequered skirt that ends just below her knees, a set of pearls, stockings (only Jackie Onassis dared to go without stockings away from the beach), high black heels, one of her small Gucci purses, of course bright red lipstick. Pausing in front of the doorway, she opens up her purse, withdraws a mirror and a lipstick the exact colour of what she's wearing so she can check her mouth. Only after she's done this will she allow herself to see if anyone's around.

She hasn't as yet, as is her wont, noticed her daughter, **Electra.**

Electra *is lurking. One of her more charming characteristics. She's part sitting, part slouching over, part disappearing into an armchair whose colours are more grey than not. Both the chair and she are almost in a corner; corners are her favourite spot because they remind her of prison though she's never been in prison.* **Electra** *doesn't want to be visible and, at the same time, she looks exactly like* **Claire.** *Except for her colouring.* **Claire's** *eyes are green and her hair is jet-black;* **Electra,** *brown everywhere, has none of the pallor of her mother's perfect skin, and wears no lipstick. In fact, it's hard to notice what* **Electra** *is wearing.*

As usual the latter is picking her lips.

The door, the one that leads to the outside, opens and **Betsy** *walks in. A woman ten years older than* **Claire. Claire's** *best girlfriend. It's obvious that* **Betsy** *is rich, richer even than* **Claire,** *because she's wearing a thrift-store dress, the same sort of colourless stockings* **Claire** *wears, and low, black heels. This constitutes the uniform of 'the girls'; women who wear designer clothing and let their wealth appear publicly are deemed 'nouveau riche'.*

Betsy, *rushing in Betsy-style or walking at an almost standard pace:* I know I'm late . . . How is he?

Claire, *still doing her lipstick:* As well as can be expected.

It's obvious that **Electra** *has left her private space to listen to all this closely because she's now slouching further into the chair, trying to be as invisible as she can.*

Two nurses, chattering to each other, enter. They're young.

Nurse 1, *motioning toward* **Electra** *as if she's dead:* That's the daughter there . . .

Pimply Nurse, *staring because she can't see properly being near-sighted:* She looks exactly like the mother though she isn't beautiful the way Mrs Alexander is.

Betsy, *her voice loud enough to be heard in the inner room:* Claire, whatever you think, you have to admit that he's been a good husband to you.

Claire, *still putting on lipstick:* I guess so.

Electra *is so fascinated by what's happening that she forgets she's supposed to not be visible.*

Betsy: A lot of husbands could have been worse.

Claire: I guess so.

Betsy: He took care of you and the kids . . .

Claire: I guess so. *(Putting away her lipstick, perks up)* Let's go to La Rotonde for lunch.

Betsy: Oh good. The new chef there does the most marvellous *crème brûlée*. I'll even go off my diet. *(They exit.)*

Pimply Nurse, *pointing to* **Betsy** *as she leaves*: And that's the one whose husband owns Wall Street. Would you believe it?

Nurse 1, *chewing gum*: She's a walking garbage can . . .

All the adults disappear. **Electra** *is left alone. Her eyes grow larger and larger as she looks at her father's hospital room's door . . .*

SCENE 2. Same room, a bit later. There's nothing here that indicates change of weather or the passage of time. Here, at the threshold of all which lies below.

Since no one is now in this room except for **Electra**, *still sprawled out all over the armchair, she reads aloud from Kallimachos'* Hymn to Apollo: 'He who sees the god is great; he who does not see him is small.'

Peter, *a sexy but fattish rocker-type, enters from the exit door.*

Peter: So is he here?

Electra: Shhh. *(Points to where her father is. So they begin to whisper.)* This is his third heart attack.

Peter, *earnestly*: Actually you're the one I'm looking for.

Electra: I like it here.

Peter: There's no one here but us.

Electra, *realizing she has to shut her book*: What's going on, Peter?

Peter: Maybe now's the wrong time. *(Changes his mind because he can't help himself.)* Look.

Electra: Don't start that.

Peter: You said to wait 'til I got money and now I do.

Electra, *disbelieving*: How d'you get money?

Peter: I sold my book on John Lennon.

Electra: I don't care about money.

Peter: We can get married.

Electra: I don't want to ever marry anyone. Especially someone with whom I'm having sex.

Peter: That's a sick way to feel. You gotta let someone in.

Electra: And there's Daddy.

Peter: What d'ya mean?

Electra: Just look at him.

Peter: Electra, your father has your mother to take care of him.

Electra: That's what I told him that night . . .

Peter: What night?

Electra: Forget it. My father knows that he's all alone.

Peter: Electra, your mother's a good woman and she loves your father very much. When they have quarrels . . . that's what people do when they live together. You're just feeling things too strongly at the moment 'cause you don't want your father to be in here.

Electra: Why don't you ever listen to me? I don't want a husband.

I want a brother. That's what I want. That's what you were to me before we had sex. If we were brother and sister, we would tell each other everything and nobody would or could ever come between us.

Peter: One day you'll grow up, Electra, and then you'll know what I'm feeling now. I'm gonna wait for you.

Electra: I don't feel anything. All I know is I don't want to get married. I'm never gonna let anyone near me or let myself get close to anyone.

Peter *looks at her.* **Electra** *is looking off into space. She does this in order to make sure that no one can trespass into her private realm. She does this most of the time. As soon as* **Electra***'s sure that this territory or herself is impenetrable, she speaks.*

Electra: You know what I want? *(If* **Peter** *really loved her, he'd give her everything she wanted. As it is she doesn't wait for his reply.)* I want my mother to have a lover.

Peter: Maybe you shouldn't talk so loud.

Electra, *not lowering her voice because* **Peter** *doesn't exist except as a figment of her imagination*: 'Cause if she understood what sex is, what actual sexual desire is, she wouldn't torment me any longer and she'd understand me. (**Peter** *starts tiptoeing towards the door to the inner room so that he can close it.)* He's got to be like one of those older European guys, in the movies, I can't remember any of their names, gorgeous but slightly sleazy so that he can be sinister. He won't let her get away with anything; when she begins to act up, like she always does, he'll slap the shit out of her. That's the only thing that's gonna make her behave properly. 'Cause she's so desperate for sex and she never gets any.

Peter, *accepting* **Electra***'s reality*: How do you know?

Electra: I was sound asleep and this huge scream woke me up, this was about four months ago, so my sister and I, now semi-awake, ran into my parents' bedroom and we saw Tinkerbell . . .

Peter: Tinkerbell?

Electra: . . . my mother's ex-poodle hanging by my father's nipple. I think he was trying to bite through it. Tinkerbell was a he. Half the nipple was hanging off.

Peter: What did your father do?

Electra: He watched.

Peter: I mean, what had he done to make a poodle . . . ?

Electra, *understanding*: Tinkerbell was protecting my mother cause my father had tried to kiss her.

Peter: What did your mother do?

Electra: Nothing.

Peter: From this you concluded that your mother needs to be fucked . . .

Electra: By an older guy.

Peter: . . . by an older guy?

Electra: I totally know what it's like to be regularly fucked by a guy who knows how to control you. My mother's either going to get hot sex, not just a one-night-stand but a relationship, or she's going to die. Don't

you see that she's doing everything she can – making my father's life living hell, tormenting me – so she can get it? She's just a bitch in heat.

Peter: Your mother is a very proper lady. There's no way she's going to meet a lover. Lovers don't exist in her world.

Electra: Yes, they do.

Peter: And even if they do, your mother's not going to take one.

Electra: We've got to make a plan. *(She starts picking her lip.)*

Peter: Why?

Electra: It's not going to happen otherwise. You already said that.

The **Pimply Nurse** *walks from the exit to the inner room and enters it.)*

Peter*, trying to think:* She could meet him at a dinner party.

Electra: Mommy doesn't go to dinner parties. I mean the kind where people meet each other. Those are for the people who spend their money on clothing. My mother's friends all know each other; they don't want to know anyone but themselves.

Peter: Your mother knows a lot of people and everyone loves her.

Electra*:* You've got to understand the difference between 'nouveau riche' and Mom's friends. Take Hope Legrand . . .

Peter: She went to that private school with you . . .

Electra: Mommy just told me that Hope married this old guy – the kind of marriage my family wants me to make 'cause the guy'll die when I'm young enough to enjoy his money. When Hope married, her grandfather gave the couple a bank as a wedding present and then Hope had a baby who was . . . *(scratches her head)* . . . Mom said it served her right . . . well Hope's mother, this is who I really want to tell you about, she belonged to the same beach club as us, she had dyed blonde hair and wore a bikini even though she was my mother's age. All that's 'nouveau riche'.

The **Pimply Nurse** *exits from the interior room, carrying a bed pan.*

Peter*, scratching his head*: What's 'nouveau riche'?

Electra: Having money and showing your money off publicly is 'nouveau riche'. It means you're insecure 'cause you didn't inherit the money from someone who inherited money.

Peter: I don't see what this has to do with your mother's lover.

Electra: I know how my mother's going to find a man. *(Pause.)* It'll be a dark night. The way the pavement looks wet in the city when all the lights are shining in it. Mommy will be so maddened by horniness, though of course she won't know what this is, that she'll tiptoe, with her high-heeled black shoes in her hand, past my father, fast-sleeping, into the dark hall, slowly open the door, the elevator man won't comment to her how late it is, down down into the night, where her lover will be waiting.

Peter: Where?

Electra: Where a single car zooms around a corner . . . the sound of high heels tapping on the concrete . . . in the distance, a cop car siren . . . my mother is walking down that street . . .

Peter: . . . and goes into a bar.

Electra: No. Mom would never go into a bar by herself. *(Recognizing that her ability to deal with reality is now being tested. Passing that test)* It doesn't matter how they meet because their meeting is pre-ordained. So they could meet . . . at the Jewish Guild for the Blind. What matters is that the moment they meet, they just know. Simultaneously Mom doesn't know because she's been so sexually fucked up. Now he . . . starts kissing her . . . there's no restraint . . .

Peter: What if your father's there?

Electra: Where?

Peter: Where they are.

Electra: They no longer know if there's anyone else around them because there's no one left in the world. Just them. The scenario I'm describing is only a metaphor for the following reality: he sweeps her off her feet and, by doing so, shows her who she is. So it doesn't matter how they meet.

Peter: What happens after they fuck?

Electra: It doesn't matter.

Peter: What does he look like?

Electra, *ignoring* **Peter** *out of necessity*: As soon as they've met, my mother begins to drink.

Peter: Your mother hates alcohol.

Electra: The truth is that the moment she drinks, she becomes a sex-maniac. When she had a drink at the beach party a month ago, she instantaneously got down on her hands and knees and crawled over to one of her friends' husbands and licked his leg. When she's not drunk, she's always telling my father that he's an alcoholic. He replies, 'Claire, I've only taken one drink; I've worked all day.' She tells him that he's worthless, he has a job only because he married into the family, all the wealth is on her side of the family. He tells her that he bought her her first mink coat. They go through this every single day. *(Pauses.* **Peter** *doesn't say anything.)* Leaving wherever they are, my mother and her lover go away to a room and fuck all night. He does things to her like spank her and call her his '*petite chienne*'.

Peter: I guess it's a good thing to be drunk.

SCENE 3. *An apartment located in the richest section of New York City's upper East side. A small apartment – its interior reveals that its inhabitants aren't all that wealthy.*

A narrow, dark green hall leads, on one side, to a large sunken living-room, the largest room in the apartment.

All the sofas and chairs in this room, of which there are many, have silk exteriors; the clear plastic that **Claire** *explains is needed to protect the pale silks from stains is never taken off except when there are guests. There are a number of antiques including a captain's desk in which there are hiding places, a table whose inlaid pads are the color of ivy. A cabinet replete with china dogs supervises the large writing desk, of the same wood, beneath it. No one ever uses this desk. Tinkerbell is*

dead. Pepper, the living dog, is standing below. He is so fat, he can hardly stand, but that doesn't matter to anyone because Pepper is vicious. He loves only one living being, **Claire***. Anything else that moves is regarded as meat. Pepper will eat anything, however his favourite food is the gold foil from chocolates that can sometimes be found in the toilet bowl. He is pedigree like everything else in this house.*

The dog's life is eating, sleeping, and biting.

Claire *and* **Nana** *are standing next to a white armchair and looking down at the clothes spread out on the pink sofa that runs against the half-cross-shaped windowseat. Since* **Nana** *is family, the plastic is still on the silk.* **Claire's** *mother is eighty years old, more than of sound mind and body. She's as sharp as they come. A stroke has paralyzed one side of her face. She is still rather beautiful in an antiquated Grande-dame style: the white hair, with lilac tinge, piled on top of her head is perfectly coiffed. So are her nails. The old lady's dress isn't as dingy as* **Betsy** *'s though it's the same style, for, disdaining stores because other humans shop in them,* **Nana** *has her own dressmaker.*

Nana: Claire, you should be ashamed of yourself.

Claire: What'd I do now? *(Flicking her cigarette.)*

Nana: Pfew! *(to the cigarette smoke)* You're going to kill yourself with those cigarettes, Claire. *(Pauses.)* I told you to buy yourself something decent, didn't I?

Claire: Yes, mother.

Nana: What do you call this? *(They both look down at the clothes on the couch. The white shopping bag that's sitting on the glass table in front of the couch says 'Sak's Fifth Avenue'.)*

Claire: What's the matter with them?

Nana: What's the matter with them? Claire. *(Walking over to the pink sofa and picking up a dress)* How could you even think of wearing something like this? Look where the hem is. Who do you think you are?

Claire: I don't know.

Electra *sneaks down into the living-room. Sneaks, because she's not allowed in there, over to a corner in front of the black banister that separates the hall from this room, but they're not noticing her, which she knows. She knows that, except when she's in danger, she doesn't exist.*

Nana: Go back to the department store and tell them that you're sorry, you're returning them.

Claire: I don't want to return them.

Nana: Pick out something nice for yourself.

Claire, *grinding out her half-smoked cigarette and lighting up another:* I'll go on Thursday. OK?

Nana: It's not as if I didn't bring you up to know how to dress yourself decently.

Claire: I said I'm going to return them Thursday. I have a lunch date with Betsy.

Nana: She knows how to dress herself. She got that magnificent silver fox at Roland's. I bet she paid next-to-nothing for it.

Claire: That's a thrift store.

Nana: Betsy knows how to buy clothes.

Electra, *staying away from Pepper, seats herself in a corner.*

Claire: So what am I going to do about the dinner party this weekend? If Bud comes home . . . Can I have a dinner party with a man in the house who's just had three heart attacks? What if he dies?

Nana: He's not going to die.

Claire: What if he isn't home by then? *(There's a pause.)* Can I have a dinner party if he's not here?

Nana: You can't hold a dinner party while your husband's away.

Claire: But what am I going to do about the caterer? *(**Electra** starts picking her nose. Pepper doesn't know whether or not he smells food.)* You know how hard it is to get this caterer . . . it takes weeks to reserve him. He's the talk of the town. Plus Alice Harte's husband, you know Robert, can only come . . .

Nana: You should have consulted me before you planned all this, Claire. I'm going to go home now.

Claire: Mother . . . Just stay for another half hour and the traffic'll have died down. You don't want to go cross-town in this traffic.

Nana, *not yet making a decision*: So what are you going to do about Bud?

Claire: I don't see what there is to do about him. It's not as if he's dead or anything.

*Pepper growls at **Electra**. She tries to move further back into the corner.*

Nana: He was a good husband to you, Claire. He took care of you and the kids.

Claire: I know. *(Folding up the clothes, placing them in the white bag)* I don't love him.

Nana: That's not what matters.

*(**Electra** crawls out of the living-room. She thinks about hiding under the dining-room table and decides not to.)*

Claire: Do you think I should get Liliane's to do those fabulous pastries they did for Beatrice's party? *(Looking through her purse)* Oh damn. I've run out of diet pills again.

SCENE 4. Hospital. The same room. Nothing ever changes because this territory is located between time and eternity. As is true of most of the locations in this play.

Electra *is sitting in the same armchair in which she last sat. This time, since she's not trying to be invisible, she appears in her normal pose: legs spread all over the chair's arms and back, one of her hands, without her being aware of its existence, on her crotch then in a nostril. Because she was kicked out of music class in third grade, she sings*:

> It's important to be a little girl
> And to lie in your bed,
> And all the men lie around you,
> And all the men are dead.

Billy *enters through the outside door.* **Billy** *looks exactly like the person she dreams is her ideal brother of all time and is her real brother. He resembles Jimmy Dean. Some of his red hair falls over one eye and he's fat. Not exactly Jimmy Dean if reality has to matter. It doesn't. Since Jimmy Dean was gay, she can't have sex with her brother.*

Electra: Hi ya, Billy. *(Seeing that* **Claire** *is right behind him, she shuts up. Takes her legs and feet over the chair and places them on the ground where they belong.)*

Claire, *in a black turtleneck and plaid kilt that stops an inch above her knees, is now stylish. She looks younger than she first looked.*

Claire: We've been looking all over for you.

Electra, *having learned from* **Claire** *that a lie's use-value in no way depends on whether it's convincing or not*: I just got here.

Claire, *recognizing her own tactic*: You're here so much these days that they might start asking you to pay rent.

Electra: I just like this room.

Claire: What's there to like about a . . . hospital? *(Now that the mother and daughter are close together, it becomes very obvious that they are physically alike. Rather than mother and daughter, they appear to be sisters. Except that* **Claire***'s lips are thinner and more elegant.)*

Electra, *looking closely at her mother*: You look good.

Claire: Oh, let's get out of here. I don't like hospitals. *(She's returned to flirting, which is one of her three major modes of dealing or being.)* They're so . . . depressing.

Electra, *shutting her book which she never goes anywhere without – it doesn't matter which one*: Where can we go?

Claire, *flirting and now noticing the unsuitability of her daughter's attire, for instance how* **Electra***'s ponytail falls over her face and even into her mouth where it's chewed*: Let's go to that deli around the corner from Bloomies. I'll treat Billy and you to lunch. Electra, can't you wear something . . . more like what the other girls wear?

Electra: It wasn't as if I was going anywhere. I didn't think I had to get dressed up. I was only going to a hospital.

Claire: Well, someone might see you in a hospital. You have to learn to take more care of yourself. Look at Penelope Wormwood.

Electra: Penelope is the class creep. *(Closing her satchel)*

Claire: At least tonight, try to wear something decent.

Electra: Why tonight? *(*****Claire** *has already exited because it doesn't matter what her messy daughter says.* **Billy** *is still occupied by boy stuff, peeking around the partly opened inner door, to the room that can't be seen. He wants to see what's inside and he doesn't want it to be seen that he's doing this. Turning to* **Billy***)* Why tonight?

Billy: Our uncle's coming to dinner.

Electra: We don't have an uncle.

Billy: We do now.

Electra: We don't have anyone. Just Mommy and Nana.

Billy: We do have an uncle. I don't know who he is.

Electra: So why does he have to come to dinner?

Billy: He's Nana's sister's child.

Electra: So what. I still don't see why he has to interfere.

Billy: Mommy said he's a famous geologist and even worked on the hydrogen bomb.

Electra: That's all the more reason to have nothing to do with him. What else did she say?

Billy: She's waiting for us . . . she's going to be angry.

Electra: Just tell me quickly everything she said.

Billy: She said that she needs a man around 'cause . . . 'cause something-or-other . . .

Electra: What does that have to do with our uncle? Daddy's going to be well soon.

Billy: . . . 'cause she doesn't know anything about business. And neither does Nana. *(Now totally speaking in* **Claire***'s voice, which he does sometimes)* She doesn't know why everyone expects her to do everything by herself all the time.

Electra, *giving up because she can never successfully fight her mother for even one moment*: So who's this man?

Billy: We gotta go.

Electra: First, tell me what you know.

Billy, *real quickly because they gotta go*: Mommy was telling Nana that he married a Swiss girl who was insane. Or she went insane. Then he married again. This wife hung herself in a closet.

Electra: Yuck. Did he find her?

Billy: The son opened the closet and saw.

Electra: The son?

Billy: So he remarried the Swiss girl who was crazy.

Electra: Is she coming to dinner too?

Billy: Those two never talk to each other. They live on separate floors in this mansion in a rich section of Cambridge where's there's never any light and lots of old American paintings which are hideous.

Electra: And then there are brats?

Billy: Three. Were. One . . . or two . . . died. One suicided. One has elephantitas. He might not have died. They're the males.

Electra: There's a girl?

Billy: Alive. She's an artist.

Electra: Then she won't be asked to dinner. How does Mommy know all this and, what matters more, why is she having this uncle to dinner? She doesn't give a damn about family plus we don't have any.

Billy: He might stay with us a week or two till Daddy comes home.

Claire's voice: Where are you two? I can't wait all day.

SCENE 5. The Alexander apartment. Dinner. The dining-room, or what passes for it, is at the end of the entrance hall, opposite the front door. Found between the sunken living-room and the parents' bedroom. The walls here are green. Above the dining-room table hangs an expensive chandelier. The dog is below.

Billy, Claire, Electra, *and* **Ford** *sit around the table.* **Ford** *is in the*

father's seat. They're eating steak, for they eat only steak in this house. There aren't many vegetables. **Claire***'s reasoning is that since poor people eat vegetables, if you eat vegetables you're poor. Especially eggplant and collard greens. If you're poor, says* **Claire***, you'll never have any friends and friends are the basis of life.*

There's no wine at this table.

Ford *is a reasonably tall, fairly heavy-set, middle-aged man. Good-looking according to those in his kind of social set. He's wearing glasses.*

The meal has been going on for several minutes, desultory conversation.

Electra: I'm going to get married.

Claire: Is there a problem?

Electra: What do you mean, 'a problem'? I'm going to get married.

Claire: You know what I mean, Electra.

Electra: *(Pauses.)* Oh. No, there isn't a problem. I just want to get married.

Billy: Who are you going to marry? *(Mumbles because his mouth is stuffed full of very rare steak.)*

Claire: Listen to me, Electra. This isn't the first time something like this has happened. We'll just take care of things. It's nothing these days; you just disappear for two or three days; nobody'll notice a thing. *(Thinking)* It can be done cheaply. I know for a fact that Beatrice's niece . . .

Electra: I want to get married.

Claire: The problem is that you didn't grow up in the suburbs or somewhere where it's nice. If we had brought you up in Mamaraneck or Westchester where there are nice girls . . .

Electra: I was brought up fine.

Billy: Can I be excused from the dinner table?

Claire: No. Eat the rest of your steak. *(To* **Ford***, flirting)* I don't know what I'm supposed to do with these children. They have no respect for me; they love me, but they have no respect for me.

Ford*, one of his hands patting one of hers*: You've done a fine job!

Claire: I've done my best. That's all I can say. **(Electra***'s looking down at her dinner plate.)*

Electra*, defiantly*: Look, I'm getting married this summer. You don't have to have anything to do with it.

Claire: Who're you marrying?

Electra: Peter Wolf.

Claire: Who's that?

Electra: He's a boy. *(Silence)* He came to the hospital.

Claire: You're too young to get married.

Electra: I have to do something.

Claire*, exasperated and forgetting* **Ford***'s presence*: I don't understand what you're talking about.

Billy: I do.

Electra: Look. *(Shows her wrists which are heavily scarred.)* I tried to suicide when I was in college this year.

Claire: You know better than to talk about nasty things at the dinner table. And in front of strangers.

Billy *examines one of the wrists.*

Ford: I have three children. Children just don't do what they're supposed to do despite all that we put into them.

Claire: Well, I've done my best whatever anyone says.

Ford: And having a husband in the hospital. It must be hard.

Claire: I just don't know how to be when I'm alone.

Ford: Well, we can do something about that.

Billy: What about daddy?

They all look at him.

Electra *sings*

It's important to be a little girl
And to lie in your bed,
And all the men lie around you,
And all the men are dead.

Pirates sailed shark-wondrous seas
And never did go home;
One day I will come home again,
One day I'll have a home.

Note

This is the first act of *Requiem*, a three-act opera commissioned by the American Opera Projects. It is currently being workshopped in New York City; full performance will take place in spring of 1998. The first two acts are based on Eugene O'Neill's *Mourning Becomes Electra*; the whole returns to the Persephone myth, that basis of the Eleusinian Mysteries. The third act is published in Arthur and Marilouise Kroker (eds), *Digital Delirium* (St Martin's Press, New York, 1997) and the whole opera in a collection of Acker's work (Arcadia Books, London, 1997).

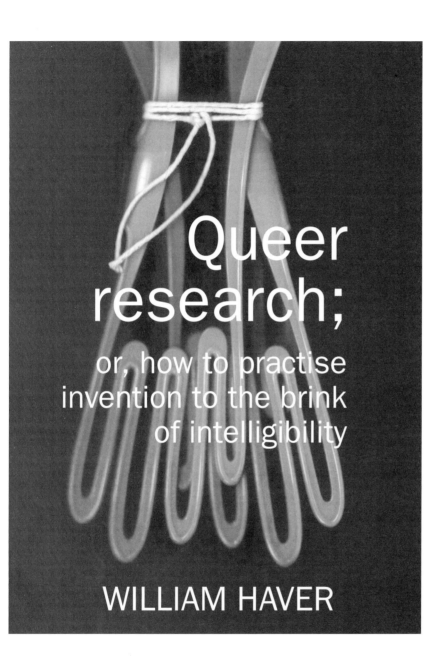

Queer research;

or, how to practise invention to the brink of intelligibility

WILLIAM HAVER

Bring the body out from the shadow of the mind, bring
practice out from the shadow of theory, in all its autonomy
and dignity, to try to discover what it can do.
(Michael Hardt, *Gilles Deleuze: An Apprenticeship in
Philosophy*)

. . . I practice invention to the brink of intelligibility.
(Timothy Hasler, in Samuel R. Delany, *The Mad Man*)

Kōiteki chokkan/active intuition

What if queer research were to be something other than a banal reproduction of academic – intellectual, epistemological – business as usual? What if queer research were to be something other, for example, than the perverse reading, from the perspective of a presumptively queer culture, of the contemporary icons of literature, video, film, and theory? Or what if queer research were to be something other than the hermeneutic recuperation of a history, a sociology, an economics, or a philosophy of homosexual subjectivity? What if, that is to say, queer research were to be something more essentially disturbing than the stories we tell ourselves of our oppressions in order precisely to confirm, yet once more, our abjection, our victimized subjectivity, our wounded identity? What if, therefore, queer research were actively to refuse epistemological respectability, to refuse to constitute that wounded identity as an epistemological object such as would define, institute, and thus institutionalize a disciplinary field? What if, that would be to say, queer research necessarily thereby actively (rather than as a merely propaedeutic gesture) refused to totalize the social field (as 'society'); what if queer research were thus to think the social field as essentially uncontainable proliferation, as multiplicity, rather than merely conceptualizing the social field as a plurality to be known and thereby managed and controlled? What if, concomitantly, queer research thus were to constitute itself in *and as* a refusal to participate in a struggle for intellectual hegemony, to provide a better explanation of the world? What if, in other words, queer research were to be something other than the *thēoria* of an essentially contemplative transcendental subjectivity, however ideal, however homosexual? What if queer research were not merely undertaken in the interest of action (by providing a new and improved theory or interpretation of the world according to which we would act) but were itself an active intervention, a provocation: an interruption rather than a reproduction? What if, therefore (but we are moving very fast here), the thought of the political were not necessarily mediated by the concept of productive culture? And what if thereby what might be called thinking were acknowledged to be always also something other than conceptualization, always also something more than the manipulation of concepts; what if, indeed, thinking were always also the surplus or supplement of conceptuality – an erotics, for example? What if queer research did not evacuate that surplus, that erotics, as so much waste? What if thereby queer research actively refused to forget that perversity, that chaos of pleasures and affects, that anonymic existential exigency which has been the occasion of its emergence? To what invention, what praxis, what revolution might we thereby come?

The insistence of the supplement

Perhaps, in recent years, there has been something very like a new thought of the social, one that is essentially and necessarily irreducible to a concept of society such as would be an adequate epistemological object of and for the human and social sciences. This thought of the social has been articulated in works of political theory, in literary and philosophical texts, in film and video, in performance art, in work less readily classifiable under commonplace rubrics, as well as in concrete investigations by some few social scientists. Some ten years ago, Ernesto Laclau and Chantal Mouffe sought to theorize sociality as such as a specific resistance to objectifications of society construed according to the normative coordinates of subjectivity, identity, and community, co-ordinates that in their analysis in fact 'suture' or 'fix' the social, reducing it to an epistemological objectivity.[1] In a not entirely dissimilar vein, Antonio Negri, in collaboration with Félix Guattari and subsequently with Michael Hardt, has sought to think, under the rubric of 'communism', a sociality that is always also something other than its objectivity[2] – a thought not without its antecedents in Marx himself.[3] Thereby, Negri has sought to think a 'dionysian labor' as the praxis of a poiesis that necessarily exceeds that productive poiesis most often denominated as culture by those working in the human and social sciences. If, as Jean-François Lyotard reminds us, the work of the *domus* (or of 'culture') in all of its discrete labours is nevertheless the constitution of the community of the cultural *domus* itself, then a supplementary, queer (or 'dionysian') poiesis will in fact be an 'unworking' that reveals the putatively adequate self-identity and auto-reproduction of the cultural *domus* to be a nostalgic fantasy.[4] This unworking, which I am attempting to think as the poiesis of a queer research, is an infinite subtraction, a movement towards a radical existential destitution, towards entropic indifference of empirical singularities bereft of the consolations of culture.

Among literary thinkers and philosophers, Maurice Blanchot sought to think that destitution that would be the existential condition of possibility for a being-in-common, or 'community', that would be strictly speaking 'unavowable' (*inavouable*); similarly, Jean-Luc Nancy has sought to think what is at stake in an 'inoperable' or 'unworked' (*désoeuvrée*) community, a thought of community as something other than the effect of cultural production and determination, something other than the reproduction of what counts for the social and human sciences as culture.[5] Here is a thought of an unsupportable sociality, a being-in-common of the destitute grounded in no ontology, an anarchic community. And, finally, in the course of a meditation on community as the being-in-common of singularities irreducible to concepts of the individual or of subjective identity, Giorgio Agamben has given political point to such reflections when he notes, apropos of the events of the spring of 1989 at Tiananmen:

What the State cannot tolerate in any way, however, is that the singularities form a community without affirming an identity, that

1 Ernesto Laclau and Chantal Mouffe, *Hegemony and Socialist Strategy: Toward a Radical Democratic Politics*, trans. Winston Moore and Paul Cammack (Verso, London, 1985), 93–148.

2 Felix Guattari and Toni Negri, *Communists Like Us: New Spaces of Liberty, New Lines of Alliance*, trans. Michael Ryan (Semiotext[e], New York, 1990); Michael Hardt and Antonio Negri, *Labor of Dionysus: A Critique of the State-Form* (University of Minnesota Press, Minneapolis, 1994), esp. 3–21 and 263–313.

3 These antecedents have been read largely in *The Eighteenth Brumaire of Louis Bonaparte*. See Claude Lefort, 'Marx: From One Vision of History to Another', trans. Terry Kartell, in Lefort, *The Political Forms of Modern Society: Bureaucracy, Democracy, Totalitarianism*, ed. John B. Thompson (MIT Press, Cambridge, Mass., 1986), 139–80; Dominick LaCapra, 'Reading Marx: The Case of The Eighteenth Brumaire', in LaCapra, *Rethinking Intellectual History: Texts, Contexts, Language* (Cornell University Press, Ithaca, NY, 1983), 268–90; and Jeffrey Mehlman, *Revolution and Repetition: Marx/Hugo/Balzac* (University of California Press, Berkeley, 1977).

4 Jean-François Lyotard, *The Inhuman: Reflections on Time*, trans. Geoffrey Bennington and Rachel Bowlby (Stanford University Press, Stanford, 1991), 191–204.

5 Maurice Blanchot, *The Unavowable Community*, trans. Pierre Joris (Station Hill Press, Barrytown, NY,

1988); Jean-Luc Nancy, *The Inoperative Community*, ed. Peter Connor, trans. Peter Connor *et al.* (University of Minnesota Press, Minneapolis, 1991).

6 Giorgio Agamben, *The Coming Community*, trans. Michael Hardt (University of Minnesota Press, Minneapolis, 1993), 86–7.

7 Judith Butler, *Gender Trouble: Feminism and the Subversion of Identity* (New York, Routledge, 1990), esp. 79–149; Butler, *Bodies that Matter. On the Discursive Limits of 'Sex'* (Routledge, London, 1993).

8 Michael Hardt, *Gilles Deleuze: An Apprenticeship in Philosophy* (University of Minnesota Press, Minneapolis, 1993).

9 Sue Golding, 'Sexual Manners', in Victoria Harwood, D. Oswell, K. Parkinson and A. Ward (eds) *Pleasure Principles: Politics, Sexuality and Ethics* (Routledge, London, 1993), 80–89. An earlier version appeared in *Public* (Toronto: summer 1993).

humans co-belong without any representable condition of belonging . . . Wherever these singularities peacefully demonstrate their being in common there will be a Tiananmen, and, sooner or later, the tanks will appear.[6]

Here, then, we have a thought, at once more and less than a concept, of what is at stake for a heteroclite – queer – sociality.

Judith Butler has pursued the possibilities of the poietic constitution or invention of such a sociality in her recent philosophical investigations of existential comportment as the performative constitution of gendered, racialized, classed and sexualized being.[7] So too, Michael Hardt, reading Deleuze reading Spinoza, has thought the 'constitution of being' as a 'materialist practice'.[8] And Sue Golding has read Wittgenstein to be pertinent to any consideration of 'sexual manners' in so far as the Wittgensteinian rule is anarchic, existing only in its enactment.[9] In spite of all their differences, what Butler, Hardt, and Golding alike attempt is a thought of the non- transcendent, non-neutral – which is to say, historical – invention of sociality. In Butler, Hardt, and Golding alike, it is a thought of a rigorous materialism which cannot be recuperated in any metaphysics of presence. To think the performative constitution of being is to think the facticity of being only in *and as* the multiplicity of its manifold articulations: there exists no outside of poiesis or praxis. It is not that there is, somehow, an already existing amorphous and inarticulate being-in-general which is subsequently manifested in the poietic practices of its articulations; it is therefore not that the poiesis of culture is the inaugural moment of a separation *from* 'nature'. Rather, it is a matter of an originary separation *as such*, a separation from nothing at all – being *as* difference. In other words, this is a rigorous thinking of being *in* and *as* its historicity and finitude. What is being thought here is the infinitesimal empirical as such as the limit of ideality, of intelligibility altogether.

Thus, performativity or the practical constitution of being is not an irony. This point is particularly important in the cases of many readings of Butler, readings that assume that the performative subject somehow exists outside of its performances – as Kierkegaard in drag, perhaps? Mere irony simply always maintains the transcendental subjectivity of the ironist in the pristine reserve of the beautiful soul. The performative constitution of being, however, is not ironic but *parodic*, by which I mean precisely: an ontological expenditure without reserve, literally *à corps perdu*. The parodic is thus an affirmation of the thrownness, or *Geworfenheit*, of existentiality as such, irrespective of anything we might construe to be an intentionality. Parodic performativity does not mean simply that anything goes, but that precisely, because anything goes, not everything goes; not that everything is possible, but that anything is possible: this is the *play* of relationality *per se*, of futurity.

In so far as 'performativity' and the 'practical constitution of being' designate effects of a rigorous thought of material existentiality as the limit of any metaphysics of presence, of intelligibility and the logos altogether, it is a thinking of the limit as determinate, finite existence.

Thus, in so far as Butler, Hardt and Golding reflect on non-transcendence (as the very necessity of non-neutrality), theirs are meditations on the 'limit-experience' (not only the experience of the limit, but the limit of 'experience'). For if being exists nowhere outside of, least of all prior to, its articulations, then to be is to be at the limit, to be *nothing but* a certain 'be-ing at the limit'.

In all these respects, then, the performative practice of the constitution of being *eroticizes* the limit as that site, locatable according to no determined co-ordinates, where relation *happens*. Therefore, the rigorously materialist practice of which I am trying to think leads us inexorably to the thought of a being-in-common of whatever singularities in their existential destitution: here is a thought of a sociality which in its material existential objectivity can never be objectified as an object for perception and knowledge.

What is being thought, therefore, in Laclau and Mouffe, Negri, Lyotard, Blanchot, Nancy, Agamben, Butler, Hardt and Golding, in their various and discrete (indeed, often contradictory) articulations, is a thought of the social as the *limit* of what the social and human sciences (as such) can think, a thought of that which the social and human sciences must refuse in order to secure what has always figured as their epistemological ground. It should be emphasized that this critical thought of the limit of what counts as intelligibility for the social and human sciences is in no sense a simple rejection or dismissal of the social and human sciences or of their enabling epistemological protocols; least of all is it a wholesale rejection of investigations undertaken by those working in the social and human sciences. Indeed, the recent investigations of a number of social scientists undertake to articulate this thought of an essentially unobjectifiable sociality *in* and *by means of* their concrete researches. I think, for example, of the new – queer – geography in the United Kingdom and in Canada that, following indications of Paul Hallam and Sue Golding, is attentive to a 'city' irreducible to the object of urban planning, a 'city' populated by the homeless, the prostitute, the injecting drug user, the queer, the person living with Aids, the *Lumpenproletariat*.[10] And I think of agrarian economists such as Nagahara Yutaka, Sakiyama Masaki, and Tomiyama Ichirō who, researching various 'minorities' find social science to be originally implicated in the constitution of 'minorities' *as such*. Without thinking the specific limits of social science, it is impossible to acknowledge that sociality that always escapes any straightforward objectification.

This thought of the social, the concomitant reflection on the limits of social science, and any consequent interrogation of the conditions of possibility for social science, are not in the first instance (and least of all in the last) merely theoretical occasions, merely events in the history of philosophical reflection or the investigations of the social and human sciences. *If the thought of the social struggles towards theoretical and philosophical articulation, it is because it is first of all articulated in the existential comportments, practices, acts and arts of those who are*

10 Paul Hallam, *The Book of Sodom* (Verso, London, 1993), 13–96; Sue Golding, 'The Address Book', in Hallam, 168–73. See also David Bell and Gill Valentine (eds), *Mapping Desire: Geographies of Sexualities* (Routledge, London, 1995).

occluded from the epistemological purview of the social and human sciences; in the lives of those whose being is situated in the interstices of the 'city', in the lives of the homeless, the prostitute, the injecting drug user, the queer, the person living with Aids, the Lumpenproletariat, for example. The social and human sciences have not been oblivious to the existence of such populations, of course. But, by and large, and for essential reasons, social science has objectified such populations only in terms of deviance, perversion or nihilism; in terms, that is to say, of a merely negative relation, a non-relation, to productive culture. And this because the social and human sciences have sought first of all to establish being as identity (broadly construed), either in asking who, what and why, or in searching for the more or less stable regularities of productive cultural practices (labour). It is no accident that we have never produced a history of the *Lumpenproletariat*, for it is precisely the possibility of a poiesis that exceeds the concept of production that is essentially outside the purview of the epistemological gaze: such a poiesis can never be the object of and for a knowledge. I do not mean to suggest that such populations, so-called, are without their specific, albeit constantly changing, protocols, rituals, etiquettes and economies, but that we can only begin to think what is at stake here – the social – if we ask not what or who bodies *are*, or *why* bodies do what they do, but, simply enough, enquire as to what bodies can *do* in their infinitesimal, microscopic negotiations of their empirical existentiality.

Much is implied in what might at first glance seem to be a simple shift of attention. Here, I would simply emphasize that a serious attention to existential comportments, to the practices, acts and arts of what bodies can do, inexorably draws our attention to the invention of the social, the ethico-political and of the cultural altogether. Necessarily, we would notice that the protocols and economies of those who inhabit the interstitial city are strictly speaking unsupportable or anarchic, and *for precisely that reason* cannot be characterized as nihilistic or terrorist. It is precisely because here the social seeks no authorization in any putatively ontological ground that, as a solicitude subject to no necessity whatever, anarchic sociality founds the ethico-political as such. The very fact that unauthorized protocols and etiquettes exist here at all is the foundation of ethicality altogether. Here, the 'new' thought of the social reanimates a venerable thematics indeed, for here, as a matter of an irrecusable existential exigency, we are charged with a reflection on the possibility of founding our being-in-common. What such comportments, practices, acts, and arts – the performative practical constitution of being – give us to think is the limit as that site, locatable according to no determinate coordinates, where sociality, as the very possibility of relation, *happens*. And this reflection is imperative, in the strongest sense of the term, unavoidable. For what is given to us to think in this, the time of AIDS, are not simply the exigencies with which our existentiality confronts us, but that exigency which *is* the existential in its unbearable historicity.

Interruption

Queer research, then, is constituted (a constitution which never amounts to an institution or an institutionalization) in and as an attention to a heteroclite sociality irreducible to any epistemological objectivity, however ideal, however homosexual. At least two aspects of such a sociality guarantee that the attention of queer research can never amount to an epistemological capture of an object by the understanding on behalf of knowledge. First, that to which queer research is attentive is an absolute destitution, the absolute destitution of empirical singularities in their entropic indifference. This absolute destitution, neither *hylē* nor *eidos*, is the limit of any and every phenomenological apprehension. Destitution is what would remain, materially, in the wake of a radical subtraction, an absolute unworking, a crossing out of predicates. Destitution is neither a pre-predicative, pre-cultural origin ('nature', for example), nor a post-predicative destination. Absolute destitution is neither cultural (an aesthetics) nor simply the 'outside' of culture (the sublime), but that which undoes the work of culture altogether. It is the unrecognizable face of the stranger each of us is at the brink of pleasure – or death: the revelation of the groundlessness, the *per se*, of social relationality. Second, queer research is attentive to the infinitesimal, empirical poiesis of what bodies can do, to the anarchic practices – protocols, etiquettes and economies – which perform the being-in-common of destitute singularities in the situatedness of their historicity: the micrological etiquettes of anonymous public sex, of drug use, of street prostitution, for example, or the economies of squatters' movements, or the rigorous codes of outlaw 'gangs', or the articulation of being-there at Tiananmen, or the *ars erotica* of SM sex. Here it is not an intersubjective recognition that is at stake but the praxis of a poiesis that is not committed to the service of production (which is not to deny that such practices are at the same time caught up in capitalist economies: it is to deny that they obey the logic of production).

 Queer research would not in the first instance be concerned to produce a description or representation of that to which it is attentive; heteroclite sociality is neither a referent nor, therefore, an object. Rather, in so far as it 'is' anything at all, it is a *lure*, a 'that-towards-which', a 'whatever' that is the occasion for an attentiveness. Because heteroclite sociality never coalesces into a *representamen*, the attentiveness of queer research can never simply resolve itself into conceptuality. Neither, however, can that attention be merely a refusal of conceptuality in an aesthetics of the social sublime (i.e., a humanism). If the only possible relation of thinking to that about which it thinks is a relation of a knowing subject to an object, and if that relation can only be articulated as the relation of an (ideally) adequate representation and conceptualization of the object to consciousness, then the relation of queer research to that about which it thinks is not a relation. But we might think, rather, that queer research is precisely, in fact, that non-relation. Neither the relation of a subject to an object, nor the sublation of relationality in a mystical

knowing, but a relation of non-relation; better, a passage from relation to non-relation.

It is true, of course, that there has long been a name for this passage from relation towards a non-relation which is no destination, from thinking towards that to which it is attentive when it thinks its thinking, from the concept towards its supplement, from the subject/object relation to that which is the occasion of its emergence. What is sometimes called 'philosophy' has, in certain articulations (Nishida, Nietzsche, Heidegger, Dōgen, for example: a comprehensive list would not be a long one), recognized that it cannot do without concepts, but that the concept inevitably bespeaks its supplement precisely in occluding that supplement from view. Here it would be fruitful to undertake a careful consideration of Blanchot's meditation on 'research' in a short text entitled 'Thought and the Exigency of Discontinuity'.[11] Elsewhere, perhaps. For the present, let us simply note that Blanchot recognizes that the classical aspiration of what is most often designated under the rubric of 'philosophy', the aspiration to a conceptuality adequate to its objects, has in fact always been a pedagogical aspiration. It is no accident, therefore, that philosophy has classically been implicated not only in the intellectual institutions of disciplinarity, but in pedagogical institutionalization, in the cultural formation of subjectivities and identities (*Bildung, Kyōyō*) as 'education'. But what Blanchot calls 'research' is an *interruption*, not merely of normative and normalizing explanations of the world (explanations that familiarize the 'world' for knowing subjects), but of the very possibility for thinking, the very possibility for the production of concepts. An unworking without destination, thinking as departure, 'research' is essentially nomadic, something that happens – an interruption, a hiatus in the very possibility for cultural (re)production – rather than something that 'is'. Queer.

Which suggests that it would be more useful to ask what queer research *does*, to ask what *happens* in queer research, than to ask what it *is*. What, that is to say, might be the praxis of its poiesis? If queer research is less a knowledge or the production of knowledge than it is a pragmatics, an interruption in the production of knowledge, then we might begin to think the praxis of its poiesis as an interruption in the formation of cultural subjects, the identities formed in and through the production of knowledge as subjects who are supposed to know. This would be to acknowledge, with Blanchot, that the aspiration to knowledge has always been at the same time a pedagogical imperative, which is to say a political imperative. I will attempt to argue in what follows that the pragmatics of queer research, undertaken in a situation where thought by and large assumes its political effects to be pedagogical, is constituted in a departure without destination, an unworking of the cultural, a nomadic passage from the cultural to the political. I shall be attempting to follow certain indications which Deborah P. Britzman has given in 'Is There a Queer Pedagogy? Or, Stop Reading Straight'.[12]

11 Maurice Blanchot, *The Infinite Conversation*, trans. Susan Hanson (University of Minnesota Press, Minneapolis, 1993), 3–82.

12 Deborah P. Britzman, 'Is There a Queer Pedagogy? Or, Stop Reading Straight', *Educational Theory*, 45: 2 (spring 1995), 151–65.

How to practise invention to the limits of intelligibility

Were we lazy or careless, a laziness or carelessness that would undoubtedly bespeak a more profound forgetfulness, we might think that queer research, in the relation of non-relation that is its attention to an essentially unobjectifiable heteroclite sociality, would bring us to an understanding, an interpretation, an explanation of the world and of what a queer relation to that world might be. Were we inattentive, we might forget that the concepts of historicity, sociality, politicality and queer are indeed concepts, but that they are concepts of what always and necessarily exceeds conceptuality as such; we might forget that the thought of the heteroclite social is always also something other than its concept. We might further thereby assume that our understanding of these concepts, which is to say our inattention to and forgetting of what is at stake, would authorize our superior explanation of the world, thus authorizing our every claim to pedagogical mastery. Were such the case, all that would be left for us to do would be to specify an application of our insights, devise a strategy or technique for such applications, and thus to promulgate a political morality secured in our fundamental intuition of the logos. All that would remain for us would be merely a tolerant and forgiving participation in the conflict of interpretations, a struggle for intellectual and pedagogical hegemony: in short, to condemn ourselves to death by conversation.

But we are neither inattentive nor lazy, and we are at least mindful of our forgetfulness. The question of a pragmatics, therefore, is perhaps something more interesting, more difficult, more tortured, more pleasurable, than a mere instantiation, realization, or manifestation of a morality grounded in the intuition of a logos immanent in the world. This pragmatics has nothing to do with the naive causalities of what is called pragmatism, for there is no assurance that a queer world would necessarily be a better world – although it could not but be more interesting – than the worlds with which we are currently afflicted. Pragmatics (from the Greek *pragma*: deed, act, business, affair), then, has this much at least in common with what Butler thinks under the rubric of the performative: that it is without ontological ground, and therefore unjustified, in the sense that it finds no authorization immanent in the world. Pragmatics, then, is part and parcel of the practical constitution of being. Here, following Britzman, we are concerned with the *pragma* – act, deed, business, affair, doing – of the pedagogical.

The question of the pedagogical must undoubtedly be allowed to resonate in several registers simultaneously: in the formal and informal disciplinary and epistemological structures of our learning, certainly; in institutional classrooms, of course, not excepting the university classroom and the seminar; but also, and perhaps most importantly, in our microscopic learnings, unlearnings and relearnings, the infinitesimal negotiations by which we learn and unlearn the world. In no case, of course, are these registers mutually exclusive. On the one hand we have, in our very comportment, always already learned the world; as Judith

Butler's meditations on the iterability of performativity indicate, the pedagogical has always already precipitated identity, culture, subjectivity; in this sense, the pedagogical has always already inscribed who and what we are, the inscription of who and what we are always already precedes the autoaffectivity of we who are. Indeed, that autoaffectivity or self-consciousness is an effect of pedagogical inscription. But *at the same time*, conversely, and more importantly for any queer research, these infinitesimal negotiations by which we learn the 'world' never, in fact, coagulate into identities, cultures, subjectivities; the pedagogy of these infinitesimal – empirical – negotiations always exceeds the objectness of its effects. And it is this disjunction, between a pragmatics and its residues, between an effectivity and its effects, that concerns queer pedagogy; it is this supplementary excess, crossing the several registers of the pedagogical, that concerns queer research.

There is, of course, a further complication here. That, quite simply, in this 'situation', as writers, translators, readers, in taking up the question of the pedagogical and its pragmatics, we are ourselves nowhere 'outside' the pedagogical. Quite apart from the supposedly general theoretical point that there is no outside as such of the pedagogical, what we are engaged upon right now is quite explicitly pedagogical. And this is true of every discourse on the pedagogical, which means that pedagogy can never become a classical object for thought. All talk about pedagogy is itself pedagogical. Which means that for us, here and now (although the here and now of your reading is not the same as the here and now of my writing), there can be no safety; when it is a matter of queer pedagogy, as Britzman points out, we are always already at risk: to think about queer pedagogy or queer research as a pragmatics, as a performative practice of the constitution of being, is always to be in a 'state of emergency'. Standard, garden-variety, reflections on pedagogy, so-called 'critical pedagogy' not excepted, is entirely devoted to the forgetting or occlusion of this state of emergency.

Whether as *paideia*, *Bildung*, *kyōyō,* or whatever, the pedagogical project of education has most generally been thought, at least in what we call our modernity, as a coming-to-culture, as the passage to the logos *as such*, as the poietic separation from an entirely unreflective 'nature', the work by which Man distances herself from the essential stupidity of the natural. The work of the pedagogical is thus a poiesis that *is* that passage to culture, and thus, as a poiesis that is, *as* the creation or invention of culture, the interminable reproduction of the cultural as such. (And indeed, this is the case even when pedagogy assumes the end of education to lie in the self- recognitions of a reunion with the One or with Nature: education as the revelation of an eidetic connaturality.)

And it has long been argued (by Althusser, for example, in his analyses of the Ideological State Apparatus) that it is as the reproduction of a culture that pedagogy is most fundamentally ideological – in the poietic creation of the 'good citizen', for example.[13] But this creation of the 'good citizen', central to every state' s concern with education of

13 Louis Althusser, 'Ideology and Ideological State Apparatuses (Notes toward an Investigation)', in Althusser, *Lenin and Philosophy and Other Essays*, trans. Ben Brewster Monthly Review Press, New York, 1971), 127–86.

course, is based on the assumption that there is an essential correspondence between knowing and acting, between the True and the Good: right thinking makes for right acting. But not every conception of the 'good citizen' is the state's docile citizen – hence every attempt to create a 'revolutionary consciousness', every attempt at a 'critical pedagogy'. Whether docile or revolutionary, the good citizen is a child of the Enlightenment, a child to be trained to take up residence in a perspective of enlightenment. What is at stake in 'pedagogy', then, as Nishida, Freud and Husserl each saw in the late 1930s, is not merely the ideological reproduction of a certain culture, a certain 'perspective', but the production and reproduction of the cultural as such, the very possibility for rationality.[14] The poietic creation of every good citizen, whether docile or revolutionary, is thereby the re-creation of the logos as such.

The very notion of a critical citizenry, feet firmly planted (or mired?) in the logos, and of a critical pedagogy that in its practice would make of the essentially stupid natural child a rational being (and here it makes no difference whether this rationality is conceived either as an alienation from nature or as the reunion with an essentially rational nature), necessarily requires a concept of the social as totality, as that from which it would be possible, if only ideally, to separate oneself. Pedagogy is, willy-nilly, obligated to hegemonic contestation, or the conflict of interpretations, precisely in its objectification of the social (as 'society') as that which is to be known, and hence managed and controlled: the project of Enlightenment indeed. From this perspective, questions of the possibility of critique or, indeed, revolution, can only revolve endlessly around notions of *mimēsis*, representation, and adequation. For here, education and pedagogy can only be conceived to be fundamentally forms of 'consciousness raising', in which a superior consciousness (capable of ideally adequate representations, necessarily persuasive interpretations and a comprehensive understanding) is a *gift* from master to student, the donation of the cultural to the natural. (Think, for example, of the commitments of what is called 'ideology critique', or indeed, 'cultural criticism': but Britzman is working towards something more essentially disturbing, more revolutionary, more queer.) The problem with this perspective, as Butler has cogently argued in her reading of Plato, is that, restricted as it necessarily is to the question of the mimetic adequacy of poietic representation to the *representamen*, to what is represented, especially in the identifications of the Socratic 'know thyself', is that it *presupposes* a *pre*reflective autoaffectivity (an intuition of the presence of the self to itself) *to which* representation (identification) is held accountable for the adequacy of its *mimēsis*, for its correspondence to an original presentation.[15] But, curiously, this means that that presumptively prereflective autoaffectivity is necessarily an effect of consciousness, because as long as one remains within the question of representation, autoaffectivity can be conceptualized only as *that which* is to be disclosed in a cultural reflection; it has no sense other than that given to it by that reflection, that representation to itself

14 I am thinking, for example, of Edmund Husserl, *The Crisis of European Sciences and Transcendental Phenomenology: An Introduction to Phenomenological Philosophy*, trans. David Carr (Northwestern University Press, Evanston, 1970); Nishida Kitarō, *Nihon bunka no mondai*, in the *Nishida Kitarō zenshū*, 19 vols, ed. Abe Yoshishige *et al.* (Iwanami shōten Toyko, 1965–6), vol. 12, 275–394; Sigmund Freud, *Civilization and Its Discontents* and *Moses and Monotheism*, The Standard Edition of the Complete Psychological Works of Sigmund Freud, ed. James Strachey, trans. James Strachey *et al.*, 24 vols (Hogarth Press and the Institute of Psycho-Analysis, London, 1953–74), vol. 21, 57–145 and vol 23, 1–137, respectively. The best introduction to these questions may well be Jacques Derrida, *Edmund Husserl's* Origin of Geometry: An Introduction, trans. John P. Leavey, ed. David B. Allison (Nicolas Hays, Stony Brook, NY, 1978).

15 Butler, *Bodies that Matter*, 35–48.

of consciousness. But what concerns Britzman (and Butler, Hardt and Golding, among others) is the possibility of marking an (auto)affectivity that would not merely be an effect of representation or mimetic identification. In other words, Britzman is concerned with a queer pedagogy, a queer research, that might be thought as a movement towards the supplement (which is not merely the 'outside') of representation, a queer pedagogy that might be thought as an erotic pragmatics. I will return to this.

Within an enlightenment pedagogy, within the pragmatic poietics of identification, a coming-to-cultural-subjectivity, within a model of education as 'consciousness raising', *paideia*, *Bildung*, or 'orthoOedipaideia', is put into practice or actualized in a number of ways. The two principal, complementary, modes of pedagogy in the current situation are the so-called 'Socratic method' – a sustained exercise in humiliation, where the measure of learning is to be found in the student's distance from the True and the Good (as in the structure of the examination, for example), and within which the student is forced to produce him and/or her cultural self in the mode of abjection ('Teach me, father: let me learn the error of my ways') – and the model of pedagogy as a maternal nurturing in a sentimental education, wherein the student is required to develop 'self-esteem', and feel good about him or her self; this is a pedagogy which produces comfortable victims and tragic heroes: 'identities on parade', as Britzman has remarked. Both pedagogical practices produce the student as an essential *lack* (hence the fundamental complementarity of apparently opposed practices). The structure here is that of the psychoanalytic transference/countertransference, an endlessly circulating (mis)recognition, endlessly reproducing the cultural hierarchy of the stupid and the wise. All such procedures can ever produce – and production is very much to the point here – are 'good citizens'; there are different conceptions of the Good here, but the category of the Good *per se* as the goal of education goes unchallenged. What this amounts to, however, is the domestication not of the '*natural*' but of the *queer*. It is for this reason, perhaps, that Britzman insists that queer pedagogy is about risking the self through the proliferation of multiple (rather than merely plural) identifications (rather than identities). What is important, she argues, is not that 'anyone might be queer', but that 'something queer might happen to anyone'. If queer pedagogy or queer research is first of all a departure, a movement towards an erotic heteroclite sociality (again: rather than a concept of 'society'), then that movement can be made only in a queer poiesis of risking the presumptive autonomy and integrity of a self which has always already come to its subjectivity through producing itself as an abject object – the comfortable victim, the tragic hero – of the pedagogy of enlightenment. The usual understanding of subjective identity, then, might well be thought to be the occlusion of heteroclite sociality, prophylaxis against any erotic relation to what is.

In that caricature of pedagogy and education which is the current situation, education and pedagogy have increasingly been conceived to

be nothing more than the production, reproduction and transmission of knowledge. Increasingly, 'enlightenment is' taken to be the reproduction and transmission of information. Certainly, this is a caricature of the project of enlightenment, but it is one that is increasingly taken to be the sole condition of possibility for thinking altogether. Three points need to be made very briefly here. First, the (re)production and transmission of knowledge (construed as information) is unreflectively taken to be the repetition of the inaugural, instituting, moment of the logos as such. We are being asked to believe that any critical possibility (by which I mean any consequent engagement with historicity, sociality, politicality) is thus taken to constitute an essential threat to the logos itself, a threat to the very possibility for rationality and thought. Thus anarchy is conflated with nihilism. The interest of this pedagogy is entirely invested in cultural reproduction as continuity, as permanence achieved through the repetition of its own protocols, in the incessant reproduction of the cultural under the sign of the Same. Here, pedagogy becomes merely an instrumental technique or strategy for the occlusion of the erotic, the heteroclite social. Second, this caricature reaches something like an apotheosis in the current valorization of the transmission of knowledge and information in various proposals for the transformation of our educational institutions in industrial and post-industrial societies according to a model of a technocratics of efficiency. We all know the possible horrors here very well – although not as well as we shall, undoubtedly. Now, this is not necessarily in all its aspects a 'bad' thing; but if any possibility for serious work is to survive – for queer pedagogy and research, queer culture, our queer lives, that is to say – serious work will need to be articulated in new ways. It may well be that the university, or educational institutions generally, will not be the site of queer research. For, third, this conception of transmission transmutes the 'use-value' of thinking into the sheer 'exchange-value' of the concept. This model of the (re)production of knowledge means, we know all too well, that an intellectual project can only be conceived to be in search of either a *method* or an *object*. Either queer pedagogy and queer research are oriented around queer objects – fags and dykes – and/or they are conceived to be a method, a technique for the reproduction of lesbian and gay cultures. This means, finally, and again, an occlusion of the erotic, of heteroclite sociality. The pedagogical has more and more frequently been defined precisely as the occlusion of the erotic altogether: small wonder, then, that the formal, institutionalized, venues for what is called safer sex education have failed so abysmally.

Now, Britzman apparently claims to offer a methodology, a guide to an epistemological security that we might assume would ultimately be a refuge from the historicity of heteroclite sociality. But what she in fact offers us are three 'methods' appropriate to what counts for her as 'Queer Theory' and a queer pedagogy: 'the study of limits, the study of ignorance, and the study of reading practices'. Strange methods, these, for any reader seeking the resolution of fundamental perplexities. And, indeed, because 'queer signifies first and foremost a social relation and

not a sheer positivity', this methodology, so-called, is most fundamentally *also something other* than (or at the very least a perverse, queer, *détournement* of) an instrumental pragmatics. For:

> Each method requires an impertinent performance: an interest in thinking against the thought of one's conceptual foundations; an interest in studying the skeletons of learning and teaching that haunt one's responses, anxieties and categorical imperatives; and a persistent concern with whether pedagogical relations can allow more room to maneuver in thinking the unthought of education.[16]

16 Britzman, 'Queer Pedagogy', 155.

I submit that what Britzman is thinking here in thinking of queer pedagogy as a set of impertinent performances is the possibility of an erotic pragmatics, a poietic practice which not only would not forget its relation to heteroclite sociality, but is in the most serious sense a performance, an enactment, a practical constitution of that sociality. If it is a matter of risking that self which it is the object of an instrumental cultural poiesis to produce, if it is a matter of the infinite and uncontainable proliferation of identities (not excepting the Impossible), if it is a matter for education, pedagogy and research of a relation to the limit, a relation to that which it cannot bear to think, of what is for a certain enlightenment unbearable, if there is 'no place of safety' because 'something queer can happen to anyone', then a practice of reading (or research) can no longer be construed simply as a privileged mode of access to knowledge, the guarantee of an epistemologico-ontological security. In that case, Britzman's intervention is a fundamental refusal of the enabling protocols of the conflict of interpretations; her intervention is in fact an *interruption*, a guerrilla thinking which makes no appeal to the permanence of any institutionality. What this 'pedagogy' that she seems to have in mind *does* is precipitate an onto-epistemological panic. The pedagogical imperative here is to precipitate, with no guarantee of any ultimate transcendence or salvation, interruption: all those hiatuses, syncopes, hesitations, suspensions, stammerings, parapraxes, caesuras and *faux pas* which mark the limit of the thinkable, the tolerable. What is at stake in all these interruptions is not merely a lapse in intellectual competence but an *ontological stammering*, the essential inability to conceptualize what is being thought when thought tries to think its thinking. Here, in the pedagogical situation (not unlike the psychoanalytic scene in certain readings of Freud – Lacan's and Britzman's, for example), thought must confront its own essential, and enabling, insufficiency: here lies the essential difficulty of thinking, and it is to a confrontation with this essential difficulty that those who are called teachers, as well as those who are called students, are brought by a queer pedagogy, a queer research, which is no mere strategy. But it is in, and by means of, these stammerings, syncopations, caesuras, hesitations and parapraxes that the very possibility for any thinking lies; once we abandon this essential difficulty, this relation of non-relation to a queer, erotic, heteroclite

sociality, we become mere intellectual technologists devoted to the service of the concept.

So this essential difficulty of thinking, this essential cruelty of the pedagogical, is also the very possibility for an erotics of thinking, for a thinking which sustains a (non-)relation to that which is irremediably its excess, its surplus. One thinks where it is impossible to think, and to think where it is impossible to think is to sustain an erotic relation; this is not to transcend the concept, but to think the relation of the concept to that which is its occasion. It is to think only at that midnight which is the coincidence of the *pars destruens* and the *pars construens*,[17] at that limit where the end of every poiesis is also the invention of the very possibility for poiesis: it is to this which Britzman's pedagogy and queer research would bring us – zero-degree revolution.

Thus there is something happening in Britzman's thinking that cannot be reduced to 'ideology critique', to 'cultural criticism', to questions of representation and interpretation or, thereby, to hegemonic contestation. Certainly, her rhetoric and address are important, but – as in Lacan, for instance – this rhetoric is not merely a strategy. What she suggests in her pedagogy – in a reading practice which always exceeds the subjectivity and identity of the reader in the proliferation of identifications, for example – is a technique or a poiesis which does not make the world familiar or comfortable for the student or reader but which defamiliarizes, or makes strange, queer or even cruel what we had thought to be a world. The 'student' or reader approaches the impossibility of saying anything at all, or the possibility of being able to say far too much – either an uncontainable loquacity in an exhaustion of predication, or silence: in any case, the impossibility of maintaining the co-ordinates, categories, or protocols according to which the world has heretofore been held to be (at least ideally) comprehensible. There are, of course, precedents. Readers of Dōgen, for example, will undoubtedly find a certain resonance here.

In any case, this would seem to be a practice of a 'de-transcendence', an *unworking*, a poiesis which, contradictorily, undoes the work of culture; what is at stake here is a kind of pure subtraction, an absolute reduction, an inverse *epochē* – a metamorphosis or a passage, in any case a movement, from pathos to affectivity as such, from the interiorities of subjectivity and identity to an exteriority that is not merely the outside of an inside, from relation to non-relation, from community to the being-in-common of whatever singularities, from history to historicity, from society to sociality, from authority to power, from communication to *signifiance*: from the cultural to the political. This is an unworking of the work of culture, but an unworking that is not thereby a return to an unreflective nature. This is a practice that, in its provocation of an essential stammering, brings us to the absolute, irrecusable necessity of inventing, yet once again but for the first time, language and the body. Here it is impossible both to speak and not to speak, to do and not to do. We are brought to the infinitesimal of the empirical as such, the site of a nothing-but-interruption: revolution. A practice, in other

17 Hardt, *Gilles Deleuze*, 50–3.

words, which brings us to the inevitability of the erotic which it has been education's sole purpose to avoid. Here, at the site of a pure interruption, at which we never arrive because it is never outside the here and now, there can be no authority; only, we might have learned from Dōgen, from Blanchot, from Britzman and how many others, that power (*potentia*) which is relationality as such. Ultimately, perhaps, queer research might be one of the stagings of that relationality, that heteroclite sociality without relation to which all thought, all culture, is merely inane.

LEGEND

ON
THE
BRIXTON
MARKET
COTTAGE
DOOR

I
READ:

"BLACKS
AND
WHITES
ARE
SNOBS

IN HEAVEN
NIGHTCLUB
LIKE
HITLER".

IT
SAID:

"BLACKS
AND
WHITES
ARE
SNOBS

IN
HEAVEN
NIGHTCLUB
LIKE
HITLER".

I
READ:

"BLACKS
AND
WHITES
ARE
SNOBS

IN
HEAVEN
NIGHTCLUB
LIKE
HITLER.

IN
HEAVEN
NIGHTCLUB
LIKE
HITLER.

IN
HEAVEN
NIGHTCLUB
LIKE
HITLER".

Dwelling

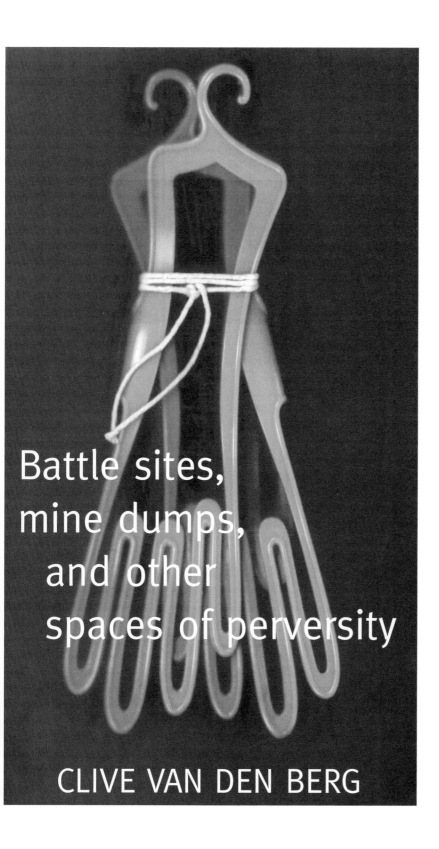

Battle sites,
mine dumps,
and other
spaces of perversity

CLIVE VAN DEN BERG

Slag heaps (mine dumps) punctuate the commercial frenzy of Johannesburg. They masquerade as nature, grassed, silent, unpeopled, and unbuilt. Yet these huge mounds were piled up by men. Under their fragile covering of grass, they are the finest dust-like talcum powder, ground from ore. My imaging on them is a kind of branding, a laying claim to – and a transgression of – facts. Unbuilt and unpeopled they alone are free of commercial activity in a city avaricious for rentable property. These piles are the wastes of avarice, accumulated at huge cost. Yet they arouse me. They are simultaneously enterprises of battle and labour, declarations of a particular, grubbing kind of history, yet also and because of their silence, emptiness, height and history, they are sites for contemplation and refiguring. Similar to battle sites, ruins, and other solitary places, both illicit and sacred, I am compelled by these dumps.

Strange, this schizophrenia that makes them attractive in the present tense, ready for historical renewal, but a renewal dependent on memories that are broad, insistent and painful, that invokes an alternative vision. All the forgotten, discarded, diseased, deceased, and frustrated impulses which are the real memorials of these spaces – they mark them as places where yearning accumulates. They are for me queer sites: our own histories and languages not easily shed.

To be gay is, literally, to be an outsider in space.

Perhaps that is why it has been my subject . . . the subject itself is the unfulfilled; an absence in bodily relationship to that world that is spatial. If I try to picture this absence, this hollowness, I conjure with two components. One is an image, and the other a feeling. The need to infuse the first with the second is the verb that determines my work.

The images are those of the 'not' – the horizon that cannot be determined, the porous surface that absorbs rather than fixes vision; a quality of light that confuses security, the perspectives of multiple imaginings . . . My body records feeling as an attenuation of nerves, a gap of sensation between cause and fulfilment. It waits for, and seeks, its subject.

The spaces I am attracted to are those which exist situated in the interstices of time. They are places where power has fled, even if its vestiges remain – hanging in the air, clinging tenuously to the bits and pieces of stuff left behind. The whitewashed stones that mark the spots of bodies interred, the only somewhat healed linear depression, a battle trench, that demarcates the very edge of possession, are the prompts for another envisioning. I know these sites as ready for re-inscription through my body. Like a divining rod, it knows its place.

When I was a child, I created my world. This took many forms. I would make tableaux-farms, monasteries, which in reality were labyrinthine piles of stone into which I would feed frogs. It always distressed me that they spurned the mansions my brother and I created for them. No matter what delights I planned, solariums, underground pools, and multiple suites, they always fled away from my ministering and grandiose planning. This early experience of forming my world achieved its most memorable

incarnation once I started to dig tunnels. I would burrow down and then along for a small body's length and lie there feeling the earth against my skin – red and moist in my nostrils. It was my earliest knowledge of an utterly complete spatial experience. It was also an aesthetic moment. Though not yet knowing the word 'artist' I knew my vocation then, lying in the half light, under the hallucinatory heat of an African backyard.

Skip twenty years or so

In 1982 the ANC placed a bomb at the base of the cenotaph in Durban. This monument is situated in Francis Farewell Square. Farewell was one of the earliest white settlers of Durban, and the square is the symbolic heart of the city hosting other monuments and statues, all of which celebrate its colonial past. Former governors share space with Queen Victoria and a rather short-legged Jan Smuts. A kind of 'heroes' acre', declaring a short history of power. The language of the place is interesting or rather remarkable in its almost complete denial of local circumstance. The messiness of conquest, the inevitable confusions and anxieties of conflicting cultures are covered over in the materials and style of colonial gravatus. Granite and marble have sealed history under a hard skin of language which, in its impermeability, neither absorbs the present nor allows access to the past. It took a bomb to tear through that skin.

That tearing through was a revelation to me. I had always known about the inadequacies of language, its ability to lie and make blind. My own body had been denied legitimacy, its capacity for pleasure censored; but here was an example of the intimacy of political and sexual censure. These were not the same, but they were inextricably joined and I could read this relationship in the languages of public space. I could sum this up as a lack of permeability, a fear of the porous.

Now we skip perhaps one year. But it is an important jump, not only because it charts a major leap in my own use of language, development if you like, but mainly because here began a series of works which figured the world imaginatively, as creations, partly of fear, but also of desire.

Looking back, it is probably significant that I was drawn to the only 'uncivilized' piece of land left in Durban. The Bluff. There is something literally prehistoric about this huge, slumbering length of earth that shadows the harbour entrance. My drawings began as fairly faithful representations of its form, but fairly rapidly I began moving things about so that while the psychic impulse of the drawings was in the thing drawn, there, at the harbour, its image had transmogrified to that of a conjoining of body to site, now erupting, as it were, with not-really-present present narratives – broken, eerie, fictive – and yet secretively, cryptically: alive, joyful.

These drawings were done in the early to mid-1980s. The country was ruled under an almost continual state of emergency. The notion of civic pleasure that was not partisan or of civic space providing the opportunity for anything other than nationalist jingoism was a concept that had not been part of my, nor many other people's, sense of what was possible. Then I went to work with a firm of architects called 'Hallen Theron' and, later still, won the Volksas Atelier Prize. This sent me to New York and, more specifically, to Paris, with bucks in my pocket, an apartment which was mine for a year and the merest smattering of French. We are getting anecdotal here, but it does have some bearing. I had arranged a marriage with a foreign national. This fell through. I returned to South Africa. Durban after New York and Paris. It was difficult and so after a while, I decided to make the move to Jo'burg.

It is an odd city, for while its pretensions to colonial order are far less developed than Cape Town's or Durban's, it has its own means of concealing its past, or of simply not caring. It is far more concerned with maintaining the present, or rather, of invoking a false past, courtesy of themed architecture.

The first things I did in the city were an attempt to situate the private in the public realm. These took the form of small paintings. Simultaneously, I was working on large drawings, which were an attempt to pierce through the immediacy of the present tense, emphasis: tense.

The Mine Dump and Faultlines Projects

In 1988, on a dune near Durban, I made my first drawing with fire. This work consisted of large letters dug shallowly on the inclined face of the dune to spell GABRIEL. These were then filled with flammable materials and set alight, functioning ephemerally as invocation, seen from the earth, but aimed at the sky. The actual duration of the work as a fire drawing is brief but potent. Its presence elusive, in and out of consciousness – celebratory, incandescent for a moment, it leaves a scar.

The dumps in Jo'burg are covered with grass, which I cut into so that an image could be created by a change of light, a form of embossing that, like the memory it serves, is fragile, elusive and only intermittently apparent.

Other demarcations were made with oxides and whitewash in the manner of simple memorials on battle sites.

All the materials and treatments used were in some way transient and contingent, the result of a search for a kind of 'material' language, in transition and speaking of that transition.

This collection of paintings/installations continues my compulsion to see in earth, traces of our actions and their consequences.

The Mine Dump Project took place during the Johannesburg Biennale in 1994. Images were made on the inclined faces of the dumps using oxides, flags, and whitewash. At night these were set alight using braziers. The brazier is a simple warming device used on the streets of

Johannesburg. It is a drum perforated with holes usually filled with coals. I arranged these along lines to form the various images. The burning lasts for about half an hour and was visible to huge audiences of commuters passing on the highways that encircle the city.

Men Loving was made as a part of the *Faultlines Project*, curated by Jane Taylor, to explore issues around truth and reconciliation, a subject currently being processed in legal and political arenas in South Africa. The exhibition was sited in the Castle in Cape Town, the oldest building in the country and still a military seat. I made an inclined battlefield on which was a double bed, a grave, the casts of two heads, a pile of white stones (of the kind used to demarcate graves in the field) spilling from a suitcase and other elements, constructed from tissue paper. The field grew despite being indoors and, over a period of weeks, lent a forlorn air to the work. The following text accompanied the work:

> In 1735, two men were taken into the bay off Cape Town. When the ship was near Robben Island, they were made to 'walk the plank' while chained together. They had loved each other.
>
> On Friday, May 8 [1996], we adopted a new constitution which forbids discrimination on the basis of sexual preference. Perhaps now loving will be easier.

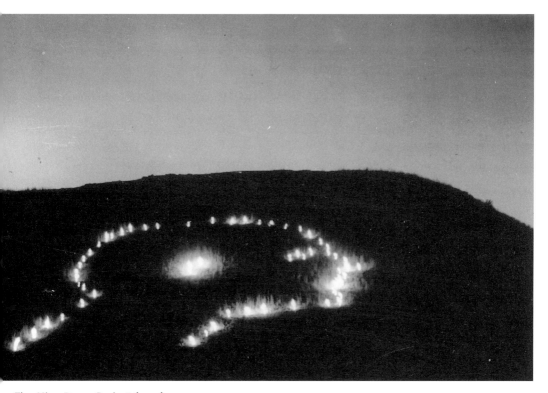

The Mine Dump Project (1994)

The Mine Dump Project (1994)

The Mine Dump Project (1994)

The Faultlines Project [Men Loving] (1996)

The Faultlines Project [Men Loving] (1996)

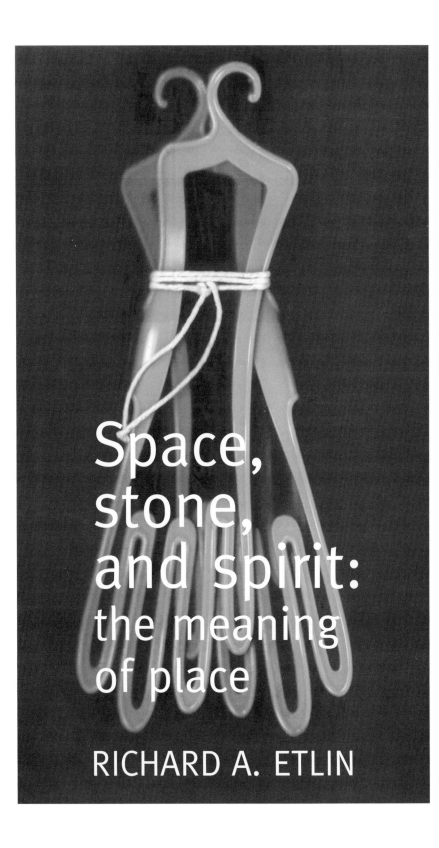

How do places acquire meaning? Social scientists who study this subject are fond of distinguishing between the words 'space' and 'place', the former designating for them a neutral container for human activities, the latter signifying those physical domains which have been invested with significant meaning or identity. '"Space" and "place" are related terms,' explain Irwin Altman and Ervin H. Zube, 'with "space" becoming "place" as it gains psychological and symbolic meaning.'[1] The purpose of this essay is to identify the ways in which such psychological or symbolic meaning becomes assigned to the built or the natural world.

Any consideration of the meaning of place would profit by situating itself within the intellectual framework established by the book co-authored by Mihaly Csikszentmihalyi and Eugene Rochberg-Halton entitled *The Meaning of Things: Domestic Symbols and the Self* (1981). While identifying those household objects which people invest with meaning, the authors show how people use objects to help themselves develop as unique beings and as members of a community. Objects are important in our lives not only for the functional purposes which they serve but also as signs by which we define ourselves and as agents through which we direct the process of our intellectual, emotional, and spiritual growth.

Of all the things which we might consider in an inquiry about meaning, none are as pervasive and as unavoidable as our physical setting, that is, the open areas, the buildings, and the natural landscape around us. When these physical settings acquire meaning for us, we customarily talk about their having attained a 'sense of place'. In this paper, I identify six different ways by which places acquire meaning. I would summarize them as follows: (1) meaning through character; (2) meaning through identity; (3) meaning through imitation; (4) meaning through being; (5) meaning through event; and (6) meaning through spirit. These summary designations are intended as helpful conceptual tags to focus on the most salient features of place-making.

Like Csikszentmihalyi and Rochberg-Halton, in studying the meaning of things – in this case, of places – I am concerned not merely with ascertaining the significance of objects and spaces but also how these meanings serve what for these circumstances can aptly be termed the construction of the self. Also like these authors, I would ground my inquiry in the same observations that they take from Jung. As Csikszentmihalyi and Rochberg-Halton remind us, 'Jung believed that unconscious drives included not only needs for physiological satisfaction but also powerful desires for personal development and spiritual union with the social and physical environment'.[2] These two issues – first, the trajectory of personal development and, second, union with the social and physical environment – are also my themes. Furthermore, as these authors explain:

> The psychic development that Jung saw as a human possibility, and
> that was given life by symbols whose structural form anticipates and
> spurs along the unfolding of the psyche, must be rediscovered by each

1 Irwin Altman and Ervin H. Zube, 'Introduction', in Altman and Zube (eds), *Public Places and Spaces* (Plenum Press, New York and London, 1989), 2. See also the discussion which follows, in which these authors review the relevant literature. Although I will question whether the word 'space' is always as phenomenologically neutral as these social scientists maintain, their distinction is helpful to the extent that it signals the intermediary of a mental process by which our physical habitat is invested with significance.

2 Mihaly Csikszentmihalyi and Eugene Rochberg-Halton, *The Meaning of Things: Domestic Symbols and the Self* (Cambridge University Press, Cambridge, 1981), 24.

person in a different way, depending on his or her location in cultural space and time. Although the steps of individual differentiation and spiritual union are essentially the same throughout history – hence the universal power of basic symbols – they have to be rediscovered independently by each person in his or her own existential configuration.[3]

Writing as social scientists, Csikszentmihalyi and Rochberg-Halton understandably have been interested primarily in the 'unfolding of the psyche' of their particular subjects. In this paper I will focus instead on identifying the universal qualities of the psyche through which each individual can create his or her self.

1. The sense of place through character

Sites in the natural world, presumably since the earliest times, have been accorded meaning because of specific characteristics which have appeared to human observers to be a manifestation of divinity. The widespread notion found in so many of the world's religions that god or the gods dwell in the heavens high above the sky has made natural landscape features, such as startling outcrops or entire mountains, seem to be either the seat of divinity or a rupture of the sacred in the profane world, a link between the human and the divine. Anne Marshall, for example, has studied the importance of outcrops in the American West, such as El Faro and Chimney Rock in the region of Chaco Canyon, to different Native Americans as manifestations of the sacred.[4]

4 Anne L. Marshall, 'Pueblo Placement: The Siting of Outlying Chacoan Structures', paper delivered at the Forty-Ninth Annual Meeting of the Society of Architectural Historians, Saint Louis, 18 April 1996. I am grateful to the author for helping me to give precision to the notes which I took during her lecture.

In addition to mountains, we can turn to other landscape features such as springs and rivers, whose ritual efficacy has served to purify humans of their moral failings, and such as groves of trees, which, like mountains, have been deemed to offer contact with the godhead. Perhaps the most famous sacred river where humans still seek purification is the Ganges at Benares. As for sacred groves, after World War I in Germany and Austria the *Heldenhain* or heroes' groves were popular ways of honouring the war dead. 'A *Heldenhain*', explains George L. Mosse, 'was a space within nature designed specifically for the cult of the fallen, the trees taking the place of rows of actual graves'. Sometimes a rough boulder, as a further sign of nature, evoking what Mosse identifies as 'symbolic of primeval power (*Urkraft*)', was placed within a *Heldenhain*.[5]

5 George L. Mosse, *Fallen Soldiers: Reshaping the Memory of the World Wars* (Oxford University Press, New York and Oxford, 1990), 87–8.

In seeking the equivalent to such landscape features and places perhaps we should turn to those Old World villages and cities whose organic aspect seems to have acquired the character of a natural physical occurrence. In *The Timeless Way of Building* (1979), Christopher Alexander perceptively identifies those features of this pre-industrial world which make it so appealing, which he terms its patterns created by the repetition of nearly identical units at human scale, units which none the less retain the subtle variations that can be found in the world of nature, as in the patterning of a field of wheat, a driving rain, or an ocean's

waves. Whether we look, for example, to Georgian or Regency London or to Second Empire Paris, we find in each what appears to be an organic consistency created by the repetition of elements in recognizable patterns, specific to each place. Within these and other cities, though, there are specific buildings and outdoor spaces which have their own unique aspect. This brings us to the second category, the sense of place through identity.

2. The sense of place through identity

Individual buildings and individual outdoor places, such as Michelangelo's Capitoline Hill and Bernini's St Peter's Square, both in Rome, have a distinct identity which creates a powerful sense of place. What is it about such places that focuses the attention so strongly? My purpose here is not to analyse the particular visual features of these and other buildings and squares but rather to suggest how distinctive architecture and cityscapes are deemed to impart a sense of place. Here I take a cue from Charles Rosen, who once observed that listening to Haydn's chamber music is like overhearing a conversation, not between voices speaking with words but rather between musical voices.[6] In other words, the conceptual category of conversation cannot be limited to the exchange of words but also includes other manners of give and take, such as between lines of music or musical instruments. Extending this insight, I suggest that encountering architectural masterpieces with distinct characteristics is like encountering a captivating personality. People and even more generally living creatures do not have a monopoly on the phenomenon of personalities. Buildings and open spaces such as plazas also have distinctive personalities, which give them a sense of place.

3. The sense of place through imitation

Throughout the history of architecture we repeatedly encounter instances in which a building imitates in some manner, with more or less precision or abstraction, some other building from the past. This process of imitation helps to invest an edifice, and likewise, a room, plaza, courtyard, or garden, with a sense of place. Imitation generally follows one of the two previous types of place-making, that is, character or identity. The subject for imitation has generally been either the natural world, especially those features that signal the presence or power of divinity, or examples of architecture considered as exemplars worthy of copying.

 In imitating aspects of the natural world, sometimes people would adhere to what is seen, as in the numerous versions of the sacred mountain that have become pyramids in various cultures, or the unseen, as in the Gothic cathedrals whose forms emulate the description of the new Jerusalem as found in the Book of Revelation, 'having the glory of God, its radiance, like a most rare jewel, like a jasper, clear as crystal'

6 Charles Rosen, *The Classical Style: Haydn, Mozart, Beethoven* (1971; W.W. Norton, New York, 1972), 141–2: 'I have hesitated to mention perhaps the most striking innovation of Haydn's string-quartet writing: its air of conversation . . . This [musical] passage is like a model for a dramatic and yet conversational dialogue in a comedy, in which the content of the words has become irrelevant to the wit of the form . . . The isolated character of the classical phrase and the imitation of speech rhythms in all of Haydn's chamber music only enhance the air of conversation . . . The eighteenth century was cultivatedly self-conscious about the art of conversation: among its greatest triumphs are the quartets of Haydn.'

7 As scholars of these periods have remarked, the passage from Revelation 21: 2–5 was read during the dedication rite: 'And I saw the holy city, new Jerusalem, coming down out of heaven from God, prepared as a bride adorned for her husband; and I heard a great voice from the throne saying, "Behold, the dwelling of God is with men. He will dwell with them, and they shall be his people . . . "' (Revelation 21: 2–3). See Otto von Simson, *The Gothic Cathedral: Origins of Gothic Architecture and the Medieval Concept of Order*, The Bollingen Library (Harper and Row, New York and Evanston, 1962, 2nd rev. ed.) 8 n.20. Both quotations from Revelation are taken from *The Oxford Annotated Bible*, (eds) Herbert G. May and Bruce M. Metzger (Oxford University Press, New York, 1962).

8 Richard Krautheimer, 'Introduction to an "Iconography of Mediaeval Architecture"', *Journal of the Warburg and Courtauld Institutes*, vol. 5 (1942), 7. As Krautheimer explains, 'This inexactness in reproducing the particular shape of a definite architectural form, in plan as well as in elevation, seems to be one of the outstanding elements in the relation of copy and original in medieval architecture.'

9 Csikszentmihalyi and Rochberg-Halton, *The Meaning of Things*, 91, 94.

10 We know, thanks to Raija-Liisa Heinonen's important study of Aalto's early classicizing work, that he was strongly impressed by the view of the Acropolis drawn by Auguste Choisy and reproduced twice in Le

(Revelation 21: 10–11).[7] Buildings which consecrate sacred events or places also have been used as models for subsequent edifices. Hence, the desire to share in the spiritual qualities of the Holy Sepulchre in Jerusalem, deemed one of the most sacrosanct sites of Christendom, prompted parishes, monasteries, and bishops 'from the 5th to as late as the 17th century' to create churches with a variety of polygonal or round shapes whereby the centralized format was enough to evoke in the minds of the worshippers the sacred model.[8]

In a chapter in their book on the meaning of things entitled 'Object Relations and the Development of the Self', Csikszentmihalyi and Rochberg-Halton explain that things 'tell us who we are, not in words, but by embodying our intentions'. Looking to the objects of the home, these authors add, 'Moreover, the belongings that surround us in the home constitute a symbolic ecology structuring our attention and reflecting our intentions and thus serve to cultivate the individuality of the owner.'[9] In architecture we find that buildings, especially institutional buildings, focus members of society on shared values and that these values are visualized as a function of the high achievements attained by other societies in the past. These imitations may be as direct as the evocation of the Capitoline Hill, understood as a timeless centre of civic authority, in New York City's Lincoln Center, portrayed as a timeless centre of high cultural activity, or as abstract as Alvar Aalto's repeated use of the configuration of the Periclean Acropolis for his civic ensembles.[10] In other words, life is understood as a process by which people reach high levels of achievement, with past cultural achievements of earlier ages enduring and becoming the points of reference to which we would anchor our own most significant accomplishments. Architecture offers one means by which this process of finding meaning in things is realized; a primary mechanism by which it operates is some manner of imitation.

4. The sense of place through being

Relating their findings in *The Meaning of Things*, Csikszentmihalyi and Rochberg-Halton repeatedly remark upon how so many of the objects in the home serve as focal points for memories about the past. These include furniture, photographs, and even books and works of art, these last two cherished as much for past associations as for the pleasure that they afford in their own right.[11] All of these objects in the home become, in a felicitous phrase used by the co-authors, 'talisman[s] of continuity'.[12] We see our lives as a progressive unfolding which proceeds in two directions. On the one hand, we anticipate the direction that our life is taking as we move from present to future. On the other hand, we look backward at our past life, not limited to our own existence but also encompassing those of our ancestors, the two weaving together a cherished record which provides us with a sense of accomplishment and of roots. The analogies between the meaning of things in the home as repositories of memories, constituting a progressive accretion of

'becoming' and hence of being, and the use of imitation in architecture, discussed in the previous section, are notable.

To gauge the strength of these associations with the past, associations that become located in the memories deposited, so to speak, in the objects of our household, we have only to consider the expressions of grief which we regularly see in photographs in the newspaper of people whose homes have been destroyed by fire. Why is this grief so strong? The function of memory itself cannot fully explain the intensity of the feeling. I do not believe that the loss of the objects themselves, as well as the loss of the comforting, because customary, surroundings can be explained solely through reference to the memory function of things and places. Rather, the reason that memory creates such a strong psychic bond through these objects and through the place itself is that the home readily becomes, through its very space and all that the space contains, from the walls and ceiling to the furnishings, an integral part of our being.

Consider, for example, the sentiments which many of us unfortunately have experienced after our home or even our automobile has been broken into by a vandal or burglar who has come in our absence. Even in the case of a burglarized automobile, we generally feel less secure than before the event. We feel that our own person has been violated. Rationally, we can tell ourselves that our body was not injured or even threatened. Yet, we still feel as if our very being has been violated. Why is this so? The reason, I believe, is that our possessions, especially our homes and even our automobiles, readily become extensions of the self. What does this mean? How can a home or a car become part of us?

To answer this question of who we are, we have to ascertain where we are. Let us first consider by analogy the planet Earth. What is the Earth? Where does it end? Is the Earth merely the great ball whose outer surface is the peripheral crust, largely covered with water? Or does it include the atmosphere which surrounds this spherical body? Does the Earth even end there or does it extend outward as far its gravitational field reaches, keeping within its proximity, as measured in astronomical terms, the body of the Moon? Although we need not decide this issue of definition here, it can guide us in our effort to define our being.

Whereas we generally think of ourselves as co-extensive with our bodies, our experience of the self encompasses the circumambient space around us. With respect to the biological functioning of life we obviously live within our bodies. If we slice the space in front of us with a sharp knife, our health is not altered. Obviously we could not do the same with impunity if we directed the knife into our body. Yet, like the Earth with its atmosphere and perhaps with its gravitational field, we too prolong our being outside of the envelope of our bodies. The architect Louis Kahn used to say that the Pantheon was a perfect building except for one problem: it has a door. Kahn meant that as soon as we enter this huge, centralized, and domed building, we immediately feel as if we are occupying the centre and filling the great room with our presence. We are already one with the space even before we traverse the distance from the entrance to the central spot under the opening of the dome.

Corbusier's *Vers une architecture* (1923). Heinonen convincingly shows that in 1926–7 Aalto used the configuration of the Periclean Acropolis in sketches for different building projects, including his unsuccessful entry in the League of Nations competition and in competition entries for three churches. With the knowledge of this youthful interest in this classical site, we can see its recurrent appearance throughout Aalto's career in his later modernist buildings, perhaps the most notable being the Town Hall (1949–52) in Säynätsalo, Finland. The procedure of abstracting the principles of past architecture without copying the stylistic features I have termed 'philosophical eclecticism', a notion that was a major tenet of nineteenth-century architectural culture. On this subject, see Richard A. Etlin, *Frank Lloyd Wright and Le Corbusier: The Romantic Legacy* (Manchester University Press, Manchester, 1994), 150–64 (chapter 3: 'Eclecticism and Modern Architecture'). See also Raija-Liisa Heinonen, 'Some Aspects of 1920s Classicism and the Emergence of Functionalism in Finland', in *Alvar Aalto*, Architectural Monographs 4 (Academy Editions, London, 1978), 23.

11 Csikszentmihalyi and Rochberg-Halton, *The Meaning of Things*, 62–70.

12 Ibid., 70.

13 Le Corbusier, *La Ville radieuse: Eléments d'une doctrine d'urbanisme pour l'équipement de la civilisation machiniste* (Vincent Fréal, Paris, 1935; 1964 reprint) 54: 'Nos épaules ont sur elles les plafonds qui conviennent'.

14 Franz Kafka, *The Trial*, trans. Willa Muir and Edwin Muir, rev. trans. E. M. Butler (1925; Schocken, New York, 1974), 106.

15 Edward T. Hall, *The Silent Language* (1959; Fawcett, New York, 1966), 158–64, and *The Hidden Dimension* (Doubleday, Garden City, NY), 107–22.

16 Maurice Merleau-Ponty, *Phénomonologie de la perception* (Gallimard, Paris, 1945), 339: 'Nous avons dit que l'espace est existentiel; nous aurions pu dire aussi bien que l'existence est spatiale.'

17 Marcel Proust, *A l'ombre des jeunes filles en fleurs*, in *A la recherche du temps perdu*, eds Pierre Clarac and André Ferré, Bibliothèque de la Pléiade, 3 vols (Gallimard, Paris, 1954), vol. I, 666: 'C'est notre attention qui met des objets dans une chambre, et l'habitude qui les en retire et nous y fait de la place. De la place, il n'y en

As the example of the Pantheon readily teaches us, we experience the self in a spatial manner, filling the rooms which we visit or inhabit with our presence. Because of this phenomenon the architect Le Corbusier was able to talk about the feeling of the ceiling over his shoulders.[13] This spatial sense of the self is responsible for the protagonist's discomfort in Kafka's *The Trial* (1925) when K., as he is known, is led by the nurse into the lawyer's empty office for an amorous encounter: 'After he had sat down K. still kept looking round the room, it was a lofty, spacious room, the clients of this "poor man's lawyer" (as he was known) must feel lost in it.'[14] The protagonist feels lost in the room because the space is too large for a comfortable feeling of well-being for one's own spatial self.

If you think that your being ends with the edge of your body, then consider how uncomfortable you feel when a stranger purposefully comes very close to you. And ask yourself why does 'very close' become 'too close'? Thanks to the studies of the anthropologist Edward T. Hall, we know that each person carries around him or her a spatial bubble which contracts or expands according to the intimacy or formality of the relationship with the other person. Hall distinguishes between four different spatial bubbles, which he labels as covering intimate, personal, social, and public distances, ranging from six inches to twenty-five feet or more.[15] Although a universal phenomenon, these space bubbles are partly culturally determined to the extent that Latin peoples tend to compress the zones of personal and social distance whereas Nordic peoples tend to expand them.

When we live in a room, apartment, or house, we fill the space with our space bubble. Space is not merely a neutral category. Space rapidly becomes existential. Writing in *Phenomenology of Perception* (1945), Maurice Merleau-Ponty has rightly asserted, 'We have said that space is existential; we could just as well have said that existence is spatial.'[16]

To gauge the importance of the spatial character of being to the meaning of things we should turn to the young narrator in Proust's *A la recherche du temps perdu* (1913–22). Young Marcel is extremely sensitive to the places in which he lives, to the point where unfamiliar rooms are immediately disconcerting and must be tamed through the familiarity which habit conveys to places and objects. Comparing his room at Balbec to the one in Paris, Marcel explains that he found no psychological place for himself in the former: 'It is our attention which puts objects into a room and habit which withdraws them and makes room for us there. Room for myself, there was none for me at Balbec (mine in name only)'.[17] Like the protagonist K. in *The Trial*, Marcel is disturbed by the space of his room. Yet whereas K. was overwhelmed by the discomforting size of the place, Marcel is troubled by its very strangeness. Only by becoming habituated to the room, by deadening its frightening newness through habit does the room become habitable. As Marcel further explains, '[T]he objects in my room in Paris troubled me no more than my own pupils, because they were no more than appendages of my organs, an aggrandizement of myself.'[18] Both the space of the home and the objects within that space readily become parts of the self.

Writing in *The Meaning of Things*, Csikszentmihalyi and Rochberg-Halton explain, 'The objects of the household represent, at least potentially, the endogenous being of the owner.'[19] This is true for all manners of things with which people surround themselves in their homes. Thus, in a study of eating utensils, one social scientist has observed, 'They give objective expression to the inner feeling of the persons involved about themselves, help to reinforce the person's opinion about himself, and increase his sense of security.'[20] Proust's text teaches us that this sense of well-being involves not only household things but also the space of the home itself into which people must insert themselves, so to speak, to tame its alien quality. Before this can happen somebody as sensitive as young Marcel feels as if his personal space has been invaded, as if there is no place for himself: 'Having no longer a universe, no longer a bedroom, no longer a body, since these were menaced by enemies all around me, invaded as far as the depths of my bones by fever, I was alone, I wanted to die.'[21] The enemies to which Marcel is referring are the objects in his room, as well as the physical features of the room itself, i.e., the walls, windows, door, and the space itself that knits all of these things into a continuum with the existential space of the self.

Whereas space and its objects can threaten, they can also invigorate the mind and exalt the spirit. This type of experience takes place in Proust's great novel when a slightly older Marcel visits his friend Roger de Saint-Loup, who is undergoing his period of military service. Anticipating another psychologically uncomfortable and hence sleepless night in a strange hotel, Marcel is agreeably surprised to discover a vitalizing space which engages his sense of being in an invigorating manner:

> But I had been mistaken. I did not have the time to be dejected, because I was not for an instant alone. That is, there remained of the old palace an excess of luxury, unusable in a modern hotel, and which, removed from any practical use, had acquired in its lack of occupation a sort of life: corridors returning to their thresholds, whose comings and goings without destination one repeatedly crossed, vestibules long like corridors and ornate like salons, which had the air of living there rather than of being part of the residence . . . In short, the idea of a lodging, simple container of our present existence and protecting us only from the cold, from the sight of others, was absolutely inapplicable to this dwelling, ensemble of rooms, as real as a colony of people, with a life, silent, of course, but that one was obliged to meet, to avoid, to welcome, when one returned.[22]

Marcel's experience in this hotel focuses our attention on the fact that our surroundings never serve merely as the 'simple container of our present existence and protecting us only from the cold, from the sight of others'. They are extensions of the self. All truly excellent architecture, whether rooms or entire buildings, exterior plazas and boulevards, gardens or even expansive landscapes, has features and spaces which prompt the life-enhancing reaction recounted here.

avait pas pour moi dans ma chambre de Balbec (mienne de nom seulement).'

18 Ibid., vol. I, p. 667: 'que les objets de ma chambre de Paris ne gênaient pas plus que ne faisaient mes propres prunelles, car ils n'étaient plus que des annexes de mes organes, un aggrandissement de moi-même.'

19 Csikszentmihalyi and Rochberg-Halton, *The Meaning of Things*, 17.

20 W. Lloyd Warner, *American Life: Dream and Reality* (University of Chicago Press, Chicago, 1953), 120, as quoted in ibid.

21 Proust, *A l'ombre des jeunes filles en fleurs*, in *A la recherche du temps perdu*, vol. I, 667: 'N'ayant plus d'univers, plus de chambre, plus de corps que menacé par les ennemis qui m'entouraient, qu'envahi jusque dans les os par la fièvre, j'étais seul, j'avais envie de mourir.'

22 Proust, *Le Côté de Guermantes*, in *A la recherche du temps perdu*, vol. II, 82: 'Or, je m'étais trompé. Je n'eus pas le temps d'être triste, car je ne fus pas un instant seul. C'est qu'il restait du palais ancien un excédent de luxe, inutilisable dans un hôtel moderne, et qui, détaché

cornices ripped from the religious heart of Athens by marauding Persians'. Then, under Pericles, during the construction of the marble Erechtheion, a rough limestone foundation wall of the old Temple of Athena Polias, which had been destroyed by the Persian sack of 480 BC, was purposefully incorporated into the composition as a reminder of the older building. Finally, at the entrance pavilion to the rebuilt Periclean Acropolis, in the building designed by Mnesikles and known as the Propylaia, the architect incorporated a fragment of the old Mycenaean fortification wall into his new building, apparently as a reminder of the city's earlier history.[26]

26 Ibid., 32–8.

6. The sense of place through spirit

The sixth way in which a place acquires significance occurs when we imagine an area, a building, or a fragment of a site as being imbued with a spirit. By 'spirit' I mean the sense we have that as living entities we have a spirit or soul which in some way inhabits our body. By extension, we can easily understand that inanimate matter readily becomes invested with life by the addition of spirit. Like the narrator in Janet Frame's novel *The Edge of the Alphabet* (1962), we readily comprehend that as 'Toby stroked the pendants in his hand', he 'could feel them growing warm' such that 'he had brought them to life'.[27] Like Aladdin stroking his lamp to call forth the genie inside, Toby strokes the pendants and thus feels as if he has brought them to life.

27 Janet Frame, *The Edge of the Alphabet* (George Braziller, New York, 1962), 37.

This psychological phenomenon is what Gaston Bachelard has termed 'le rêve d'imprégner', the reverie of impregnating.[28] The reverie is universal and virtually timeless. Consider, for example, how in Genesis man is created: 'then the Lord God formed man of dust from the ground, and breathed into his nostrils the breath of life; and man became a living being' (Genesis 2: 7). The learned commentary to this passage in *The Oxford Annotated Bible* teaches us, 'Man is not body and soul (a Greek distinction) but is dust animated by the Lord God's *breath* or "spirit" which constitutes him *a living being* or psycho-physical self'.[29] In spite of the subtle differences between the Hebrew and Greek concepts of the self, they share, along with so many other cultures, the basic outlook that matter has been invested with spirit.

28 Gaston Bachelard, *La Terre de les rêveries du repos* (José Corti, Paris, 1948; 1971 6th printing), 35.

29 *The Oxford Annotated Bible*, 3.

One of the most remarkable aspects of the human mind is that through the 'reverie of impregnating' it readily imagines this spirit as capable of travelling outside of the body through some type of representative agent. Marcel Mauss offers a striking example of this phenomenon in his discussion about the exchange of gifts among the Maori in his 'classic work' *The Gift* (1950):

> [A]ll goods termed strictly personal possess a *hau*, a spiritual power
> . . . Hence it follows that to make a gift of something to someone is to
> make a present of some part of oneself . . . In this system of ideas one
> clearly and logically realizes that one must give back to another person

what is really part and parcel of his nature and substance, because to accept something from somebody is to accept some part of his spiritual essence, of his soul.[30]

Mauss proceeds to outline the reasons why the gift must be reciprocated so that through this action the spirit is returned to its point of origin. These include the fear that the gift possesses a magical power which can curse the new possessor.[31] Whereas the belief that the spirit inhabiting a gift retains a volition to return to its point of origin and thus can harm if thwarted in its desires is specific to the Maori and to other archaic cultures which share similar beliefs, the sense of the material object being invested with the giver's spirit that is then passed on to another person represents a universal psychological phenomenon.

Consider, for example, the stones from Cambridge University and Oxford University built into the garden walls at the Graduate College of Princeton University. They are the result of gifts and their position in this wall is intended to invest this younger American university with the spirit of its older English counterparts.[32] Likewise, the Chicago Tribune Building, constructed in the 1920s, has embedded in the outer wall around the main entrance at eye-level fragments from the great monuments of world architecture and from buildings of significant cultural institutions. This collection of architectural relics, so to speak, is intended to convey the sense not that this newspaper is merely a local institution but rather that its publication has worldwide and timeless significance.

The stones that one finds at the Chicago Tribune Building are truly like relics in their psychological functioning. In making this analogy I intend no disrespect to those religions which believe in the spiritual reality of a saint's relics. I am merely noting the similar psychological mechanism by which people will readily imagine that the fragment of the body of a saint and the fragment of a building, especially a stone, can seem to carry the spirit of its former being, whether a person or a building.

In *The Cult of the Saints: Its Rise and Function in Latin Christianity* (1981), Peter Brown remarks upon the psychological dynamics whereby the smallness of the relic, which exists as a fragment, carries a spiritual power greater than the entire body itself. Brown calls this phenomenon the 'effect of "inverted magnitudes"', which he further characterizes as an 'imaginative dialectic'.[33] Here Brown is using the notion of the dialectic after the manner of Gaston Bachelard, whereby the simultaneous presence of two contrary things reinforces the sense of each by mutual opposition. Bachelard cites the example of a story by Baudelaire in which the author remarks that it seems to be much cosier inside by the fireplace when there is a winter storm outside.[34] With respect to relics, as Brown explains, it is the small and compact aspect of the relic which assures its psychological efficacy. In the case of a saint's relics, Brown sees this efficacy as effectuating a distancing from the mortal aspects of death:

The result of this dialectic had been not merely to block out the negative associations of physical death with all the resources of an imagery of paradise, but to raise the physical remains of the saints

30 Marcel Mauss, *The Gift: The Form and Reason for Exchange in Archaic Societies*, trans. W. D. Halls (1925; Routledge, London, 1990), 11–12. The characterization is by Csikszentmihalyi and Rochberg-Halton in *The Meaning of Things*, 37, who also quote a portion of this passage.

31 Mauss, *The Gift*, 12–13.

32 These stones can be found in the walls of the Dean's Garden next to Wyman House, part of the Graduate College complex designed by Cram, Goodhue, and Ferguson and dedicated in 1913. In *Princeton Past and Present* (Princeton, 1947), V. Lansing Collins provides the following description: 'The Dean's Garden . . . contains ivies from Haddon Hall, England, from the Martin Luther House at Wittenberg, and from Bemerton, the home of George Herbert. Set in the garden wall are window arches from University College, Oxford, of which Shelley was a member, and the window bases from Christ's College, Cambridge, Milton's college, given by the Master of Christ's, Vice-Chancellor Shipley.' The inscriptions read: 'Sills from Christ College/Cambridge/The College of Milton' and 'Arches from University College/Oxford/The College of Shelley'. I am grateful to John Pinto for generously responding to my request both for photo documentation and precise historical information about these stones, which I remember seeing over two decades ago.

33 Peter Brown, *The Cult of the Saints: Its Rise and Function in Latin Christianity*, The Haskell Lectures on History of Religion, new series, no. 2 (University of Chicago Press, Chicago, 1981), 78.

34 Gaston Bachelard, *La Poétique de l'espace* (Presses Universitaires de France, Paris, 1957; 1970 6th ed.), 51–2. I discuss this phenomenon more fully in *Frank Lloyd Wright and Le Corbusier: The Romantic Legacy*, 32–3.

35 Brown, *The Cult of the Saints*, 78.

36 As quoted in ibid.

37 Bachelard, *La Poétique de l'espace*, 141: 'l'imagination miniaturante'.

38 Ibid., 140–1, and *La Terre et les rêveries du repos*, 162. For a discussion of this theme with respect to architecture, see Etlin, *Frank Lloyd Wright and Le Corbusier: The Romantic Legacy*, 70–5.

39 Bachelard, *La Terre et les rêveries du repos*, 52–3: 'la dialectique du grand et du petit qui pourtant est la dialectique de base.'

40 Bachelard, *La Poétique de l'espace*, 146: 'La miniature est un des gîtes de la grandeur.'

41 Paul Ricoeur, *Freud and Philosophy: An Essay on Interpretation*, trans. Denis Savage, The Terry Lectures (Yale University Press, New Haven, 1970), 15–19, 30–1.

above the normal associations of place and time. At their graves, the eternity of paradise and the first touch of the resurrection come into the present. In the words of Victricius of Rouen: here are bodies, where every fragment is 'linked by a bond to the whole stretch of eternity'.[35]

As with my earlier discussion of the *hau* which was passed along by the Maori in their gifts, here we must distinguish between those psychological aspects that pertain to the cult of saint's relics and those that have a wider application.

One aspect not stressed by Brown in this discussion is the psychological functioning of what might be called the dialectic of the concentrated essence. As Victricius remarked, 'You see tiny relics, a little drop of blood'.[36] This 'imaginative dialectic' 'of inverted magnitudes' is an example of what Gaston Bachelard has termed the 'miniaturizing imaginaton'.[37] To the purely rational mind, explains Bachelard, there is essentially no difference between two figures drawn at different scales other than their relative sizes. Yet to the imagination the small figure acquires a power through the sense that the larger one has been made into a miniature whereby its essence has been concentrated.[38] In a catalogue of imaginative operations, the miniaturizing imagination participates in what Bachelard has termed 'the dialectic of the large and the small', which, he explained, 'is the basic dialectic of them all'.[39] As Bachelard has further observed, 'The miniature is one of the sites for grandeur.'[40] The saint's relic from a fragment of the body, the genie in the lamp, and the stone from the distant monument, all partake of the efficacy of the imaginative dialectic of inverted magnitudes whereby the small seems to concentrate a limitless power through its miniaturization and through a natural process of animism whereby we invest matter with spirit.

One of the principal types of symbolization whereby buildings and places are invested with a sense of spirit proceeds from the dialectic of contamination and purification, where the particular type of contamination occurs as a moral stain. Paul Ricoeur has stressed the fundamental role that such concepts play in conceptualizing the moral world, a process that works largely through symbols and related symbolic actions.[41] When a site has been invested with meaning because of evil events, then people feel the need to respect the memory of those events either by leaving the place untouched or by purifying the place.

During the French Revolution, for example, the site of the Bastille, which had come to symbolize the oppression of the Ancien Régime, was deemed in need of purification, rendered by the two-part operation of dismantling the building and then, as part of the festivities associated with the 14 July 1790 Festival of Federation, by the erection of an open-air pavilion as a temple of liberty whose contours retraced with verdant walls the outline of the former sombre stone prison and at the centre of which a mast now rose to the height of the former Bastille to fly a flag announcing *liberté*. By repossessing the form of the Bastille,

this new festival pavilion symbolically purged the site of its moral stain.[42]

In an analogous manner, the location of the destroyed SS headquarters in Berlin was the subject of a design competition for a memorial sponsored in 1982 by the Berlin senate and in which the winning project envisaged a site treatment that retained a sober reminder of the evil perpetrated there while offering an image of partial redemption. According to the design proposed by the landscape architect Jürgen Wenzel and the artist Nikolaus Lang, the site was to be sealed, as James E. Young relates, 'with great plates of cast iron, broken only by round holes large enough for a tight and orderly grid of hundreds of chestnut trees'.[43] Documents from the SS files would be reproduced in relief on the iron plates not only to bear witness to the events but also to cause passers-by, in the words of the artists, 'to stumble over their own history'.[44] The chestnut trees offer a metaphor of purification, which, however, is only partial, never complete, for the space below the plates remains for ever inaccessible, for ever invested with the spirit of evil, which emerges to the surface as eruptions on the iron plates in the form of the raised documentation.

Finally, there are times when any common and especially joyful use of a site contaminated by evil seems morally out of the question. There is a lake at the Mauthausen concentration camp where over a hundred thousand inmates were purposefully worked to death in the stone quarries. At the base of the quarry cliff where countless hapless victims either jumped or were thrown to their deaths, there is a sign by the water's edge 'ask[ing] visitors not to swim or picnic' there.[45]

In reviewing the six ways in which meaning is imparted to a place, we have seen that sites acquire significance through the manifestation of divinity, through human activity that imparts a pattern to the habitat which echoes the rhythms of the organic world or which creates a distinctive personality, through the purposeful imitation of either natural topographic features or of other buildings or artificial sites, through significant events which have occurred there, through the way that the space surrounding our bodies readily becomes inseparable from our understanding of the self, and through the workings of our imagination which readily invests dead matter with spirit such that it can travel from one location to another while retaining all of its psychological efficacy. When considered together, the various ways in which places acquire meaning exhibit all of the complexity of life itself. As a secular parable, this study teaches us to look for the meaning of things in complex and multifarious ways.

Note

This paper, with different opening paragraphs suited to the occasion, was first read at the symposium The Meaning of Things, 18 May 1996, sponsored by the Cooper-Hewitt, the National Design Museum of the Smithsonian Institution, New York City.

42 For a further consideration of this issue, see Etlin, *Symbolic Space: French Enlightenment Architecture and Its Legacy* (University of Chicago Press, Chicago, 1994), 37.

43 James E. Young, *The Texture of Memory: Holocaust Memorials and Meaning* (Yale University Press, New Haven, 1993), 85–7.

44 As quoted in ibid., 87.

45 Ibid., 97.

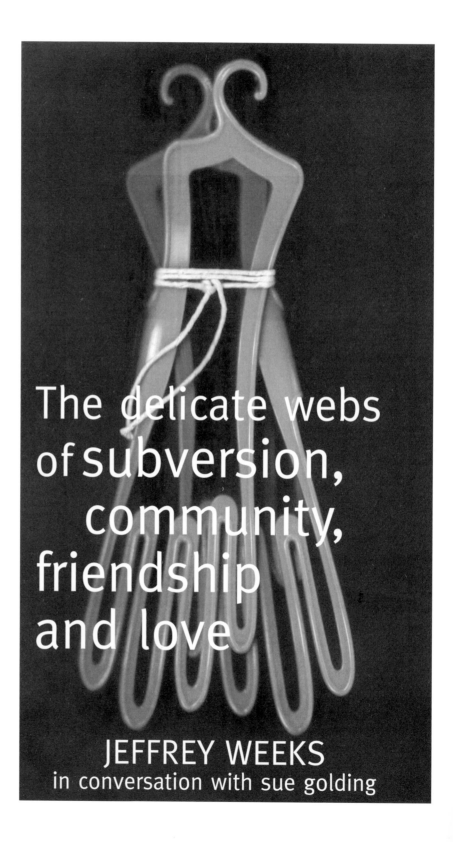

The delicate webs
of subversion,
community,
friendship
and love

JEFFREY WEEKS
in conversation with sue golding

Sue Golding: For well over two decades, your work – pioneering and prudent at one and the same time – has spun around the nuances (sexual, ethical, moral, aesthetic, historical) of that strange little word called: gay. What does it mean to be 'gay' for you?

Jeffrey Weeks: I still think that being gay is subversive, and being subversive is, paradoxically, about trying to create things, like a mole burrowing under the ground and throwing up little hills. You are creating ways to make ground level, but you can also suddenly pop up here, there and everywhere at key points. However 'respectable' then we all become, as we get older and our books are published and so on, I think that there is still an element of subversiveness in what we write. Actually, I don't want to write anything that isn't subversive. Just to give you an example: I was, I guess, a pioneer of gay history and that was over the last twenty, twenty-five years. People are still working around the same areas, and they are going deeper and deeper into the same sort of themes that we looked at twenty, twenty-five years ago, like the influence of legal change in the nineteenth century and the impact of the Oscar Wilde trial, or whatever. Now, I feel that I don't want to go into more detail on all that, not because it isn't important, but because I want to do something new. Intellectually I always have to go into something fresh, even though, looking back on it, you can see there's a single path, a single trajectory. So, I'd much rather start new things and let others finish them off, than explore everything in absolute detail.

sg: You use the word 'subversive'. Do you think that that has something to do with the fact of the act of sex itself, actual sexual fucking – its individual practices and orifices – or is being subversive connected with something else? And would you say that subversiveness has a 'history' in that it can change to something else, something, say, 'less' or even 'more' subversive than that which has gone 'before'? Do you think there's ever a time when sex is not subversive?

jw: I think there are many kinds of sex that are not subversive. I'm a great believer in not judging an act by what it is, but by the context in which it takes place. And the same act can have different meanings in different contexts. I remember giving this analogy to a colleague many years ago. You see two men in a café, or in a lay-by on a motorway, and they're dressed in leather, and they've left their bikes there. They are leather boys, macho, Hell's Angels type of people, and you could be scared for your life. However, you can go into a gay bar in any major city in the West now and you can see two men looking exactly the same with their motorbikes outside, but the meaning of their presence is completely different. They are into a particular culture of sexuality where leather plays a part, but they are very different from the leather boys, the Hell's Angels on the motorway. The two things look identical, but they have a world of different meaning. It's the same with any sexual act. Fucking can be extremely aggressive, it can even be destructive. It can also be affirming, loving, caring. It can be transgressive and it can be reactionary and from

the act itself you can't judge anything. You have to see the context, the meaning, the implications of that act in order to say whether it's – I'm trying to avoid using the words 'good' or 'evil' – whether it's life-affirming or life-denying.

What is subversive at one time becomes absolutely respectable at another time. When you look at the literature today on gay marriages, gay partnerships, for example, I think back to the beginnings of gay liberation and the horror we had that there was an institutional pressure to marry, and the relief that we weren't going to live through that. Now the same generation wants to affirm their vows, affirm their relationships, and I can recognize now why people want to do that. A climate still exists which says that heterosexual marriage is a gateway to respectability so to say, well, actually why can't I as a gay man, or you as a lesbian, get married, can be subversive of all that. And yet from another point of view it's simply another stage in the assimilation of gayness into straight society. So many of these phenomena are extremely ambivalent. They can have a radical moment and a conservative moment.

sg: Bataille, as you know, sets up a distinction between the sacred and the profane – or, to be more accurate, sets up a distinction which pits the sacred/profane, as being on the one side, which is then 'opposed to' or utterly 'divorced from' mediocrity, neatly set, as it were, on the other. In this way, he introduces a somewhat peculiar form of the binary, which, despite this kind of division (or perhaps because of it) speaks of 'identities' as a weird, mobile kind of tapestry. Now, this sense of the sacred and profane as being on the same side of 'the equation' certainly fuelled many people's sense of being gay, especially in the erotics of gay life, which was supposedly anything but mediocre! But I think that part of the richness of your work, especially from *Sex, Politics and Society*[1] (or even earlier, with your *Coming Out*[2] book), has insisted on the fullness of that tapestry so as to include, and indeed bring to light, the 'whole picture' as it were. It seems that you were saying, that 'yes, being gay has something to do with this relationship between the profane and the sacred, but normalcy, too, had its "subversiveness" tropes as well'. This important 'inclusion' allowed you to explore in various detail the myths, the ironies and the questions of the everyday. Would you say that this is, in part, what you've been addressing or is it something else altogether?

jw: I'm not sure I've got a straight answer to it. Perhaps I shouldn't have a straight answer for this. What my work has attempted to do, what the style of my work tends to do, is to take what I know society regards as abnormal or peculiar, as absolutely normal, taken for granted. Once you do that, you can then look for nuances within the 'taken for granted', so you can raise issues within the discourse of absolute naturality, which you could even work on in a calm, rational and reflective way without having to bother to defend this abnormal normality against convention. It's like in a way, ignoring the conventions, it's saying that this is another form of normality and what I want to do is to trace the nuances within this normality.

1 *Sex, Politics and Society: The Regulation of Sexuality since 1800* (Longman, London, 1981). See also Jeffrey Weeks's *Sexuality and its Discontents: Meaning, Myths and Modern Sexualities* (Routledge, London, 1985).

2 *Coming Out: Homosexual Politics in Britain, from the Nineteenth Century to the Present* (Quartet, London, 1977).

sg: How does one go about researching something like that? How do you research something that doesn't really exist that way?

jw: Well, let me just say that I try to do this in my book *Invented Moralities*.[3] What I was interested in doing in that book was to try to explore the ways in which people in a world without given meaning, without valid traditions to impose meaning on people, have to create meanings for themselves and how they – we – do that. I suggest we do it by drawing on invented traditions: for instance we draw on particular histories, we draw on particular struggles, there's a variety of ways to do it, and we do it in our own individual lives. But within such doing, there are always two moments, which are in different ways the same as the sacred and profane. It's what I call in the book 'the moment of transgression' and 'the moment of citizenship', which is a way of half saying the same thing. What I suggest is that in any radical political movement there's always the moment of transgression when you try to pull the pillars down, when you try to challenge the *status quo*. In terms of gay liberation, it was the moment of gay liberation itself, of exploring sex, of cross-dressing, of experimenting with drugs, of exploring relationships, or whatever: that's like the moment of transgression. But linked to that is the moment of citizenship, which is the moment of making claims on society, a claim for inclusion. Making that claim for inclusion may seem assimilationist, but actually making demands on a culture which denies you is extremely radical: it identifies the frontiers of the conventional, it demarcates the lines of struggle. So, you can see transgression and citizenship as simply the different faces of the same moment of challenge. One is separating, the other is calling for belonging. But you can only do one with the other. Transgression, that moment of transgression, is needed by those who argue for citizenship, for belonging, so you can say, 'look, if you don't let us in, there are all these weirdos out there, including us, who will go on being disruptive. And the weirdos out there who are also us can also say we're different, but we also want this difference to be recognized and this difference can only be recognized in the transformation of citizenship.'

sg: So that seems really to raise two more issues or two more degrees of the same issue with respect to identity (or identities). One has to do with the question of rights, and the way in which one takes on a collective identity so that the politics of the situation can change based on the position that even though we're different 'we're all the same', too. Our 'rights' turn on the fight to make things more human, and in any event, certainly less oppressive and cruel, at a politico-legal level. But it seems also to take as a given the notion of an always-already given 'community' that in some way is counterposed to another sense of community, one that in its political struggle tries to break with the *status quo* (albeit still an 'alternative' notion of) community. In a sense, then, there is a given agenda, the 'what needs to be done given the crummy situation' and, at exactly the same time, it allows one to talk about growth in a way that doesn't then have a certain agenda at all; i.e.,

3 *Invented Moralities: Sexual Values in an Age of Uncertainty* (Columbia University Press, New York, 1995).

doesn't have a 'fixed' notion of what it is to be human, or gay for that matter. So it seems to me you have the question of rights on the one hand and, with it, individual rights; while on the other hand you have a kind of 'right' to be whatever it is that one is (or wants) to be, and whether or not that 'want' may form a critical mass, that 'right to be' is in some ways pitted against a given set of norms and values we call 'community'. But is this not an old trap, analytically, politically or otherwise, the trap, that is to say, of 'either-or' distinctions?

jw: Let me take something autobiographical which may help this. When I look back on my work, I begin to realize what it's all about and see a consistency in the themes without having started out with a desire to elaborate those themes. I could look further back and see how, really, my political work and the critical work associated with it is deeply rooted in my background. I come from a mining village in South Wales where there was a strong sense of community, neighbourhood, identity related to geographical place, place in your own family, place in work, where there was a tight nexus between position in the labour market, position in the neighbourhood and gender and sexual identity. I found this a trap. I had to escape it. I escaped it by being clever in school, by going to university, the first of my family to go to university – all that. And then I realize, looking back on my writing and my research, that I haven't really escaped the trap at all. There are two dominating themes in my writing: about identity and about community. And I can see now that it's almost like an attempt to resolve the conflict, the tension, which I have lived through since my childhood. I think the two themes that come through are the fragility of both identity and community, and the resilience and necessity of identity and community. Emotionally, politically, intellectually, what preoccupies me is this incredibly difficult, incredibly fragile, tentative but absolutely essential attempt to link personal and social identity with social community.

sg: In what way does this tension, this journey around new forms of social identities or communities, create new forms of moralities (or perhaps ethics) that we might term: friendship? Or, to put this question slightly differently, do you think that this thing called friendship is a kind of networking, a kind of respectful webbing – not even quite a discourse – that is part and parcel of the journey of inventing/re-inventing a different kind of community?

jw: Well, it depends what you mean by friendship. I think what's interesting is the way in which the gay community is like the model of, the paradigm for, the postmodern community, in that it's based both on intimacy and distance. Intimacy in the sense that one's link to the community is often through sex, through the sort of vast, dense network of sexual relationships and sexual friendships that many gay men of my generation have been through. A large number of my friends I have had sex with – perhaps only once. Perhaps they were ex-lovers, perhaps they were lovers of lovers. Or they were friends of lovers of lovers. But there is

a sexual genealogy that's there. And in a sense the HIV/Aids crisis reveals that, which is one reason why it has been such a lightning conductor for moral anxiety. So intimacy is very important to the development of our sense of community. But, there is also the distance, in the sense that I have friendships and identifications with people I rarely or never see. I'm like my parents in many ways, but I'm also like the early generation of gay men in Australia, New Zealand, Canada, various part of the USA, various parts of Europe, whom I may have had a sexual relationship with or I may never have met. But we share a sexual knowledge, an ease of talking about sexuality, a lot of common assumptions. There's also this invisible college of links that you establish through writing, through sending books, articles, going to conferences. It's a dense network, where you may have slept with various people or you may have known people who've slept with them or you may not. That doesn't matter because you feel the diasporic consciousness that is related to our self-knowledge about sex and about our sexual exclusion, our sexual experimentation, our sexual development, our sexual needs and a sense of a sexual community that emerges around them.

sg: Yes, I would call that friendship.

jw: That's what I meant at the beginning. It depends what you mean by friendship. You can call that friendship. I call it a sexual community.

sg: OK, let's say that 'sexual community' is in fact another name for 'friendship'. Networking and sexual genealogies make up this 'bigger picture'. But where, in this picture, does anger fit in? The devastating impact of Aids on the community itself certainly has produced whole new forms of organization and political will. It has also – and rightly so – produced a whole network of anger. I am so angry about HIV-related disasters that I don't often know what to do with it. Yes, in some real way that anger is 'politicized', but the devastation has been so immense, that part of the difficulty is that 'friendships' within the community of queer people are often torn asunder. The 'boys' network, which included boys, girls, and transsexuals, has also broken down in a certain way – I mean so many, many are dead. It's a fact. Those boy radicals who were on the front lines (of friendship, sexual playtimes and so on) are simply not around. So how does one 'pick up the gauntlet' these days: in part, through anger, no? Is that not what makes up the kind of 'second generation' to our community: friendship-as-anger . . . ?

jw: You talk about an amazing feeling of anger. That is an obvious reaction to the Aids crisis, and of course I share it. But I don't think that work has to be angry to be effective. I think my work has become increasingly concerned, not with anger, but actually with the meanings of love. That encompasses a wide number of things, love for an individual, an individual who may have died, and love in a broader sense, closer to your sense of friendship, perhaps, so there's a variety of forms of love. But what increasingly preoccupies me is, given the recognition of the inevitability of death which the Aids crisis has brought into my generation,

I've always been committed to the intellectual idea that identity exists through a recognition of others. Identities are always relational, and therefore constantly shaped and re-shaped by one's relationship with others. But I think the thread I have just tried to pull out in recent things I've been writing is more about the relationship between self and others in terms of ethics, values, morality, whatever we call it. Because I do actually profoundly believe that meaning is given to individual lives by a sense of the importance of others, and however selfish I might be in my personal life, or with the others I'm involved with, there is only ever any meaning in the relationships between us through a recognition of each other and a sense of responsibility for each other. And therefore I've become very preoccupied with what in the book I suggest are four key aspects of love: care, responsibility, respect and knowledge. Care for self, care for others, responsibility for self, responsibility for others, respect for one's self, respect for others, knowledge of one's self, knowledge of others. And it's how you balance those four elements that determines whether a relationship is good or not so good. And that goodness and not-so-goodness has nothing to do with heterosexual or homosexual, 'perverse' or 'normal'. It's got to do with the quality of those four elements, those four virtues. I think that's what makes a relationship good or bad.

sg: I'm wondering if, as an historian, whose theoretical premises move along the lines of the discursive, you accept certain forms of, say, humanism – something the postmodernists (of varying descriptions) would reject along with, for that matter, the very concept of history.

jw: I'm temperamentally opposed to millenarianism, or eschatological politics of any sort. I think the idea of the end of history is bizarre. I can see the context in which it emerged, the end of the grand narratives and of ideology is there in the culture, and I can see why people home in on this sort of nice metaphor in trying to describe a post-1989 world. But I still think it's wrong because what all the changes of the last ten or twenty years have done is to restore the human in politics. Anthony Giddens talks about the growth of 'life politics' and I think there is a way in which the whole range of issues around sexualities, gender, race, environmental events does constitute a new way of putting the human back at the centre of politics. Whatever one thinks of the zaniness of some of those new enthusiasms – environmentalists (or homosexual politicians, come to that) – it's actually putting issues which were hitherto regarded as private into the centre of public debate, or it ought to do that. We actually know at the same time, of course, that conservative forces over the last ten years have simultaneously pushed what used to be public issues back into the private domain. There is a curious sort of tension there, and gay activists literally have pushed what used to be private into the public domain at the same time as conservatives were pushing the public into the private domain. But there are underlying cultural tendencies which show the importance of what used to be regarded as marginal issues. Issues around sexuality are at the centre of

political discourse today. You could say the government in Britain is so concerned with divorce legislation, in a way no previous government has been, because it poses fundamental questions about sexual moralities. Even some of the stuff about Europe is about the intervention of the European Courts of Justice interfering in British affairs in relationships to pornography or drugs, as well as sexual relations. So the whole question of social morality, sexual morality and so on, is actually becoming central to wider political discourse.

sg: What would you say is the relationship between sex and ethics?

jw: I'm not a philosopher by training and therefore I can't go into the debate over ethics. But I do actually think that there's a way of being which is based around the protection of life, and I'm a respecter of that. In my book I quote Agnes Heller, who says what we should strive for is not the aesthetic life but the meaningful life, and I actually think that's important. It doesn't imply there's a final meaning out there to be sought for, discovered, but it does mean that in relationship to self and others, me and lovers, it's possible to work at creating the meaningful life. It's not so much a matter of rejecting the aesthetic life as an end in itself but of recognizing that through the search for a life of individual pleasure, one cannot create a meaningful life, which involves the recognition of the importance of others to my being, my self.

sg: This recognition of others seems also to cut across the divide of an 'us' versus a 'them'.

jw: Yes, but there's otherness and otherness, isn't there? I doubt that my gayness and my responses to gayness were set up simply in opposition to some imagined heterosexual norm. I perceive difference stemming from my self, my own needs, but the point is my own needs can only be articulated in relationship to others, significant others. My sense of myself as a gay person was affirmed not through opposition to heterosexuality but through positive evaluation, positive recognition, in others who were not myself. Like, first of all in the novels of James Baldwin, for instance, whom I read avidly as a late adolescent, or Christopher Isherwood or E. M. Forster on the intellectual level, but also through my experiences of pleasure and joy and dismay and fear in my friendship with the first person I really recognized I loved when I was a student, who didn't reciprocate it. It was a recognition of absolute, deep, intense desire, love, not sexual, because I'd not had sex, I didn't know what one did, but I just knew I desired, I wanted this other, and I wanted to be this other. He in fact turned out to be a completely boring person, well boring's too unfair, perhaps. I think he recognized my desire but spurned it and he backed away and his backing away underlined my difference.

sg: What kind of link is there, if indeed there is one, then, between sex and identity?

jw: The person who fucked with me and whom I fucked the first time I didn't know from Adam. I was nineteen, twenty. Then the first person I liked and had sex with, well, let's go back: the first person I liked I didn't have sex with. So, I realized it's possible to have a feeling more than simple lust, and the first time I combined lust and joy and love was with Angus, and I was already twenty-four, twenty-five. So, there were different phases in the relationship between sex, love, pleasure, identity. It's like a narrative, and you see the erotic areas that pop up better, you see the shapes differently depending on how you shape the story, or how you are shaped by the story.

sg: Let us shift to another sense of identity. In the last few years, the whole field of computer/virtual realities/cyborg identities have come to the fore. Some suggest that we are in a post-human or trans-human age: where genital bodies are altered, genetically or surgically, to produce new kinds of beings, new kinds of identities. As a scholar whose lifework has been dedicated to the understanding of identity and identity formation, what do you make of these 'new forms' of identities? And what do you think about those 'virtual beings' whose orifices seem to be singularly absent?

jw: First of all, identity shifts all the time so it's not surprising that new modes of communication can provide the space for new identity. So that's not too difficult to understand. The second thing is that the idea of virtual identities, of new forms of relationships through the Net, seems to me simply an exaggeration, and hyper-realization, of what was already there. I talked earlier about the diasporic consciousness of lesbians and gays which transcends national boundaries, if you like. Well, the Net is simply one way of keeping in touch with those members of the diaspora. The main challenge is to see if we can do it through the Net, but I personally don't think there's anything fundamentally new in that. The important thing that has to be said is that you can't really go to bed with a computer. It's important to realize that. There is something important about the messiness, the chaos, the come, the blood, the shit, the piss, the sweat, of actual physical contact, and I don't think there's any alternative to that sort of messiness and the joy of that messiness.

sg: I agree with you – the messiness of life – excrement, disease, depression, whatever – and yet isn't there a kind of loud secret, the kind everyone knows about, which whispers: wouldn't it be nice to live without the 'bad things' . . . ?

jw: I don't think it's ever going to be possible to be free of those 'bad things'. And the sort of enthusiasm for the body without genitals, or whatever, is simply another phase of what has dominated my generation, in fact other generations: the attempt to find the 'key' to transcendence. In the 1960s it was acid and rock or dope, in the 1970s the political rebellion, in the 1980s it was the pursuit of money, in the 1990s it's virtual reality and so on. It's always a search for a way of escaping the ordinariness of our daily life, and there are always different agents. In the

1960s it was the campus rebellion, black militants, in the 1970s it was the working class, in the eighties it was the yuppies, in the nineties we're not quite sure who the agents are, but it's perhaps the computer geeks or whatever. But, the truth is there is no magic solution, there is no breakthrough, there is no agent who's got the secret to transcendence. It's just us with our ordinariness, our inventiveness, our jealousies, our pains, our pleasures, muddling along; sometimes we make great breakthroughs like we did in 1989, as we may do the next century. And at other times we struggle with the consequences of our breakthroughs. But I'm a humanist at heart, I call myself a radical humanist, and I do actually believe it's in our hands. It's in no one else's hands and it's certainly not in Bill Gates's hands.

sg: So, would you say, then, that theories sported by, for example, the Frankfurt School – which argued, in part, that fascism was and remains the logical product of a technological/capitalism, are not accurate?

jw: I really think the Frankfurt School partook of a cultural pessimism. I'm not pessimistic actually about the world today.

sg: Even though there's been a Holocaust? You're not pessimistic?

jw: It's been a ghastly century. It's probably been the worst century in human history in terms of organized murder and cruelty and I'm not pretending that that's over. It's occurring as we speak in parts of Africa and in other parts of the world. Of course, one can't deny all that, that horror, and it's been a horrific century. But what amazes me and moves me, in thinking about all that, is the enormous resilience of people, and the way in which we find pleasures in tiny things, amongst all the horrors. What amazes me about the Aids crisis is both the tragedy and pain of the deaths but also the amazing resilience of the survivors, and of the people who have worked with survivors. I think that's a triumph of the human spirit. So, in disaster you can still find amounts of hope, and that's what keeps us all going in the end. Otherwise, if we just took the bleakness, we'd end it. What's the point of going on? I actually do think that there are moments of hope even in the most awful circumstances, and I think people search for those moments of hope even in despair. That's what keeps them – us – going.

sg: This kind of 'carrying on', this kind of journey, mixed as it is with the sense of, say, a gay diaspora and aloneness – does this form any kind of 'home'? or citizenship?

jw: Very good question, because I think my use of the term 'home' varies enormously. When I'm speaking to my mother and planning to visit my birthplace where she still lives – she lives in Wales – I say 'I'm coming home next Sunday or Monday' – whenever it is. When I'm at work and I'm about to leave I may shout to my secretary, 'I'm going home now' and my home is actually a different place. It's not South Wales, it's up in north London. When I go see my partner, Mark, when I go visiting to his flat, I feel a different sense of home then. It's not the home in Wales or in

north London, it's the home where I feel at home at that moment. I feel relaxed and I hope he feels the same when he comes to my place. So, there are different meanings of home. It's not a fixed place for me, it's a place where I have a sense of belonging. I don't feel at home when I visit friend X or colleague Y, necessarily. I may do, but I normally don't. It is related to a mixture of familiarity, familiar smells, familiar objects on the wall, familiar people, whether it's my mother or my homemates or Mark. It's to do with memories.

sg: So, is that what citizenship is then?

jw: Another very good question. You know Kenneth Plummer in his latest book *Telling Sexual Stories*[4] talks about the emergence of a new notion of citizenship. Historically, there's been political citizenship, economic citizenship, social citizenship. He argues that there is now emerging a new concept of citizenship, what he calls intimate citizenship, which is about the ways in which our stipulation of our private needs and our private lives enters into public discourse and is recognized. I feel that it's going to be very difficult for our political culture to recognize intimate citizenship in some ways. What we're talking about is the development of a quality which allows people to feel that they can fully participate without being excluded on grounds of race, gender, sexuality, etc. But that quality is not the whole of their lives. I don't think politics should be about every detail of one's life. When we jump into the public domain in order to insist on the right of privacy, that's the paradox of sexual politics. We come out in order to stay in if we want to. So the crucial thing is to develop a politics which recognizes the limits of politics. I think, in the end, politics should be about the creation and sustenance of an arena where differences could be worked out without the state, the community at large having to intervene in all aspects of life. I'm not actually for social-cultural *laissez-faire* but for providing forums where differences could be worked out without necessarily getting to a level of the state. Chantal Mouffe[5] once talked about the political community as being a community of communities and I like that idea – that the function of community through the state is to allow other communities to flourish in their overlapping and difference.

sg: Well, rather than speak of communities, perhaps we should really be speaking of cities. It is the city, with its anonymity and urbanness that seems more to the point . . .

jw: Simon LeVay has edited a book called *The City of Friends*. I have not actually read it, but as he's a great advocate of the Gay Brain, I start off suspicious. But it's about gay culture and the point about it is it's so evocative: Cities of the Plain, postmodern cities, cities which grow and grow, cities which emerge and disappear. It suggests almost islands in a sea of nothing. I like the idea of a city. It also evokes the American city on the hill, doesn't it?

sg: Yes. But also, doesn't the notion of the city also carry with it the sense of glamour and draw of the neon lights, the ability to be alone and

4 Kenneth Plummer, *Telling Sexual Stories* (Routledge, London and New York, 1995).

5 See for example her 'Democratic Citizenship and the Political Community', in C. Mouffe (ed.), *Dimensions and Radical Democracy: Pluralism, Citizenship, Community* (Verso, London, 1992), 225–39.

yet with strangers, holding out a kind of 'secret', a kind of 'everyday a new type of day' promise? My identity, in part anyway as a gay person, requires the city. I could *never* live in the suburbs . . .

jw: I agree. It's the same for me. I had to leave. I love my mother. I love my brothers and their offspring. I feel intensely loyal to where I came from. But I knew, I know, I couldn't have survived in that circle. I had to come to live in, and to love, the anonymity and intimacy of the city, to become what I wanted to become . . .

I don't spend my holidays on the beach. I tend to spend them in cities. After Angus died I was absolutely devastated and exhausted and I wanted a complete break. I didn't go to a desert island. I went to New York and San Francisco.

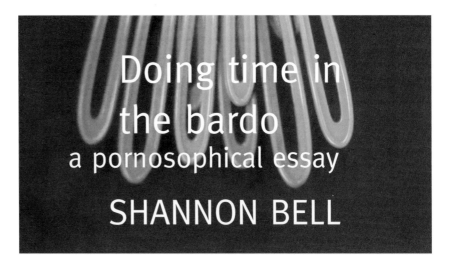

Doing time in
the bardo
a pornosophical essay

SHANNON BELL

For Gad, my master
For Shmuel, my godfather
For Lloyd, my uncle
Possession: a woman needs to learn to possess [herself].

[B]ar means in between, and do means island or mark; a sort
of landmark which stands between two things . . . The
concept of bardo is based on the period between sanity and
insanity, or the period between confusion and the confusion
just about to be transformed into wisdom; and of course it
could be said of the experience which stands between death
and birth. (Trungpa, 1992, 26)

'You are a highly educated person, there is a question I want to ask you.
Do you believe in God?' The question took me back in years and space to
E, the beautiful red-headed, green-eyed Jewish philosopher. E, in her
Dietrich voice: 'Shan, do you believe in God?' That time, holding the
phone in my hand and trembling, from the asking, all I could give was
'Yes'; a yes that comes from that space just below the solar plexus at the
centre of being. This time, time, time, the moment shifted to before, to
the big-daddy Israeli bank robber: 'I don't believe in God, so I am free.'
Okay, so I am only willing to engage in discussion about g-d with the
toughest. I knew he did believe; he knew I knew. Words. I had seen his
soul too many times between those hours of four and six a.m. when time
stops and space expands to eternity.
 God, I love the smell of butch men, a smell that comes through the
voice. My interior butch male answered my dying uncle's question. 'Yeah,
I guess so, I mean there is something, energy, something.' Then I turned
the question: the answer was in the asking. He began: 'I know there is a
soul, one time, oh twenty years ago, I was lying in the other bedroom
beside M., waking in the early morning . . .'

Ravages of working-class time: body reformed to match occupation, rounded shoulders, missing teeth; ravages of sickness: inability to lift legs, permanent oxygen lifeline tied to tank, lungs filling up with fluid, cancer eating groin; the ravages of loss: life, ego. Eyes searching the prairie horizon for, for eternity. I sat on the side of your bed, breath matching your breath, looking over the flat summer prairie fields to the distance, looking through your eyes, seeing what you were seeing. The view shifted, our vision shifted, we saw for ever: blue, green, gold, red the colours of earth, water, fire, air and space, the elemental; the colours of eternity. 'Wow, the view is amazing here'; words came from deep inside me, arriving in that low, raspy, throat catching voice. 'Yes, but I stayed too long.'

He lived and died in true butch fashion, old butch, butch of the 1930s, 1940s and 1950s; butch ended in the fifties. I grew up on Saturday night John Wayne movies at the Souris theatre, all through the early sixties. The rest of the world was revolutionizing gender roles, relationships, and how to spend time. I was breathing in maleness. Always admired the Duke's inability to talk to the ladies. Words. Later, found out I was in good company: Dietrich fucked him. 'I'll have one of those for Christmas', she is reported to have said the first time she saw Wayne. Possession: a woman needs to learn to possess.

I found John Wayne again in the 1980s in gay bars, he had come back as a gay icon. 'Odd, that guy who looks more like the older John Wayne, Rooster Cogburn in *True Grit*, than anyone I've ever seen, is here in a dyke bar in Province Town: what's *he* doing here?' My Genet-like consort with the sardonic sneer that I've come to love, respect, and fear just a little bit, commanded 'look again.' 'Oh my God, he is a woman, oh my god she is the most beautiful creature I've ever seen, she's with the blond bombshell, both in their late fifties.' I stared at them. The bombshell ignored me. He gave me that crooked half smile/sneer Wayne was known for. I burst into tears. I could be John Wayne; I could have a goddess on my arm. You can be your idol; it's postmodernity. Be your own icon.

The smell of oil rigs, hand rolled rough cut *Daily Mail* tobacco, powder from shotgun shells, prairie dirt, death, the prey of the hunt; yes my uncle was a hunter; he and his wife skinned, carved, packaged and ate what he caught. The thought of being in the basement, skinning a deer with him turned me on; I was getting hard in the presence of this man; my voice was going, going deep, raspy and guttural.

'I looked down, we were lying there as peaceful as can be,' he continued, 'I travelled out of my body, just floated away for a while, I could see everything for miles, and then I thought oh better come back, but I could have kept on going.' 'Don't remember it happening again. But it happened.' The hours of eternity, inner space and aeonic time. Time stops between four and six in the morning.

'If it is four o'clock in the morning in Casablanca, what time is it in New York City?' Rick enquired. I used to ask myself this as a mantra as I drifted in those moments between awakeness and sleep: 'if it is four o'clock in the morning in New York City what time is it in Tel Aviv?' The

gangster and Box, the maternal boxer who had a passion for shaking cats to death, a passion discipline could never curb, would appear on the horizon. Watched *Casablanca* fifteen times to hear that line. It was a Zen koan. One day it solved itself. As Janis Joplin said: 'it's the same fucking day'; only on a smaller scale: it's the same fucking moment. One line of Buddhist thought claims that if one can realize the moment, one is free of all past and future.

4.01 a.m., ran hashish out of Jaffa; ancient drug in an ancient land. Flying high in a World War II white army jeep marked with skull and crossbones. The hash brick the size of a building brick:

> The philosopher believes that the value of his philosophy lies
> in the whole, in the building: posterity discovers it in the bricks with
> which he built and which are then often used for better building. . . .
> (Nietzsche, 1977, 33)

Use-value only; the drug was not for exchange. Surplus value gained in 'the karmic activity of increasing wealth': 'wealth in terms of time and space' (Trungpa, 1992, 57). 'One can exchange everything between human beings except existing' (Levinas, 1987, 42).

Sitting, following our breath, I understood what you were telling me. Should I tell you about soaring through the planes of existence as a kid, leaving from the top of my head, seeing my young femme body lying on the bed, flying through my bedroom window and travelling the worlds, ancient worlds of desire, love, wisdom, fighting to get back into my young unrecognizable body? Should I tell you about my apprenticeship at sixteen with the local crones and witches, who taught me to channel my sexual energy into the divine, who explained my youthful astral travels across the geography of time and space as the result of having entered the next life, my present life, too soon? I never could make it past the western continent:

> If you are going to be born in the western continent, Enjoyment of
> Wishfulfilling Cows, you will see a lake adorned with horses and
> mares. Do not go there but come back here. Although it has great
> pleasures it is a place where dharma does not flourish, so do not
> enter it. (*The Tibetan Book of the Dead*, 1992, 211)

No, he didn't need to know this. I answered 'Yeah'. I had come to respect one-word butch answers as saying more than words can convey. 'I know it', I added. 'I know it': those words, with that particular tone, they came from the past, from deep inside and from some other time.

Time is different if you are in prison, dying, meditating. Time that great device to break-up space. 'What's it mean to spend time?' the gangster used to question me. Somewhere along in Buddhism I found the answer: to be here now, always present, eternally present in the moment.

I return to the view through the window. 'God, there is a lot of space, you can see for ever.' Our eyes lock. I wondered where he'd been in this moment, his wife dying earlier that morning. He was waiting, waiting to

die. We were waiting, waiting for him to decide it was time, time to leave his home for the last time, time to call the hospital and ask for an ambulance. We were waiting. Exchanging the gift of time.

The gangster, the philosopher and I, fondly and cruelly named the 'little girl' by the two, lived together for a time. The philosopher had given me as a gift to the gangster, and she had given the gangster to me as a gift; they mediated their desire for one another through me. I desired them both. They broke my heart, both of them, individually and sequentially. The philosopher was also a whore; the gangster also a mother who upon coming out of prison opened a restaurant to feed hungry ghosts. The philosopher fucked the hungry ghosts, the gangster fed them. I fucked the gangster and ate.

Bisexual, that's the term. I fuck souls and icons, iconoclastic icons; it's what exceeds the icon that turns me on.

> [I]n none of these discourses we are analyzing . . . does the moment of death give room for one to take into account sexual difference; as if, as it would be tempting to imagine, sexual difference does not count in the face of death. Sexual difference would be a being-*up-until*-death. (Derrida, 1995, 45)

Favourite philosopher: Hannah Arendt; not for her words but for her life, her aesthetics of existing, never repudiating Heidegger, master/apprentice, turning the tables, becoming the philosopher, surrounding herself in old age with a coterie of young men; the book cover picture of her smoking a cigarette, eyes scanning an absent horizon.

Favourite colour: black; relative nothingness, the cross-over somewhere between Buddhism and sadomasochism, between meditation and the rack, between following your breath and the lash of the whip, is the elemental. 'Twenty bucks says they will all be wearing black, head-to-toe black'; 'No way, they will be wearing new-age colours'; 'Hey, I am not spending a weekend dying with people in new-age colours.' G and I were disembarking at the Boston airport en route to a weekend meditation on dying with the Clear Light Society of Massachussetts which has helped people die since 1977. I was there to die; but not with new-agers. 'You owe me $20'; the woman picking us up was in head-to-toe black. 'I'm a clear light junkie', I explained as we drove to the seashore workshop location. 'It is Light exhaling into Light.' 'Dissolving into the Great Light.' 'Merging with the Great Light.' 'Reunion with the Great Light' (Clear Light Society, 1992, 2).

We three, the philosopher, gangster, and little girl, lived in the second stage of the bardo as hungry ghosts, never able to fill the other; endlessly other; trying to get into the skin of the other. I screamed for both of them, all of us; screamed, screamed, screaming, slipping back from ego to self, remembering R. D. Laing's 'Ten Day Voyage' into a nervous breakdown. Fighting ten hours, or was it a lifetime, or a moment, to go and return; the demons whirling at me, the voices, noise – 'the noise of life' (Lingis, 1994, 92), the noise of my particularity. Darkness. Ego dead. Silence except for the beating of heart. Counted,

hung on. The solidity and fire of a small hand not letting me go, the hand of the philosopher's seven-year-old daughter, Sophia: wisdom. Fought, counting, fought, counting, pulling self back through the dark cone-shaped whirlwind with the light at the small end, 'from immortality back to mortality, from eternity back to time, from self back to a new ego' (Laing, 1967, 106). The bardo is one place I have been. Was it then that the philosopher and gangster became part of my soul, acknowledged as emanations of my soul; slave freeing herself, slave to what, to whom, to passion, to self? Self coming out of the bardo, becoming, being.

Skin: 'the surface of another' (Lingis, 1994, 63) the boundary where one enters another, what holds one in. Desire: feeling someone burn through your flesh to your bones, wanting them deeper. Smell of burning flesh, the brand, as his mistress/master's mark seared his skin; beneath the surface of the high femme dom is a pirate, renewing his mark on the bones of his slave.

Stages of Dissolution of a Corpse (A Buddhist Meditation)

1 swollen blue and festering
2 eaten by birds, dogs, jackals, worms
3 reduced to a skeleton with some flesh and blood held in by tendons
4 reduced to a blood-smeared skeleton without flesh but held together by tendons
5 reduced to a skeleton not smeared with blood
6 reduced to bones gone loose, scattered in all directions
7 reduced to bones white in colour like a conch
8 reduced to bones more than a year old, heaped together
9 reduced to bones gone rotten and become dust

Ten seconds per stage. A moment in time. Time: 'the very relationship of the subject with the Other' (Levinas, 1987, 39). Will the mark endure to be once again renewed on flesh? New surface; ancient relations. 'Remembering a corpse, I think: I myself will soon be just like that' (from a Buddhist meditation on death).

'The hand extended to the other makes contact with the vulnerability, the weariness, and the suffering of the other and extends into the place of the other's dying' (Lingis, 1994, 175). Saw his bones, hand went to shoulder, reached through skin, the heat of the elemental collecting in finger tips, searing cancer rotting flesh. Fell in love with you, with the gangster, philosopher, little girl of my soul, with the elemental.

The most exciting part of the Book of Job is his submission. Job submits to God: 'Wherefore I abhor *myself*, and repent in dust and ashes' (Job, 42:6, King James version). Judaism had made much out of the all-powerful, punishing god. Job questions the Lord. And

the Lord answered Job out of the whirlwind. (Job, 38:1)

Gird up now thy loins like a man: for I will demand of thee, and answer thou me. (Job, 38:3)

Where wast thou when I laid the foundations of the earth? declare, if thou hast understanding. (Job, 38:4)

Who hath put wisdom in the inward parts? or hath given understanding to the heart? (Job, 38:36)

Hast thou an arm like God? or canst thou thunder with a voice like him? (Job, 40:9)

The key is understanding: Job is a part of it all, a part of the elemental, the voice of God is a part of the elemental, Job submits to himself. You can be your own master.

'To live is to echo the vibrancy of things' (Lingis, 1994, 96).

'It is a hell of a thing to come home to.' Home: an odd word. I hadn't been at my uncle's for twenty years; it was purely by accident that I was in the same province, visiting my mother. Home fit. That place of the soul, just below the rib-cage and above the stomach, came alive. 'I want to be here.'

'I went down to Piraeus' (Plato, 1968, 327a). Read that line again and again, through sips of Johhny Walker Black Label, endless Camel cigarettes, the smell of the desert, the scent of your skin. Waiting for you. 'Missing me one place, search another, I stop somewhere waiting for you' (Whitman, 1981, 75). Found me, waiting for you. The rest of the text, the foundational Text of Western philosophy never held up. Knew that outside the city of perfection, the city where we are all in our places, hoping to become a philospher, being a worker, all frozen in our places, outside that city, was a place for me. Plato always betrayed himself; his unconscious twisting through Western philosophy; Socrates' soul endures. Went down to Piraeus, outside the city of speech to the city of power, whores, exchange, 'disorder', 'outlandish ways of life' (Bloom, 1968, 440, n. 3), democracy. Book One of the *Republic* a 'false start', the pagan moment, gateway into imperfection, living. The philosopher was a whore. The butch Straussian philosopher came down to me after the talk: 'I love the smell of your leather.' 'I like the way you do theory; the way not the end; the way come short of the end,' I said. No *telos*, no climax, just the doing.

The little girl became a gangster philosopher: stealing words, recombining thoughts, possessing her lineage all the way back to Socrates. One of Plato's greatest fears, as disclosed through Socrates in the *Phaedrus*, was that writing, unlike the spoken word, 'cannot distinguish between suitable and unsuitable readers' (Plato, 1973, 275e). Cultivating this ability to distinguish between suitable readers or listeners was the task of one who knows: the philosopher. For Socrates, Plato, and

the Straussians the most suitable listeners were aristocratic young males whose souls were to be cultivated for excellence, elitism. Hidden here and there in Plato's texts, however, is the Nietzschean 'Moment'; the gateway to other readings.

> They are in opposition to one another . . . and it is here at this gateway that they come together. The name of the gateway is written above it: "Moment". (Nietzsche, 1977, 251)

At the gateway, in the moment, we see that 'everything straight lies . . . All truth is crooked, time itself is a circle' (Nietzsche, 1977, p. 251). The moment contains its opposites, both/and, and all possibility, it is the moment of ambiguity where the text opens to time. Readers read from position in the world: the reader need no longer strive or pretend to limit herself to interpreting the author's intended meaning; she knows she is actively producing time, rearranging originary space. You can 'be your own master' (Plato, 1956, 358c), you can be your own slave. You can be.

'It's time.' Decision. Time and space coincided in action. The volunteer ambulance driver and attendant were a mother-and-daughter butch dyke team; 'want to ride in with your uncle?' 'Yeah.' I could taste the dirt from the country road seeping in through the windows. 1969, fourteen years old, watching John Wayne as the tough old deputy marshal Rooster Cogburn haul the tough young fourteen-year-old Mattie (Kim Darby) out of the snakepit: 'Can you hold on to my neck?' (Portis, 1968, 180). 'There were two dark red holes in his face with dried rivulets of blood under them where shotgun pellets had struck him' (Portis, 1968, 180). As Mattie wrapped her arm around his neck and lay against his back, I felt a hardness and surrendering in my young pussy. Wayne tied Mattie's waist to his saddle, even slashed his pony's withers to make him go faster, racing against the poison spreading through her young boyish body. When the pony fell to the ground and died, Rooster ordered Mattie to climb on his back; she held tight with her good arm, the one without the snake-bite, around his neck. Supporting Mattie's legs with his arms, Wayne ran with her until he could at gunpoint commandeer a wagon and team from a hunting party. The scene that filled my young pussy-space was Wayne, sixty-two, playing a man at least ten years younger, breath heaving as he carried Mattie in his arms; sweat running from his unshaven face, down his excessively square jaw on to Mattie's neck.

Did you know that you were turning me on, could you see me contracting pink flesh, as I held your yellow fingers on the skin of my knee? '[G]azing toward the erotic darkness' (Lingis, 1994, 116). Finger tips against finger tips, energy shot out of you, circled my clit and raced, coming out the top of my head. Held my soul in your gaze. 1969, fourteen years old, Mattie fucked the Duke. Slid over him, hands pressed hard on his eyes, the good one and the one with the black patch. 'Take me.' The Duke submitted and took. When Wayne made *True Grit*, he was beginning the cancerous death process, skin yellowing, cough persistently punctuating words.

Returned to the hospital the next day. 'Won't be long now, almost died last night,' he told me. The smell of masculinity in the clear light energy elicited the taste of him, a remnant of the night before when skin, space, time suspended and held, the fire in our fingers going home, finding each other in our own sexual centre. 'I know there is a soul, I came out the top of my head, looked down and saw us lying there.' Fingers found fingers again, it was becoming a compulsion wanting this man, my uncle. Incest, sort of; proto-necrophilia, not yet, but soon, maybe. Energy circled my clit twice, shot to my toes, came up to my sexual centre and held, as I held you in 'the liquidity of the elemental' . . . (Lingis, 1994, 131). 'Next thing you are going to want to start necking with me.' I blushed, he smiled a crooked Duke-like smile. The blush sent the energy up from my sexual centre through the heart chakra and out the top of my head. His hand caressed my knee as I contracted four times. 'You might find a use for this,' my uncle said as he took his worn silver jackknife from his key chain, fondling the silver case between his left thumb, index and third fingers, the same fingers I rode through eternity the night before, stroking the case as he had done for years by the look of the worn silver. Fondling it with intention 'that ought to about do it, here.' 'I never expected to like you so much,' I confided in that deep, halting voice as I touched and took the knife. 'Well, thank you, kindly', was his response. We had exchanged gifts of life and death. Words and totem object.

Just past high noon the next day, I was absently clutching the knife in the palm of my hand; the woman across the aisle starting choking, fighting for breath. 'If there is a doctor on the plane, please identify yourself.' A moment before the husband-and-wife doctor team came forward, the choking woman's and my eyes met. They were my uncle's eyes or the eyes of god, 'glisten[ing] . . . with the liquidity of the elemental' (Lingis, 1994, 131). Uncle's recorded time of death: three minutes past noon; cause: pneumonia, choked to death.

Enjoyed a fortnight of nocturnal post-death visits from the bardo of becoming.

> Life is enjoyment . . . Every enjoyment is a death: a dying we know,
> not as the Heideggerian anxiety knows it – being hurled from being
> into nothingness – not as pain knows it – a being mired in oneself and
> backed up into oneself by the passage into passivity – but as
> dissolution into the beginningless, endless, and fathomless plenum of
> the elemental. (Lingis, 1994, 126–7)

Each visitation culminated in the ecstasy of saint/sinner, with the blade of the silver jackknife on my clit as I rode the clear golden light through the bardo of becoming. After two weeks, the jackknife disappeared; vanished. God came out of the whirlwind.

I only fuck icons; fucked the biggest icon of them all: God. 'God is a [philosopher] whore exactly like other whores' (Bataille, 1986, 269). God is a gangster. 'I went down to Piraeus'; bought my own jackknife.

Bibliography

Bataille, Georges (1986) *Eroticism*, trans. Mary Dalwood (City Light Books, San Francisco).

Bloom, Allan (1968) 'Notes and Interpretive Essay', *The Republic of Plato*, trans. Allan Bloom (Basic Books, New York).

Clear Light Society (1992) 'The Clear Light Meditation for the Dying', *Peaceful Heart, Clear Mind* (Clearlight Society, Brookline, Mass.).

Derrida, Jacques (1995) *The Gift of Death*, trans. David Wills (The University of Chicago Press, Chicago).

Fremantle, Francesca and Chogyam Trungpa, trans. (1992) *The Tibetan Book of the Dead, The Great Liberation through Hearing in the Bardo* (Shambhala, Boston).

The Holy Bible, 'The Book of Job' King James version (Toronto: Canadian Bible Society).

Grimm, George (1978) *Buddhist Wisdom: The Mystery of the Self*, trans. Carroll Aikins, ed. M.Keller-Grimm (Motilal Banarsidass, Delhi).

Laing, R. D. (1967) *The Politics of Experience* and *The Bird of Paradise* (Penguin, Harmondsworth).

Levinas, Emmanuel (1987) *Time and the Other*, trans. Richard Cohen (Duquesne University Press, Pittsburgh).

Lingis, Alphonso (1994) *The Community of Those who have Nothing in Common* (Indiana University Press, Bloomington).

Lodo, Lama (1982) *Bardo Teachings, The Way of Death and Rebirth* (Snow Lion Publications, Ithaca, NY).

Nietzsche, Friedrich (1977) *Assorted Opinions and Maxims* and *Thus Spoke Zarathustra*, part III, in *A Nietzsche Reader*, trans. R. J. Hollingdale (Penguin, London).

Plato (1956) *Protagoras*, trans. W. K. C. Guthrie (Penguin, Harmondsworth).

——(1968) *The Republic of Plato*, trans. Allan Bloom (Basic Books, New York).

—— (1973) The *Phaedrus*, trans. Walter Hamilton (Penguin, Harmondsworth).

Portis, Charles (1968) *True Grit* (Signet Books, New York).

The Tibetan Book of the Dead, The Great Liberation through Hearing in the Bardo, (1992) trans. Francesca Fremantle and Chogyam Trungpa (Shambhala, Boston).

Whitman, Walt (1981) 'Song of Myself', *Leaves of Grass and Selected Prose*, ed. Lawrence Buell (Modern Library, New York).

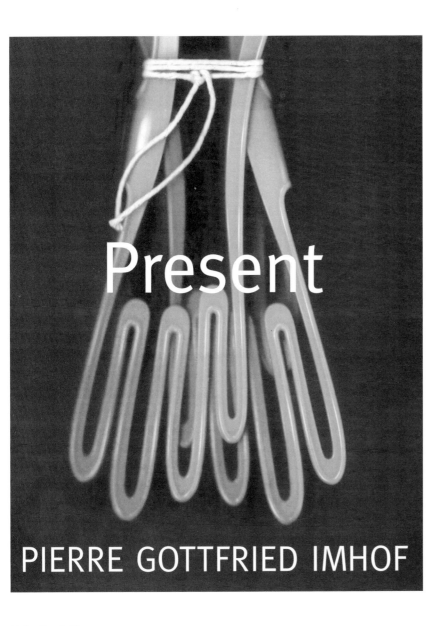

List of paintings

Present: 1958–1996, Acrylic, crayon on canvas and paper, 72" × 64", 1996

Present: 1952–1988, Acrylic, crayon on canvas and paper, 70" × 56", 1996

Present: 1950–1991, Acrylic, crayon on canvas and paper, 60" × 56", 1996

Present: 1949–1996, Acrylic, crayon on canvas and paper, 44" × 44", 1996

Present: 1967–1996, Acrylic, crayon on canvas and paper, 72" × 76", 1996

All dates and all paintings are interchangeable. No one painting is assigned to one particular date.

SUBURBAN MANNER

IN MY HOUSE
THE CURTAINS ARE DRAWN.
THE TV IS ON.
AND MY FRIENDS HAVE GONE.
AND DAD LEFT A NOTE
THAT SAID:

'THE FABULOUS BEAST.
IS CHAINED UP IN THE KITCHEN.
FOR ALL ETERNITY.'

IN MY HOUSE
THE CURTAINS ARE DRAWN.
THE TV IS ON.
AND MY FRIENDS HAVE GONE.
AND DAD LEFT A NOTE
SAYING:

'THE FABULOUS BEAST.
IS CHAINED UP IN THE KITCHEN.
FOR ALL ETERNITY.'

IN THIS HOUSE
THE CURTAINS ARE DRAWN.
THE TV IS ON.
AND MY FRIENDS HAVE GONE.
AND DAD LEFT A NOTE
WHICH SAID:

'THE FABULOUS BEAST.
IS CHAINED UP IN THE KITCHEN.
FOR ALL ETERNITY.'

'THE FABULOUS BEAST.
IS CHAINED UP IN THE KITCHEN.
FOR ALL ETERNITY.'

'THE FABULOUS BEAST.
IS CHAINED UP IN THE KITCHEN.
FOR ALL ETERNITY.'

'I'VE LEFT THE BEAST.
CHAINED UP IN THE KITCHEN.
FOR ALL ETERNITY.'

NOTES ON CONTRIBUTORS

Kathy Acker

Author of ten books including *Blood and Guts in High School*, *Empire of the Senseless*, *Pussy, King of the Pirates*. She wrote the screenplay *Variety* (dir.: Bette Gordon); the libretto for the opera *Birth of a Poet* (dir.: Richard Foreman), and most recently, the libretto *Requiem* commissioned by The American Opera Projects. She has also worked with many rock/punk-rock bands, having just released the record/CD version of *Pussy, King of the Pirates*, with the Mekons for Touch/And/Go records.

AJAMU

Professional fine art photographer since 1990. He has exhibited in galleries around the world, including New York, London, São Paulo and Frankfurt. Over the years, through experimentation and risk-taking, AJAMU's work has set out to extend, transgress, and push the boundaries of contemporary theoretical and practical debates around race, sexuality, representation and fun.

Shannon Bell

Author of *WHORE CARNivAL* (Autonomedia, 1995) and *Reading, Writing and Rewriting the Prostitute Body* (Indiana University Press, 1994 (Italian translation (Edizioni Culturali Internationali Genova) and Japanese (Siekusha) forthcoming). Most recent is her collaborative book *Bad Attitude\s On Trial: Pornography, Feminism and the Butler Decision* (University of Toronto Press, 1997). Member of the Political Science Department at York University (Toronto, Canada), teaching classical political philosophy; feminist; legal and postmodern theory. She also teaches '[Queer] Sex and Intimacy' in the Sociology Department at the University of Toronto.

Andrew Benjamin

Professor of Philosophy and Director at the Centre for Research in Philosophy and Literature at the University of Warwick. His books include *Art, Mimesis and the Avant-Garde*; *The Plural Event*; and *Present Hope*.

Steven Berkoff

Actor, director, playwright and author. His staged and/or published plays include *East, West, Sink*

the *Belgrano!*, *Decadence*, *Kvetch*, *Acapulco* and
Brighton Beach Scum Bags. National and
worldwide adaptions of Kafka's *Metamorphosis*
and *The Trial*; *Agamemnon* (after Aeschylus);
Hamlet, Wilde's *Salome*, and Poe's *The Fall of the
House of Usher*. His books include *I am Hamlet*,
Coriolanus in Deutschland, *A Prisoner in Rio*, and
his autobiography *Free Association*. Film credits
include *A Clockwork Orange*, *Octopussy*, *Beverly
Hills Cop* and *Rambo*. He directed (and co-starred
with Joan Collins in) *Decadence*. He lives in London.

Pascal Brannan

Live Art Projects 96/7; MR MADAM services
including Horticulture and Make-Overs. Part of
the team that brought you *BUM BOY* quarterly:
publication, installation, and sounds. Solo work
Milk, Milk, Lemonade; *Way Down, I AM A BEE*.
Worked with *Station House Opera*. Tours:
Australia, North America, Europe, and Japan.

Carolyn Brown

Teaches critical theory and comparative literature
at the University of Greenwich. She is currently
working in the zones of the uncanny, with
particular emphasis on death and its limits.

Anthony Burke

Conceptual artist and writer. GB, USA and
Germany. Studied UCL and the Courtauld Institute
of Art, London. Favourite colour: turquoise frost.

Chila Kumari Burman

Since completing her MA at the Slade in 1982,
she has exhibited widely within the UK, USA,
Canada, Europe, South Africa, Pakistan. One of a
vanguard of political artists whose work has
influenced cultural policy in Britain for well over
two decades. Her work includes: *The Thin Black
Line*, *Along the Lines of Resistance*, *28 Positions
in 34 Years*, and *Contemporary Feminist Art*.
Selected for the Havana Biennale, Cuba, 1995 and
for the first Johannesburg Biennale, March 1995.
Her monograph, *Beyond Two Cultures* by Lynda
Nead, is published in 1997.

Richard A. Etlin

Professor of Architectural History at the University
of Maryland. His earlier books include *Modernism
in Italian Architecture, 1890–1940*, which won the
Alice Davis Hitchcock Award for 1992 from the
Society of Architectural Historians. His most
recent books include *Symbolic Space: French*

Enlightenment Architecture and Its Legacy, *Frank Lloyd Wright and Le Corbusier: The Romantic Legacy*, and *In Defense of Humanism: Value in the Arts and Letters*.

Christopher Fynsk

Professor of Comparative Literature and Philosophy, and Chair of the Department of Comparative Literature, at Binghamton University (New York). He is author of *Heidegger: Thought and Historicity* (Cornell, 1994) and *Language and Relation* (Stanford, 1996).

Sky Gilbert

Playwright, poet, actor, director, film-maker and drag queen extraordinaire. One of Canada's most controversial artistic forces, he is the co-founder and artistic director of Buddies in Bad Times Theatre. Sky has written and directed his own hit plays, including *Play Murder*, *The Dressing Gown*, *Drag Queens on Trial*, *Ban This Show*, *The Postman Rings Once*, *Capote at Yaddo*, and *Ten Ruminations On An Elegy Attributed to William Shakespeare*. Sky's plays have been produced throughout Canada, the USA and England; his films have been shown in festivals throughout North America and Europe.

Paul Gilroy

Teaches at Goldsmiths College, University of London.

Sue Golding

Political philosopher and director. Born in New York, resident now in London, her bacchanalia spans the mobile arts, digital media, and the monastery of libraries. Continues to write and lecture extensively on the democratic and radical technologies of contemporary political philosophy, ethics and aesthetics, and is Reader at the University of Greenwich in that field.

Paul Hallam

Avoided Brodlove Lane and arrived in Soho. He is currently Writer in Residence at Central St Martin's College of Art and Design. He has written/co-written numerous screenplays, including *Nighthawks*, *A Kind of English*, *Young Soul Rebels*, and *Caught Looking*; and a play (*The Dish*). His book, *The Book of Sodom* (Verso) will be followed by a second, *The Rent Book*. Paul is also writing his Ph.D. dissertation on prostitution at the University of Greenwich.

William Haver

Associate Professor of History at Binghamton University. The author of *The Body of This Death: Historicity and Sociality in the Time of AIDS* (Stanford University Press, 1996). He is currently working on a book entitled *Extremity* on the arts of S/M and the political constitution of being.

Gad Horowitz

Professor of Political Theory at the University of Toronto, Canada. Writer, co-writer, and lecturer of several articles and books on democracy, sexuality, and repression, Gad is also a therapist in alternative healing methods and the pleasures of the body.

Pierre Gottfried Imhof

Born in Fribourg, Switzerland, Pierre has resided in London since 1979. Studied art at Middlesex Polytechnic. He has had solo and group exhibitions in Brazil, Britain, Switzerland, Canada and the USA. Projects include *The Ship of Fools* (Zurich, 1989), *New York Diaries* (New York, 1991), and *12 months/365 days/one year in the life of* . . . (London, 1995). He is currently translating Roberto Ohrt's *Phantom Avant Garde*, on the Situationist International.

Arthur and Marilouise Kroker

Internationally recognised writers and lecturers in the areas of technology and contemporary culture. Their extensive writings, published by St Martin's Press, include *Spasm* (1993), *Data Trash* (1994), and *Hacking the Future* (1996). They have co-edited the Culture Texts series, which includes a trilogy of books on contemporary feminist theory: *Body Invaders* (1987, 1988), *The Hysterical Male* (1991), and *The Last Sex* (1993). Currently co-editors of the electronic journal *CTHEORY (http://www.ctheory.com)*.

Ernesto Laclau

Professor of Politics and Director of the Centre for Theoretical Studies in the Humanities and Social Sciences at the University of Essex. Publications include: *New Reflections on the Revolution of our Time* (Verso, 1990); editor and contributor to *The Making of Political Identities* (Verso, 1994); and *Emancipation(s)* (Verso, 1996).

Doreen Massey

Professor of Geography in the Faculty of Social

Sciences at the Open University. She is the author of many works, including *Spatial Divisions of Labour*, *High-tech Fantasies* (with Paul Quintas and David Wield), and *Space, Place, and Gender*. Doreen is also Editor (with Stuart Hall and Michael Rustin) of *Soundings*, a journal of politics and culture.

Jean-Luc Nancy

Born in 1940, he is Professor of Philosophy at Strasbourg (France), and Visiting Professor at various universities, including the University of California (Berkeley) and Berlin University. Writer of more than twenty books, many of them translated into English, including *The Birth to Presence*, *The Experience of Freedom*, and *The Muses* (all with Stanford University Press). Most directly related to the topic of *The eight technologies of otherness* is his book *Corpus* (Paris: editions A.M. Métailié, 1992).

Zachary I. Nataf

Born in Harlem, New York in 1957 and lived in San Francisco and Paris before settling in London in 1980. He took a BA (Hons) in Film at the London Institute/London College of Printing, and a Masters in Drama: The Process of Production at the University of London, Goldsmith's College. A transgender activist, he also writes screenplays, film analysis, and transgender theory and is the author of *Lesbians Talk Transgender*. Zach has also directed the vampire film *The Mark of Lilith*. He currently works in film distribution for the London Filmmakers' Co-op and plans to curate an International Transgender Film Festival in 1997.

Joan Nestle

Author, editor, archivist, and teacher. Co-founder of the Lesbian Herstory Archives (New York), the oldest and largest collection of its kind in the world. She explores in her work the crossroads where sex, memory and history meet. Her award winning publications include *A Restricted Country: Documents of Desire and Resistance* (Firebrand Books, and Pandora); *A Femme–Butch Reader* (Alyson Publications), *Women on Women 1, 2, and 3* (Plume Books), *Sister and Brother: Lesbians and Gay Men Talk About Their Lives Together* (Harper, San Francisco) and *A Fragile Union*.

Catherine Opie

Artist, living in Los Angeles and teaching at the University of California.

Adrian Rifkin

The author of *Street Noises: Parisian Pleasure 1900–40* (Manchester University Press, 1997).

Hans A. Scheirl

Born in Salzburg, Austria in 1956, Hans now lives in London. In 1979 started to make super-8 'home-movies' with fellow students of the Academy of Fine Arts in Vienna. 1992: first feature film *Flaming Ears*, co-directed with Ursula Purrer and Dietmar Schipek. Hans' new film *Dandy Dust* is Transgenre, Transgender, Cybertechno Splatter F/X Cinema and will be out in 1997.

Allucquère Rosanne Stone

Discourse surfer and architectural designer of spaces, bodies, consciousnesses and cyber-trans-sex jam sessions. She is director of the Interactive Multimedia Laboratory (ACTlab) in the radio-television-film department at the University of Texas at Austin. Her latest book is *The War of Desire and Technology at the Close of the Mechanical Age* (MIT, 1995).

Jeliça Šumič-Riha

Research Fellow at the Institute of Philosophy at the Centre for Scientific Research, Ljubljana and Lecturer in Philosophy at the University of Ljubljana. Books include *The Real of the Performative* (Analecta, Ljubljana, 1988); *The Foundations of the Legal Discourse* (KRT, Ljubljana, 1993); *Authority and Augmentation* (Analecta, Ljubljana, 1995); and *The Totemic Masks of Democracy* (ZPS, Ljubljana, 1996). Currently finishing a book on argumentation and the logic of hegemony (Verso Press).

Bernard Walsh

Sculptor/installation artist. Currently completing an MA in the Fine Arts at Central St Martins, London.

Vron Ware

Lives in London and is currently teaching in the School of Humanities at the University of Greenwich. Her published work includes *Beyond the Pale: White Women, Racism and History* (Verso, 1992).

Jeffrey Weeks

Professor of Sociology in the School of Education, Politics and Social Science at South Bank University, London. He is the author of *Sexuality and its Discontents: Meanings, Myths and Modern Sexualities* (1985); *Sex, Politics and Society: The Regulation of Sexuality Since 1800* (2nd ed. 1989); *Sexuality* (1986); *Between the Acts: Lives Of Homosexual Men 1885–1967* (with Kevin Porter, 1990); *Coming Out: Homosexual Politics in Britain from the Nineteenth Century to the Present* (2nd ed. 1990); *Against Nature: Essays on History, Sexuality and Identity* (1991); and *Invented Moralities: Sexual Values in an Age Of Uncertainty* (1995).

Clive van den Berg

Lectures at the University of the Witwatersrand, Johannesburg, in the Department of Fine Arts. He is a practising artist whose interests/works include the imaging of queer identity, land as the bearer of memory, and the transformation of public space to reflect changing social, sexual, and political norms.

Kimball Lockhart (translator)

Co-founding editor of *Enclitic* and served on the editorial board of *Diacritics* 1979–83. He is editor of The Film Issue, *Diacritics* (1985) and translator of Doris-Louise Haineault and Jean-Yves Roy, *Unconscious for Sale* (1993). Editor and co-author, with John S. Beckmann, Tom Conley and Michael Mann, of *Five* (1995), as well as a fiction, *Foibles* (forthcoming). Completing a doctoral dissertation on the verbal and the plastic in Modern Literature and Philosophy entitled 'Non-Correspondence in Baudelaire'. He has lectured on French, American, English, and Continental Literatures; Film, Media, Literary Criticism, and Design Theory at Cornell University, the University of Minnesota, and at the Minneapolis College of Art and Design.

Subject index

Name index